*Partners with the Sun*

# Partners with the Sun

## SOUTH CAROLINA PHOTOGRAPHERS
### 1840–1940

## Harvey S. Teal

PUBLISHED BY THE UNIVERSITY OF SOUTH CAROLINA PRESS
FOR THE SOUTH CAROLINIANA LIBRARY WITH THE ASSISTANCE OF
THE CAROLINE MCKISSICK DIAL PUBLICATION FUND
AND THE UNIVERSITY CAROLINIANA SOCIETY

UNIVERSITY OF SOUTH CAROLINA *BICENTENNIAL*

© 2001 University of South Carolina

Published in Columbia, South Carolina, by the
University of South Carolina Press

Manufactured in the United States of America

05 04 03 02 01   5 4 3 2 1

Library of Congress Cataloging-in-Publication Data

Teal, Harvey S.
  Partners with the sun : South Carolina photographers, 1840–1940 / Harvey S. Teal.
    p. cm.
  Includes bibliographical references and index.
  ISBN 1-57003-384-6 (cloth : alk. paper)
  1. Photographers—South Carolina—Biography. 2. Photography—South Carolina—
History.  I. Title.
TR139 .T39 2001
770'.92'2756—dc21                                                          00-010791

*This book is dedicated to the photographers
identified in this work who created a visual record
of the history and heritage of South Carolina.*

# Contents

# *Acknowledgments*

During the ten years spent in the development of this work, hundreds of individuals and dozens of libraries, museums, historical societies, and other institutions contributed information, research assistance, photographs, advice, and other services to support this endeavor. Just a listing of all of the institutions would be a directory for most of the museums, public libraries, and public and private colleges and universities in South Carolina, as well as a number of institutions out-of-state. Likewise, a listing of individuals would include many staff members of South Carolina institutions and hundreds of private citizens. For this reason the author offers a sincere word of thanks to each individual and institution in lieu of an entry on a long list.

Some individuals and institutions made substantial contributions to the development of this work and, for that reason, are due special recognition. Joe Lee of Covington, Georgia, shared his research and photographic collection on J. A. Palmer of Aiken and on other photographers who worked in both Georgia and South Carolina. Bill Baab of Augusta, Georgia, provided photographs produced by Palmer and other South Carolina photographers. Karin and Jack Ramsay provided information and photographs of George S. and George LaGrange Cook. Dr. George Childers of the University of South Carolina Chemistry Department allowed complete and unrestricted use of his extensive research file on William H. Ellet. Mrs. H. R. Wyman provided extensive information and photographs on her Hamilton family studios in the Pee Dee section of South Carolina. Louise Pettus and Lindsay Pettus shared information on Lancaster, York, and Rock Hill photographers. Mr. and Mrs. Murphy Hall kindly shared information and photographs pertaining to their Nichols family studios. Dr. Charlie Peery provided information about some Civil War Charleston photographers. Researcher and author John Hammond Moore, knowing of this work, noted and pointed out to the author many items about photographers he chanced upon in the pursuit of his research projects. Horace Rudisill generously shared his knowledge of Darlington photographers. George Whiteley, IV, graciously permitted the publication of South Carolina images from his collection.

Pat Hash, Joe Holleman, and Steve Hoffius of the South Carolina Historical Society were especially helpful with research assistance and securing publication rights to photographs in their collection. Steve Massengill of the Division of Archives and History in Raleigh, North Carolina, provided information about North Carolina photographers that enabled the author to discern which photographers operated studios in both states. Bob Zeller provided information and advice on the topic of stereographs.

Without the existence of the South Caroliniana Library and its photographic collection, and the assistance of its dedicated staff, this work would not have been possible. Before her retirement Eleanor Richardson, photographic curator for the library, spent many hours sharing her expertise and information during the research in the library photographic collection. Her successor, Beth Bilderback, not only continued these services, but read and critiqued much of this manuscript. As the library acquired new photographs she quickly informed me about them. Additionally, she placed the orders for securing prints for over half of the images found in this work. Henry G. Fulmer and Laura M. Costello of the library staff were helpful in pointing out and pulling manuscript files containing photographs and getting them copied. Dr. Thomas L. Johnson provided assistance with collections of African American family papers and photographs, especially those of Richard Samuel Roberts. Dr. Allen Stokes, director of the library, supported this endeavor through his staff and directly with information about library collections or historical topics and always with words of interest and encouragement. All other staff members from time to time rendered valuable assistance. The entire library staff cannot be thanked enough for all their assistance and encouragement during the past nine years.

Family members, especially a spouse, are keenly aware of the time and other resources required to complete a study such as this. I am grateful for the patience, support, and understanding my wife, Catherine, bestowed on me as I developed this study.

To all who provided assistance, a very sincere, heart-felt thank you is proclaimed.

*Partners with the Sun*

# Introduction

For many years most American museums, universities, colleges, and other repositories of historical materials collected photographs, but few allocated extensive resources to cataloging, conserving, and publishing them. As an example, in the 1940s and 1950s at the University of South Carolina, Margaret Babcock Meriwether, wife of South Caroliniana Library director Robert Lee Meriwether, created a "picture file" and worked intermittently as an unpaid volunteer cataloging and filing photographs and pictures the library happened to acquire. Far more attention and effort were devoted to collecting and preserving manuscripts, newspapers, books, and pamphlets at the library than to its photographic holdings.

By the 1960s attitudes and practices concerning photographs began to change in South Carolina. Interest in photographic images began to increase. Within three decades authors completed a number of pictorial works on South Carolina counties, towns, and communities that featured the use of "period" photographs. About this time Ken Burns completed his monumental nine-and-a-half-hour PBS "Civil War" television series that also featured extensive use of period photographs, including a number from South Carolina. Quite obviously South Carolina photographs and photography were beginning to receive more attention from some authors and institutions, but was a book on the subject justified, and, if so, what should its emphasis be?

The first step in answering these questions required the determination of what scholars had already written about South Carolina photography and photographers in their theses or in county and state histories, and to what extent this subject had been treated in South Carolina pictorial works. A search of the catalog for the 800 linear feet of graduate theses on file at the South Caroliniana Library (representing about sixty-five years of scholarship at the University of South Carolina, from 1930 to 1965) provided a starting point.

During the sixty-five year period, only two U.S.C. theses had been devoted to the topic of South Carolina photography. For his 1982 M.A. thesis in Journalism, Thomas J. Peach wrote a biography of George Smith Cook, the famous Charleston photographer of the 1849–1880 period. In 1991 Renee Stowe completed for her M.A. thesis in Applied History, "The Development of the Commercial Photographic Industry in Sumter, S.C.," a study of Sumter County photographers from 1849 through 1929.

To determine the extent to which theses had made use of photographic material, fifty linear feet of randomly selected U.S.C. theses (containing 669 theses) were examined. Many of the theses employed diagrams, charts, maps, graphs, tables, and formulas, but no photographs; fifty-two contained photographs. Of these, about 90 percent exhibited very limited

use of photographs, each containing fewer than six images. Forty-nine of these fifty-two theses were devoted to scientific subjects, and the photographs used were generally produced in the past two decades. Researchers used "historical" photographs in only three of the fifty-two theses.

Over the years the South Caroliniana Library had collected several hundred theses devoted to South Carolina topics written by scholars at other institutions in the state and elsewhere in the nation. A search of them failed to turn up any that treated the topic of South Carolina photography. It was clear that, as far as theses were concerned, photographs ranked at or near the bottom of the totem pole in terms of treatment and emphasis or even recognition by the scholarly community.

These older theses generally predated word processors and computers and therefore should not be expected to contain photographs. However, the true test of the importance of photographs to historians and scholars may be gauged by moving beyond theses to published works, and evaluating the extent to which they discussed and included photographs.

Two chronological parameters applied. Since the Frenchman Louis Jacques Mande Daguerre did not share his process with the world until August 1839, the subject of photography would of course be absent from any South Carolina history written before 1840, and since halftone plate printing was not perfected until 1880, no South Carolina history written before that date could include photographs as illustrations.

An examination of books written on South Carolina history from 1880 through 1940 revealed only a limited use of photographs, except in public-school histories. Over time the use of photographs in public-school histories continued to increase and its extent is apparent today just by flipping through the pages of such books.

In the post–World War II period pictorial histories employing period photographs began to appear, on subjects ranging from counties and towns to schools, churches, mills, and other businesses. These pictorial works were commissioned by chambers of commerce, colleges, and local and state historical groups. Undoubtedly the development of photographic collections by state and local historical societies, colleges, and museums contributed substantially to the development of pictorial works. In many instances photographs from these collections also have been used as visuals in broadcast media.

An examination of hundreds of such histories containing period photographs, written both by amateurs and professional historians, revealed one glaring omission. Almost without exception, no mention was made of the photographers themselves. In most captions and credits authors carefully cited the person or institution owning a photograph, but failed to mention its creator. Photographs seem to have been viewed as free "manna from heaven" that required minimal citation. The emphasis was not on the many hundreds of men and women who produced these wonderful images, but on the subjects of the photographs.

A work was long overdue that would identify these men and women, illustrate and describe their work, and give them proper credit and recognition for the preservation of South Carolina's heritage and history. I decided to research and write a book dedicated to that purpose.

# Research

At the outset, I further decided to limit the study to the first hundred years of photography, 1840–1940. Attempting to cover the history of photography in South Carolina to the present would enlarge the study well beyond the limits of a single volume. Additionally, researching and describing the creation and distribution of visual imagery in the last half of the twentieth century presented mountains others seemed more suited to climb.

Even with a limitation of one hundred years, the other requirements to produce this work were considerable: five or more years of time; examination of every South Carolina city directory; examination of school annuals and catalogs; examination of photographs in books, pamphlets, and brochures; research in photographic and manuscript collections in South Carolina colleges, museums, and historical societies and in many privately held collections; scanning of all South Carolina newspapers for photographic ads and other information; examination of photographic collections in out-of-state institutions such as the Western Reserve Historical Society, Library of Congress, National Archives, and the Valentine Museum; review of existing photographic histories; participation in photographic research groups.

In this study two sources of information were consulted to only a limited degree: the United States censuses, and in-person surveys of the communities where photographers worked. The South Carolina totals from the censuses and the state indexes were used, but information from them about specific families and individuals has not been studied. Except in a few cases, field research in towns where photographers worked was not undertaken. However, enough information has been presented here to serve as a foundation for others who may wish to do a detailed study of a particular photographer or location. Obviously a single work such as this could not contain an extensive biographical treatment of each of the more than 600 men and women who practiced photography in South Carolina over an entire century. Finally, considering the monumental amount of sources used in compiling this study, and my desire to remain as true to the original sources as possible, the reader will come across varying spellings of photographic terms (i.e. "Daguerreian," "Daguerrian," and "Daguerrien," just to name a few). Quotations from original news items and advertisements have retained their original—even if incomplete or contradictory—spellings and stylings.

# Organization

Following this introductory chapter, each of chapters 2 through 8 covers a specific block of time ranging from five to twenty years. Each chapter contains a framework of historical information treating both photography and the time period that enables the reader to understand and to place the discussion of each photographer in a proper historical context. In each chapter, towns in which photographers worked are sequenced alphabetically, with photographers presented chronologically by the dates they worked in each of these towns.

Chapters 2 through 8 are *not* designed as a technical history of photography, although in reading them one should be able to gain an overall understanding of the development of

photography from 1840 to 1940. These chapters are instead designed to identify and discuss professional photographers who operated studios in South Carolina and who made their living in part or completely from photography. However, exceptions are made for individuals who were not professional photographers but who did participate in significant photographic projects, such as the Penn School teachers and visitors who created more than three thousand photographs primarily from 1905 to 1944.

These chapters identify when and where a photographer worked in South Carolina. Since the period of time a photographer worked in the state may span the time periods of more than one chapter, information about a given photographer occasionally is included in more than one chapter. However, this practice has been employed sparingly and only when justified by historical considerations. Also, photographers often worked in more than one South Carolina town; information about a photographer is usually presented under the town in which he or she first worked. All of the photographers who worked in a particular town may be identified by consulting the town name in the index of this work. Chapter 9 is devoted to African American photography, 1865–1940, and chapter 10 to female image makers, 1840–1940.

Chapters 11 and 12 are devoted to speciality photographic fields. Chapter 11 describes those photographers who produced stereographs and panoramic photographs. Many books and a national organization of collectors are already devoted to stereographs, with many collectors confining their interests exclusively to this subgroup. Less attention is usually given to panoramic photographs by institutions and the collecting community. Chapter 12 turns its attention to photographers who produced picture postcards. Beginning around the turn of the twentieth century the collection of picture postcards became a widespread hobby and even today continues to be a popular one.

Chapter 13 explores photography as a profession. Aspects of a photographer's work arrangements—such as studio, pricing structure, training, standing in the community, membership in professional organizations, business practices—are treated.

## Illustrations

Although historians generally have not embraced the advice that "a picture is worth a thousand words," it would have been unconscionable to write a history of photography or photographers devoid of photographic illustrations. Wherever space permits and resources were available, a picture of the photographer and a specimen of his work are included.

Sadly, identified examples of the works of fewer than half of the 600-plus photographers are known, and photographs of less than ten percent of these photographers were located. Several factors contribute to this scarcity.

From 1840 to the late 1850s, photographs were primarily daguerreotypes or ambrotypes placed in cases similar to those used for miniature paintings. Only a very few South Carolina photographers identified themselves on these cases.

The tintype that began to appear in the late 1850s and remained popular for many decades thereafter did not provide an easy placement for identifying information by its

creator. The photographer might attach a paper label containing his name, or he could place his name on the tintype case, but photographers did not consistently follow either practice. When *cartes de visite* and stereographs began to appear in the late 1850s, photographers used the paper surfaces of the mounts of these photographs to advertise their name and studio.

Another factor contributing to scarcity of surviving photographs is the amount of work a given photographer produced. When a photographer worked only a few months, he did not create a large volume of photographs from which many examples could survive. Other photographers who worked over longer periods of time still produced only a limited output if competitor studios had the lion's share of business in a particular location. Often photographers, especially itinerants, sold their negatives to their successors. The fact that a particular photographer's name appears on a photograph, then, cannot always be accepted as incontrovertible proof that the named photographer created the negative or "took" the photograph. In the present study, information about the sale or transfer of negatives is detailed under each photographer wherever it is known.

Many photographic enterprises were partnerships or firms employing several assistants to produce photographs. Most firms imprinted only the name of the firm or studio owner on its photographs and gave no recognition to assistants. When possible in this work, assistants and partners in firms have been identified, although in many cases individual photographs are not attributable to particular employees.

Despite these limitations, an impressive array of photographs were located, selected, and reproduced in this work that collectively document and portray both the profession of photography and the history and culture of a people. These photographs and the information unearthed about them and their creators present a one-hundred-year photographic story of South Carolina. Additionally, this work places South Carolina into a larger national context, and by so doing, improves the reader's understanding of photography in the nation.

# Photographic Beginnings and Expansion, 1840–49

History indicates that several individuals may experiment and work independently on the same invention during the course of its perfection. That was the case with photography. The *Great Western* steamship, arriving in New York City from England on 10 September 1839, brought newspapers containing a description of Jacques Mande Daguerre's process for producing what became known as the daguerreotype. On 20 September 1839, copies of a more detailed manual for the process arrived by boat. In August of that year this information had been shared with a number of individuals in France.

Several Americans, including Samuel F. B. Morse, were already aware of Daguerre's process. Morse met Daguerre in Paris on 9 March 1839 to share the newly invented telegraph with him and, in return, receive a briefing on Daguerre's photographic process. Morse was impressed with both Daguerre and his process, although he did not receive full details about it. Within a few weeks after his return to America, he secured Daguerre's election to the National Academy of Science, thereby publicizing his process for the American intellectual community and the world.

Daguerre's process began with a piece of sheet copper thinly coated with a highly polished layer of silver. In order to make this plate light-sensitive, it was placed in a box and exposed to iodine vapor until it turned a light orange color. The plate was then placed in a camera and exposed to light for up to twenty minutes. In order to produce an image on the plate, it required exposure to mercury vapor at about 140 degrees Fahrenheit. After this exposure, the plate was "fixed" by washing it in a weak solution of sodium hyposulfite (a common salt solution was used in the early days). The result of this process was a basic daguerreotype.

In order to prevent abrasion of the image, a case, a glass cover, and a transparent cover known as gilding were features added to the daguerreotype. Over its history many other improvements were made in the production of the daguerreotype, but the basic process remained the same.

William Henry Fox Talbot of England developed a process for recording images on paper in the 1830s and shared it through a publication on 17 February 1839. Since Talbot required anyone using his process to purchase the rights, it never received the acceptance of Daguerre's process and did not catch on in America. However, by the late 1850s improved paper processes developed by others were replacing Daguerre's process.

Photographic historians have recorded the experiments and efforts of many others preceding Talbot and Daguerre. There is general agreement, however, that these two individuals

should receive the lion's share of the credit for developing pioneer processes that made photography possible.

Before 10 September 1839 sketchy news announcements about Daguerre's process inspired some Americans to begin experiments, but after that date, when the process was described in fairly complete detail, many others entered the fray. Much of this experimentation was concentrated in Boston, New York, and Philadelphia, and many photographic historians such as Newhall and the Rinharts chronicled these activities.

By the end of 1840 the pioneer days of photography were coming to a close, and daguerreotypists began to practice their art in the more remote geographical areas of the country. The spread of daguerreotyping has been chronicled by many photographic historians, but these histories do not contain many details of local interest since much of the research uncovering those details was spotty and incomplete. Additionally, if these details were researched and included, these histories would become far too voluminous.[1] In the preparation of this work, these local sources have been researched and studied.

## South Carolina in 1840

In 1840 South Carolina's population numbered 258,084 whites and 335,314 blacks for a total of 594,398. Only 8,276 of the 335,314 blacks were free African Americans. The population of the state was 45% white, 53.5% slave, and 1.4% free African Americans. Most of the 327,098 slaves were laborers on farms and plantations whose chief activity was producing cotton or rice. A small number of local entrepreneurs built textile mills and engaged in a few other manufacturing endeavors, but the state was primarily an agricultural one.

The white population, sparsely distributed over 31,055 square miles in twenty-nine counties, averaged 8,934 per county, or eight persons per square mile. Ten of the twenty-nine counties contained fewer than 6,000 white inhabitants. Charleston, the only large city in the state, reported a population of slightly more than 30,000. Most other towns, including county seats, contained a thousand or fewer white inhabitants.[2]

In South Carolina the pool of potential paying customers for photographs was much smaller than the total population figure. Slaves certainly had limited resources with which to buy photographs. Furthermore, society was dominated by males at the time. Although children and women and, to a lesser extent, slaves could become the subject matter for photographs, potential paying customers for the photographer were primarily confined to the white adult male population—a group numbering about 70,000 or less. Most photographers who worked in South Carolina understood these local society and market conditions.

## The Beginnings of Photography in South Carolina

### Columbia

**WILLIAM H. ELLET.** Ellet graduated from Columbia College in New York City in 1824 and entered the medical school there shortly thereafter. Due to a disagreement with the trustees, the medical school faculty seceded and formed Rutgers Medical School. Ellet,

along with most of the students, followed the faculty. He subsequently earned his medical degree from Rutgers Medical School and, upon graduation, received the gold medal for his class. He became a professor of chemistry at Columbia College in New York City in 1832 and a professor of chemistry, mineralogy, and geology at South Carolina College, now the University of South Carolina, on 4 June 1835.[3]

Serving on the faculty of South Carolina College with Ellet was Dr. Maximilian LaBorde, a professor of metaphysics, logic, and rhetoric. LaBorde authored *History of the South Carolina College,* published in 1859, which contained a short biography of Ellet and gave a firsthand account of the production of the "first" photographic portrait in South Carolina.

> When the first intelligence was brought of the brilliant discovery of Daguerre, Dr. Ellet set to work at once and was taking photograph likenesses before the next vessel crossed the Atlantic. I think I was his first subject—I might say, victim. He had informed me he was getting up an apparatus, and I was under contract to sit for my likeness. When all things were ready, he called, and took me to the scene of his operations, which was in the rear of his laboratory. The spot selected was one of the sunniest in the "sunny South," and the day was one of the hottest in a Southern spring. The reader will bear in mind that the art was now in its infancy, and that the effort of the Professor was strictly experimental. The light was to sketch the picture, and it was conceived that every thing depended upon having enough of its August presence. To make sure of this, a frame of ten feet square was constructed, and upon this was spread a sheet of snow white canvas. I was required to sit with

*Dr. Maximilian LaBorde photograph, taken from a printed carte de visite by Wearn & Hix in the 1899* Garnet & Black. *South Caroliniana Library (SCL).*

my head uncovered in the hottest sun at noon day, and this frame of canvas was placed immediately behind me. My situation was about as painful as that of Regulus when the Carthagenians cut off his eye-lids, and brought him suddenly into the sun, that it might dart its strongest heat upon him. How long I occupied the chair I cannot tell, but I know repeated attempts to catch my likeness were made, and that my poor brain felt as if it would burst from congestion. At last it was announced to my infinite joy, that he had a portrait. I left my seat with the feelings of a martyr. There was a portrait; but what a portrait! The eyes were closed, the forehead corrugated, and the expression hideous. Yet it was a portrait, and the great fact proved that the light could paint it! I preserved it for many years, and though I would not have it to grace the present volume, I would be glad, on account of its historic interest, if it had a present existence.[4]

The exact date Ellet produced this photograph is not known, but, based on corroborating evidence from South Carolina newspapers, it was probably produced in May 1840. On 8 October 1840 a *South Carolina Temperance Advocate* reporter stated he had seen two daguerreotypes, one of Dr. Ellet and one of a Philadelphia scene that he thought Dr. Ellet produced. He further stated that "Professor Ellet had devoted a good deal of time and care to this interesting art, and has several excellent engravings he made of places about Columbia last spring."[5]

Research in the papers of Professor Francis Lieber, a contemporary South Carolina College faculty member and close friend of Ellet, reveals further information about Ellet's early photographic activities. Lieber wrote to his son Oscar in Hamburg, Germany, on 22 September 1839 and recounted a trip he and Dr. Ellet took the day before to a chemist in New York City. He gave this detailed description of the creation of a daguerreotype on 21 September 1839.

My Boy, Yesterday I saw some of those images made by the sun upon silver. You recollect you saw paper in Columbia which the sun made black. Dr. Ellet took me yesterday to a chemist. He took a copper plate, plated over with silver; this silver side was placed over iodine, a substance chiefly obtained from sea-weed. So soon as it is exposed to the air, dark vapors of a violet colour rise. These colored the silver blackish. The plate was then placed in a camera obscura, which was directed to the object we desired to take. It was a steeple, and a statue on a cupola. We left it for nine minutes and when we took the plate out there was a minute and most accurate image of these objects, so accurate, that everything appeared only the clearer and more minutely accurate when looked at through a magnifying glass. Some acid was then put upon the plate which makes the image permanent, so that it cannot fade, or be wiped off. Now mark Oscar, it is not the heat of the sun which produces the picture, for the plate may be placed over coals and it does not change. It is the light, and especially the violet ray in the light, which affects the metal. How wonderful! But what is it, you will say, how can the light scratch in the plate as it were? Perhaps the light is a substance inconceivably fine, but still a substance, which chemically

*Ninth-plate daguerreotype by an unknown artist*
*of Oscar Lieber, the recipient of his father's letter*
*describing Professor Ellet's daguerreotype production*
*on 21 September 1839. SCL.*

affects the plate. Perhaps man will discover yet the truth; whether or no, it will be, as I have often told you, one of the choicest blessings in heaven when God who knows all will reveal the principles and last laws of his creation, to those of his children who have been attentive here, and strove and longed to know the truth, and find his wisdom in all things.[6]

Ellet took a leave of absence from South Carolina College from 25 May 1839 to the beginning of school in October for the purpose of serving on the board of visitors of the United States Military Academy at West Point.[7] During this period of time he either visited New York City a number of times, or actually lived in the city.

On 28 August 1839 Ellet purchased for South Carolina College, from James R. Chilton in New York City, chemicals valued at $54.23.[8] He represented the college in a long-standing business relationship with Chilton. In all likelihood, Ellet returned to Chilton's chemical store with Lieber on 21 September 1839 and then produced or assisted in the production of the above described daguerreotype of what was probably a nearby building. This event took place only eleven days after the *Great Western* steamship brought newspapers containing details of Daguerre's process to America and only one day after the arrival of detailed manuals for the process!

Photographic historians such as Robert Taft, Beaumont Newhall, and Floyd and Marion Rinhart discuss the topic of who first produced a daguerreotype in America. A case was made for D. W. Seager, who reported he produced one on 16 September 1839. Several days later Mr. Seager's work was reported on display in James R. Chilton's chemical store at 263 Broadway, New York City. Samuel F. B. Morse confirmed that Seager produced a daguerreotype prior to the production of his first on 28 September, but he did not confirm the 16 September date. We have only Seager's word on that date.[9]

Ellet's daguerreotype was produced only four days after that reported by Seager and must be ranked as one of the very earliest produced in America, even preceding by a week

the first reported by Samuel F. B. Morse. More importantly, confirmation of Ellet's daguerreotype occurred on 22 September, the very day after its production, by a third party—Dr. Lieber. The quality of the image judged by 1839 standards must have been quite good, since Lieber described the minute details present when he and Ellet examined it under a magnifying glass.

The fact that the literature reflects no claim by Chilton or another chemist for producing the first or even one of the earliest daguerreotypes in America suggests the chemist supplied Ellet with the materials and Ellet actually produced the image. In fact, that was probably the case with Seager as well, since Morse reported on 28 September 1839 that Seager "had been having some results at Mr. Chilton's on Broadway" and since his work was displayed in Chilton's window.[10] The fate of the image produced by Ellet is unknown, but it too may have appeared in Chilton's window.

Apparently Ellet experimented with light-sensitive paper prior to his work with Daguerre's process.[11] These experiments would have taken place sometime before June 1839 since Lieber's son Oscar left Columbia for Europe that month and since Ellet's leave of absence began on May 25. His experimentation with light-sensitive paper was probably based on William Henry Fox Talbot's brochure on "Photogenic Drawing" published in February 1839.[12]

On 19 February 1841 the *Charleston Courier* carried a long article giving a detailed account of the Daguerre process. Toward the end of this article the reporter stated, "To Dr. Ellet of the South Carolina College, Dr. Mitchell of Philadelphia, and Dr. Morse of New York, the chief credit of these discoveries are due. And the first named of these gentlemen has also discovered a method of making the picture etch itself at the moment it is taken. It is said he intends publishing an account of this method."[13]

On 4 March 1841 the *South Carolina Temperance Advocate* of Columbia carried a correction to the 19 February *Courier* article.

> The correspondent of the *Courier* is mistaken in this. Dr. Ellet is unquestionably entitled to great credit, for the zeal and success for which he has presented this interesting discovery, and we know no chemist, who is more likely to discover a process for making the picture etch itself; but as yet, this discovery has not been made, nor has Dr. E. any idea of publishing such a thing. He has, however, discovered a principle, which if carried out, promises fair to produce this result. The editor of the *Courier,* in speaking of Mr. Mayr's (of Charleston) apparatus says it is so highly improved, that he produces those likenesses in the shade. That is by no means a recent improvement. Some of the very best pictures Dr. Ellet has produced have been taken in the shade. Some in the shade of a house, and others on cloudy if not rainy days.[14]

On 10 March the *Courier* acknowledged these corrections.[15]

The South Carolina College Treasury records from 1835 to 1841 provide clues as to when Ellet bought daguerreotype supplies from supply houses. After these purchases he began his experimentation and production of daguerreotypes at the college.[16]

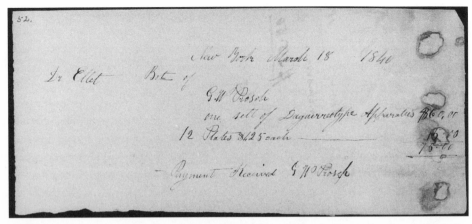

*18 March 1840 receipt from G. W. Prosch to Dr. Ellet for the purchase of a daguerreotype camera and other equipment for the South Carolina College. Treasurer's Records, South Carolina College Archives, SCL.*

Before 27 November 1839 Ellet purchased for the college "Plated Copper for Daguerreotypes, Plate of pure silver for Daguerreotypes, silver for nitrate, iodine and a Lens & Box for a Camera Obscura." He probably bought these items from James R. Chilton in September 1839, while in New York City, and had them billed to the college.

On 18 March 1840 South Carolina College paid the firm of G. W. Prosch for "one sett of Daguerreotype apparatus" and "12 plates at $1.25 each." In August 1840 Dr. Ellet bought for the college from Prosch a "Meniscus for Daguerreotype" and a "Small Daguerreotype apparatus."

In September 1840 Ellet purchased from Cornelius & Co. in Philadelphia "24 Plates for Dague." In the same month Ellet bought a thirty-dollar mahogany camera from G. W. Prosch for the college. As late as December 1840 the college bought an unidentified item or part for a "Camera Obscura" (a portion of the original manuscript voucher was missing, thereby preventing the identification of this item or part). The 1841 and 1842 college records contain no evidence of purchases indicating photographic activities by Ellet.

These South Carolina College records indicate that LaBorde was not merely speaking figuratively when he stated that, after the publication of the Daguerre process, Ellet was "taking photograph likenesses before the next vessel crossed the Atlantic." His experimentation began as early as September 1839 and continued at least into 1841. He probably produced "likenesses" of Columbia buildings and street scenes before he produced the photograph of LaBorde about May 1840.

In addition to personally experimenting in the production of daguerreotypes, Ellet almost certainly taught his students the principles of Daguerre's process since college funds were used to purchase daguerreotype equipment and supplies. However, a review of graduating class rosters of the college for six years, from 1839 to 1845, did not reveal a single name identifiable as a daguerreotypist. Ellet probably included the chemistry involved in the daguerreotype process as a part of his instruction in the larger context of chemistry as a whole.

At this time, from 1839 to 1842, the New York City scientific community in chemistry was apparently close-knit and cozy. This was demonstrated in 1842 when Morse submitted his telegraph to the Committee of Arts and Sciences of the American Institute in New York, seeking their endorsement as he attempted to market his invention. This committee was composed of three chemistry professors from New York City colleges; the already mentioned local chemist, James R. Chilton; Dr. William H. Ellet, formerly of New York; and two other men, Edward Clark and Charles A. Lee, M. D. Because of this fact and the fact that Ellet demonstrated the telegraph in Columbia in the 1840s, Ellet and Morse undoubtedly also would have discussed Daguerre and photography in the course of their associations together.[17] Chilton, Ellet, Morse, and one of the three above mentioned college professors, John W. Draper, all experimented either together or singly with Daguerre's process in September 1839.

Ellet left South Carolina College in November 1849 and was employed by the Manhattan Gas Company until his death in 1859. At Ellet's funeral, held in the New York City home of a Dr. Gilman, a mourner remarked, "All the men of science of New York accord him the highest genius for scientific pursuits."[18]

Although many facts about his photographic achievements remain unknown and a complete appraisal of his contributions is difficult, sufficient information has been presented for summarizing Ellet's known accomplishments: he experimented with using the sun to blacken paper before working with Daguerre's process; produced a daguerreotype in New York City on 21 September 1839; experimented in making daguerreotypes in Columbia in the fall of 1839; produced credible daguerreotypes, including portraits, at least by the spring of 1840; experimented for more than a year in photography; probably taught his students about the daguerreotype process in his chemistry classes; produced photographic work well-known in South Carolina; was probably the first person to produce a photograph in South Carolina.

### Charleston

In late 1840 Charleston was the location of the first commercial photographic gallery in the state. As with information about Daguerre's process and news items concerning Ellet's work in Columbia, other information treating photographic matters began to appear in local newspapers and periodicals as a prelude to the establishment of the first commercial gallery in South Carolina.

In February 1840 George Prosch advertised in the *Charleston Courier* his "Daguerreotype apparatus" for sale at thirty dollars. He also advertised plates manufactured by Corduan, Perkins & Co. and instructions for making daguerreotypes.[19] The periodical the *Southern Cabinet of Agriculture, Husbandry, Rural and Domestic Economy, Arts & Sciences, Literature, Sporting Intelligence, Etc.*, published in Charleston in 1840, carried short items about photography.[20] The February issue reported the achievement of M. Bayard, a clerk in the French Finance Department: "By the means of a chemical process he has succeeded in fixing the impressions of the camera obscura upon paper." The April issue carried a reprint

of a news item from the *New York Dispatch* to the effect that "Mr. A. S. Walcott has introduced some very striking improvements in this new discovery." An item concerning Professor O'Shaughnessey's use of gold with Daguerre's process was reprinted from The *Asiatic Journal* in the July issue, and the September issue reported an improvement by Daguerre himself.

On 12 May 1840 the *Charleston Courier* reported that Mr. J. P. Beile had a daguerreotype of a French hotel on exhibition at his bookstore on King Street.[21] The report also included an abbreviated description of Daguerre's process. The 29 July 1840 issue of the *Courier* reported that Mr. Beile had two daguerreotype miniatures of William Gilmore Simms, the South Carolina author, on display in his bookstore.[22] At this time Simms had published a history of South Carolina and had just returned to Charleston the previous Saturday from visiting his literary agent in Philadelphia.[23] While there he probably visited the studio of Robert Cornelius and secured these two daguerreotypes. In addition to the usual benefits derived from showing examples of this new "art," Beile may have used them to publicize his store and Simms' new history book.

CHARLES TAYLOR. Taylor placed this ad in the *Courier* On 29 December 1840 and thereby probably inaugurated commercial photography in Charleston and South Carolina: "Perfect likenesses taken by the action of light, in miniature form, by this new and beautiful invention, on moderate terms, by Charles Taylor, at the bend of King St. over Mr. John S. Bird's store. Ladies and gentlemen are invited to call and examine the apparatus and witness the mode of its operation. Rooms open every fair day from 9 a.m. to 2 p.m." The next day, 30 December 1840, he advertised again and stated his price of five dollars per likeness.[24]

In January 1841 he continued to advertise his business. A pupil of Samuel F. B. Morse, Taylor soon failed as a businessman and was not able to pay Morse for his instructions in the art.[25] Whether Taylor was in Charleston or had moved to another town when he failed is not clear.

JOHN HOUSTON MIFFLIN. By 6 January 1841 John Houston Mifflin from Philadelphia opened a daguerreotype gallery at 137 King Street in Charleston. He advertised the production of daguerreotypes "as faithful in resemblance as the reflection of the face in a mirror." He further advertised "architectural views are represented with perfect corrections; statuary, whether in a group or single, copied with fidelity." Mifflin's stay in Charleston lasted no more than six weeks. He was in Augusta, Georgia, unveiling the daguerreotype there on 20 February 1841.[26]

CHRISTIAN MAYR. The *Courier* reported on 19 February 1841 that "There are several individuals, now in the city, who practice the art; and we observe that Mr. C. (Christian) Mayr, who was so greatly admired as a portrait and fancy painter among us last winter and spring, has returned, and opened a studio in King Street, opposite Hassell St. over the store lately occupied by Jonathan Bryan & Son, where in addition to his labors with the pencil, he produces full length likenesses with the daguerreotype."[27] No identified examples of Mayr's photographic work are known today, but many individuals and museums display with pride paintings executed by Mayr. His painting *The Fire Marshals* hangs in the city hall of Charleston.

The use of the words, "several individuals" by the *Courier* reporter probably included Mayr, Mifflin, and Taylor, but there may have been others who relied on hand bills for advertisement and never placed ads in the local papers. In any event, by the spring of 1841 Charleston was on the way to becoming a regular stop for itinerant artists from the North. The establishment of permanent galleries by resident or out-of-state artists did not occur for several more years.

## Photographers, 1841–1849

### Abbeville

**JOHN LEIGH.** Leigh, late of New Orleans, advertised in July 1849 to the citizens of Abbeville that he planned to be in town for only a short time and would provide "a fine likeness and picture of themselves and friends." John Leigh was the "Leigh" of the Augusta, Georgia, firm Leigh, Tucker & Perkins, which operated in the early 1850s.[28]

### Camden

**ISAAC B. ALEXANDER.** Alexander, a native of Camden, was a miniaturist and jeweler who also had an interest in science. Due to these professional interests embracing both science and art, it is understandable that Daguerre's process would have been attractive to him. He first appeared in Columbia in December 1842 at a gallery operated jointly with Dr. Adam Libolt. By March 1843 he produced "Photographic Miniatures" in Camden from a room in the courthouse. The Rinharts show him in Charlotte, North Carolina, in June 1843. In 1860 Alexander painted the Secession Banner that hung in the hall where the Secession Convention met in Charleston.[29]

Alexander did not advertise again in Camden until April 1845 when he took "a room at the residence of J. R. Smith, for a few weeks, where he [was] prepared to take miniature likenesses in a very superior style, with all the late improvements." His next and last ad in Camden papers appeared in March 1848, advertising his services from a room he had fitted up over the post office.[30]

Alexander's chief sources of income were his painting and the jewelry business; daguerreotyping was a side line. His son, William S. Alexander, would become an excellent local photographer in the last quarter of the nineteenth century and is discussed in chapter 5.[31]

One example of Alexander's photographic work has been located—a colored daguerreotype of Jane Douglas Young (1797–1853). It demonstrates an excellent mastery of the art by Alexander.

**A. COBURN.** Coburn's ad for producing "Daguerreotype Likenesses," which ran in the *Camden Journal* of November 1848, began with a rhyme: "You who have beauty, should to Coburn take it. You who have none, should go and let him make it." His gallery was over the post office, probably in the rooms vacated by Alexander. This rhyme was also carried in

the *Danville Register* (possibly Danville, Virginia). He seems to have moved on after a short time and was reported in Charlotte, North Carolina, the next year.[32]

### Charleston

**B. A. and W. W. Chilton.**   In late 1841, B. A. and Washington W. Chilton arrived in Charleston from New York City and began producing daguerreotypes at 269 King Street. They placed examples of their work on display at the Charleston Hotel, Pavilion Hotel, Planters Hotel, and at their gallery on King Street. On 17 December 1841 the *Charleston Courier* reported, "We have been much pleased with the inspection of several miniature likenesses, taken after the manner of Mons. Daguerre, of Paris, by Messrs. B. A. & W. W. Chilton, No. 269 King Street three doors above Wentworth. Among the finished specimens they exhibit, of this beautiful art, are admirable likenesses of the Rev. Dr. Capers and his son, F. W. Capers. The Messrs. Chilton succeed in taking likenesses with perfect accuracy in the shade and in any kind of weather, and occupy the time of the sitter but a few seconds." The Chiltons continued their stay in Charleston for a time in 1842.[33]

**C. Page.**   In early January 1842 one C. Page opened his gallery on Meeting Street in the boarding house of Mr. J. Durea and stated he would be in town a short time. An H. C. Page was an artist in Charleston in 1830 and may have been the "C. Page" of 1842.[34]

**Chilton & Co.**   This firm opened a gallery in February 1842 at 188 King Street, opposite the Victoria House, and advertised the taking of photographic miniatures. What relationship, if any, they had with B. A. and W. W. Chilton is unknown. The Rinharts listed a Chilton & Co. at 281 Broadway, New York City, in 1844 and 1845.[35]

**The Fletchers.**   In February 1842 the *Charleston Courier* carried two advertisements for a Phrenology Office and Daguerreotype Gallery operated at the same address by a man and his wife. Mrs. A. Fletcher was the daguerreotypist, and her short ad read: "Daguerreotype miniatures executed in a very superior manner by Mrs. Fletcher, 149 Meeting Street. Charges including case or frame, $5." John Fletcher advertised his services as a phrenologist for $1.00 per examination.[36]

Photographic historians Susan M. Barger and William B. White state that "This science [phrenology] was based on both visual and tactile information about head shapes and daguerreotypes provided records of specific 'types' that could be studied and reproduced in journals." They further note that some American daguerreotypists also practiced phrenology.[37]

The other and more significant point of interest concerning the Fletchers in South Carolina is the fact that Mrs. Fletcher was the first female on record to operate a commercial gallery in the state. In fact, another did not appear for almost three decades. Mrs. Fletcher advertised her gallery for only a few weeks, while Mr. Fletcher advertised his phrenology business for several more weeks.

**John C. Simons.**   In 1842 another "first" occurred in Charleston and South Carolina. John C. Simons advertised for sale a complete line of daguerreotype supplies at his "Artists Repository" at 208 King Street. How long he carried a daguerreotype line in his store is unclear, but his was the first such establishment on record in South Carolina. The

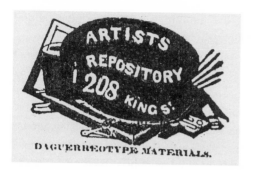

*Artwork for John C. Simons ad.* Charleston Courier, *12 July 1842. SCL.*

fact that his store featured this line of supplies suggests that there was sufficient business in the art in Charleston and the geographical area served by the city to support such an endeavor. At this point in time Charleston merchants drew customers from parts of Georgia and North Carolina and all of South Carolina. Simons demonstrated his continued association with photography in 1849 by serving as agent for the Langenheims in their efforts to market rights to William Henry Fox Talbot's photographic process in South Carolina.[38]

MR. PETTEE. In early January 1843 a Mr. Pettee informed the local citizenry that he would be leaving his rooms in Victoria House in a few days. "Persons having Paintings, Engravings or specimens of Architecture, which they wished preserved, can have it done in a most perfect manner."[39]

ANONYMOUS. An unnamed daguerreotypist advertised in July 1843 that "improved colored daguerreotypes" were being "taken at the Saloon of the New Theatre" and that specimens were on exhibit at Cleveland's drug store on King Street.[40]

WHITEHURST & MANNING. In February 1844 the firm of Whitehurst & Manning arrived from New York and opened a gallery at 190 King Street. In their work the Rinharts include extensive biographical notes on a Jesse H. Whitehurst who operated a gallery in Norfolk, Virginia, from 1844 to 1846. The Whitehurst of Whitehurst & Manning was probably that of "Jesse" himself since J. H. Whitehurst advertised his imminent departure from Charleston in June 1844. As Manning's name does not appear in this ad, he may no longer have been associated with Whitehurst.[41]

A. PAULSIN[SON] & CO. By July 1844 Mr. A. Paulsin[son] & Co. produced "Miniature Portraits" from their room in tenement No. 4, Burrell's Row, on Meeting Street. They advertised "several" years experience, up-to-date equipment from abroad, reasonable prices, and "Instruction in the art . . . at less than half the expense of going to the North for that purpose."[42]

JOSEPH PENNELL. Pennell's photographic career spanned the period from 1840 to 1848, and was primarily spent in New York City; Cabotsville and Boston, Massachusetts; and Waterbury, Connecticut. Pennell—a pupil of Samuel F. B. Morse and a former partner of Albert Southworth—came to Charleston in 1844 to teach in a private school, and while in town ordered "plates and cases" to be sent to him. Apparently he continued his daguerreotyping activities in Charleston for a time.[43]

**A. BEALS & CO.** In August 1845 this firm located at 190 King Street, opposite Victoria House, and produced "Daguerreotype Likenesses." As with most of their predecessors, their stay in Charleston was short. The Rinharts mention an A. Beals & Co. who operated a gallery on Broadway in New York City from 1846 to 1854.[44] The A. Beals & Co. in Charleston in 1845 were probably the same gentlemen.

**SAMUEL BROADBENT.** Another associate of Samuel F. B. Morse, Samuel Broadbent, visited Charleston in October 1845 as an itinerant daguerreotypist and operated a gallery at 271 King Street for a couple of months. Shortly before Christmas 1845 he opened a gallery in Columbia in the same rooms of Maybin's Hotel that were occupied by Dr. Libolt the previous summer. His ad carried the title "colored Daguerreotype portraits."[45] Broadbent is recognized by photographic historians as one of the important pioneers in the field of photography.

**STERLING C. MCINTYRE, J. J. CRYGIER AND W. S. MCVAUGHT.** In April 1846, 190 King Street was occupied by Mr. Sterling C. McIntyre and his associate, J. J. Crygier— a former assistant to John Plumb, Jr. For most of the next three years, from 1846 to 1849, McIntyre operated or maintained an interest in a Charleston gallery.

In an effort to allay fears about the permanence of daguerreotypes, McIntyre ran an ad in November 1846 quoting the English scientist Michael Faraday: "Likenesses taken by this interesting art in its earlier days were liable to fade in a few years. The late improvement of Chemical gilting on the surface of the plate, forms a pure image of silver and gold which must retain its brilliancy for ages."

In this same ad McIntyre gave specific instructions to patrons about how to dress before coming to his gallery: "Ladies are respectfully recommended to dress in figured or dark material, avoiding white or light blue; a scarf or shawl gives a pleasing effect to the picture. Gentlemen a black or figured vest, also figured scarf or cravat; so that the bosom be not too much exposed. Children plaid stripped or figured dresses; lace work adds much to the beauty of the picture."

McIntyre's gallery frequently closed for intervals of several months while both he and Crygier pursued the art in other South Carolina towns and in other states. McIntyre

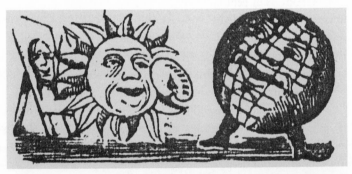

*Nationally used artwork employed by Sterling C. McIntyre from 1846 to 1847
to advertise his gallery.* Charleston Courier, *SCL.*

*Daguerreotype of Edisto Island resident William Seabrook, produced by Sterling C. McIntyre. McIntyre identified his work by placing a ribbon carrying his name on the table by Seabrook's left hand. Courtesy of Mr. and Mrs. Parker Connor Jr. and Henrietta S. Sanders. This print courtesy of George S. Whiteley, IV.*

attempted to dispose of his Charleston gallery during the period from 1848 to 1849. In November 1849 he advertised in the Charleston press the opening of a gallery on Broadway in New York City and that Mr. W. S. McVaught would continue his business on King Street. McIntyre left New York City in 1850 and went to California. Nothing further was heard of W. S. McVaught.[46]

From June to September 1848 J. J. Crygier operated a gallery in Greenville at McBee & Thurston's Store, and in September he advertised "Colored Daguerreotypes." In May 1849 he put in a short stint in Sumter, returned to Greenville in July, and in November showed up in Laurens in a room in the Masonic Hall over D. Bailey's Mercantile Store.[47]

**CHARLES L'HOMDIEU.** L'Homdieu first advertised his gallery at the corner of King and Market Streets in February 1847. In October that year, after returning from the North, he touted "Doubled Gilded Daguerreotypes," a process that "matured while at the north." His ad gave a general description of the process, stating that it involved placing more gold on the surface of daguerreotypes to make them more durable and give them a richer finish. He also stated that all the old, experienced operators approved of and used the process.[48]

L'Homdieu's interest in and experiments with gilding continued, and on 25 October 1852 he received a patent for gilding daguerreotypes by electrolysis. This process had been tried in the 1840s by a number of artists, but had been abandoned. According to L'Homdieu, his patented process was designed to replace the cloudy appearance of earlier efforts with images of deep, warm, golden tones.[49]

Little is known about L'Homdieu's origins, his training in the art, or his career after he sold his gallery in August 1853.[50] He was an experimenter and innovator in his field, and

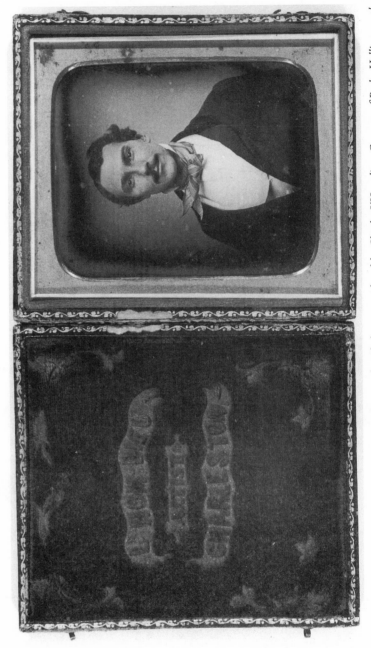

*Daguerreotype of an unidentified man, produced by Charles L'Homdieu. Courtesy of Becky Hollingsworth.*

# L'HOM-DIEU'S
# DAGUERRIAN GALLERY
### AND
# PHOTOGRAPHIC DEPOT.

## OLD ESTABLISHED STAND,
### *South-east corner King and Market-sts.*

Having every facility *necessary* to the *perfection* of the art, is

prepared to execute

# LIKENESSES
In a style which stands unrivalled.

## Apparatus, Plates, Cases, Chemicals &c.
*For sale on reasonable terms.*

☞ Instruction given in the art.

ABOVE: *Charles L'Homdieu ad.* Charleston City Directory, *1849. SCL.*

*Charles L'Homdieu used this ad and artwork to advertise his gallery in 1847 and 1848.* Charleston Courier. *SCL.*

he supplied Charleston with its first established gallery. The term "established gallery," as employed here, refers to a gallery in operation long enough to have a local track record and an established clientele.

In 1851 he exhibited eleven daguerreotypes in the South Carolina Institute, the title for the first State Fair.[51] Unfortunately, only a list of the exhibitors was published and none of the winners. Enough examples of his work have not surfaced to judge its quality. However, it must have been quite good since he was in business in Charleston for about six years and was an experimenter and inventor.

**JOHN H. LUNQUEST.** In March 1847 Lunquest advertised his return to Charleston and that he had "been instructed in the art of taking Daguerreotype Miniatures, in the latest style by the best operators in America." His gallery was at 261 King Street, next to Babcock's bookstore, and must have contained more space than he needed since his ad stated, "A few gentlemen can be accommodated with boarding." Since Lunquest stated in March 1847 that he was "returning to Charleston," he apparently had been there the previous year or even earlier.

He must have been pleased with his sojourn in Charleston since he returned to his old location in January 1848. His March 1848 advertisement featuring "Skylight Pictures" made his the first gallery in Charleston to tout this innovation. In June 1848 he advertised his imminent departure from the city. In January 1849 he located a gallery in Griffin, Georgia, and bought supplies from George S. Cook, operator of a gallery there. Cook located in Charleston several months later.[52]

**JOHN McDONALD.** In January 1848 John McDonald from New York advertised his gallery at 212 King Street as producing images that "are of superior beauty and excellence, having a brilliant white tone; and when required will be colored up to nature, surpassing the beautiful style of Miniature Paintings." His name appeared in the 1849 city directory as a daguerreotypist, and he apparently left the city that year.[53]

**PERRY & BROTHER.** On 25 January 1848 Perry & Brother thanked the citizens of Charleston for their liberal patronage two years before and advertised that they had taken their old stand at 267 King Street. The Rinharts also listed a gallery owned by a Perry & Brother on Broadway, New York City, from 1846 to 1847. William A. Perry, trained by John Plumb, Jr., was considered one of the top operators in the country. The Perrys seem to have spent a part of only two winters in Charleston, 1846 and 1848.[54]

**MR. SIMS AND WILLIAM M. RANTIN.** The year 1849 proved to be an eventful one for daguerreotyping in Charleston. L'Homdieu's gallery was in operation and McIntyre still maintained a presence in the city with Crygier and McVaught. In May an itinerant daguerreotypist by the name of Sims located on King Street, but he was soon gone. In July William M. Rantin located on King Street, two doors below John Street, and was again listed in Charleston in 1852, but on Radcliffe Street.[55]

**GEORGE SMITH COOK.** The most significant photographic event of 1849 in Charleston was the October arrival of George Smith Cook. Cook was born in Stratford, Connecticut in 1819. His parents died when he was very young and he was reared by his maternal grandmother in Newark, New Jersey. At the age of fourteen he left home and

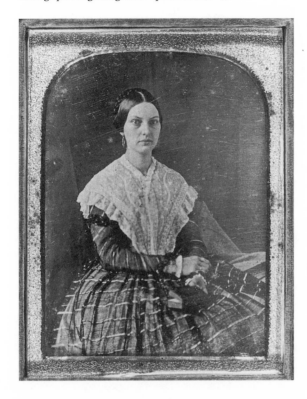

*Quarter-plate daguerreotype of an unidentified female, produced by George S. Cook in Natchez, Mississippi, in 1847, while he was an itinerant. Some of the lady's jewelry is hand-tinted. SCL.*

made his way to New Orleans. He soon became interested in painting and followed that artistic pursuit until the daguerreotype made its debut. This new art held an attraction for him and he began to visit a local gallery to experiment with and to study daguerreotyping. Before much time elapsed, he mastered this new medium and became one of the most accomplished daguerreotypists in the city.[56]

Beginning in late 1846 and continuing for about three years, Cook worked as an itinerant daguerreotypist, traveling from St. Louis to Mississippi, Alabama, Georgia, and Charleston, South Carolina. He established galleries along the way, which he left in the hands of operators he had trained. Lawrence A. Koscher and Howard Dearstyne state that "to George S. Cook is due the credit for the early spread of photography throughout the inland South. Long after he opened his business in Charleston his erstwhile students continued to look to him for advice and to purchase through him the chemicals and photographic equipment which they needed in their work."[57]

When Cook arrived in Charleston, at least two dozen other daguerreotypists had preceded him over the previous nine years. Due to his experience and contacts, he very quickly developed what could be described as an established gallery. For the next thirty-one years he maintained a gallery in the port city and, on occasion, in other states. He was destined to become the premier southern photographer during the Civil War.[58]

**MONTGOMERY P. SIMONS, H. S. SMITH, AND J. H. LONGMAN.** A few weeks after the arrival of Cook in 1849, another significant event occurred. A pioneer daguerreotypist

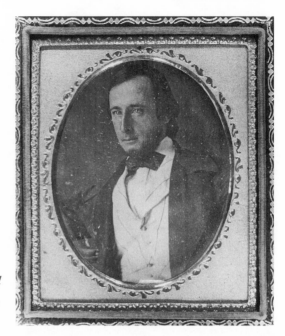

*Sixth-plate daguerreotype of an unidentified man, produced by George S. Cook. SCL.*

from Philadelphia named Montgomery Pike Simons arrived in town and established a gallery. The career of Mr. Simons was treated in detail by Laurie A. Baty in The *Daguerreian Annual,* 1993.[59]

The exact date Simons arrived in Charleston has not been determined, but it was prior to 20 November 1849, since he won a silver medal on that date for the best daguerreotype miniature in the South Carolina Institute, the first State Fair. His first known advertisement in the local papers appeared on 20 November and featured complimentary quotes from the Philadelphia press. On 13 March 1850 a Simons & Co. ad referred to Simons having taken more than one thousand daguerreotypes "over the last four months." This strongly suggests he set up his gallery in late October or early November 1849.[60] The fact that many northern daguerreotypists liked to come south in the fall (taking advantage of a warmer climate and a higher sun that permitted longer working hours) further supports a fall establishment date for Simons' gallery.

In the fall of 1849 keen competition existed in the Charleston daguerreian community and was reflected in the local press. Both the Rinharts and Baty report the following ad Simons placed in the local papers when a brother photographer questioned his winning the silver medal in the State Fair.

> We have understood that a brother Artist has, upon several occasions, expressed dissatisfaction regarding the award made us at the late Fair held in this city.
>
> We are at a loss to know on what grounds this dissatisfaction is based, is it because we have by our industry, perseverance and indefatigable researches in the profession, always been successful in bearing off the palm? Or is it because our pictures "were not all made in this State." As an American citizen we claim the

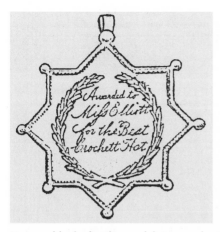

*Front and back of a silver medal given at the 1849 South Carolina Institute for the best "Crochett Hat."*
*A similar medal was probably given for first place in all categories, including daguerreotypes. Undated*
*Columbia newspaper clipping. Collection of the author.*

privilege of submitting our specimens before the scientific bodies of each and every
state in the Union for their consideration and impartial decision, yet notwith-
standing this, we are willing to meet this last objection by placing three Daguerreo-
type Pictures, which were executed by us in this city, and exhibited among our
specimens at the Fair, along side any three our neighbor may select from his entire
gallery, the respective merits of each to be decided by a committee of Artists, cho-
sen by both parties. This we conceive to be the fairest way of settling, and as it is
the only question which the public can be interested in, we hope our disappointed
friend will be willing to have it honorably tested.[61]

Who was the local artist that raised questions about this matter? There is no ironclad evi-
dence identifying this individual, but certain facts strongly suggest he was none other than
George Smith Cook. Cook came in second at the 1849 fair, receiving a diploma for his entry.
No other photographers besides Simons and Cook were included in the 1849 premium list.
Cook, therefore, qualified as the aggrieved party. Simon and Cook placed competing ads
in the local press for the next three months. Cook did win first place in the fair the next
two years.[62]

An incident occurred in Charleston in 1856 that sheds further light on Cook's com-
petitive spirit and faith in the quality of his work. Tyler & Co, a "fifty-cent gallery" with
twenty employees, located in Charleston in late 1855 and provided serious competition to
Cook and others who sold their daguerreotypes for a dollar or more. On 31 March 1856
Tyler & Co. placed an ad in the local paper to address the opposition raised to them.
George S. Cook was obviously their chief opposition as he had been for Montgomery P.
Simons seven years earlier.[63]

Simons' ad about the complaining neighbor artist used "we" and "our" more than
two dozen times and the 13 March 1850 ad carried the firm's name as M. P. Simons & Co.

**HEAR**
**TYLER & CO.**

**CITIZENS LISTEN.**

TYLER & CO. wish the public to distinctly understand that the wind raised in opposition to them is backed by certain Daguerreotypers of Charleston with the aim of running TYLER & Co. aground. If they had succeeded in their weak attempt, the price of DAGUERREOTYPES would have been immediately raised to their former exorbitant rate, $2.50. The fifty cent shop in the neighborhood was started to do the worst kind of work that the public would become disgusted with cheap pictures. TYLER & Co. have too strong a foothold, and will thoroughly pick, scald and *Cook* their enemies ere they leave. The "galled jade winces."          1          March 31

*This Tyler & Co. ad was placed in response to criticism of their gallery. Note Cook's name is italicized.* Charleston Courier, *31 March 1856. SCL.*

A 17 September 1850 ad indicates that H. S. Smith was an associate of Simons when he established his gallery in Charleston, and that Smith probably produced most of the photographs while the firm operated there. Smith stated "he was the sole acting partner since November last." Certainly by September 1850 Simons ceased to have any presence in Charleston. In 1851 Smith called his gallery "The Southern Photographic Depot" and in July brought J. H. Longman, formerly of Columbia, into the business. The name of the firm became Smith and Longman and they operated at 233 King Street at least until November 1851.[64]

In summary, Montgomery P. Simons' stay in Charleston was very short, probably less than three months. He and his associate produced more than one thousand daguerreotypes in four months, won first place in the State Fair, and established a gallery that operated for a minimum of two years. No daguerreotypes produced in South Carolina by Simons or Smith have been identified, although Baty illustrates two possible examples.

**THOMAS WORTHINGTON WHITTRIDGE AND B. J. JENKS.** In his book on Virginia photographers, Louis Ginsberg lists these two men as daguerreotypists operating in Charleston, West Virginia, and also in Charleston, South Carolina. Whittridge and Jenks actually worked in Charleston, Virginia (now West Virginia), and not Charleston, South Carolina. Whittridge was an accomplished artist and did have a South Carolina connection through visits to a relative, Dr. Joshua Barker Whitridge, who lived in Charleston and, later, on Wadmalaw Island. On one of his visits Thomas W. Whittridge did a drawing of Rose Bank, the Whitridge plantation on Wadmalaw.[65]

### Cheraw

**J. HERVEY.** A reporter of the *Farmer's Gazette & Cheraw Advertiser* stated on 26 May 1841 that "We have seen several likenesses taken by Mr. H. which are quite equal to

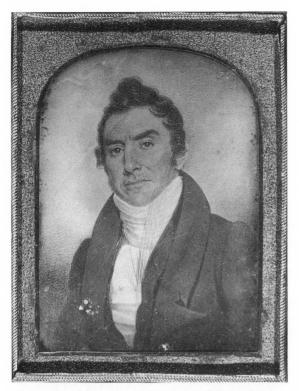

*Quarter-plate daguerreotype of a painting of Thomas Bennett, governor of South Carolina from 1820 to 1822. The original painting, probably created during Bennett's term as governor, could not be located. It may have been by Samuel F. B. Morse since Morse painted Bennett's mother and worked in Charleston a portion of the time when Bennett served as governor. The creator of this daguerreotype, which appears to date from the late 1840s, is unknown. SCL.*

those taken in New York and Charleston that have come under our notice. Mr. Hervey deserves great credit for his enterprise and we confidently anticipate for him a bountiful reward."

By 15 February 1842 Hervey relocated his gallery to Columbia in Mr. Stanley's building, next door to Weir's bookstore, and advertised taking "Daguerreotype likenesses in a few minutes." His was the first gallery to be recorded in the capital city.[66]

## *Columbia*

**Dr. Adam Libolt and Isaac B. Alexander.** In December 1842 Dr. Adam Libolt of New York City made the first of many visits to Columbia. His 1842 ad indicated that he and Isaac B. Alexander of Camden were in business together in a studio at Carolina Hall. For a period of at least four years, Dr. Libolt included Columbia and Charleston in his southern tour.[67] The Rinharts also show Dr. Libolt in Athens, Georgia, in May and June 1843.[68]

Samples of Libolt's work are not available to judge its quality. However, The editor of the *South Carolinian* in Columbia commented in March 1845, "We have visited the best Daguerreotype Galleries in the northern cities, and have never seen better or more life-like pictures, than those executed by Dr. Libolt." Later that month the editor visited the gallery again and provided this marvelous description of Libolt's work and his gallery:

> They who have seen only the miserably dark, gloomy and cadaverous looking Daguerreotypes heretofore taken in this city, can form no idea of the remarkable, expressive, and life-like beauty of those now taken by Dr. Libolt. They give every lineament of feature and figure with wondrous minuteness and distinctness, together with the complexion, color of the dress, etc., and are so tastefully filled up with elegant drapery, books, etc., and landscape scenery in the background, as to form, not only correct likenesses alone, but also strikingly beautiful pictures. Dr. Libolt takes three sizes one much larger than any Daguerreotype we have before seen, and all the most perfect and beautiful transcripts of "the human face devine," that we have ever met with, of any kind while the price strikes us as remarkably moderate. However, all this is scarcely necessary, for Dr. Libolt's room is so frequently crowded with the beauty and respectability of our city, that nearly all must be prepared to judge for themselves ere now; and it may therefore, be taken merely as an expression of our own individual gratification alone, as experienced in looking over his numerous miniatures, and prompted by the heartfelt pleasure we have in making it, rather than by any hope, however strong the desire, of serving the respectable and intelligent artist, or the community.[69]

**W. CHILTON.** In December 1842 W. Chilton of New York advertised that he "proposes to visit Columbia in the course of a few days, when he will be happy to accommodate each person as may wish specimens of his art."[70] This gentleman was probably one of the Chiltons who also visited Charleston about this time.

**JOSEPH T. ZEALY.** Zealy was born in Charleston in 1814, married Sarah Bell Badger in 1836, and moved to Orangeburg where he worked as a carpenter and contractor. During November and December 1846, Zealy opened a photographic gallery in Columbia. As an itinerant daguerreotypist, Zealy visited other states, but maintained his base in Columbia. Although Dr. Adam Libolt worked in Columbia for a few weeks each year between 1842 and 1845 and had a following, Zealy's gallery became the first truly established gallery in the capital city.[71]

The source for Zealy's training in daguerreotyping remains unknown. Whatever the source, he learned his lessons well and developed a thriving business. His ads frequently featured new equipment and new techniques. He advertised the production of "Colored Daguerreotype Portraits" in 1846, new and beautiful cases in 1849, a skylight in 1853, and up-to-date equipment later that same year. By February 1856 he had made the transition from daguerreotyping to ambrotyping. In 1859 he advertised "Zealy's Combined Sky Light Ambrotype & Photograph Gallery," where ambrotypes were made for a dollar and old daguerreotypes enlarged to life-size.[72]

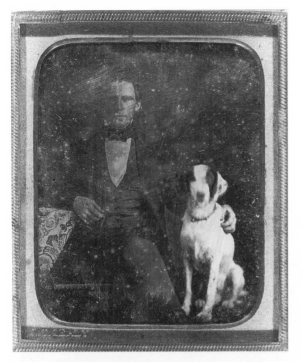

*Quarter-plate daguerreotype of Dr. Michael Clarke and his dog, produced by Joseph T. Zealy. Pets were seldom photographed at this time due to problems with keeping them stationary during an extended exposure time. SCL.*

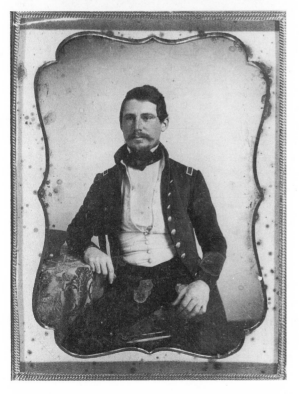

*Quarter-plate daguerreotype of Dr. Michael Clarke in his Mexican War uniform, produced by Joseph T. Zealy. SCL.*

*Artwork used by Zealy to advertise his gallery.*
*Columbia Banner, 26 April 1853. SCL.*

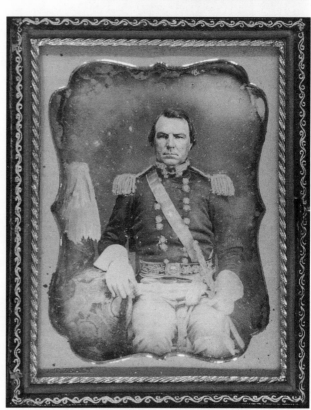

*Daguerreotype of South*
*Carolina Militia General Paul*
*Quattlebaum, produced by*
*Zealy circa 1850. The general,*
*his uniform, and the tablecloth*
*are hand-tinted on the original.*
*Courtesy of Francis S. Massey.*

Examples of Zealy's work, especially during his daguerreian period, are not plentiful, but Professor Louis Agassiz commissioned Zealy to take some photographs when he visited Dr. Robert W. Gibbes and some South Carolina College professors in 1850. This photographic anthropology project he did provides a limited sample for judging his work. Agassiz or his agent asked Zealy to take photographs of selected slaves from B. F. Taylor's Edgehill plantation near Columbia and a few selected slaves from other local owners. Agassiz sought photographic examples of slaves from different African tribes to support his belief that humans were not a single species. Selected slaves were brought into Zealy's Columbia

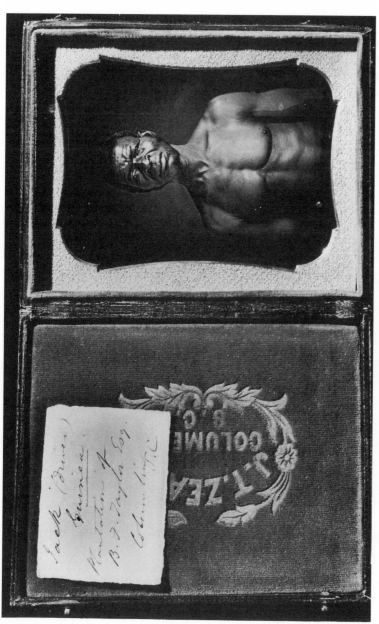

*Daguerreotype of Jack from Guinea in Africa, a driver on B. F. Taylor's Plantation, produced in 1850 by Joseph T. Zealy. The manuscript note was written by Dr. Robert W. Gibbes, who arranged for the production of the image. Harvard University Peabody Museum of Archaeology and Ethnology. Photograph by Hillel Burger.*

studio and photographed in different poses, including nude and semi-nude ones. Zealy's fifteen daguerreotypes remained unpublished in the Peabody Museum of Archeology and Ethnology at Harvard University until recently.[73]

On one occasion Zealy entered eleven daguerreotypes in the State Fair. Louis Perrin Foster secured a portrait from Zealy in 1856 and remarked to his sister when he mailed her the image, "They were taken [by] Mr. Zealy who is considered the best artist in the up country."[74] Two daguerreotypes of Dr. Michael R. Clark, one posed with a dog and the other in his Mexican War Uniform, further demonstrate the quality of Zealy's work.[75]

**J. S. WEAR.** Wear operated in North Carolina on four separate occasions; he was in Wilmington in 1846, Fayetteville in 1853, and Salem in 1855 and 1857.[76] He visited Columbia briefly in 1847 and advertised patronage of his gallery with a rhyme: "Of those for whom you fond emotion cherish, Secure the shadow e'er the substance perish." His next appearance in South Carolina was five years later in September 1852. Wear's advertisement in the Sumter paper stated, "Portraits taken from life or copied from other paintings." On 15 December 1852 Wear notified the citizens of Georgetown that he would be in their town, prepared to serve them, on or about 16 December.[77]

Wear then took another hiatus from the state before showing up in Winnsboro as a photographer in September 1857. He located his gallery in the Thespian Hall where he took various types of ambrotypes and advertised himself as "J. S. Wear, Artist of Charleston."[78]

**[R. L.] WOOD.** Wood's Daguerreotype Rooms, "where can be obtained most beautiful and elegant finished Daguerreotype Likenesses, warranted durable for ages," opened over A. Young's Jewelry Store in December 1848. The Rinharts document an R. L. Wood in Athens, Georgia, in February and March 1849.[79]

**T. H. WALSH.** In the spring and fall of 1849 T. H. Walsh, daguerreotypist, advertised "Rooms over I. D. Mordecai's Store, where likenesses will be taken in the best manner." This simple, straightforward ad is the extent of the information found on Walsh.[80]

## Edgefield

**M. M. COBURN.** "M. M. Coburn from Savannah and recently from Augusta respectfully informs the citizens of Edgefield that he will remain here a short time for the purpose of taking Daguerreotype Miniatures." Coburn's ad in April 1844 indicates he took rooms in the local courthouse as Alexander of Camden and J. M. Fraser of Georgetown did.[81]

**VALENTINE.** In March 1848 a Mr. Valentine from New Orleans set up a daguerreotype gallery in the Glover & Bart Hotel. The local paper reported the examination of some of Valentine's products and they "seem[ed] to be well executed." The article went on to say that "the very marked attention which his almost magical art has received from the public is an evidence of its merit and great beauty."[82]

## Georgetown

**DR. E. A. BENJAMIN.** In March and April 1842 a Dr. E. A. Benjamin produced "Daguerreotype Miniatures" at Mrs. Lester's for $5.00 each. In his ad he described the

production of a daguerreotype as a "process entirely being one of chemical action in accordance with natural laws, they neither flatter or prejudice. . . ."[83]

**S. WILMOT, JR.** This son of a local jeweler opened a daguerreotype gallery over his father's store in November 1843 and advertised that he had made all the preparations necessary to produce daguerreotypes according to the latest improvements of durability. A week later the *Winyah Observer* reported that he produced the same quality of work as that found in Charleston.[84]

**J. W. MOULTON.** Georgetown was visited in March 1846 by J. W. Moulton, who took daguerreotypes from rooms on Bay Street.[85]

**J. M. FRASER.** In February 1848 J. M. Fraser from New York did as Isaac B. Alexander did in Camden in 1843 and as M. M. Coburn did in Edgefield in 1844. He took rooms in the local courthouse for the purpose of producing "plain And Colored Daguerreotypes."[86]

### Greenville

**B. L. BURNETT.** B. L. Burnett opened his daguerreian rooms in the Odd Fellows Hall in August 1847. He advertised, "Persons wishing likenesses are requested to call immediately, as Mr. B.'s time is limited to one week only."[87]

### Laurensville (Laurens)

**HARRISON WALKER.** Walker took rooms over Mr. Thomas Day's Shoe Establishment for a short time in May 1846 and produced "Daguerreian Likenesses, carefully and neatly taken."[88]

**S. T. CORLEY.** Mr. S. T. Corley advertised in July 1849 he would return to Laurensville on the next Friday and remain in town for several days. While in Darlington in March 1850, a Mr. Corley, probably "S. T.," purchased supplies from Cook of Charleston.[89]

### Pendleton

**E. YOUNG.** Young took a room at Lawrence's Hotel in August 1848 and stated he was "prepared to take Photographic Likenesses in the highest style of the art."[90]

### Yorkville (York)

**JOHN C. HUDSON.** According to a letter he wrote in 1848 from Georgia back home to his sister in Yorkville, Hudson was an itinerant daguerreotypist on his way to Mississippi through Georgia and Alabama.

> I have been well since I left home. We are now in Cobb County. We have got along so far very well as it regards traveling, but we have done very little work yet

in our line. We did stop at a little town and took a few pictures, but the prospects of making anything is very gloomy this trip. Daguerrian artis[ts] are as common in Georgia as tin peddlers are in South Carolina and I heard the other day that in Alabama the legislature of that state has put a tax upon Daguerreotyping so heavy that a common man cannot pay it and run the risk of making anything. The license of the state is $100.00 so we do not expect to make anything this side of Miss. if we make it there and I do not expect to clear traveling expenses, but we are determined to test it well, etc.

In all likelihood Hudson practiced daguerreotyping in Yorkville, his hometown, before July 1848 when he left to go south. He used the pronoun "we" several times in his letter, an indication he worked with another daguerreotypist.[91]

**JOHN R. SCHORB.** Schorb operated from a number of towns in South Carolina and other states between 1846 and 1852 before locating his gallery in Yorkville in 1853. He maintained a gallery in town after 1853 for the next fifty-five years.

Shortly before his death in 1908, Schorb dictated some biographical information to Captain L. M. Grist, editor of the *Yorkville Enquirer:*

> John R. Schorb was born in the Grand Dutchy of Baden, Germany on October 24, 1818. He came to the United States in 1834, and remained at Buffalo, N. Y., for about two years. He then removed to Michigan City, Indiana, where he remained for about two years. Michigan City is on the lake opposite Chicago, and at the time of his residence in Michigan City in 1836 was not larger than the town of Yorkville. In 1839 he returned to Buffalo, where he remained for two years. . . .
>
> When he left Buffalo the second time, he went to Rochester, N. Y., and by the assistance of friends, prepared himself for entering college. He entered Hamilton College in New York State, and graduated in one year's time.
>
> One of the faculty at the College was Prof. Avery, who had a short time before Mr. Schorb's graduation, returned from France, whither he had gone to learn daguerrotyping from Daguerre, the discoverer and inventor of the art.
>
> Prof. Avery was a particular and warm friend of Mr. Schorb and taught him daguerreotyping, and supplied him with an outfit to practice the art on his own account.
>
> He first engaged in the taking of pictures in the state of New Jersey, and after a time went to the state of Virginia, practicing the art in various towns and cities in that state. He then went to Charleston, S.C., thence to Columbia, and finally stopped in 1848 at Winnsboro, South Carolina. Here he accepted the position as one of the professors in Mount Zion Institute, where he continued for three years. During the time he could spare from his duties as a teacher, he was employed in making pictures.[92]

According to Hamilton College records, Schorb was enrolled there for three years, from 1844 to 1847, but did not graduate. Professor Avery's diary at Hamilton College makes no

mention of his visiting Daguerre in France. Due to Avery's interest in photography, he assuredly would have recorded and described such a visit. Avery actually acquired much of his knowledge about photography from Samuel F. B. Morse.[93]

In 1866 Schorb advertised that he had "twenty years experience in the Art," meaning 1846 was the year he started practicing photography.[94] If he were correct about the 1848 date of arrival in Winnsboro, then his itinerant travels through New Jersey, Virginia, and the South Carolina towns of Charleston and Columbia began at some point in 1847 and ended prior to his arrival in Winnsboro about a year later.

Schorb moved to Yorkville in 1853 and took a position as teacher at the Yorkville Female College. He also taught part time at the King's Mountain Military School there. In June 1853 he opened his daguerreotype gallery in "a room in Mr. Clawson's new house next door to McConnell & Miller's Grocery."[95] He eventually gave up teaching and devoted full time to his photographic business until his death in 1908. To date, few examples of his daguerreotypes have surfaced, but there are literally thousands of his later photographs extant. They indicate he was an artist in the full sense of the word.

## Summary

South Carolina photography during the decade of the 1840's proved to be interesting and quite eventful. When the decade dawned, the existence of Daguerre and his process was known to only a very small number of individuals in the state. However, beginning in 1839 and before the end of the first year of the new decade, Professor Ellet conducted photographic experiments and produced many daguerreotypes in Columbia, and Charles Taylor took daguerreotypes in his commercial gallery in Charleston. By the end of the decade at least fifty-three daguerreotypists had practiced their art in the state.[96]

With the exception of George S. Cook and Charles L'Homdieu of Charleston, and Joseph T. Zealy of Columbia, all of these daguerreotypists were itinerants and generally spent only a short period of time in the state. Three other exceptions were Dr. Adam Libolt, who visited the state over a four year period; Sterling C. McIntyre, who was present periodically over a three year period; and J. J. Crygier, who worked for McIntyre in Charleston and also included several other South Carolina towns in his photographic tours. The remaining forty-seven generally came to Charleston, stayed for a short time, and left the state without going to other towns.

All of the firms were operated by men with the exception of Mrs. Fletcher of Charleston, who in 1842 became the first woman to operate a photographic gallery in South Carolina. Women were involved in photography in many other ways such as the role of hostess played by the wife of Dr. Libolt in Columbia. A later chapter on women photographers describes them as photographers and explores other roles they played in the profession.

Documentation as to who trained photographers that practiced in South Carolina or the location of their home bases is rather skimpy, but from their photographic ads and other sources, a partial picture has emerged. These photographers had the following connections:

thirteen from New York City, three from Philadelphia, two from New Orleans, one from Virginia, one from Savannah, one from Boston, and four native South Carolinians. New York, Philadelphia, and New Orleans influences seemed to have been more prevalent in the South Carolina daguerreotype picture. Many of these early daguerreotypists gave, as they put it, "Instructions In The Art." George S. Cook, Charles L'Homdieu, Montgomery P. Simons, and Samuel Broadbent enjoyed national reputations.

Charleston, the only large city in this predominantly agricultural state, became the center of much of South Carolina daguerreotype activity. In addition to its regular population of more than 30,000 people, Charleston attracted thousands of visitors each year because of the city's economic and cultural opportunities. These visitors frequently included one of the daguerreotype galleries on their itinerary. Of these fifty-three artists, thirty-three visited the port city.

The fifty-three daguerreotypists in South Carolina were documented visiting only fourteen South Carolina towns between 1840 and 1849: Abbeville, Camden, Charleston, Cheraw, Columbia, Darlington, Edgefield, Georgetown, Greenville, Laurens, Pendleton, Sumter, Winnsboro, and York. The number of towns increased to twenty-six by the end of the daguerreian period in the 1850s.

Due to incomplete or nonexistent newspaper files for many towns and the lack of other sources, one must assume there were quite a few more artists who operated in the state. For example, several more daguerreotypists probably visited Columbia, the capital city, but part of the town was burned in 1865, leaving sources such as newspaper files incomplete.

# From Daguerreotype to Carte de Visite, 1850–59

In 1850 the United States government conducted a census as prescribed by the Constitution. The seventh census was the first to carry statistical information on the occupation of photographer. Due to technological changes in photography at the time, the name for a photographer varied. Consequently, in the 1850 and 1860 censuses, one cannot discern overlap in the reported number of artists, photographers, daguerreotypists, and ambrotypists. For example, the 1850 census reported eleven South Carolina daguerreotypists and twenty-eight artists. Who among the twenty-eight practiced daguerreotyping, and whether the eleven also wielded a paintbrush, are unknown.

The 1860 census figures are even more uncertain. That census reported thirteen daguerreotypists, nine photographers, four ambrotypists, and twenty-two artists in South Carolina. These figures are suspect since no South Carolina photographer in 1860 could be found who advertised his services as a daguerreotypist. They practiced ambrotyping or other types of photography by then.

Events in the South and the nation that eventually would result in the Civil War punctuated the decade of the 1850s. During this decade American photographers captured, on silver, glass, iron, and paper, images of individuals who would play a prominent role in this conflict, including the thousands of men destined to become foot soldiers and sailors, as well as their wives and children. To a much lesser degree, photographers captured buildings, street scenes, and other aspects of society and culture.

In the 1840s photographic experiments in the United States and abroad continued along a variety of lines. Experiments continued in the 1850s and led to the perfection of new processes, equipment, and supplies. As a result, this decade produced some of the most dramatic technological changes in the history of photography. Many photographers boasted of "new" discoveries and "new" processes or techniques in their advertisements. On occasion, some were truly new and not advertising hyperbole. On even rarer occasions, a few South Carolina artists secured patents or copyrights. Two artists, Charles L'Homdieu and Solomon N. Carvalho, perfected a procedure or made a discovery while working in South Carolina that was recognized nationally. However, most new discoveries and developments occurred elsewhere.[1]

By March 1851 William Scott Archer's experiments led to the perfection of the collo-
dion process. In order to produce collodion, gun cotton was dissolved in alcohol and then
poured over a clear glass plate. The coated plates were sensitized in a bath of silver nitrate,
placed in a camera, and exposed before they dried. They were then fixed, washed, and dried.
They were called "wet" plates.[2]

In 1854 John Ambrose Cutting of Boston patented a process for producing a positive
image from a collodion-coated glass plate. This process bore his middle name—the
"Ambrotype." The process involved adding nitric acid or mercuric oxide to the mixture for
coating the glass plate. By painting the other side of the glass black, the image became a
positive. In 1856, using a thin iron plate coated in the same manner as the ambrotype and
lacquered black, Hannibal L. Smith perfected the ferrotype. This was also called a melain-
otype, but was more popularly known later as the tintype. Both the ferrotype and the
ambrotype were positive photographs.[3]

Another process on which W. H. F. Talbot and others experimented involved pro-
ducing a paper that could be sensitized when desired, placed in a camera, exposed to light,
developed, fixed, washed, dried, and framed, resulting in a finished photograph. By the
early 1850s egg albumen mixed with sodium or ammonium chloride was used to coat paper
that could be sensitized in a solution of silver oxide when desired. Dealers were soon sup-
plying this paper to photographers in any quantity they desired. A photographer with a col-
lodion glass negative could produce many paper prints quickly and cheaply. These
developments produced a rapid decline in the production of daguerreotypes.[4]

Another development of the 1850s insured the shift from daguerreotypes to
ambrotypes and other types of photography. David A. Woodward patented an enlarger in
1857 whereby large (up to life-size) photographs could be produced on paper.[5]

Two other developments of the 1850s should be noted: the carte de visite and the
stereograph. The carte de visite, or visiting-card size photograph, patented in France in 1854,
was popular in the United States by the end of the decade.[6]

The technology for the stereoscope, developed by the 1830s, was not applied to pho-
tographs for several years and did not became popular until the 1850s. Some of the first
stereoscopic views during the daguerreian period actually combined the viewing lens and
the view in the same unit. The Rinharts chronicled the history of the stereoscope in detail.
According to them, it was not until Oliver Wendell Holmes "invented a simple hand stereo-
scopic viewer in 1859 that the invention began to appeal to the public." Charleston mer-
chants, F. von Santen's Bazaar at 288 King Street and S. G. Courtney & Co. at 9 Broad
Street, featured stereoscopic views for sale in 1858 and 1859.[7]

A decade that began in 1850 with daguerreotypes mounted in artistically decorated
cases to emulate miniature paintings ended with a mixture of several types of photographs.
Many photographers continued the daguerreotype tradition by mounting ambrotypes, fer-
rotypes, and paper photographs in cases, but a great many produced uncased tintypes,
cartes de visite, stereographs, and other kinds of paper photographs. Some of these new
forms of photographs were destined to last for many years with little or no change.

*Image cases in use between 1840 and 1860 were variously decorated. This quarter-plate ambrotype case sports a South Carolina subject, an imprint based on John B. White's painting titled* Inviting an English Officer to Dine. *White's painting portrayed the Revolutionary War event when General Francis Marion fed sweet potatoes to his "flag of truce" guest. SCL.*

Charleston continued to dominate the state's photographic affairs. In 1850 George Smith Cook, Charles L'Homdieu, H. S. Smith, and Montgomery Pike Simons operated established galleries in the port city, but occasionally experienced competition by itinerants. As the decade unfolded a number of other first-class galleries opened in the port city.

In 1857 William Gilmore Simms, a South Carolina literary figure of national repute, wrote an article on Charleston architecture for *Harper's New Monthly Magazine* in which he described the local photographic scene. Along with the article, Simms submitted to the magazine a series of about eighteen photographs for use by engravers in creating printing plates for illustrations. Although Simms called these photographs daguerreotypes, they probably were both ambrotypes and daguerreotypes since most photographers also produced ambrotypes by mid-1857. Simms remarked, "Talking of daguerreotypers, by-the-way, reminds us to report that we owe our pictures to several of the best in Charleston, Cook, and Cohen, and Bowles[Bolles] and Glenn; all of whom deal with the sun on familiar terms, making as free use of the solar establishment as if they had a full partnership in the concern. We suppose, however, that the privilege is not confined to these parties, and that Brady and others are permitted to share upon occasion, and when Apollo is not engaged with better company."[8]

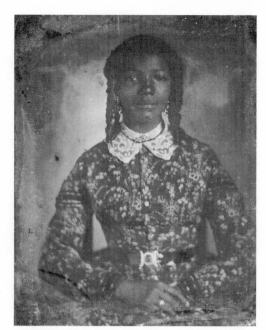

*Quarter-plate ambrotype produced by an unknown photographer of Hester, a house servant in Cross Keys in the 1850s. Courtesy of Jon P. Ward.*

## Photographers

### Abbeville

**David Goff.** Goff visited the village of Abbeville in April 1851 and briefly produced daguerreotypes from rooms in the old Masonic Hall. S. & D. Goff located in Unionville (now Union) in January 1852, producing daguerreotypes from the office formerly occupied by J. H. Thomson. D. Goff was probably David Goff and S. Goff was David's brother or father. By April 1852 the Goffs had moved to the nearby village of Cross Keys, advertising in the Union paper they would remain a few days in Cross Keys for the taking of daguerreotypes.[9]

**Leonard & Adams.** J. S. Leonard and S. H. Adams advertised in the *Independent Press* of Abbeville on 22 February 1856 their "coming from Newberry C. H. to Greenwood, Cokesbury, and will shortly be at Abbeville Court House." In April 1856 J. S. Leonard advertised in the Laurens paper his departure for Clinton. Adams' name did not appear in this ad. By April 25 Leonard arrived in Clinton and advertised a "Daguerreotype and Ambrotype gallery." This ad indicated that an unnamed brother had joined the business.[10]

**M. H. Deale.** Deale informed the citizens of Abbeville in August 1856 that "The Ambrotype Car Will Be Out In A Few Days." He called ambrotypes the finest pictures ever produced by light and promised complete satisfaction. In October Deale notified the small village of Lowndesville that he would visit them in his "Celebrated Ambrotype Car." In June 1857 he returned to Abbeville and again produced ambrotypes there.[11]

**Robert P. Knox.** In April 1856 Robert P. Knox advertised, "Ambrotype Likenesses Over H. W. Lawson's Tin Manufactory."[12]

**W. L. MICKLE.** Mickle came to town in early January 1857 and briefly operated an ambrotype gallery in the Marshall House.[13]

**C. H. ALLEN.** Allen produced ambrotypes in July 1857 at Abbeville.[14]

**A. E. McCLELLAN.** In September 1858 McClellan came to town during court week, hoping the increased traffic would be advantageous for his ambrotype gallery.[15]

### Anderson

**WEARN AND RICHARDSON AND WEARN AND ROBERTSON.** According to the account books of George S. Cook, a firm by the name of Wearn and Richardson, located in Anderson, bought photographic supplies in 1854. Wearn no doubt was the Richard Wearn who located in Columbia in 1859. A firm by the name of Wearn and Robertson also bought supplies from Cook in 1853, but no town was listed for them.[16]

**DAVID PALMER.** By 1856 the town of Anderson charged photographers a $15.00 per year licensing fee to operate a studio in town, either in a room in a building or from the portable studios employed by many itinerants. David Palmer "Daguerreotypest" was ordered to pay this $15.00 fee in October 1858, indicating he practiced the art that year in Anderson.[17]

### Camden

**A. D. GALE.** In March 1850 A. D. Gale set up a gallery in the Camden Odd Fellows Hall and advertised taking daguerreotypes in only two to five seconds. In early 1851 Gale worked for Cook in Charleston. He appeared in Darlington in March 1851, opened a daguerreian gallery in the office formerly occupied by J. E. Muse, and advertised that he had nine years experience in the art and would be in town for only a short time. By June 1851 Gale had relocated to Macon, Georgia. He advertised in the local paper there that he had nearly ten years experience, meaning his beginning date in photography was in late 1841.[18]

**H. E. SQUIER.** H. E. Squier from the "northern circuit" indicated in a May 1850 ad that he worked with Bostwick in Georgetown. He also may have been with him a few weeks earlier in Charleston. In 1850 Squier won second place in the State Fair.[19]

*Ad for Deale's "Ambrotype Car" gallery.* Abbeville Banner, *20 August 1856. SCL.*

He was probably the H. E. Squier who appeared in Sumter in March 1851 and produced colored daguerreotypes at China's Hotel. He opened a gallery in Camden in November 1851 "in the Hall over the store of Mr. William B. Campbell." His ad featured a sky light and expertise in photographing children. From August 1853 until May 1854 Squier advertised his return to Sumter. In January 1856 he appeared in Chester, moved into rooms formerly occupied by E. Elliott, and produced daguerreotypes.[20] At this time he apparently had someone else working with him since his ad carried "& Co."

**JAMES P. TIBBETS.** In December 1854 Mr. Tibbets visited Camden briefly and produced daguerreotypes in rooms over the post office that recently had been occupied by a Dr. McCaa.[21]

**A. MORRISON.** Morrison located in Camden in November 1854 and produced daguerreotypes from rooms over the post office. He advertised complete satisfaction for pictures taken either singly or in groups with modern equipment.[22]

**W. P. HUGHES.** A "Wm. P. Hughes" from Charlotte, North Carolina, was listed in a business with a Dr. Wilde and daughter in Yorkville in December 1853. From 1854 to 1857 he worked in the North Carolina towns of Salisbury, Charlotte, and Asheville.

In January 1858 W. P. Hughes thanked Camden citizens for their patronage on a "former occasion," thereby indicating he practiced his art there in 1857 or earlier. He advertised that "It has become a well known fact that the Ambrotype and Photograph is the picture of the day." He included in his ad an interesting novelty item. "In addition to the Ambrotype and Photograph, he is prepared to execute pictures upon patent leather." Hughes returned to Camden for a short time in 1866 and again in 1868.[23]

*Ad for the sixth South-Carolina Institute Fair.* Charleston Courier, *17 September 1856. SCL.*

## Charleston

GEORGE S. COOK.  Cook's business, established in late 1849, steadily expanded during the 1850s. In 1851 Mathew Brady chose Cook to manage his New York City gallery while he toured Europe. While in New York Cook bought C. C. Harrison's gallery located a little farther up Broadway and operated it for about a year. He entered into a studio partnership with Samuel M. Fassett in Chicago in 1857. One of the noteworthy photographs that they produced was a "beardless" Abraham Lincoln in 1859. Cook continued to expand and opened a studio in Philadelphia in 1858 and a second one there in 1860.[24] However, he did not neglect his South Carolina business during this period, but expanded it.

In order to handle the volume of work in his South Carolina studio and to operate the studio in his absences, Cook employed other photographers. For a part of 1851, when Cook was in New York City, A. D. Gale worked in his studio. However, by June 1851 Gale had left South Carolina to operate a studio in Macon, Georgia.[25] Professor A. G. Park worked in the Cook gallery for a time in the early 1850s. In June 1853 Theo Lafar stated he had worked in Cook's gallery for some years. A. McCormick was in Charleston as a photographer in 1856 and probably worked for Cook since he was in Cook's employ in 1860. In 1859 F. W. R. Danforth was listed in the Charleston directory as an ambrotypist working for Cook, but before the Civil War left Cook's employ. At some point before 1861 L. R. Phillips had been an assistant in Cook's Charleston studio.[26]

While Cook had been itinerant in the South, he developed contacts that enabled him to establish a flourishing photographic business with other photographers, selling them cameras, chemicals, and other supplies. His customers were drawn from North Carolina, Georgia, Alabama, and South Carolina. By 1860, more than half of the documented photographers operating in South Carolina were his customers.[27]

In Charleston Cook took on all opponents and rose to the top of his profession both financially and artistically. In 1850 and 1851 he won first place in the local fair.[28] His local business outlived that of all his prewar competitors and lasted until 1891.

The Cook Papers at the Library of Congress and the Valentine Museum in Richmond, Virginia; his biography by his great-grandson; and editorials and ads in local newspapers and periodicals reveal much about him as an artistic photographer and businessman. In 1852 the press invited "especial attention to the local Daguerreotype Rooms of Geo. S. Cook. Cook is indeed an artist. The tone & finish of his likenesses, the peculiar appropriateness of the position selected, his just idea of the happy moment of the sitter, make them generally the very finest specimens of the art." A Charleston reporter expressed similar sentiments in 1854.[29]

Cook kept current with advances in his profession through the operation of his studios in the North and visits to other studios where he observed and learned about new developments. In 1853 he advertised his return from five months' study in the North and his readiness to produce the most up-to-date daguerreotypes. In March 1855 Cook advertised "Photographic Paintings" and secured the services of an English artist, "Wm. Hunt," to assist him. How long he worked with Cook remains to be determined, but letters to

*Quarter-plate daguerreotype of an unidentified female, produced by the Root Gallery of Philadelphia while George S. Cook was a partner in the gallery. Note the wording "Cook Artist." SCL.*

*One half-plate ambrotype of Elias H. Deas, produced by George S. Cook. SCL.*

Cook from Hunt in 1861 indicate that the two kept in touch for several years.[30] Hunt's paintings for Cook were probably based on a photograph or were hand colored photographs. In either case they demonstrated that Cook was creative, progressive and forward thinking.

When ambrotypes came upon the scene, Cook became one of the first to produce them locally and advertised that he was the first to introduce them in New York City in 1855 at Brady's Gallery.[31] If Cook's assertion were verifiable, this would be one of the most significant events in the history of photography.

In his biography of Cook, Jack Ramsay speculates that a rift occurred in 1851 between Brady and Cook. The rift was supposedly due to Cook buying and operating a competing gallery while managing Brady's gallery. This may have been the case, but they apparently had repaired their differences to a degree by 1855 since Cook produced ambrotypes in

*Whole-plate daguerreotype of Thomas Farr Capers, a Charleston attorney, produced by an unknown artist. Courtesy of George S. Whiteley, IV.*

A "photographic painting" and frame from George S. Cook's gallery dated circa 1855. Cook applied one of his paste-on stickers to the reverse of this image of a Mr. Sanders. Courtesy of a private collector.

BELOW: An unusual ambrotype that was produced in the Root Gallery while George S. Cook was a partner. This image features a man who is dressed like a bandito, wearing goggles, with a watch chain hanging from his mouth, a coin silver spoon stuck in his hatband, and someone else's hand with a missing digit that sports a feather coming up behind his hat. On the table are a pair of boots, an unusual rotary valve clarinet, and an upside down saucer. It is an enigma image that is yet to be explained. Courtesy of George S. Whiteley, IV.

Brady's gallery late that year. However, in 1861, when the Civil War interrupted Cook's photographic supply lines, Brady refused to help him import supplies from the North.[32]

Cook took advantage of local and national developments in his business. He displayed copies of Harriet Beecher Stowe's photograph in his studio shortly after her book *Uncle Tom's Cabin* became a national sensation. In 1861 he photographed Major Robert Anderson at Fort Sumter and widely sold the photographs in both the North and South.[33]

**BOSTWICK & SQUIER.** A Mr. Bostwick stated in a May 1850 Georgetown newspaper that he was "recently from New York & directly from the City of Charleston" and that he would "be assisted by Mr. Squier, an experienced operator direct from the Northern Circuit." It is not clear whether or not Squier was with Bostwick in Charleston, but he showed up over the next five years in a number of South Carolina towns.[34]

**SOLOMON NUNES CARVALHO.** Solomon N. Carvalho, the son of Sephardic Jewish parents, was born in Charleston in 1815 and spent his youth there. Solomon's family moved several times and he would later do the same, living for a time in a number of places, including Barbados, Baltimore, Philadelphia, and New York.

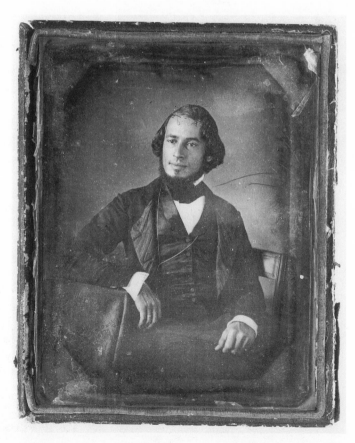

*Self-portrait daguerreotype, produced by Solomon Nunes Carvalho circa 1848. Courtesy Library of Congress.*

He is best known for his brush, producing portraits of Abraham Lincoln, John C. Fremont, Brigham Young, and Warka, the Utah Indian Chief, as well as many other types of paintings such as western landscapes. His accomplishments in photography, although less well-known, are quite noteworthy.[35]

When the daguerreotype process was unveiled in America in 1839, Carvalho, a young man of twenty-four, was already an accomplished artist. From the start this new medium interested him and he experimented with it. By 1846 he demonstrated proficiency in this new art by producing a credible self portrait. He experimented to discover a method to protect daguerreotype plates from abrasion. In January 1848 he met with Samuel F. B. Morse and discussed the matter with him.[36] In late 1850 or early 1851 he returned to Charleston and set up a daguerreotype gallery at 230 King Street where his ads indicate he produced likenesses "equal to any that [have] been made in this country." By April 1851 he moved his gallery to the corner of King and Wentworth Streets in the ground floor of the Masonic Hall.[37]

Carvalho was an active exhibitor in the 1851 State Fair; displaying a portrait of Henry Clay, a fancy head, a gentleman of Charleston, a portrait of H. S. Butterfield, and specimens of colored daguerreotypes.[38]

A reporter for the *Charleston Courier* visited his gallery on 3 February 1851 and reported the following:

> Within the last year numerous improvements in the process of Daguerreotyping have been introduced, which we have taken occasion from time to time, to notice. Among the latest is a new style resembling a highly finished miniature on ivory, several specimens of which are on exhibition at the rooms of S. N. Carvalho, 230 King Street. Mr. C. is a native of this city, where he has returned, after an absence of a few years, with recruited health, and experience in the profession to which he has devoted himself, with the view of taking up his permanent residence among us. His studio has been recently opened to the public, but he has already accumulated a number of likenesses of well known residents of this city in photographic and oil paintings; his familiarity as a professional artist with the philosophical of light and shadow, enabling him to combine the study and practice of both to great advantage. An exquisitely delicate and life like fancy sketch in oil, which he has just completed, is attracting the admiration of his visitors, and considered by many good judges among them to be a highly successful effort, in the delineation of a difficult subject, attitude and expression. Mr. Carvalho's room are open at all hours of the morning and afternoon for the inspection of ladies and gentlemen desirous of seeing his specimens and improvements in the art.[39]

Carvalho perfected a clear solution that when applied to a daguerreotype made it almost impervious to abrasion. A news item concerning Carvalho's gilding process appeared in the *Boston Daily Evening Transcript* of 14 February 1852.[40] Others were experimenting in this same field and Edward Anthony, the well-established northern photographic supplier, advertised a solution for sale that was reported by H. H. Snelling, editor of the *Photographic*

*and Fine Arts Journal.* Carvalho wrote Snelling about his invention on 23 March 1852 from Charleston. "I Never Purchased It, nor had I the first idea from any other person on the subject. I have arrived at the present perfection of a highly transparent enamelled surface to daguerreotypes, precluding the necessity of glass covering, by a long continued series of experiments. If the discovery is not new it only exemplifies the old adage or proverb, `there is nothing new under the sun.'"[41]

Ever restless, Carvalho left Charleston for New York and worked in J. Gurney's gallery for a time coating daguerreotypes with his transparent enameling solution. In 1853 Carvalho joined John C. Fremont's western expedition for the purpose of documenting the West with his camera. He kept a journal that when printed was the only published record of this expedition. Unfortunately, the daguerreotypes that he took on this expedition have been lost; but engravings of some were made and have survived.[42]

Although Carvalho operated a daguerreotype gallery for a number of years, he continued to paint throughout most of his adult life. Today Carvalho's work bears testimony to the imprint this native son of Charleston and South Carolina had on the art and photographic worlds.

**BURGESS & FREDERICKS.** Just before Christmas 1851 Nathan G. Burgess and C. D. F. Fredericks of New York opened a gallery at 233 King Street and advertised taking likenesses "in a style of finish greatly superior to any before offered in this city." They continued in business for a time in 1852 before moving to another location. Burgess attained national prominence for the books and articles he wrote on photographic topics.[43]

**DANIEL L. GLEN AND SOLON JENKINS, JR.** In 1852 Daniel L. Glen opened the Palmetto Daguerrean Gallery in Charleston at 221 King Street. He won a silver medal the next year in the State Fair, and this was reflected in one of his ads. In 1855 he advertised his return "from the North posted up in all the late Improvements In Daguerreotyping and Photography." By February 1856 he added ambrotype production to his gallery and "Photographs Painted In Oil as Large as Life."[44] Mrs. E. M. Link, a local female artist, colored photographs for Glen at that time. A daguerreotype by Glen of the Washington Course and grandstands, a horse racing facility in Charleston, was the basis for an engraving by H. Bosse that appeared as an illustration in a pamphlet on the course. J. B. Irving, the writer

*Burgess & Fredericks ad.* Charleston Courier, *23 December 1851. SCL.*

*Quarter-plate daguerreotype of an unidentified family produced by Daniel L. Glen. SCL.*

of this publication, stated, "The Building is from a Daguerreotype taken expressly and gratutiously for this work by D. L. Glen, a native of this city, pursuing his vocation as an artist." The last antebellum evidence of Mr. Glen in Charleston was an ad for his gallery at 215 King Street in the *Southern Inventor* in 1858.[45]

Glen located a gallery in Sumter before September 1859. Daniel Glen bought photographic supplies from Cook of Charleston in November 1861, but the location of his gallery was not given. Glen had relocated to Charleston by September 1865 and in June 1866 was reported in Georgetown.[46]

Glen apparently produced quality work to survive the spirited competition of Cook and others between 1851 and 1858 and to win first place in the fair. An ad of his in October 1856 may have been descriptive of his work: "Full many a flower is born to blush unseen, and waste its fragrance on the desert air, but a likeness of yourself or some dear friend, taken by Glen, could no more escape the admiring eye, than could the sun at noon day conceal its radiance."[47]

From 1852 to 1854 Glen employed an operator in his gallery named Solon Jenkins, Jr. who moved to Columbia in 1854 to open his own gallery. S.C. Mouzon was described in 1884 as a "some time apprentice to Glen." They probably would have worked together prior to 1856 when Mouzon opened his gallery in Charleston. Glen may have employed others whose identities are unknown.[48]

**WILLIAM A. WELLMAN.** According to *Humphrey's Daguerreian Journal* William A. Wellman operated a gallery in Charleston from 1852 to 1853. No address, listing, or advertisement of this gallery could be located, however. In December 1852 he advertised he would be in Georgetown for a short time producing daguerreotypes at the Winyah Engine Hall, and in June 1853 he set up a gallery in Sumter next door to the *Sumter Banner* offices. In his Sumter ad he noted he was from Charleston. Apparently Wellman used Charleston as his base from 1852 to 1853 while operating as an itinerant daguerreotypist in the state. Wellman left South Carolina at some point and operated a gallery in New York City from 1855 to 1858.[49]

*Sixth-plate daguerreotype produced by William A. Wellman of two men from Georgetown, South Carolina, by the names of Sisson and Hazard. SCL.*

**PARK & CO.**  Charles L'Homdieu sold his Charleston gallery in August 1853 to Park & Co. Professor Albert George Park claimed ten years' experience in the art and that he was the oldest operator in the southern country. On 6 August 1853 Park further stated he was the principal operator of Park & Co., indicating at least one other photographer also worked in the firm.[50]

The Rinharts place Park in Mobile, Alabama, in 1844 and 1845 where he received training in daguerreotyping from C. Barnes, but his ad indicates he began practicing the art by at least 1843. Between those years and the opening of his Charleston gallery in 1853 he was an itinerant artist in Alabama, worked for Brady in New York, and worked for George S. Cook in Charleston in the early 1850s. He was probably employed by Cook when he bought out L'Homdieu.[51]

Park indicated in August 1853 that "His Gold Enameled and Chemically Colored Daguerreotypes which produced so much sensation in the City of New York, and which are now on exhibition at the World's Fair are conceded by all connoisseurs to be far superior to any heretofore produced by the Photographic Art."[52]

His claim seems to have been accurate since less than a year later in March 1854 he advertised that "the highest premium was awarded to Brady, of New York at the World's Fair, for the best Daguerreotypes, and why it's easily told. He secured the services of PARK, The Celebrated Southern Artist, while on a visit to the North, who made some of the finest Gems, exhibited in the Crystal Palace."[53]

Park was a frequent advertiser in the Charleston papers from August 1853 to April 1854, but had left the city by April 1855 and was succeeded by John A. Talmadge. Park called his gallery the Star Gallery at the "Sign of The Stars and Stripes." In one early ad he enticed customers with this poem: "If you would from the human face devine, Transfer each look, engrave each vital line, Copy the speaking lip and visual spark, Just try the New Gallery and sit for Park." Park later operated a gallery in Tennessee.[54] Why he was called "Professor" is not known, but that title suggests he taught somewhere for a time. Park's work must have been superior for at least two reasons. His work won premiums in the World's Fair in 1853. A reporter for the *Charleston Courier* visited the galleries of Cook and Park in February 1854 and reported "we have lately had repeated occasions to visit two galleries, and examine specimens from two establishments that cannot be surpassed, as we think."[55]

**THEO LAFAR AND COHEN & LAFAR.**  In June 1853 Theo Lafar advertised in the Chester newspaper that he would be in town and was prepared to take portraits of children and large groups. He further advertised himself as being "from Cook's gallery, Charleston," which was "well known as the best in the Southern States," and that he had experience there for "some years." His Chester studio was in the courthouse. Artists must have enjoyed special treatment by the local authorities as the portrait painter G. W. Fitzwilson was located a few weeks earlier in a jury room of the courthouse.[56]

Lafar went into partnership with A. D. Cohen in a Charleston gallery at the corner of King and Liberty Streets in November 1853. Their partnership lasted until early February 1854, when Cohen advertised his business as a "New Daguerreotype Gallery" at King and

*Sixth-plate daguerreotype of a Charleston street scene produced by an unidentified artist. Collection of Greg French.*

Liberty Streets with Lafar's name not included. His new business apparently faded into oblivion by the end of 1854 since he was not listed in the city the next year.[57]

Lafar pursued his business elsewhere in South Carolina. In 1854 he visited Sumter, in October 1855 paid a return visit to Darlington, and in 1856 operated a gallery in Marion. In his Marion advertisement he referred to himself as "Mr. Lafar from Charleston." He apparently became an itinerant artist operating out of Charleston. As several daguerreotypists in other South Carolina towns did, he located his gallery in the courthouse of the town.[58]

**J. M. Osborn and Osborn & Durbec.** The first mention of Mr. Osborn was an ad in the Charleston paper of April 1854 reminding the public that "at the last Fair [1853], the first premium was awarded to this establishment." His gallery was the "Eagle Daguerreian Gallery, Sign Of The Spread Eagle, 233 King Street." In 1855 Osborn's gallery appeared to be state-of-the-art in photographic improvements and processes. In January he advertised life-size portraits "taken by the Photographic Process, On Canvas with a Mammoth Camera, by J. M. Osborn, beautifully colored by W. A. Ashe. . . . Likenesses and views taken by the above process on paper, and orders filled for one dozen or one thousand." In December 1855 Osborn became the first South Carolina photographer to advertise ambrotypes.[59] The other Charleston and South Carolina photographers quickly followed suit, with most producing ambrotypes by 1856.

On 24 December 1855 Tyler & Co. operated from the 233 King Street location that had been Osborn's location fourteen days earlier. He probably sold out to them, but also might have joined their firm as an employee or part owner. By February 1857 Quinby & Co. succeeded Tyler & Co. at 233 King Street, and in December that year Osborn advertised he was with Quinby & Co.[60]

In November 1858 J. M. Osborn and Frederick E. Durbec opened a gallery at 233 King Street, the location of S.C. Mouzon's gallery in 1856 and of the firms previously listed at that address.[61] From 1858 to 1861 Osborn & Durbec operated from that location.

In December 1859 Osborn & Durbec advertised some of the new photographic techniques. "They have succeeded in accomplishing the desired results, viz: in multiplying Photographic Pictures in such an extensive manner that Miniature Likenesses, equaling the finest Daguerreotype in detail, may be produced for a small sum of three dollars per hundred. These Photographic Miniatures, (which are about the size of a postage stamp) may be used in various ways, such as, for instance, sticking one on a plain enameled visiting card, instead of the written Autograph."[62]

In the summer and fall of 1860 Osborn & Durbec engaged in a photographic project that has a number of implications today, not only for photographic historians, but for historians in general. The *Charleston Mercury* reported in October 1860 that

> for four months Messrs. O. & D. have been steadily engaged in obtaining the most accurate stereoscopic views of places in and around Charleston. Among these we may mention the Charleston Hotel, Mills House, Pavilion Hotel, Sullivan's Island, and a number of plantation scenes, including the negro quarters, cotton picking, etc. These views are now for sale by them at wholesale and retail. Their industry and enterprise in the matter is certainly worthy of commendation, and, joined with their well known eminence in their profession, entitles them to the liberal patronage of the Charleston public.[63]

Apparently they were the first photographers to document, with their cameras and to this degree, many sites in and around Charleston; sites such as Sullivan's Island, Goose Creek,

*Albumen print by Osborn & Durbec taken in 1860 of the "Charleston Parade" or the turnstile that was located where the Charleston Battery is today. The turnstile, designed to keep animals out of the area, was removed early in the war when that area was fortified. This image usually appears as a stereograph. SCL.*

**DAGUERREOTYPE NOTICE**

THAT OLD DAGUERREOTYPE STAND, corner King and Market, (late PARKS,) which has been closed for a few days, is again opened. All who would like one of those fine toned life-like MINI-TURES, which are the peculiar production of this Mammoth sky-light, would do well to call and examine some of the many beautiful specimens to be seen at this Gallery. All the latest improvements are used in producing those beautiful PICTURES, which are so much admired by all who see them.                     TALMADGE, Artist.

April 18

ABOVE:  *Paste-on sticker applied by Osborn & Durbec to their 1860 stereographs. Collection of the author.*

*Ad for Talmadge Gallery.* Charleston Courier, *26 April 1855. SCL.*

Mt. Pleasant, and Rockville. Some of these photographs or their negatives were printed after the Civil War by Quinby & Co. and S. T. Souder. James H. Devoe worked as an operator in this studio in 1860 and may have helped produce these photographs.[64]

During this four month period they probably also journeyed on the Northeast Railroad to Florence. Here they produced several images of local buildings such as the Gamble House, a local hotel, views of the railroad and an engine, and a street scene that included their portable tent "studio." Since Osborn & Durbec were not in business together after the Civil War, these photographs must have been produced in late 1860 or early 1861.[65]

**JOHN A. TALMADGE.**  Talmadge operated as an itinerant photographer with a Mr. Alvord in 1850 and 1851, appearing in Athens, Georgia, and the South Carolina towns of Sumter and Greenville. In April 1855 he succeeded A. G. Park at 215 King Street with a daguerreian gallery. One example of his work has been identified—a daguerreotype taken in 1851 of Greenville artist Thomas Stephen Powell and his female companion.[66]

**HENRY J. MOUZON.**  In 1855 Mouzon was listed as a daguerreotypist in Charleston, but had no business address.[67] In December 1855 and January 1856 he sold daguerreotypes for one dollar from his gallery over D. J. Winn's Store in Sumter. He faded from the scene until 1860 and 1861 when he took photographs in Spartanburg.[68]

**TYLER & CO.**  As indicated earlier, Tyler & Co. opened their daguerreotype gallery in December 1855 at Osborn's old location at 233 King Street. According to one of their ads they did a business of $150,000.00 annually while in New Orleans and won a wager there for taking 1,000 portraits in four hours.[69]

They advertised a work force of twenty employees and listed the names of eleven of them and the job each performed. Although these men were listed as performing certain

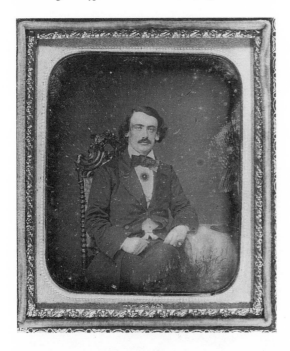

*Sixth-plate daguerreotype of Henry Tim-rod taken by Tyler & Co. in 1855 or 1856. Timrod, a writer of note, became poet laureate of South Carolina during the Civil War. SCL.*

specialized tasks in the daguerreotype process, they undoubtedly were familiar with the process as a whole and likely performed most of the tasks involved in it. For that reason they have been included here as daguerreotypists. The men listed in the 18 March 1856 ad, excluding salesmen and office force, were: Roland Fay, operator; Thomas Rue, mercury man; D. S. Jones, gilder; P. Schlump, colorist; J. Brown and Thomas Hill, finishers; J. Dearborn, chemist; W. Durbec, coater. The individual tasks listed for these men collectively provide a description of the entire daguerreotype process.[70]

Missing from all Tyler & Co. advertisements was information on Tyler himself, including no mention of his first name. An E. A. Tyler purchased photographic supplies from Cook in Charleston in June 1854 and he may have been the Tyler of Tyler & Co. The Rinharts list a Tyler & Co. firm in Boston in 1855.[71]

With twenty employees and steam-powered equipment, Tyler & Co. were mass producing their product. Many artists questioned the quality of a mass-produced product, a product that was sold for a cheap price. They applied the unflattering term of "fifty-cent gallery" to firms such as Tyler & Co.

The first period of operation for Tyler & Co. in Charleston was from December 1855 to June 1856. They returned in November 1856 and reopened their gallery at 233 King Street. Their ads in November and December 1856 boasted 55,000 portraits taken during their first visit to Charleston and that 600 people visited their gallery daily in May 1856. A November ad boasted $187.50 in receipts the previous day. That would represent 375 daguerreotypes if the figure reflected only the taking of daguerreotypes. This ad also boasted that "Tyler & Co. are the only daguerreotypists who manufacture their own material, which accounts for their selling fine cases so cheap."[72]

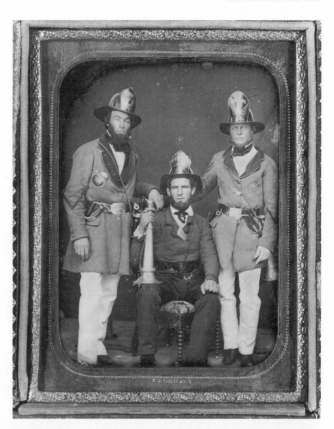

*Daguerreotype of a Charleston
fire company taken by Tyler &
Co. in 1855 or 1856. Courtesy of
Library of Congress.*

Identified Tyler & Co. cases were not included by the Rinharts in a chapter they devoted to the subject. Newhall illustrated a Tyler & Co. paper label on an 1854 daguerreotype produced in Boston, Massachusetts.[73] A few Tyler & Co. daguerreotypes produced in Charleston have also surfaced.

A 24 December 1856 ad featured an English photographer, Mr. Turbout Quinbie, who, according to Tyler & Co., was to take portraits on silk. They stated that Quinbie had "received from the Royal Academy of Art the degree of Dictator bestowed on him for his many discoveries in art, and for the completion of his Acromatic Lens, which has a focus of twenty three inches." By February 1857 Tyler & Co. sold out to Quinby & Co.[74]

Tyler & Co.'s sojourn in Charleston spanned the periods from December 1855 to June 1856 and from November 1856 to February 1857. They had an impact on the photographic community in the city, reducing prices and, in the process, raising opposition from Cook and others. They were primarily a daguerreotype operation, although they did advertise the taking of ambrotypes in December 1856. The daguerreotype was on its way out by this time and that may account for their selling out to Quinby & Co.

The quality of their work is difficult to judge without any large number of identified examples to examine. George S. Cook and some other Charleston artists did not think highly of their product, but their opinions may have been colored by economic considerations more than artistic ones. Tyler & Co. claimed winning three gold medals, but gave no

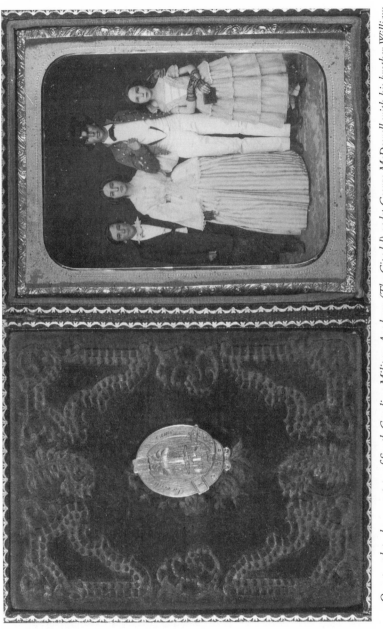

*Quarter-plate daguerreotype of South Carolina Military Academy (The Citadel) cadet George McDowell with his brother William and sisters Phillapenia and Lulu, taken by Tyler & Co. Note the South Carolina state seal pin affixed to the case. Collection of William A. Turner.*

particulars. They were certainly patronized by the public and produced a credible product, but one that lacked the artistic treatment Cook and others gave their work.

**JAMES CUMMINGS.** In 1856 Cummings was listed as a photographer living at 259 Meeting at the corner of Line [Street]. Cummings probably worked as an operator for one of the Charleston firms and did not own a gallery.[75]

**S.C. MOUZON.** Mouzon came to town in December 1856 and opened a daguerreotype and ambrotype gallery at 233 King Street. In February 1857 he advertised "A Daguerreotype Instrument and Apparatus For Sale."[76] Apparently he intended to produce only ambrotypes in the future. After the Civil War S.C. Mouzon operated a gallery in the town of Spartanburg from 1865 to 1894.

**JESSE H. BOLLES AND F. A. WENDEROTH.** Jesse H. Bolles advertised on 2 February 1856 that he had recovered from a severe indisposition and was reopening his gallery at the corner of King and Liberty Streets, the former location of A. D. Cohen's gallery. This ad suggests he went into business at an earlier date, probably late 1855. Bolles advertised his gallery for the remainder of 1856 with ads about being open on July 4, specializing in photographing children, and winning first premium in the last fair.[77]

By January 1857 F. A. Wenderoth, an artist and photographer, joined the firm. That month the *Charleston Courier* reported on a "beautiful photographic plate lately executed by Mr. Wenderoth and designed to illustrate two works which are shortly to be issued by Professor F. S. Holman of the College of Charleston." This probably was an engraving prepared for printing purposes that was based on a photograph. No record could be found to indicate these works by Professor Holman were ever completed and printed. In March they advertised a stereoscopic ambrotype in color "Produced only at the Charleston Premium Gallery by its inventor, A. Wenderoth." Wenderoth's name does not appear as a part of the firm's name after 1857.[78] About this time Wenderoth relocated to Philadelphia.

Mr. Wenderoth has been given a giant share of the credit for developing the ivorytype, a work of art produced by placing a painting and a photograph of the same subject over each other into a kind of sandwich that is then sealed together with beeswax.[79] He probably perfected the ivorytype while in Charleston. Bolles, his former associate in Charleston, certainly advertised this new type of photograph, the ivorytype, in 1858.[80]

*Ad for Bolles's Gallery.* Southern Inventor,
*1 November 1858. SCL.*

By 1859 Bolles called his gallery, "BOLLES TEMPLE OF ART." That his was a temple of art where quality photographs and paintings were produced was supported by a reporter for the *Charleston Courier* in May 1859.

> But not satisfied with having attained the highest point in the profession to which he has devoted his talents and time, he has recently engaged the services of two gentlemen, eminently endowed for those branches of the arts they pursue. The steel tools of Mr. Burrell, and the brush of M. Theodore Rosseau are constantly at work in this popular and busy studio.
>
> Yesterday, we recognized several of our townsmen in the white grain of shells, among whom are Dr. J. Bellinger and A. H. Haynes, esq.
>
> These cameos are most exquisitely cut, and present lineament and expression with singular fidelity. With the daguerreotype before him, Mr. Burrell brings out the front face, of the profile, from the rough, hard surface of the conch; and through the process consumes more time and costs more later than one that looks plainer in the camera, the likeness is quite as truthful as that impressed by the sun.[81]

Bolles maintained a gallery in Charleston during the Civil War and after, until about 1870.

**GEORGE A. JEFFERS AND OTHERS.** A firm by the name of Jeffers and Doty operated briefly in New Bern and Kingston, North Carolina in 1855 and appeared in Georgetown in February 1856. They took rooms in "Winyah Hall where they [were] prepared to take Daguerreotype Likenesses in every style." They stated patrons should come early since they would soon leave for Charleston. By late March Jeffers arrived in the port city and set up a gallery at the corner of King and Market Streets. Doty had disappeared from the scene by this time. Jeffers' ads touted ten years experience in the art. His first Charleston advertisement featured the favorable opinions of the Troy, New York press about his work. The ad quoted from five different papers covering the period from 1851 to 1854 when he operated a gallery there.[82]

Jeffers appeared to have two objectives in mind to accomplish in South Carolina; establish a base in Charleston from which to visit other towns in South Carolina and operate a "fifty-cent gallery" in the fashion of Tyler & Co. His arrival coincided with the tenure of that firm in Charleston. Jeffers called his gallery in Charleston "The Star Gallery at the Sign of The Flag."

For a time during the summer of 1856 he closed his Charleston gallery, visited Chester in September, and produced ambrotypes there for about two weeks. About this time he put in an appearance in Charlotte, North Carolina.[83]

Jeffers reopened his Charleston gallery in December 1856, advertising on December 22 the adding of employees to his firm and that "among the corps of artists the following names may be found, viz—G. A. Jeffers, W. H. Cook, Professor Lafayette, W. Henri, G. Allen, R. Edwards, H. Williams, Anthony Karll, etc. etc." Tyler & Co. were on their way out at this time, and these may have been some of their employees.[84]

Jeffers advertised the production of a "new" kind of photograph, the ferrotype, or "Likeness On Iron," and that he had received the rights from the patentee to produce it.

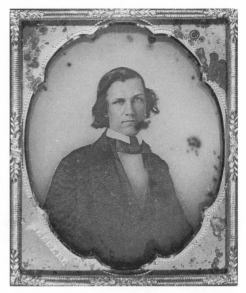

ABOVE: *Ad for Jeffers's Gallery. Chester Standard, 11 September 1856. SCL.*

*Sixth-plate ambrotype of an unidentified member of the Sams family of Beaufort, produced by George A. Jeffers. Sams Family Papers. SCL.*

Jeffers made no mention of the identity of the patentee, but it may have been Hannibal L. Smith, the inventor of the tintype.[85] By the spring of 1857 he apparently left Charleston and South Carolina. A few identified Jeffers works produced in South Carolina have surfaced.

QUINBY & CO. This firm operated a gallery in New York City from 1854 to 1858. C. J. Quinby was the "Quinby" of Quinby & Co. and advertised his firm in February 1857 as successors to Tyler & Co. The firm claimed a work force of twenty "manipulators & artists" who made pictures in all the forms being practiced at the time. Quinby & Co. further stated they produced their own chemicals and used only Holmes, Booth, and Hayden instruments. A few days later they advertised the addition of five ambrotype artists. Perhaps these were some of Jeffers' work force. In March they boasted the production of ambrotypes by combining the skills of the artist and the chemist. The chemist superintending their laboratory formerly worked for Chas. A. Seely & Co. In addition to producing chemicals for their use, they produced and sold chemicals to others.

In March they boasted the production of 600 photographs daily and referred to their operation as a "Depot Of Art." Four days later they boasted making 400 photographs daily, quite a difference from 600. Later that year in October, one of their ads stated they were "Manufacturers And Importers Of Photographic Goods, Factory At Waterbury Conn., Galleries located at Charleston, S.C., Augusta, Ga. and Broadway, N. Y."[86]

Quinby & Co. continued in business in Charleston during the early part of the Civil War and after, until 1871. What portion of the business in Charleston remained in the control of or was owned by C. J. Quinby when the Civil War began is not known, but only two individuals were listed as operators for Quinby & Co. in the 1860 Charleston city directory, Mowlray Heslop and George Isles.[87]

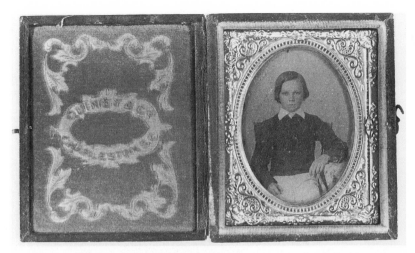

*Ninth-plate ambrotype of a boy from the Summer/Brown/Caldwell families of Newberry, produced by Quinby & Co. Summer/Brown Caldwell Collection, SCL.*

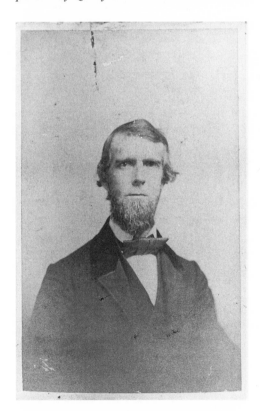

*Carte de visite of Henry William Ravenel produced by Quinby & Co. SCL.*

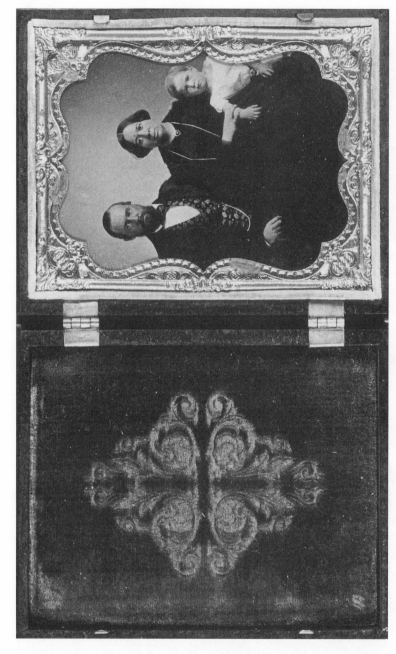

*Ambrotype of Dr. Paul F. Pritchard with his wife, Catherine K. Pritchard, and their son William, produced by Quinby & Co. This is the family for whom Pritchardsville, South Carolina, is named. Courtesy of Mary Powell.*

*Holmes, Booth, and Hayden case that houses the Pritchard family ambrotype. Courtesy of Mary Powell.*

*Quinby & Co. sometimes bought cases from Holmes, Booth, and Hayden and then placed their identifying labels over that of Holmes, Booth, and Hayden as they did inside the case for the Pritchard family ambrotype. Courtesy of Mary Powell.*

*A carte de visite of a deceased member of the Holst family of Charleston, produced by Quinby & Co. Courtesy of Chester County Historical Society.*

*Ad by Quinby & Co. (Charleston) Southern Inventor, 1 November 1858. SCL.*

### Cheraw

**G. H. BROWN.** Brown of Baltimore opened a daguerreotype gallery for a short time over R. T. Powell's store in July 1856. No record of him in other South Carolina towns was found. He was also in Salisbury, North Carolina, in 1856.[88]

**K. R. MASON.** "This is the last time this season, that K. R. Mason will have the pleasure of waiting on his friends & patrons of this place." So read a March 1857 ad for Mason's ambrotype gallery located in the Town Hall. The wording of this ad strongly suggested that Mr. Mason had visited Cheraw at an earlier time and established a clientele there.[89]

### Chester

**E. ELLIOTT.** *Humphrey's Journal* in 1851 listed an "E. Ellicott" operating a daguerreotype gallery at Chester, South Carolina. This undoubtedly was a misprint, and should have read "E. Elliott." Throughout 1852 and 1853 Elliott ran an ad in the local press for his

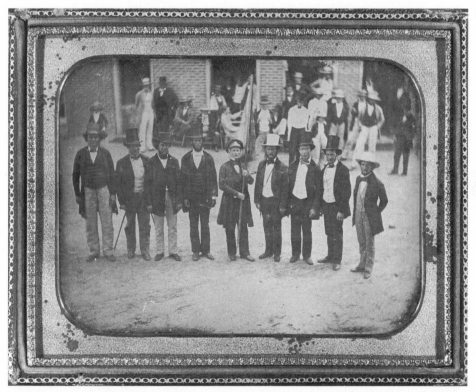

*Half-plate daguerreotype by an unknown artist of a group of Chester, South Carolina, Mexican War Veterans. The man in the center is Nathaniel Eaves, Color Bearer, First South Carolina Regiment of Volunteers. E. Elliott produced daguerreotypes in Chester from 1851 to 1857 and probably created this image. SCL.*

"Daguerreian Rooms" located opposite Kennedy's Tin Factory. Part of the time in 1854 and 1855 E. Elliott operated a daguerreotype gallery in Chester. By 1857 he had made the transition to ambrotypes and advertised his "Chester Sky Light Gallery." In addition to operating his photographic business, Elliott served as the town clerk during the 1850s.[90]

**M. M. MALLON.** In June 1853 M. M. Mallon advertised in the Chester paper he was from Charleston and was located in the Thespian Hall where he was prepared "to execute likenesses In the Highest Style of the Art!" Mallon next appeared in South Carolina in 1854, advertising the production of "Electrine" daguerreotypes at Solon Jenkins' gallery in Columbia. At this time he advertised himself as being from Baltimore. When he referred to being from Charleston and Baltimore, he was referring to places he had been located and not his permanent residence. This becomes more obviously the case when we add the fact that he also practiced his art in the North Carolina towns of Wilmington, Raleigh, Beaufort, and Tarboro from 1854 to 1860.[91]

**J. McCANTS.** McCants took rooms at the new hotel opposite the Chester Depot in March 1856 and advertised his services for taking daguerreotypes. In 1854 one J. McCants purchased photographic supplies from George S. Cook of Charleston.[92]

### Cokesbury

**E. EG. RANKIN.** Rankin advertised being in town for a few days in November 1858 and taking ambrotypes from his gallery at Mr. Mahon's Store.[93]

### Columbia

**W. H. THOMAS.** In 1847 W. H. Thomas purchased two daguerreotype instruments from George S. Cook while Cook operated a gallery in Huntsville, Alabama, indicating he probably was itinerant in that area. Thomas next appeared shortly before Christmas 1852, when he opened a daguerreotype gallery over Fisher & Agnew's Store. Thomas stated he was preparing "to become a permanent resident of Columbia."

In Chester and Yorkville newspaper ads in February 1853 he thanked the people of Columbia for their patronage and promised to give the citizens from other areas of the state the same service. He mentioned the recent purchase of a camera from Mr. Cook and promised, "If long & close study, with a perfect knowledge of perspective, drawing and painting is any advantage to his art, he has nothing to fear." Judging from this statement, he was a painter also.

It is not clear whether or not Thomas actually operated in Chester and Yorkville, but he probably did not since ads ran in the papers of these towns over the same period of time. In June 1854 Solon Jenkins, Jr. stated he had moved into the old stand of Thomas, indicating Thomas may have remained in Columbia to early 1854.[94]

**I. Tucker, Solon Jenkins, Jr., M. M. Mallon and John Usher, Jr.** In June 1854 Solon Jenkins, Jr. advertised the opening of a daguerreotype gallery in Columbia over Fisher & Agnew's Store, the old stand of Thomas. Jenkins stated in his ad that he had worked for Glen in Charleston for two years and took 4,000 daguerreotypes while working there. An ad later in June advertised the production of a recent discovery, Electrine Daguerreotypes, by M. M. Mallon. Mallon, previously located in Baltimore, was in town for a few days.[95]

Jenkins was from West Cambridge, Massachusetts, and while there in 1851 received a patent for securing daguerreotypes to tombstones. Jenkins died on 17 November 1854 from yellow fever and was buried in Columbia.[96] On 22 November, I. Tucker from Augusta, Georgia, came to town and placed this ad in the Columbia paper: "The Proprietor of the Palmetto Daguerrien Gallery (formerly known as the Jenkins Gallery, corner of Plain and Richardson Streets, would) respectfully announce to the public that his rooms are again open for the reception of visitors, and that he has secured the valuable services of Mr. John Usher, Jr., who has formerly operated with success in St. Louis, Mobile, and more recently

*Ad for Jenkins Gallery.* South Carolinian, *8 & 10 June 1854.* SCL.

in Augusta, Georgia, and he hazards nothing in saying that all who wish correct likenesses, and pictures of that deep mellow tone so much admired by good judges, can obtain them by calling at above."[97]

The relationship between Jenkins and Tucker is not clear, but it would appear from this ad that they were partners, or that Jenkins worked for Tucker in this Columbia gallery. I. Tucker, in partnership with J. W. Perkins, operated a large photographic business that not only produced photographs in Augusta, but supplied many other photographers in Georgia and South Carolina with equipment, chemicals, and other supplies. They also operated branch galleries in other towns.

John Usher, Jr., according to this ad, worked in St. Louis, Mobile, and Augusta prior to coming to Columbia to operate the Palmetto Daguerrean Gallery for Tucker. In October 1856 Usher still operated this gallery as witnessed by a letter he wrote to Tucker from Columbia ordering photographic supplies.[98] The date this business closed has not been determined, but by 1859 Usher sold sewing machines in Columbia. After the Civil War he operated a studio in Augusta, Georgia, for several years[99]

RICHARD WEARN AND WEARN & HIX. According to his obituary, Richard Wearn, in a fit of insanity ended his life on 9 January 1874 with a derringer pistol shot. His obituary further stated that his family moved to Charlotte, North Carolina, from the Isle of Man when he was a boy, that he lived in Newberry for a time, had worked as an "enthusiastic" photographer for the past fifteen years in Columbia, was buried in the First Baptist Church cemetery, and left behind a grieving widow.[100]

In an account book in the George S. Cook papers in the Library of Congress, a firm from Anderson by the name of Wearn and Richardson bought photographic supplies from

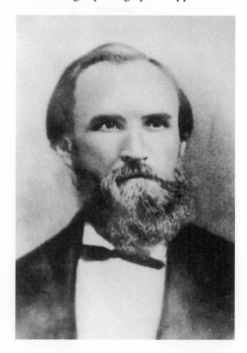

*Copy print of a photograph of Richard Wearn circa 1870. Courtesy of Confederate Relic Room and Museum.*

Mr. Cook of Charleston in 1854. A year earlier Wearn & Robertson also bought supplies, but the location of the firm was not given. The Wearn in these accounts was probably Richard Wearn.[101]

In March 1856 Richard Wearn advertised in an Abbeville newspaper as an ambrotypist and daguerreotypist who would be in town for a few days with his "Celebrated Car, being a combination of a sky light and the side light by which light only can a true picture be produced."[102]

In 1858 Richard Wearn and C. H. Kingsmore were in partnership in a gallery over W. H. Hunt & Co.'s store in the town of Newberry. By 1859 Wearn left Newberry and moved to Columbia where he set up a gallery. In an 1859 Columbia city directory display ad Wearn mentioned that he won awards in the "So. Ca. Fair in 1856, '57 & '58." In the 1858 catalog of the fair a "C. Wearne" from Newberry was listed as a winner. This undoubtedly was a misprint and should have read "R. Wearn." Wearn won first place in the 1859 fair for "oil photographs" and for ambrotypes. The photographic collection of the South Caroliniana Library contains a few examples of Wearn and Kingsmore's work.[103]

After joining the Wearn firm in 1860, William P. Hix worked in the business for most of the time until Wearn's death. Hix continued the gallery in 1874 and subsequently associated others in the business with him. George V. Hennies assumed control of the firm in the early 1880s.

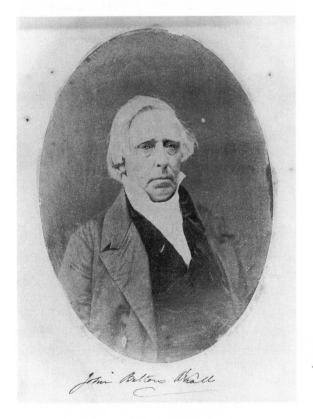

*Salt print of John Belton O'Neall produced by Wearn & Kingsmore in 1858. SCL.*

**WEARN'S**

PREMIUM

Photograph and Ambrotype

**GALLERY AND STOCK DEPOT,**

No. 170 Richardson Street, Columbia, So. Ca.,

(OVER MESSRS. FISHER & AGNEW'S STORE.)

Four Premiums awarded at the So. Ca. Fair in 1856, '57 & '58.

PHOTOGRAPHS, IVORYTYPES, HALLOTYPES,

AMBROTYPES, MELAINOTYPES, STEREOSCOPES, ETC.,

MADE AND FINISHED IN THE BEST STYLES OF THE ART.

**PHOTOGRAPHS MADE FROM MINIATURE TO LIFE SIZE,**

Plain, or Colored in Oil, Water or Pastil,

BY ONE OF THE BEST ARTISTS IN THE UNITED STATES.

PRICES, FROM ONE TO ONE HUNDRED DOLLARS.

**Daguerreotypes, or any kind of Pictures copied or enlarged.**

STATUARY, MACHINERY OR LANDSCAPES,

COPIED OR STEREOSCOPED.—SOMETHING NEW AND BEAUTIFUL.

Photograph and Ambrotype Stock and Chemicals

FOR SALE LOW, FOR CASH ONLY.

INSTRUCTIONS GIVEN IN THE ART.

The community generally are respectfully invited to call and judge for themselves.

**RICHARD WEARN.**

*Richard Wearn ad.* Columbia City Directory, *1859, SCL.*

On several of the surviving photographs produced by Wearn & Hix, Wearn was listed as a photographer and Hix as a portrait painter. It was customary at this time to hand-tint many photographs. Hix probably did most of the hand-tinting for the firm as well as produced photographs in his own right.

The photographic career of Richard Wearn spanned at least twenty-one years, from 1853 to 1874. As a result, he created daguerreotypes, ambrotypes, tintypes, cartes de visite, stereographs, and albumen paper photographs. After six or more years as an itinerant photographer, Wearn became a "resident" photographer in Columbia.

Very few Wearn & Hix daguerreotypes or ambrotypes have been identified. However, Wearn won awards in the fairs of the South Carolina Institute, leading to the conclusion

*Cased image on ivory of William R. Gist, produced by Richard Wearn. This image was hand-tinted by J. E. Richard. Courtesy of Confederate Relic Room and Museum.*

that he ranked at or near the top of his profession in South Carolina. In the collection of the South Carolina Confederate Relic Room & Museum in Columbia there is an exquisite photograph of William M. Gist, the son of Governor William H. Gist, that vividly illustrates the quality of work produced by Wearn & Hix.

**JOHN G. GLADDEN.** In the 1859 and 1860 city directories of Columbia John G. Gladden's occupation was listed as that of daguerreotypist. However, he was not included in the business listings as the owner or operator of a studio. He may have been employed by Joseph T. Zealy or may have produced photographs from his home. He does turn up again in March 1866 as an ambrotypist operating a gallery on Main Street south of Blakely & Copeland's Store. He boasted a "sky-light" and was charging one to five dollars for cased ambrotypes.[104] Although he remained in Columbia, his name after this date was no longer associated with photography.

**WATSON.** In April 1860 Watson opened a gallery over Marshall's Dry Goods Store, advertised the production of pictures at half price, and that he would only be in town for a short time.[105]

### Conway(borough) (Horry District)

**B. F. RICHWOOD.** In the State Fair for 1851 B. F. Richwood of "Horry District" was listed as an exhibitor of daguerreotypes. In September 1853 he ordered photographic supplies from Cook in Charleston.[106] Apparently, Richwood was involved in producing daguerreotypes for more than two years.

*Leigh's ad for his "Daguerrean Car" gallery.*
Edgefield Advertiser, *29 November 1855. SCL.*

## Edgefield

**JOHN LEIGH AND OTHERS.** John Leigh came to Abbeville from New Orleans and produced daguerreotypes in 1849, but he worked in Augusta, Georgia, prior to going to New Orleans. Leigh began work in Edgefield in January 1850 when he advertised the taking of daguerreotypes from his rooms in Spann's Hotel. Later in 1850 and 1851 he worked with Tucker & Perkins in Augusta. In 1851 he advertised winning first place in the Georgia State Fair. In 1853 and 1854 Leigh visited Edgefield with his daguerreian car. By 1856 Leigh also operated a store in Edgefield and used it as a base for his itinerant photography business.[107]

Leigh joined forces with a number of other artists from time to time. On 30 May 1856 Leigh and an artist named Lyon produced ambrotypes in Laurens. On 11 July 1856 Leigh and Lyon visited Clinton with their ambrotype car. On 30 September 1856 Leigh and a Mr. Chalmers of Augusta, Georgia, appeared in Edgefield and produced ambrotypes. They also operated a gallery together at this time in Augusta. The artist was probably A. T. Lyon of A. T. Lyon & Co. who produced ambrotypes for a short time in Edgefield in November 1856.[108] However, an artist by the name of R. Newton Lyon worked in Laurens in 1861.[109] In 1856 Edgefield was visited by at least five different artists, including I. Tucker.

**MORRIS & HUETT.** Shortly before Christmas 1855 these two men arrived in town and advertised a daguerreotype gallery in their rooms in the Carolina Hotel. They were probably taking advantage of the holiday season, producing daguerreotypes to be used as Christmas presents.[110]

**I. TUCKER.** In May 1856 I. Tucker, the well-known Augusta artist, opened an ambrotype business in Edgefield for a few months. His stay seems to have been coordinated with the other artists who came to Edgefield at different times that year.[111]

**JOHN S. DUFFIE.** Duffie wrote to Mr. Tucker (presumably I. Tucker of Augusta, Georgia) from Lexington, South Carolina, in November 1856. His friend in Columbia, Mr. Usher, had recommended Tucker as an honest dealer in cases and chemicals, and Duffie asked him to send a price list to Edgefield.[112]

**HILDEBRAND & GIBSON.** These two artists took rooms in May 1859 in the Planters Hotel and produced ambrotypes and melainotypes for a short time.[113]

## Georgetown

**E. A. PARKER.** Parker from New York, who has "traveled in the Northern States and Canada, is now on a tour through the Southern States. He has taken rooms at Winyah Hall for a few days. . . . Mr. Parker will be pleased to wait upon those who may wish perfect

*Sixth-plate daguerreotype by an unknown artist of Felix Harling who lived in Edgefield District. SCL.*

Likenesses of themselves or friends." Parker was in Georgetown in December 1854 and January 1855.[114]

**D. Laurence & Co.** Winyah Hall was again patronized by traveling artists when D. Laurence & Co. took rooms there in December 1857 to produce "Ambrotypes, Sperotypes, Melainotypes and pictures on Oiled Silk for sending in letter."[115]

*Graniteville*

**Mr. Pinkham.** Pinkham bought photographic supplies from Cook of Charleston in April 1850.[116]

*Greenville*

**ALVORD & TALMADGE.** Shortly before Christmas in 1850 Alvord & Talmadge took rooms in China's Hotel in Sumter and produced daguerreotypes. They next appeared in Greenville in May 1851 at McBee's Hall and also produced daguerreotypes there. Thomas Stephen Powell visited McBee's Hall on 14 August 1851 "where a Mr. Talmadge took a daguerreotype of us together." Powell, a local painter who secured this daguerreotype of himself and a female companion, was also a diarist and recorded this and later visits to galleries in Greenville. Alvord, whose first name was never listed, disappeared from the scene. John A. Talmadge, the other half of this partnership, showed up in April 1855 with a gallery at A. G. Park's old stand in Charleston.[117]

**CHARLES H. LANNEAU.** For a few years prior to the advent of the daguerreotype in 1839, Lanneau painted portraits in Charleston.[118] By 1850 a Charles H. Lanneau produced daguerreotypes in Greenville and, for at least eleven years, practiced photography in South Carolina as an itinerant. His base became Greenville and, over the course of the 1850s, he operated galleries in five different South Carolina towns.

In March 1853 Lanneau took daguerreotypes in Edgefield from his rooms in the Spann Hotel and boasted his likenesses were "Superior to any ever taken." By April 1853 he had moved upstate to Abbeville and briefly produced daguerreotypes from his rooms in Ramey's Hotel. He made a return visit to Abbeville in 1854. In February 1855 he worked in the village of Cokesbury for a few weeks taking likenesses from Dr. Conner's Hotel. October 1855 found him in Sumter producing daguerreotypes from rooms in China's Hotel. In

*This portion of a Furman University diploma designed by artist Thomas Stephen Powell shows an engraving produced from Powell's sketch of Furman that was based on a daguerreotype of the school by Charles H. Lanneau. The original daguerreotype could not be located. Courtesy of Furman University Library.*

*A daguerreotype by an unknown artist in the 1850s of the main building of Wofford College. Courtesy of Wofford College Library.*

*Carte de visite by Charles H. Lanneau of James C. Furman, President of Furman University, 1859–61. Courtesy of Furman University Library.*

1859 he was back in Abbeville at the Marshall House producing "Ambrotypes, Sperotypes, Melainotypes & 'relievo' Types." In April 1861 he practiced his art in Spartanburg.[119]

The Greenville diarist and painter Thomas Stephen Powell on 19 September 1855 wrote, "In the afternoon I went to Mr. Lanneau's & borrowed a daguerreotype of the college to put on my design for the diploma." Commissioned by Furman to create a design for their diploma, Powell wished to incorporate a view of the school.[120]

This account takes on added significance when one examines an 1854 daguerreotype of Wofford College located in Spartanburg about thirty miles distance from Lanneau's location. Having taken a picture of Furman University in 1855, Lanneau may have taken the 1854 daguerreotype of Wofford. He was in Spartanburg in 1861. Powell again visited in Lanneau's Greenville gallery on 17 July 1856 and borrowed photographs. Lanneau is also a likely candidate for the production of a daguerreotype of Limestone Springs Female High School circa 1850.[121]

Mr. Lanneau's career as a photographer spanned at least eleven years. During that time he produced the full range of photographs. Although few examples of his work are available for judging its quality, his training as a painter likely helped him turn out a superior product. If he produced the Wofford College daguerreotype, then his product was indeed superior.

### Lancaster

**J. H. Cousart.** In September 1852 J. H. Cousart came to town and offered local citizens "an opportunity of procuring perfect likenesses of themselves & friends." This same

*Daguerreotype attributed to J. H. Cousart of Jane and Simon Beckham. Viola C. Floyd Collection. Courtesy of Lancaster County Library.*

ad ran for a year to September 1853. Cousart remained in Lancaster and operated a store there in 1853.[122]

**S. H. Martin.** In November 1852 S. H. Martin announced he had taken rooms at Cousart's for a short time and advertised his ability to take almost any picture one could imagine.[123]

**S. N. Davis.** Davis took rooms in Catawba Hall in March 1854 and announced "that he is prepared to execute in the best manner and most approved modern style, daguerreotype likenesses." He was probably the "Davis" of Davis & Franklin who were in Laurens the next year.[124]

**W. B. or W. P. Hughes.** W. P. Hughes located in Camden, South Carolina in January 1858 and took photographs. In April that year W. B. Hughes advertised in the Lancaster press the taking of ambrotypes, chrystallotypes, and melainotypes at the Odd Fellows Hall. Lancaster is about thirty miles north of Camden on the route to Charlotte, North Carolina. A "Wm. P. Hughes" from Charlotte took daguerreotypes for a short time in 1853 in Yorkville, a town located about halfway between Lancaster and Charlotte. It is likely that these Hugheses were the same person.[125]

**J. M. Crowell.** Crowell took rooms in the Odd Fellows Hall on 23 September 1857 and invited citizens to examine his ambrotypes and secure one for themselves or friends.[126]

**M. W. Bailey.** Rooms in the Odd Fellows Hall were again the site for taking ambrotypes in September 1859 by a Mr. M. W. Bailey.[127]

### Laurens

**Charles Friedal.** Friedal came to town in January 1850 and advertised long experience in the art, instruction given in the art, large supplies of materials and daguerreotype likenesses that compared favorably to any produced elsewhere. Mr. Friedal was reported in Tallahassee, Florida, in 1852.[128]

**F. A. Hoke.** Hoke took rooms next to the Masonic Hall in January 1851 from which he was "prepared to take miniatures equal to any in the country as he [was] in possession of all the late improvements." He departed from Laurens by August.[129]

**John Toland.** Toland advertised in August 1851 that he had "fitted up his apparatus in the room formerly occupied by F. A. Hoke over Dr. J. H. Henry's Drug Store," where he was prepared to take daguerreotype likenesses by the latest method and color them.

In September 1853 a firm by the name of Toland & Smith located in Newberry and ordered photographic supplies from Cook in Charleston. This Toland was probably John Toland. H. S. Smith operated or worked in a gallery in Charleston from 1849 to 1852. He may have been operating an itinerant business with Toland in 1853.[130]

**Davis & Franklin.** In March 1855 the *Laurensville Weekly Herald* carried this item: "Messrs. Davis & Franklin have arrived in our village and taken the room over Green & Bakers Store, for the purpose of taking daguerreotype likenesses. Our readers should not let the opportunity pass of securing good likenesses of their relatives and friends. We believe

Messrs. D. & F. are good operators, and hope they will meet with encouragement." Davis was probably S. N. Davis who is discussed under "Lancaster" in this chapter.[131]

**L. A. GREEN.** In October 1855 the editor of the *Laurensville Weekly Herald* carried a news item about L. A. Green taking a room at Simpsons Hall to produce daguerreotypes. He opined that "Mr. Green is not easily surpassed in his line, as many of our readers know." This statement suggests that Green had previously visited Laurens.

The next mention of Green was his ad on Christmas eve 1856 in the Laurens paper for taking "Superior Ambrotypes." He was back in Laurens in 1860 and secured the services of E. Hix to build him a sky light for his ambrotype and photograph gallery in John Garlington's small brick building.[132] For the first year or more of the Civil War Green operated a gallery in Columbia.

**E. J. BROWN.** April 1859 witnessed something new in Laurens according to Mr. Brown—"Raised Ambrotypes." Brown produced them from his car and encouraged patrons to visit him. Photographic historians do not discuss "Raised Ambrotypes."[133]

### Limestone Springs

**UNKNOWN.** In 1850 Limestone Springs, a small village in Spartanburg District, was the home of the Limestone Springs Female High School. In about 1851 a photographer produced a daguerreotype of the school from which a drawing was made by one Rosalie Roos. The drawing was followed by an engraving and finally a published lithograph in 1852. This daguerreotype may have been the work of Charles H. Lanneau of Greenville.[134]

### Newberry

**KINGSMORE & WEARN.** Charles H. Kingsmore, a portrait painter, also took up the allied art of photography. In 1858 he and Richard Wearn were in business together in a Newberry gallery "over W. H. Hunt & Co's Store." After Wearn left in 1859 Kingsmore continued his gallery. For two months in late 1860, W. A. Cooper worked with Kingsmore. Throughout 1860 and early 1861 he advertised his services as both a photographer and a portrait painter.[135]

**J. M. PHILLIPS.** Phillips of Newberry bought photographic supplies from George S. Cook of Charleston in August 1853.[136]

### Orangeburg

**MR. DINSLER.** Dinsler purchased photographic supplies from Cook of Charleston in April 1850.[137]

**J. M. CLARK.** In June 1853 J. M. Clark of Orangeburg purchased photographic supplies from George S. Cook of Charleston. A "J. M. Clark" was a member of the New York State Daguerreian Association and, in 1851, served on a committee to investigate L. L. Hill's so-called color process.[138]

## Pickens

**C. N. REID.** Reid's ad in May 1857 simply stated he had opened his ambrotype gallery and was prepared to take ambrotypes "by which the human features may be truthfully perpetuated for a great length of time."[139]

**H. A. H. GIBSON.** Gibson referred to his ambrotypes with the phrase, "a thing of beauty is a joy for ever" in July 1860. He stated that "none but good portraits will be allowed to leave my establishment." Gibson showed up in Walhalla in 1871 as a photographer.[140]

## Russell Place

**THOMAS STUMAN.** In 1854 Russell Place was a small village in Kershaw District a few miles northeast of Liberty Hill and very close to the Lancaster District line. Today it is known as Stoneboro. A Mr. Stuman of that village purchased photographic supplies from Cook of Charleston in June 1854.[141]

## Spartanburg

**J. FORREST GOWAN.** Gowan opened his ambrotype and photographic gallery over Twitty's Store in December 1856 and continued in business in 1857. He advertised pictures of "surpassing loveliness and imperishable beauty."[142]

## Sumter

**JOHN W. McROY.** McRoy advertised as an ambrotypist in December 1857 and produced quality work as reported in the *Sumter Watchman* in January 1858. McRoy did not stay in business very long, however, as he attempted to sell out in October that year.[143]

**CHARLES W. DAVIS.** In 1857 this engraver, fancy printer, and lithographer established a gallery in Sumter and operated it on a regular basis until the early part of the Civil War. He specialized in ambrotypes and daguerreotypes.

On 2 October 1858 he claimed to have discovered a process for making mirrored and grained ambrotypes, a "new" discovery. He described this product in the following terms: "It is far superior to anything as yet discovered or practiced in the Ambrotyping Art, in point of durability, its varied colors, too, makes it beautifully rich, while at the same time it has the advantage of the Stereoscope, causing the most superficial observer to exclaim 'how it sette out.' It seems raised right out, or to the surface of the plate, while the background presents that lustrous richness, in the far distances imparting that sweet tone so desirable to a picture. It is the only practicable picture, that really combines statuary with art."[144] Davis's images appears to have been a type of stereograph as that medium does add much depth to a picture, giving it a sculptured or three-dimensional appearance.

**E. M. BURCH.** In June 1859 E. M. Burch occupied the rooms vacated by D. L. Glen at the Sumter Hotel and advertised the taking of cartes de visite. By this date many photographers produced paper photographs.[145]

**JOHN W. DAVIS AND JOHN S. BROADAWAY.**  These two artist set up a gallery above the store of White, Colcough, and Company in November 1859 for a short time. The name Broadaway was listed for a Spartanburg photographer in 1860 and a Greenville one in the 1870s. The Greenville listing was for J. S. Broadaway and may have been John S.[146]

### White Hall

**W. G. KENNEDY.**  White Hall was a small village in Abbeville District. In July 1857 Kennedy advertised ambrotype production there for a "moderate remuneration."[147]

### Winnsboro

**J. K. CARLISLE.**  For three years, beginning in December 1856, Carlisle advertised his ambrotype business in Winnsboro at the Market Hall.[148]

### Yorkville (now York)

**MR. DE SHONG.**  The editors of the *Yorkville Miscellany* reported on De Shong's gallery in January 1851: "We take pleasure in announcing to our readers that Mr. De Shong the celebrated and successful Daguerian is now occupying the room one door North of our office and is doing a splendid business in our line. Mr. De. S. arrived at our village a short time since, and in the brief space of a few weeks has taken more likenesses and given more general satisfaction than all the Daguerrian artists who have hitherto visited us." A W. H. De Shong operated in Greensboro, North Carolina, in 1857 and was perhaps the same gentleman.[149]

**THOMAS. D. CORY.**  Cory took rooms in a store house across from Goore's Hotel in April 1852 and advertised the production of daguerreotypes. Specimens available in his gallery for examination were Governor Means, President Fillmore, and the Giant Boy—an interesting combination. Whether these were the works of Cory or simply display items is not clear. He also operated a gallery in Salisbury, North Carolina, in 1852.[150]

**DR. J. W. F. WILDE & DAUGHTER AND WM. P. HUGHES.**  From 1849 to 1853 the Wildes practiced their art in the North Carolina towns of Hillsborough, Greensboro, Charlotte, and Asheville.[151] These daguerreian artists took rooms in Walker's Hotel in Yorkville in December 1853 and described themselves in this manner: "Their reputation as well as their pictures, have too extensive a circulation in this state to require an extended notice here-the one being the oldest and most experienced operator in the United States, while the other (Miss W.) as a colorer, is unsurpassed anywhere, and unequalled in the South." At the end of the ad their names, J. W. F. Wilde, Augusta Wilde, and William P. Hughes, were listed as proprietors.[152]

# Cameramen during the Conflict, 1860–65

## Military Action in South Carolina, 1861–65[1]

On 17 December 1860 a group of South Carolinians convened a Secession Convention in Columbia. Due to a smallpox scare, this convention moved to Charleston, and on 20 December South Carolina seceded from the Union. Other states also seceded and on 4 February 1861 representatives from these states met in Montgomery, Alabama, to begin organizing the Confederate States of America as a separate nation.

The first military action in South Carolina involved the Union held forts guarding Charleston and its harbor. The Union commander of these forts, Major Anderson, realized he could not hold all of these fortified positions, and on 26 December 1860 he secretly consolidated his forces at Fort Sumter. On 12 April 1861 the Confederate forces began a bombardment of Fort Sumter from Fort Moultrie, Morris Island, and other points. After thirty-four hours of this bombardment, and with his supplies running low, Major Anderson surrendered the fort to General P. G. T. Beauregard and his forces.

From mid-April to early November 1861 the state continued preparations for war. South Carolina troops participated in early battles, but no fighting occurred inside the state. The Union navy began a blockade of the South, but to be effective they needed southern bases to resupply their blockading ships. On 7 November 1861, after a brief fight, a Union force supported by a flotilla of ships occupied Hilton Head and thereby secured a southern base. The Union army quickly occupied the nearby town of Beaufort, since the Confederate forces abandoned it, and this area of South Carolina remained in Union hands throughout the remainder of the war. Union photographers soon appeared on the scene in numbers.

Union forces occupied many of the sea islands from Charleston to Savannah, with Confederate forces establishing defensive positions at strategic points between these islands and the interior. Battles such as Pocotaligo, 29 May 1862; Secessionville, 16 June 1862; Coosawhatchie, 22 October 1862; and Honey Hill, 30 November 1864 were fought and lost by the Union forces. From their base on Hilton Head, the Union army and navy staged these battles and a number of small skirmishes and raids along the Confederate defensive line as they attempted to cut the Charleston and Savannah Railroad and capture Charleston. Neither of these objectives were achieved until after William T. Sherman began flanking the

Confederate forces on 1 January 1865 when he started his march through South Carolina from Savannah, Georgia. Union photographers provided extensive coverage of some aspects of Union activities in this region.

Photographers from both sides photographed attempts of the Union army and navy to capture Charleston. Sherman's march through South Carolina received minimal photographic coverage. A few photographs exist of Sherman's army in camp in Beaufort taken by Samuel A. Cooley or his assistants in early January 1865. Photographs were taken at Fort Sumter and Charleston after their occupation in February 1865, and in mid-April when the United States flag was restored to Fort Sumter. In 1865 and 1866 Richard Wearn and George N. Barnard produced other photographs of Union army destruction in Columbia.

General Edward E. Potter marched from Georgetown to Camden, from April 5 to April 26, 1865, burning and pillaging as Sherman had done. Jefferson Davis traversed the state in his flight to avoid capture. General Stoneman raided through several northern South Carolina counties in April 1865. None of these activities received contemporary photographic coverage.

### Technical Limitations[2]

An ingredient of the Civil War was action or movement. Soldiers, horses, and machines were in constant motion as they maneuvered for battle, then fought, and repeated the process to fight again. Technically, most photographers from 1860 to 1865 could not capture movement; that is, they could not stop moving subjects for a clear, focused photograph. Since 1839 the amount of exposure time to produce a photograph had been greatly reduced, but it was a number of years after the Civil War before "stop action" photography was readily available to all photographers.

"Action" photographs produced during the war usually represent action that has been "stopped" to accommodate taking the photographs. Consequently, they only represent reality to a degree. Since most photographs had to be staged to a certain degree, they appear formal and lack spontaneity. From a practical point of view, a photographer could produce photographs of camp life, battle preparations, battlefields after the battle, forts, individuals, and non-moving objects, but production beyond those areas was extremely limited.

### Wartime Laws Affecting Photographers

At the inception of the Civil War each side thought the war would be of short duration. Consequently, neither side foresaw the need to plan financially for a protracted conflict. As time passed and costs mounted, however, each side began to enact revenue generating measures, some of which affected photographers. These laws involved licensing fees, income tax, and a United States stamp tax on photographs that took effect in June 1864.

By September 1862 United States law required photographers to pay an annual license fee ranging from $10 to $25, depending upon the amount of annual business. By April 1863

the Confederate government required photographers to pay $50 annually plus 2½ percent of their gross.

Beginning in June 1864 the United States required photographers to buy and place a 2 or 3 cent revenue stamp on each photograph sold. By 1 June 1865 tax districts were reestablished in South Carolina and enforcement of this revenue measure began. By 1 August 1866 this measure was discontinued by the United States government due to lobbying by photographers.[3]

## South Carolina Photography in 1860

Early in this study it became apparent that a very limited number of Confederate and Union photographers produced military photographs of battlefields and related scenes. To exclude other photographers in business at the time who produced only civilian, non-war images would present an incomplete picture of the subject. Consequently, all photographers, North or South, verified in business in the state during the Civil War are included.

From extensive research in antebellum newspapers, city directories, periodicals, books, photographic collections, and other sources, information on photographers operating in South Carolina in December 1860 has been developed. One source was the papers and account books of George S. Cook of Charleston, who sold supplies to many photographers. If an individual ordered supplies from Cook, he has been recorded in this work as a photographer. These combined sources reveal that some of these photographers were itinerants from South Carolina and other states including the North. However, many were South Carolina residents operating from a local studio.

A comparison of advertising, photographs, and other aspects of South Carolina photographers' business to those of other photographers across the nation demonstrates they were on a par with their counterparts when the Civil War began. Statements about technical advances and new photographic techniques frequently appeared in their photographic ads of the late 1840s and the 1850s. Information, equipment, and supplies flowed freely throughout the nation, but the war quickly disrupted this picture.

The Census of 1860 contained a compilation of the number of photographers by states and showed thirteen daguerreotypists, nine ambrotypists, and four photographers in South Carolina for a total of twenty-six. Research for this work identified thirty photographic firms in business in South Carolina at the beginning of the war. Including their proprietors, these firms employed forty-three photographers. More than one-third of these photographers were located in Charleston, meaning that about twenty-eight men produced photographs in the remainder of the state.

Union photographers who came to South Carolina during the Civil War were identified primarily from photographic collections and Union newspapers published in Beaufort after its capture in November 1861. Information about photographers from these and some additional sources is included.

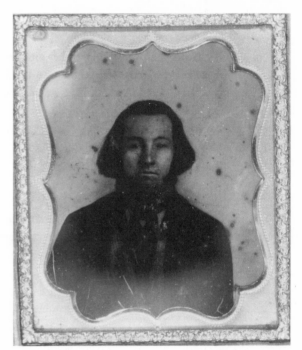

*Ambrotype of Abraham Leroy,
Lieutenant, Co. E., 1st. (Orr's) South
Carolina Rifles, Pickens District. Since
Leroy was mustered into service at
Sandy Springs in July 1861, I. H.
Ligon probably produced this image.
Courtesy of Confederate Relic Room
and Museum.*

## South Carolina Photographers, 1860–65

### Abbeville

**I. H. LIGON.** Ligon from Abbeville purchased photographic supplies in April and May 1861 from George S. Cook in Charleston. He also placed an order with Cook for a Major Anderson photograph, likely planning to reproduce and sell copies of it.

On 9 August 1861, while in camp at Sandy Springs near Pendleton in Anderson District, Frederick Bischoff wrote in his journal, "a good many of the fair sex were present and cheered us Embryo Soldiers up to our important calling. A ambrotypist from Abbeville put up a gallery of Art in a Shantee next to the hospital, to give the boys a chance to take their Counterfeit Sweethearts along and also to leave a faint shade with their love ones, if their substance should fade in the defense of our common country."[4]

### Anderson

**MR. MILLWEE.** On 14 August 1860 a Mr. Millwee advertised in the *Anderson Intelligencer* that he would produce photographs in Millwee's Gallery. We next hear of him on 28 February 1861 through another ad in the *Anderson Intelligencer.*[5] The wording of his 1860 ad that "he would be in town for only a few days" suggests he was an itinerant photographer.

Millwee was a Confederate photographer who produced ambrotypes and stereoscopic views of the forts and other locations in Charleston. Instead of taking negatives for these

photographs himself, he may have purchased negatives in Charleston and produced prints for resale.

**F. C. von Borstel.** On 16 November 1865 an F. C. von Borstel advertised in the *Anderson Intelligencer* that "as the war is ended and old things called by new names. I will take liberty to call attention. . . .that again I am at my old place of business." Von Borstel advertised a combination jewelry store and photographic gallery. He began his jewelry business in 1848, but did not produce photographs then. Von Borstel remained a jeweler and photographer in Anderson at least until 1870.[6]

### Camden

**H. B. McCallum and McCallum & Brother.** On 1 May 1860 H. B. McCallum advertised the opening of a "Permanent Ambrotype & Photograph Gallery!" in Camden. The term "Permanent" as used by McCallum must have been for advertising purposes only since he left for a time. By October 1860 he had returned. In January 1861 McCallum & Bro. advertised their ambrotype gallery next door to McCain's. After the Civil War McCallum operated a studio in Sumter from 1866 to 1869 and occasionally came to Camden as an itinerant photographer.[7] Several postwar photographs of McCallum have surfaced, but none for the war years.

**J. P. Boswell.** In July 1860 Mr. Boswell opened a gallery over Alexander's. He stated he had traveled with the artist Hughes and was trained to produce quality photographs. He probably accompanied W. P. Hughes as his assistant when he visited Camden in 1858. Boswell may have been from Charlotte, North Carolina, since Hughes frequently worked out of that city.[8]

### Charleston

The Charleston city directory of 1860 listed five photographic firms. Some firms were partnerships, while others were single proprietorships employing one or more assisting photographers. For example, Alma A. Pelot and J. E. Smith were assistants to J. H. Bolles. Cook, Quinby & Co., and Osborn & Durbec all employed assistants. Several of these assistants, all photographers in their own right, opened galleries in Charleston after the war. Only fourteen photographers were documented working in Charleston in 1860, but there may have been a few more.

Charleston photographers recognized the opportunities provided by secession, the creation of a new nation, the raising of armed forces, and, finally, war. Most photographers immediately began capturing the events and activities occurring in Charleston and its environs. Events were followed in the newspapers of the day and any photographic images of individuals or locations involved were eagerly sought and purchased.

Halftone technology for transferring a photograph directly to a printing plate without the intervention of hand engraving was some thirty years away. As a result, the production and distribution of individual photographs at that time served in lieu of the later

mass production and distribution of them in various forms of print. The cheapest photographs for sale cost a dollar or less and were cartes de visite, which were so popular with the public from 1860 to 1870. They are the type of photograph found most frequently today in family albums and photographic collections dating to that era

**GEORGE S. COOK, J. J. MUNDY, A. McCORMICK, AND F. W. R. DANFORTH.** In 1860 George S. Cook employed as operators J. J. Mundy and A. McCormick. In photographic literature an operator was a person who took photographs and performed other services for his employer. In many cases the term was used as a synonym for "photographer." Cook himself used "operator" in 1849 as a synonym for photographer when he advertised that he supplied "Operators with stock." With Cook's volume of business, he certainly needed other hands for mounting, retouching, tinting, and other tasks associated with a large studio.

In 1860 or early 1861 A. McCormick returned to his home in Oxford, Pennsylvania. Cook exchanged letters with him from April to June 1861 attempting to convince him to return to Charleston. McCormick employed a sick mother, the political situation in South Carolina, and poor health as his reasons for not returning. He did, however, ask for and receive aid from Cook in setting himself up in a photographic business in Oxford. Mundy worked for Cook as late as 1863, but by June 1865 had opened a photographic firm in Charleston at 243 King Street and remained there until about 1867 or 1868. Although Cook probably personally photographed most of his firm's products during the war, it is reasonable to assume both Mundy and McCormick did some photographing for Cook's firm in 1860 and 1861.[9]

F. W. R. Danforth worked for Cook in 1859 and at least until June 1860. The Charleston city directory that year lists Danforth as an artist, but includes only a home address. However, after leaving the city Danforth wrote Cook in 1861 from Petersburg, Virginia, and discussed old friends and associates in Charleston as well as North/South problems.[10]

*An 1860 receipt for photographs produced by the George S. Cook gallery that is signed by one of his operators, F. W. R. Danforth. Courtesy of a private collector.*

No pictures of the sessions of the Secession Convention held in Columbia and Charleston are known; however, Cook did take a photograph of the inside of the Secession Hall in Charleston after the convention adjourned. Photographs of the exterior are known and were probably produced by a number of photographers. By early February 1861 Cook and other Charleston photographers had photographed Fort Moultrie, Fort Sumter, and other fortifications around Charleston. Stereographs and cartes de visite of them were on sale in late February in local towns such as Anderson.[11]

On 8 February 1861 the *Charleston Mercury* reported that "Mr. George S. Cook the well known Photographer, visited Fort Sumter on Friday, and succeeded in taking several life-like likenesses of Major Anderson and a group of the officers under his command. Mr. Cook has made copies of the originals, which may be seen and procured at his fashionable gallery, King Street, opposite Hassell."[12]

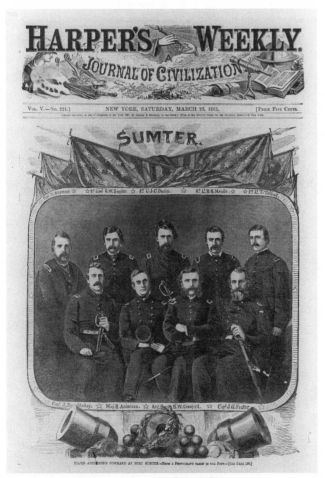

*Front page of 23 March 1861 issue of* Harper's Weekly *containing the engraving of Major Anderson and his officer that was based on Cook's photograph of them. SCL*

Abner Doubleday of baseball fame served as a Union officer at Fort Sumter in 1861. In his 1875 book, he wrote that "On the 8th [Feb. 1861], some photographic artists were allowed to come over and take our portrait in a group. I think it proved a profitable speculation, for the sale was quite large." Doubleday made reference to only the group photograph. Between 14 February and 1 April 1861 Dr. S. W. Crawford on Major Anderson's staff wrote seven letters to Cook ordering copies of individual photographs of the Major and others Cook captured on 8 February. One letter requested photographs of Fort Moultrie and any other similar photographs Cook could supply. Since the Major and his forces had occupied Fort Moultrie and other military positions around Charleston only two months earlier, the requests for these photographs probably were motivated by a desire to send copies to loved ones and not for spying purposes.[13]

Cook's studio on King Street sold many copies of the group photograph of Major Anderson and his officers, locally and to northern firms such as E. Anthony, for mass production and sale. *Harper's Weekly* produced an engraving for the front cover of their 23 March 1861 issue. This became one of the most widely distributed photographs to date and established George S. Cook as a pioneer in the field of photojournalism.[14]

During the weeks after the Anderson photographs, Cook produced dozens of photographs of Confederate soldiers in his studio. His next important photographic accomplish-

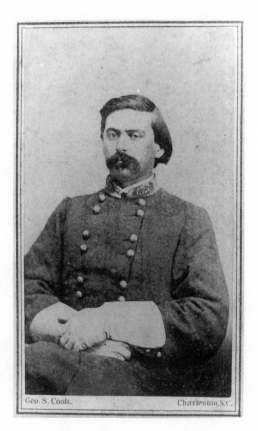

*A carte de visite of Pierce Manning Butler Young, a typical photograph of Confederate soldiers being produced by George S. Cook early in the war. SCL.*

ment involved taking views of Fort Sumter on 15 April 1861, after Major Anderson's surren-
der. As a matter of fact, most of the Charleston photographers swarmed "a la ducks on a
June Bug" to the fort after its surrender. Jesse Bolles and his assistant, Alma A. Pelot, were
soon on the scene. Osborn & Durbec later advertised for sale stereoscopic views taken after
the bombardment and surrender. A Confederate soldier present at the fort remarked in his
memoirs written years later, "Before leaving the fort Capt. Cathcart had the Company
formed and had a photograph taken of it. Several photographic views were taken of the
interior of the fort."[15]

By the end of 1861 the blockade began to pinch. This was especially so in the case of
photographers, since almost all of their supplies had been imported from northern firms
before the Civil War. Although Cook supplied others with equipment and photographic
supplies, he too purchased most of them from northern firms for resale. However, the
blockade did not put Cook out of business and his greatest wartime photographic exploits
were yet to come.

Cook owned shares of stock in several blockade runners and was thereby assisted in
getting supplies for himself. However, his account books indicate that his practice of sup-
plying other photographers nearly ceased by early 1862.

*Albumen print of interior of Fort Sumter showing the breached wall, taken by George S. Cook
on 8 September 1863 or later.*

By 1863 the Union blockading forces tightened the noose considerably on Charleston and on several occasions attempted to capture Fort Sumter and the city. Although these efforts were repulsed, the fort suffered severe damage, including the breaching of one of its walls. The fort had for months suffered bombardment from the blockading fleet.[16]

Cook's relationship with General P. G. T. Beauregard enabled him to visit Fort Sumter and take photographs. During a visit on 8 September 1863, Cook produced two of the most remarkable photographs of the Civil War—an "action" photograph of the Union ships *Weehawken, Montauk,* and *Passaic* firing on Fort Sumter and Fort Moultrie, and a photograph of an exploding shell inside Fort Sumter.

*The Charleston Daily Courier* of 12 September 1863 provided this colorful description of Cook's exploit:

> During the heavy bombardment of Fort Moultrie, Fort Sumter and Battery Bee, which took place on Tuesday last, one of the most remarkable acts was performed among other things in the *taking* as above mentioned of the frigate Ironsides and Monitor. The heroes of the incident are George S. Cook and J. M. Osborne, of this city, and the manner of its occurrence was as follows: It being desirable to preserve a faithful delineation of the ruins of Fort Sumter, and to show to future generations what Southern troops can endure in battle, Gen. Jordan sought to obtain the services of a photographic artist for the purpose, and making known his wish, Mr. Cook and his associate promptly volunteered. Provided with their instruments they reached the fort under fire, then cooly ascended to the parapet, "planted their battery" upon a gun carriage and commenced work. The enemy, meanwhile, were throwing their eleven and fifteen inch shells against and into Fort Sumter, rendering personal exposure hazardous in the extreme. Under these circumstances scene after scene from the interior of the dilapidated old pile was faithfully transferred to the plates, until nearly every portion of the ruins—picturesque in their deformity—had its "counterfeit presentment." This done the artists turned their attention to the fleet and had the good fortune to secure, amid the smoke of battle in which they were wreathed, a faithful likeness of the Ironsides and two Monitors. Mr. Cook requested permission to go outside of the fort and take a picture of the exterior from the water, but it was thought that this would draw additional fire from the fleet, and the project was abandoned.
>
> Thus our citizens and country have had preserved to them a valuable memorial of the defence almost unequalled in its obstinacy—one worthy to be transmitted to future generations. The feat itself is unparalled as far as we know, and no little praise is due to the gentlemen who had the hardihood to risk their lives for the purpose of securing an heirloom so precious. The wonder is that an operation requiring so much nicety of judgment, any individual could maintain a "sang froid" sufficient to do the necessary dodging, and at the same time carry out the various details required by taste and art.[17]

*Albumen print of an exploding shell, taken by George S. Cook on 8 September 1863. Valentine Museum. Richmond, Virginia.*

While taking interior shots of Fort Sumter, Cook produced the other "first" of 8 September—a photograph of an exploding shell inside the fort. The authors of *Shadows in Silver* provided a description of this event.

> Cook's camera caught a clear image of the explosion and the flying debris, which can best be explained by assuming that he had the shutter open for a time exposure when the shell burst and that the accompanying flash was sufficiently intense to make the recording despite the slow speed of the plate. However this may have been, the picture represents another landmark in the technical advance of photography since it is the first photograph on record of a bursting shell and one of the earliest examples of instantaneous photography.

The associate accompanying Cook on 8 September was J. M. Osborn, who was in partnership with F. E. Durbec when the Civil War began. He may have been in business with Cook in 1863, but the fact that photographs dated on 8 September 1863 bear only Osborn's backmark suggests otherwise.[18]

On 22 October 1863 William Elliott, the brother of Stephen Elliott and commander of Fort Sumter at the time, wrote to Miss Barnwell of Augusta, Georgia, that "Charlotte. . . is very much flattered by the present from General Beauregard of a series of Photographic views of the Fort taken since its destruction." These no doubt were either Cook or Osborn 8 September photographs. Beauregard's sharing these photographs with friends indicates he appreciated and understood their historical significance. Due to this well developed "sense of history," in December 1863 Beauregard ordered Lt. John Ross Key and Conrad Wise Chapman, artist, both from the Confederate Engineers Office in Richmond, down to Charleston to sketch Fort Sumter. Key used some of Cook's photographs to complete details of his sketches of the fort. In April 1864 Beauregard ordered a recording of the history of the defense of Charleston, a history that would eventually be completed in 1889.[19]

In early 1864 Cook moved his family to Columbia. He set up a studio there and apparently operated it until his studio and part of the city burned on 17 February 1865. He also kept open his Charleston studio, probably with the aid of an associate—perhaps J. M. Osborn.

He visited Charleston occasionally to capture scenes of destruction produced by constant Union artillery shelling. *The Photographic History of the Civil War* by Francis Trevelyan Miller contains a few interior views of Fort Sumter taken in 1864. These were probably the work of Cook, but, in contrast to the 1863 visit, no mention by the local press of anyone taking photographs at the fort in 1864 could be found.[20] No works produced by Cook in Columbia have been identified.

Cook was one of the very few South Carolina photographers to remain in business throughout most of the conflict. He reopened his business in Charleston by May 1865 and continued it until 1880 when he moved to Richmond, Virginia. His eldest son, George LaGrange Cook, remained in charge of the Charleston business in 1880.

The title for Thomas J. Peach's M. A. thesis in Journalism at the University of South Carolina, 1982, is "George Smith Cook: South Carolina's Premier Civil War Photojournalist." Peach succinctly describes Mr. Cook's place in history.

> Cook's performance as a photojournalist has long been neglected. The concept of news-worthy events being photographed for the public and posterity was formed and molded by Cook as he worked in Charleston during the early years of the Civil War. He magnificently forged his talent, his social connections and his medium to foster a new form of reporting in South Carolina—that of photojournalism. His efforts and photographs stand as contradiction to the myth that Mathew Brady was *the* photographer of the Civil War. In the South, and especially Charleston, South Carolina, the Master of all was George Smith Cook.[21]

In 1994 the great-grandson of George Smith Cook, Jack C. Ramsay, Jr., wrote a biography of his great-grandfather. In his concluding chapter titled, "Faithful to a Heritage," he describes Cook as the "first to photograph the war." Ramsay goes on to explain, "Unlike Brady, Cook was an able manager of his own affairs . . . , an able businessman . . . , a skilled craftsman . . . , a person of integrity . . . , [who] possessed a passion for his work . . ., [was] dedicated to his medium," and in the concluding paragraph he states that Cook "had a sense of continuum, believing that the craft of the photographer was a significant means of preserving the human experience for future generations. This was the heritage to which George S. Cook was faithful."[22]

**J. M. Osborn, Frederick E. Durbec, and James H. Devoe.** Osborn operated a photographic gallery in Charleston for several years prior to the Civil War, and by 1858 F. E. Durbec had joined the firm. Their firm maintained an account with Cook in May 1861 and advertised for sale stereoscopic views of Fort Sumter. Osborn & Durbec also produced a series of cartes de visite on Charleston that included 1861 views of Fort Sumter. At this point Mr. Durbec disappeared from the scene until 1868 and 1869 when he was in business with R. Issertel at 235 King Street.[23]

*Albumen print of exterior of Secession Hall produced in 1860 by Osborn & Durbec. SCL.*

The Florence County Historical Society owns a photograph taken by Osborn & Durbec of the Gamble House, a Florence hotel not completed until 1860 or 1861. At some point in late 1860 or 1861 they must have traveled to Florence, probably by the Northeast Railroad, and taken this photograph and a few others.[24]

Osborn was an associate of Cook when the two photographed Fort Sumter and the blockading ships on 8 September 1863. The Beaufort County Public Library collection contains an interior view of Fort Sumter by Osborn with a manuscript date of 8 September 1864. This undoubtedly is an error and should read "1863." This same photograph, appearing in Miller's *The Photographic History of the Civil War*, was attributed to George S. Cook in 1863. If Osborn did visit Fort Sumter in September 1864, the local press did not cover the event. The exact relationship existing between Osborn and Cook in 1863 or later is not known, and the amount of credit due Osborn for the photographic exploits of 8 September 1863 is likewise unknown, but certainly he is due some measure of credit for them.[25]

By May 1865 Osborn reopened a gallery in Charleston and operated there at least until 1868. Since some antebellum Osborn & Durbec photographs were reprinted by Quinby & Co. after the Civil War, Osborn may have sold his studio to them in 1868. James H. Devoe, an operator for Osborn & Durbec from 1860 to 1861, was listed as an artist in Charleston in 1867 and a Mr. Devoe, probably James, was working for George N. Barnard when he relocated to Chicago from Charleston in 1871. In 1882 Devoe appeared again as a photographer in Charleston.[26]

**JESSE H. BOLLES, J. E. SMITH, AND ALMA A. PELOT.** Jesse H. Bolles is listed in the 1860 Charleston city directory at King & Liberty Streets. At that time J. E. Smith and Alma A. Pelot worked as assistants in the Bolles firm. Bolles and Pelot photographed Fort Sumter after its surrender in April 1861. Bolles bought photographic supplies from Cook in 1861. How long he remained open during the Civil War is unknown, but in December 1865 he opened a gallery at the corner of King and Market Streets and continued there at least until 1870. His business apparently prospered as he advertised it in a Sumter newspaper in 1870. Pelot, a native Charlestonian, enlisted in Confederate service in 1862 and after the war located in Augusta, Georgia, working as a photographer there for more than forty years.[27]

**FREDERICK K. HOUSTON.** For years Charleston photographer Frederick K. Houston was credited with being at Fort Sumter on 15 April 1861 and producing photographs. The basis for this credit was a photograph at the U.S. Army Military History Institute at Carlisle Barracks "done" by Houston of the interior of Fort Sumter. This photograph is a postwar print from a wartime negative. Houston never operated a gallery in Charleston until 1871 (see chapter 5).

**D. G. RYAN AND E. GARDNER.** The firm of D. G. Ryan & E. Gardner was listed at 334 King Street in the 1860 Charleston city directory and had an account with George S. Cook as late as June 1861. D. G. Ryan later moved to Savannah, Georgia, and produced photographs there. One of his works appears to be a postwar carte de visite of Generals Robert E. Lee and Joseph E. Johnston in civilian clothes.[28]

*Several Charleston photographers such as Osborn & Durbec, George S. Cook, Quinby & Co., and probably Ryan & Gardner captured this scene on 15 April 1861 after Major Anderson surrendered Fort Sumter to Confederate forces. F. K. Houston was not present, but reprinted this photograph from a war-time negative after the war, probably in the early 1870s. Courtesy of U.S. Army Military History Institute, Carlisle Barracks.*

C. J. QUINBY, MOWLRAY HESLOP, AND GEORGE ILES. Quinby & Co., who began their Charleston business in 1857 at 233 King Street, had two operators in 1860: Mowlray Heslop and George Iles. Heslop & Iles operated a gallery in Jacksonville, Florida, in November 1860, indicating that these two men no longer worked for Quinby & Co.[29]

Judging from the great number of their cartes de visite of Confederate soldiers that have survived, Quinby & Co.'s volume of business early in the war rivaled that of Cook. Many of their wartime cartes de visite feature a small paste-on sticker containing the name of the firm and a flag with a palmetto tree. A few of their wartime cartes carry a small green label or a larger sticker without the palmetto tree.

As was Cook, Quinby & Co. apparently were successful in obtaining supplies through the blockade. On 25 November 1862 they advertised in the local paper that "they have just opened a large assortment of fine photographic materials selected with great care in London and imported directly from Europe by the last steamer. Among other articles are a lot of very rich and tasteful photographic albums, beautifully bound and well arranged so as to contain, in sufficient form, a number of Cartes de visite. We advise a call at Quinby's Gallery."

Quinby & Co. advertised the sale of photographic supplies to photographers. They reopened their business after the war and operated it from late 1865 to 1871 when they sold out to Bertha Souder.[30]

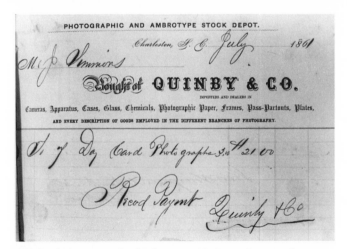

*Quinby & Co. receipt dated July 1861 to Mr. James Simmons for photographs. Courtesy of a private collector.*

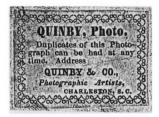  

*A selection of Quinby & Co. Civil War backmarks. SCL.*

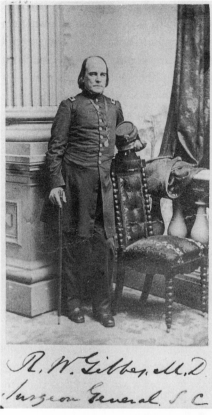

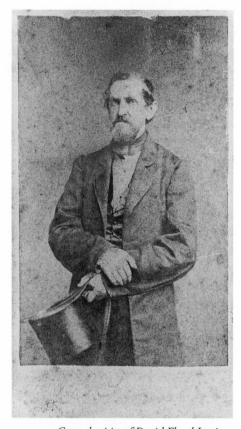

*Civil War carte de visite of Robert Walcott*
*Gibbes, produced by Quinby & Co. SCL.*

*Carte de visite of David Flavel Jamison,*
*President of the South Carolina Secession*
*Convention, produced by Quinby & Co. SCL.*

## Columbia

Columbia was a relatively small town in 1860 with a white population numbering a little more than 6,000. It was, however, the center of state government, a center of commerce, and, with schools like South Carolina College and the Columbia Female College, a center of education. All of these factors created business for Columbia photographers and offered opportunities not found in most South Carolina towns.

Prior to the Civil War a number of itinerant photographers visited Columbia for short periods of time, but few remained very long before moving on to another town.

**L. A. GREEN.** Green worked in Laurens in 1856 and 1860, but relocated to Columbia by February 1861. On 26 February 1861 he wrote George S. Cook in Charleston, "I have heard that Prest. Jef. Davis is in Charleston or will be in a day or so & I want you to take me a 4/4 negative of him & send it to me & I will pay any price for it that is in reson. Don't fail. I have Alex. Stephens V. P. & I want the Southern President." The last reference found to Green in Columbia was in 1863.[31]

**JOSEPH T. ZEALY.** As indicated in chapter 2, Joseph T. Zealy was an exception among the Columbia itinerant photographers. Beginning in 1846, he came to town often and set up a more permanent business in the capital city. In a letter to Cook on 20 April 1861 he stated, "I take the liberty of suggesting to you to start a factory in this section, What do you think of it." Zealy evidently could foresee problems of getting supplies as the war continued. In early 1862 Zealy was still ordering photographic supplies from Cook. Later references to his business during the Civil War have not surfaced and very few wartime Zealy photographs have been located. In 1861 he chiefly produced cartes de visite of Confederate soldiers and civilians. After the war he became a merchant in Columbia and ceased to be a photographer.[32]

**RICHARD WEARN AND WILLIAM P. HIX.** Prior to locating in Columbia in 1859, Richard Wearn also worked as an itinerant photographer in Anderson, Newberry, and probably other South Carolina towns. Richard Wearn was joined by William P. Hix, and for the next fifteen years these two gentlemen conducted their business in the capital city. In addition to being a photographer, William P. Hix painted portraits and probably used his talents to hand-tint many of the photographs the firm produced. At some point a J. E. Richard also tinted photographs for the gallery.[33]

At the beginning of the Civil War, Confederate soldiers from Camp Hampton, Camp Lightwood Knot Springs, and other points visited Wearn & Hix for "likenesses" to send home to loved ones. Today cartes de visite of these soldiers grace the pages of many family albums. As the Civil War progressed, only Wearn's name appeared on the photographs, suggesting Hix had gone into service or, for some other reason, was no longer with the firm.

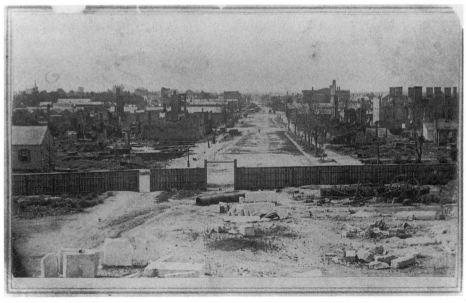

*Richard Wearn carte de visite taken from the front of the State House showing Columbia in its burned condition. Probably produced in late spring or summer of 1865. SCL.*

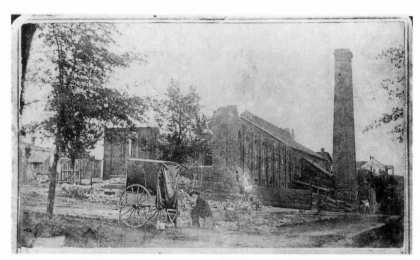

*Richard Wearn's carte de visite of the Palmetto Armory, probably taken in late spring or early summer 1865. Note Wearn and his "What is It" wagon in the foreground. SCL.*

Photographs produced by Wearn are known dated in 1863. Although no Wearn photographs dated in 1864 or early 1865 have surfaced, it is presumed he stayed in business until 17 February 1865 when, as William Gilmore Simms expressed it, his business was "Shermanized." Photography was practiced in Columbia in 1864 according to B. H. Teague of Aiken who reported having his picture taken there that year.[34]

Within a few weeks or months after the Civil War ended, Wearn produced and sold a series of nineteen cartes de visite of buildings burned by Sherman's army in Columbia. Wearn advertised on 7 September 1865 his "pleasure in announcing to his friends & patrons, that he has reopened his gallery, on Assembly Street, near Plain Street." But Simms reported preparations by Wearn to reopen in August 1865. Wearn probably produced these photographs in May 1865 since none of them bear the United States revenue stamps required as of 1 June 1865. Later cartes de visite of Wearn bear these stamps.[35]

One of these views bears the words, "copyright secured." Another of these photographs is of the State Armory on Arsenal Hill. Reputedly in the foreground of this photograph is Richard Wearn and his "What is it?" wagon, a term used during the Civil War to describe a photographer's field wagon.

Photographs of wartime destruction of Columbia are not plentiful. Photographer George N. Barnard accompanied Sherman's army for a time, but was not with the army when it came to Columbia. He later came to Columbia and took four views of destruction that he included in a book published in 1866.

### Greenville

**CHARLES H. LANNEAU.** On 17 April 1861 Charles H. Lanneau advertised taking rooms for a few days and being prepared to create ambrotypes and other types of photographs. This ad in the *Spartanburg Express* stated Lanneau was from Greenville. He was an

itinerant photographer from 1850 to 1861 who worked in a number of South Carolina towns, but from a Greenville base. How late in the war he worked is not known.[36]

**J. Bursey.** One J. Bursey of Greenville bought photographic supplies from George S. Cook of Charleston in September 1861. A "J. Bursey" operated a general store in Greenville in the 1850s, but it has not been established that he was the same gentleman.[37]

### Laurens

**R. Newton Lyon.** Lyon advertised on 27 February 1861 that he would be taking the rooms recently occupied by L. A. Green, opening a gallery, and that he was ready to take ambrotypes, melainotypes, and photographs on paper that would fit into letters.[38]

**M. A. Cooper.** From April to September 1861 M. A. Cooper of Laurens had a photographic supply account with George S. Cook of Charleston.[39]

### Myersville and Friendfield

**E. J. Jones.** On 21 January 1861 Jones ordered photographic supplies from Cook while at Myersville, a small village in Williamsburg District. On 8 May 1861 he ordered photographic supplies from Cook while at Friendfield, a small village in Marion District. Jones instructed these supplies to be shipped by the Northeast Railroad.[40]

### Newberry

**Charles H. Kingsmore.** Before the Civil War Kingsmore painted portraits and produced photographs in his Newberry studio over Hunts & Brothers' Store on the south side of the public square. Kingsmore, like many other South Carolina photographers, bought supplies from George S. Cook of Charleston. On 2 April 1861, after a visit to Charleston, Kingsmore wrote Cook stating, "I saw in your gallery a small plain print of Chief Justice O'Neil 4–4 in size. Please send a plain print not mounted to me. Do not retouch it." Kingsmore apparently had a market for photographs of Judge John Belton O'Neall, a prominent local resident, and planned to produce and sell them. Samples of his wartime work have not been identified and no reference to his being in business during the Civil War after mid-1861 could be found.[41]

He reopened his photographic studio after the war and, in 1867, advertised he was "Prepared to Take Ambrotypes & photographs." He stated that he would visit the country or neighboring towns to paint portraits. By 1868 Kingsmore left Newberry, thus ending a ten year artistic association with the town.[42]

### Reedy Creek

**E. J. Ellen.** In 1861 Reedy Creek was a small village in Marion District about fifteen miles northeast of the town of Marion. On 15 March 1861 E. J. Ellen of Reedy Creek wrote George S. Cook acknowledging the arrival of his photographic supplies and placed an order for other materials.[43]

## Reidville/Spartanburg

**R. H. TUCK AND F. M. TUCK.** In 1861 Reidville was a small village in Spartanburg District about ten miles southeast of Spartanburg. On 2 and 21 April 1861 the Tucks ordered photographic supplies, such as collodion, from George S. Cook.[44]

## Spartanburg

The Cook Papers in the Library of Congress contain an interesting letter pertaining to photography in Spartanburg. On 2 April 1861 a Mr. T. McKinny wrote Cook on behalf of a friend who wanted to know the cost of photographic supplies and equipment necessary to set up a gallery. Whether or not McKinny's friend went into business remains a mystery, but it is noteworthy at this early stage of the war, to enter the photographic business seemed a worthwhile venture. McKinny lacked the foresight to discern the collapse of southern photography resulting from the war.[45]

**WILLIAM M. BROADAWAY.** On 11 January 1861 Broadaway ordered photographic supplies from Cook while in Spartanburg. On 11 April 1861 Broadaway wrote Cook from North Carolina.[46]

**E. T. MARTIN.** On 15 and 28 March and 6 May 1861 Martin ordered photographic supplies from Cook while in Spartanburg.[47]

**H. J. MOUZON.** From March to August 1860 one H. J. Mouzon advertised his gallery in Spartanburg. Five years earlier, in 1855, he operated a gallery in Sumter for a time. Although an itinerant, he seems to have remained in Spartanburg for several months in 1860. On 30 January 1861 he advertised his return from Charleston as "Good News from a Far Country." On 21 April 1861 he advertised, "Terrible News! Mouzon has no idea of leaving Spartanburg for Good!!" A "Mouzon" was listed in the account books of George S. Cook in 1861. Judging from his advertisements, he specialized in cartes de visite.[48]

## Summerville

Frederick Bischoff's journal contains a description of Summerville. He wrote on 11 September 1861 that Summerville was "a small town completely hid among tall pines. . . . The houses are neatly and well finished. There are 3 stores. . . . a Paintshop, a carpentershop, an ambrotype Gallerie." Unfortunately, Bischoff did not provide the name of the proprietor of the "ambrotype Gallerie." This may have been an itinerant photographer in town from Charleston or elsewhere taking advantage of the photographic opportunities offered by the presence of Confederate troops.[49]

## Sumter

**C. W. DAVIS.** Davis continued his Sumter gallery for a time after the Civil War began, but apparently soon closed it. By April 1866 he reopened the gallery and continued in business for a few months.[50]

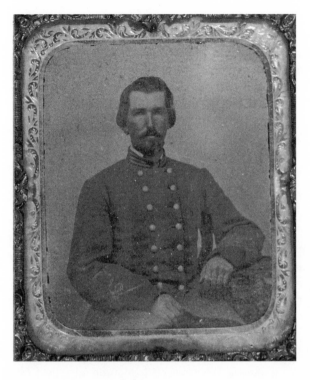

*Ambrotype of Captain Freeman Culpepper, Darlington District, Co. C, Wilson Light Artillery, 3rd. S. C. V. Artillery Battalion; taken by William H. Hunter. Courtesy of South Carolina Confederate Relic Room and Museum.*

## Sumter District-Stateburg

**W. H. A. Richbourg.** When the Civil War began W. H. A. Richbourg operated a studio in Sumter District in the Stateburg area near the present day Shaw Air Force Base. In December 1861 he offered a twenty-five percent discount to Confederate volunteers. He specialized in cartes de visite that could easily be mailed in a letter.[51]

## Timmonsville

**Dr. James Madison Hunter.** Dr. Hunter, a medical doctor and photographer, produced cartes de visite in Timmonsville in the 1860s and 70s. Among his known works is a carte de visite of James F. Culpepper in a full Confederate uniform. Hunter also operated a drug store in Timmonsville in 1877.[52]

## Winnsboro

**A. W. Ladd.** On 20 December 1860, A. W. Ladd of Winnsboro advertised his "Art Gallery" and that he was "now prepared to execute all kinds of work in the Photographic Line." At this time, Mr. Ladd had run this ad for more than six months. Exactly when he closed his business during the war has not been determined, but he did reopen it in late August 1865.[53]

*York(ville)*

**JOHN R. SCHORB.** Although he had worked as an itinerant earlier, when the Civil War began J. R. Schorb had been an established resident photographer in Yorkville for seven years. He advertised his gallery in local newspapers until early 1862. About this time he closed his studio and went to Columbia where he served as a chemist at the Confederate Hospital on the grounds of South Carolina College. While in Yorkville he produced cartes, ambrotypes, and ferrotypes. He reopened his Yorkville studio in October 1865 and continued in business there until 1908.[54]

## Possible South Carolina Photographers

The George S. Cook Papers in the Library of Congress contain names of individuals having photographic accounts with Cook whose places of business have no location indicated. Several of these names were identified as being photographers in other states, but a few names could not be attributed to any state. The following individuals may have been located in South Carolina: C. R. Reese, S. R. Phillips, Dr. Peter Laurens, Captain J. H. Norman, R. H. Brown, J. H. Philyaw, J. R. Paris, Henry Bursey, and a Mr. Jordan.[55]

## Foreign Photographers

From the beginning of the blockade in 1861, the Union navy did not permit foreign merchant ships to visit Southern ports. As neutrals, however, both British and French naval vessels were permitted to visit Southern ports and from time to time did so. These visits occurred more frequently early in the Civil War when these countries still maintained consulates in some of the Southern port towns. In October 1863 the Confederate government and not the blockade finally ended the British consulates in the South when Jefferson Davis ordered them closed due to lack of support and recognition from the British.[56]

On 24 December 1862 the French corvette *Milam* was in port at Charleston and the local newspaper reported, "The French Corvette Milam now in port -like all French ships-of-war has a photographic corps fully equipped and furnished with the best apparatus. Several good views in and around our city have been taken." While in port the sailors from the *Milam* were entertained at a dance by some of the ladies of Charleston.[57]

While the French corvette *Milam* was in port the British man-of-war *Petrel* also visited Charleston, but it is not known whether the British ships were equipped photographically as was reported for the French ships.

## Union Photographers in South Carolina, 1861–65

From mid-November 1861 to the end of the Civil War the Union army and navy controlled the Beaufort/Port Royal/Hilton Head area. Where only a few months earlier cotton grew, by early 1862 Hilton Head had developed into a base for the army and navy, leading to the

*During the Civil War most mail from Union soldiers and sailors occupying coastal areas of South Carolina was brought to the post office of the new town of Port Royal for mailing north. However, some was mailed from Beaufort, South Carolina, and some went by ship directly to northern post offices. Union servicemen often sent home carte de viste portraits of scenes in war-time covers (envelopes) like these two mailed from Port Royal and Beaufort. Collection of the author.*

creation of a military and civilian city, with a population about the size of Charleston, that they named Port Royal. Although most of the inhabitants were soldiers and sailors, many civilians such as sutlers, store owners, barbers, undertakers, bottlers, ministers, teachers, photographers, etc. provided a variety of goods and services both to military personnel and civilians. Many of these civilians located on Hilton Head, but a number came to Beaufort and put to their own use the homes and businesses abandoned by natives in November 1861 when the area fell to Union forces. One wartime business set up in Beaufort was a newspaper

called the *Free South*. From ads in this paper much information was uncovered on the local photographic industry.

Photographers went into business to meet the demand for photographs of soldiers and sailors who sent them home to loved ones. An appetite and market also developed in the North for other photographic images such as forts, guns, ships, stores, plantation homes, former slaves, cotton fields, etc. Soon Union photographers came in numbers to the South Carolina coast and photographed everything from "Spanish moss to fiddler crabs." An indication of the profits to be made was found in J. V. Thompson's ad of 9 April 1864 in the *Free South*. He offered "a splendid chance to obtain a stand where a fortune can be made in one year in the photographic business."[58]

Union photographers working along the South Carolina coast fell into two categories, military and civilian. Photographers were employed by the United States military to record forts, fortifications, and maps that were distributed as photographic copies for use in the field. Some of these men were in the armed forces and others, such as Timothy H. O'Sullivan, Samuel A. Cooley, and George N. Barnard, did work for the United States army as civilian photographers. Phillip Haas and Washington Peale were regular soldiers who were assigned to photographic work for the military. Most Union photographers in South Carolina during the Civil War were civilian ones, however. The product of military photographers and that of civilians working for the military would eventually be reproduced and sold as individual prints to the public.

TIMOTHY H. O'SULLIVAN. The O'Sullivan family immigrated to the United States from Ireland during the potato famine in 1842 when Timothy was only two years old. They settled at Staten Island, New York, near Mathew Brady's home, and O'Sullivan as a youth performed odd jobs for Brady in his New York City gallery. As time passed he learned photography and became an assistant to Brady. When Alexander Gardner took over Brady's Washington, D.C., gallery, O'Sullivan moved to Washington and worked as an assistant in that gallery. In 1861 Gardner dissolved his working relationship with Brady and established his own business. O'Sullivan joined with Gardner and the two produced thousands of photographs during the Civil War.[59]

O'Sullivan's connection with South Carolina began in November 1861 when the Union army and navy captured Hilton Head and Beaufort. He was in United States military service as a civilian attaché at the time and, from late 1861 to May 1862, produced a number of photographs of ships, troops, forts, and plantations in the area occupied by the Union army. Many of O'Sullivan's photographs later appeared on a list of Civil War views Brady was selling. Brady must have acquired some of O'Sullivan's prints or negatives and later presented them as his own, since during most of the war O'Sullivan was a field photographer working for Gardner and not an employee of Brady.[60]

After leaving military service in late spring 1862, he accompanied the Army of the Potomac as a civilian photographer on many of its maneuvers, marches, and battles. His photographs produced during this period, portraying in graphic detail the more grisly, bloody aspects of the Civil War, provide better documentation of this aspect of the war than those of almost any other photographer.[61]

James D. Horan, a biographer of Brady, also wrote a biography of Timothy H. O'Sullivan. This work chronicled in detail, with profuse illustrations, his wartime photographic accomplishments, those of his later years in the western United States, and those as a photographer for the 1870 Darien Expedition to explore a possible canal site across the Isthmus of Panama.[62]

**SAMUEL A. COOLEY & ASSISTANTS.** Although O'Sullivan began his photographic work in late 1861, the first "permanent" studio in this occupied area seems to be that of Samuel A. Cooley. Cooley, from Connecticut, had been an antebellum photographer there. He served as a sutler in 1862 with the Sixth Connecticut and was commended by Union military authorities for assisting wounded soldiers after the Battle of Coosawhatchie on 22 October 1862.[63]

Cooley next surfaced on 1 June 1863 in the pages of the *Free South*. His advertisement read "Photographs, Melainotypes, Vignette, Carte De Visites, etc., Next West of The Arsenal, Beaufort. The Subscriber having for a long time seen the necessity of a first class Photographic Gallery in this city, has by the kind permission of General Hunter and Governor Saxton, established over his store an extensive saloon with a large skylight and secured the services of three skillful operators from New York, and is now prepared to take likenesses in every style of the art. . . . He will visit any of the plantations and take views for a reasonable price."[64]

*Albumen print taken on board the U. S. ship* Arago *at Hilton Head, South Carolina, in late 1861 or early 1862, by Samuel A. Cooley. Courtesy of George S. Whiteley, IV.*

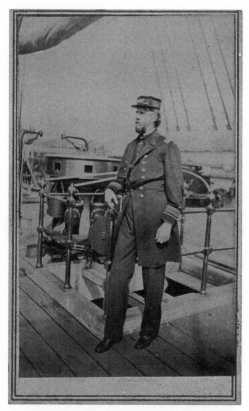

*A selection of Cooley & Becket backmarks.*
*Collection of the author.*

*Carte de visite of Captain William Reynolds on*
*board the warship* New Hampshire *at Port Royal,*
*produced by Samuel A. Cooley.*

Cooley knew profits awaited him from this venture since he had the support of military officials and since there had developed a growing appetite in the North for news and pictures of locations where loved ones were fighting. His bringing down three operators from New York is a further indication of his belief that profits awaited him. The identity of these operators are not known, but they may have been Kidney, McKinley, and Walder (Waldher) since these three individuals were in Cooley's employ in early 1864.[65]

After another trip to New York, Mr. Cooley next advertised in the *Free South* on 12 December 1863: "Photographs for the Million! Mr. Samuel A. Cooley, having just returned from New York with a large assortment of photographic materials, together with a complete apparatus for executing all the latest and improved styles of Sun Pictures, at his gallery at Beaufort, and Folly Island, S.C. is now prepared to supply his numerous customers, with Large Portraits, Carte Devisettes, Ambrotypes, Mellainotypes, etc., etc., etc."[66] Note that he then operated an additional gallery on Folly Island. In 1864 he further extended his business with galleries at Jacksonville, Florida, and another on Morris Island, South Carolina.

In May 1864 Cooley sold his business to one of his associates, Edward Sinclair & Co., and stated his intention to return to the North. Subsequent events indicate he must not

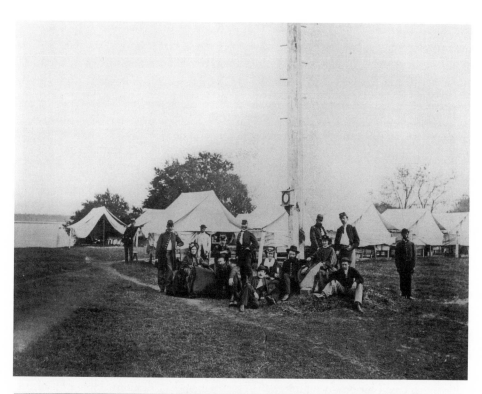

*The above information was recorded on the back of this albumen print and is the key for identifying individuals shown such as Samuel Cooley and members of his family. Courtesy of George S. Whiteley, IV.*

have stayed there very long, if in fact he went at all. Some time after Sherman's capture of Savannah, Georgia, in late December 1864, Cooley was in business with Isaac Becket. Photographs exist showing Cooley and Becket simultaneously operating studios in Savannah, Hilton Head, and Beaufort. The two probably did not remain in business together very long since some of these photographs also show Becket's name stricken out.[67]

Cooley or one of his assistants was present with a camera very soon after Union forces occupied Fort Sumter and Charleston in February 1865 and may have also been present on 14 April 1865 during the restoration ceremonies for the United States flag over the fort.[68]

When Cooley advertised himself as "Photographer Dept of the South" in 1864 and 1865 he did so legitimately. He corresponded directly with Quartermaster General Montgomery C. Meigs and made arrangements as a civilian photographer to supply him with photographs of subjects found in the occupied territory in South Carolina and Georgia. On 20 December 1864 Cooley sent Meigs a number of apparently complimentary photographs followed by photographs sent on 9 January 1865 billed at $2,670.00. On 8 March Cooley billed him for an additional $2,440, making a total of $5,110.00 in about three months.[69]

In 1866, in addition to being an auctioneer, town marshal, and a businessman in Beaufort, Cooley sold prints of his wartime photographs. He advertised more than 2,000 negatives of photographs "from Charleston, of all the Sea Islands, to St. Augustine." Cooley returned to his native Connecticut and spent his remaining years there.[70]

Although his motive for being in the photographic business was largely for profit, he is due much credit for producing more than 2,000 images of Beaufort, Hilton Head, and the sea islands of South Carolina that permit a better understanding and appreciation of the history of those areas during this period. Any credit given to Cooley must be tempered by the knowledge that he employed several others and probably personally created very few of the photographs that bear the name of his firm. Today several hundred of his glass negatives are a part of the holdings of the Western Reserve Historical Society in Cleveland, Ohio. Individual copies of his work are found in collections, public and private, throughout the nation.[71]

**EDWARD SINCLAIR & CO.** The date Edward Sinclair came to South Carolina has not been established, but Cooley may have encouraged him in 1863 to come. A Mr. "S. W." Sinclair was listed as a Cooley employee in March 1864. This was undoubtedly an error in the initials and should have read "E. W." In any event E. W. Sinclair bought out Cooley on 21 May 1864. Many stereoscopic views bear the wording, "Photographed By E. W. Sinclair For Sam. A. Cooley." In September 1864 Sinclair operated studios in Beaufort, Hilton Head, and Jacksonville.[72]

**R. V. BALSAN AND J. V. BALSAN.** In a 1 November 1863 ad R. V. Balsan stated he "is now prepared to take Photographs, Ambrotypes and Melainotypes in every style, size and shape. . . . He also tenders thanks to all his friends who have so liberally patronized him during the time he has been in Beaufort and County. Gallery near Camp of 56th N. Y. V."[73]

J. V. Balsan was listed as an assistant artist and was probably R. V.'s son or brother. The ad also stated R. V. was from Florida. In all probability, he was not a native Floridian, but a Union photographer who worked there before coming to South Carolina.

**IRA C. FEATHER.** The first reference to Feather was a 12 August 1863 ad listing him with a "Military and Naval Photographic Gallery, 19½ Sutler's Row, Port Royal, S.C." He continued at that location at least until July 1865 when he advertised he "prepares his own chemicals, as by Profession, he is a Chemist, Surgeon and Physician." Apparently Feather primarily produced portraits of soldiers and sailors stationed in the area. How long he remained in business on Hilton Head Island is unknown, but he had probably departed by the end of 1865.[74]

**JOHN H. BLAUVELT AND ERASTUS HUBBARD.** In August 1864 Blauvelt & Hubbard called their business, which was located on Hilton Head Island at the corner of Ninth and "F" Street, the Monitor Gallery. They advertised the taking of "Carte de visites, Melainotypes, Ambrotypes, Views of Camps and the surrounding country." Several cartes de visite show only the name of Erastus Hubbard as proprietor, indicating that he must have been in business alone before Blauvelt joined him. Hubbard was probably one of the proprietors of the Hubbard & Mix firm discussed later in this chapter.[75]

*Backmark from a photograph of J. T. Reading & Co.'s Savannah gallery. They also operated a gallery in South Carolina. Collection of the author.*

**J. T. READING & CO.** This firm advertised in another Union paper, the *Palmetto Herald,* in November 1864. They were located on Merchants Row, Port Royal. They also operated a gallery in Savannah, but undoubtedly only after Sherman took that City in December 1864. They came to Charleston after its surrender and took a number of views of that city.[76]

**HUBBARD & MIX.** The Beaufort County Public Library and the South Caroliniana Library own Hubbard & Mix photographs dated in 1864. Hubbard was probably Erastus Hubbard of the firm of Blauvelt & Hubbard previously discussed. Hubbard & Mix

*Carte de visite by Hubbard & Mix of a Beaufort, South Carolina, bank. SCL.*

*Carte de visite by Hubbard & Mix of two baskets typical of those made by African Americans along the South Carolina coast before, during, and after the Civil War. These baskets are called "Sweet Grass" baskets and are still being made today. This photograph is a Civil War documentation of their production. SCL.*

remained in Beaufort after the Civil War and advertised on 16 June 1866 the production of "Cartes De Visite, Porcelain or Albatypes, Ambrotypes, Stereoscopic Views, Etc. They have for sale singly or by the dozen, a series of over Two Hundred Stereoscopic Views, including Plantation Scenes, Streets of Beaufort and Public Buildings." The South Caroliniana Library collection contains a Hubbard & Mix carte de visite dated 15 June 1866 with an attached three cent United States revenue stamp required at the time.[77]

**BONHAM & READING.** On 26 March 1864 Bonham and Reading advertised a "New Photographic Establishment. Carte De Visites, Large Photographs and Photographic Views of all descriptions equal to those of the first artists North." Their gallery was located in the rear of No 23 Sutlers Row. Reading was probably J. T. Reading of J. T. Reading & Co mentioned above.[78]

**H. C. FOSTER.** Foster advertised on 1 September 1864 a "Photographic Gallery, Morris Island near Fort Shaw. Cartes De Visites, Ambrotypes, Etc. made in the best manner by experienced artists." A carte de visite of W. C. Roberts, 1st. Lieut., Co. A, 55th Mass. Vol. taken by Foster at the Morris Island studio is part of my own personal collection. Today the sea has reclaimed most of Morris Island and little remains even of the land where these wartime activities occurred.[79] In May 1865 H. C. Foster opened a studio in Charleston at the corner of King and Market Streets.[80]

**ISAAC BECKET.** In late 1864 and early 1865 Cooley and Becket operated studios in Savannah, Hilton Head, and Beaufort. Other details of their business was included under "Samuel A. Cooley" earlier in this chapter. Becket seemed to be the sole proprietor of a studio in Savannah, Georgia, in 1865. He apparently was also one of the Union photographers who descended upon Charleston after the Civil War.[81]

**HENRY P. MOORE.** Moore, a New Hampshire photographer, came to South Carolina in February 1862 and, for about a year as a civilian photographer, produced photographs from Edisto Island, Hilton Head, and Fort Pulaski near Savannah, Georgia. Glass negatives for many of these photographs are in the Western Reserve Historical Society in Cleveland, Ohio. The New Hampshire Historical Society has a large collection of Moore photographs, and several other institutions have examples of his Civil War images. Moore returned to Concord, New Hampshire, in 1863 and continued working as a photographer there for many years.

On Edisto Island he produced a number of photographic views of plantations and other scenes that included Union soldiers and slaves in home and work settings. Clara Childs Puckette included fourteen of these photographs in her book, *EDISTO, A Sea Island Principality* published in 1978.[83] A number of Moore's photographs produced while on Hilton Head Island were included in *The Forgotten History: A Photographic Essay on Civil War Hilton Head Island* written by Charles and Faith McCracken and published in 1993. In

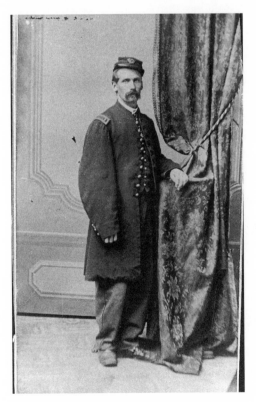

*Backmark from Becket's Savannah Gallery. Collection of the author.*

*Carte de visite of "Wilson C. Roberts, 1st. Lieu., Co. A, 55th. Mass. Vol.," produced by H. C. Foster. Collection of the author.*

1999 W. Jeffrey Bolster and Hilary Anderson authored *Soldiers, Sailors, Slaves, and Ships: The Civil War Photographs of Henry P. Moore,* a comprehensive biography of Moore containing forty-eight of his Civil War images.[84]

The Edisto Island photographs and others indicated Moore usually portrayed carefully composed and staged scenes where soldiers were in relaxed settings of camp life rather than scenes showing the violent side of the war. His documentation of slave life in the South is especially noteworthy. Moore's special attention to details, such as composition and light and shadow, probably reflect his earlier training as an artist.

**PHILLIP HAAS AND WASHINGTON PEALE.** Around 1808 Phillip Haas was born in Germany and presumably received his training as a graphic artist there. He came to the United States in 1834 and by 1835 had located in Washington, D.C., where he established a lithography business. Haas published many portraits of prominent individuals such as President Martin Van Buren and United States senators and representatives.

While in Washington Haas did contract work for the United States government. In addition to an earlier project for the navy, he lithographed and published *Public Buildings and Statuary of the Government: The Public Buildings and Architectural Ornaments of the Capitol of the United States at the City of Washington* in 1839. The 1840 edition contains dozens of illustrations showing buildings, paintings and sculpture of the nation's capital.

When the daguerreotype was unveiled in 1839 Haas became a prime candidate to study, master and practice the art. From his studio in Washington, Haas captured in silver many important political figures of the time, including such luminaries as John Quincy

*Albumen print No. 20 of Captain Ashcroft's Battery, produced by Haas & Peale. SCL.*

*Albumen print No. 43 showing Fort Sumter as almost a pile of rubble, produced by Haas & Peale on 23 August 1863. SCL.*

Adams, John C. Calhoun, Andrew Jackson, Henry Clay, Edward Everett, and many more. Haas opened a studio in New York in 1844, but continued to work in Washington, especially when Congress was in session.

When the Civil War began, Haas's photographic business seemed in decline and he sought employment by the United States army. On 23 September 1862 he enlisted in the army and was assigned in 1863 to photograph fortifications for General Quincy Adams Gillmore's army in South Carolina.

The Peale of Haas & Peale was Washington Peale, the son of James Peale, Jr. of Philadelphia. Washington Peale was a painter in Washington, D.C., before the Civil War.[85]

From studios on Morris and Hilton Head Islands in 1862 and 1863 Haas & Peale produced a series of more than 40 views of ships, batteries, forts, and other scenes on these islands. At this time most photographers produced ambrotypes, cartes de visite, stereographs, and tintypes. Haas & Peale also produced many of these kinds of photographs, but departed from these traditions when they produced the South Carolina wartime photographs. These photographs are five by eight inches and are mounted on printed cards bearing a Haas & Peale printed hallmark. Their exceptional clarity and quality provide much information and detail not found elsewhere. These Haas & Peele photographs generate more interest and use than Haas's earlier lithographs and photographs of prominent political figures.[86]

The rigors of war appeared to be too much for Haas who complained of ill health for himself and Peale in letters from November 1862 to May 1863. On 25 May 1863 Haas resigned

his commission. Two days later he requested the quartermaster to take charge of certain photographic articles in his possession. Twenty-five glass plate negatives produced by Haas and Peale today are in the holdings of the National Archives.[87]

Although no longer in the army, Haas and Peale remained on Morris Island and continued to produce photographs. Number forty-three in the series produced by them is of Fort Sumter and is dated 23 August 1863.[88] Slightly more than two weeks later on 8 September 1863 George S. Cook, at Fort Sumter with his camera aimed at Morris Island and other points, produced documentation from the Confederate viewpoint.[89]

GEORGE N. BARNARD. Barnard began his career in Oswego, New York, in 1846. From that year until 1853 Barnard learned and practiced his art, participated in professional photographic associations and achieved recognition. From 1854 to 1857 he operated a gallery in Syracuse, New York, with a Mr. Nichols. After 1857 Barnard worked on a mapping project and produced cartes de visite and stereographs for the Anthony firm in New York City. Some were taken by Barnard on a trip to Cuba. Early in the Civil War he worked for Brady, Gardner, and Anthony in Washington and the surrounding area, producing mostly photographs of military activities. In late 1862 and 1863 he was back in Oswego working in Tracy Gray's studio.[90]

Barnard's employment by the United States Military began in late December 1863 when he was chosen to work as a photographer by the Topographical Branch of Engineers, Army of the Cumberland. He worked for Captain O. M. Poe, who ran that army's photographic activities. The army was interested in the use of photography for copying maps, sketches, and diagrams and producing other photographs for military purposes. Barnard gained experience in this type of photography earlier in his career and his expertise in this area was known to the United States military.[91]

Throughout 1864 Barnard busily photographed maps and documented military subjects as Sherman's army moved through Tennessee into Georgia, captured and destroyed Atlanta, and, shortly before Christmas, marched to the sea at Savannah. Poe left Barnard in Savannah when Sherman began his campaign through the Carolinas, but on 23 January 1865 ordered him from Savannah to New York City, permitting him to take thirty days leave. After his leave Barnard sailed to Charleston and, in March 1865, set foot on South Carolina soil. He began a South Carolina connection that, with few interruptions, lasted until 1880.[92]

In Charleston Barnard captured the scenes of destruction. In 1866 he published a book of sixty-one photographic views of Sherman's campaign that included ten South Carolina views. He closed the volume with six photographs of Charleston. These were not scenes of destruction produced by Sherman's army, but rather by the Union forces that besieged Charleston and captured the city while Sherman captured Columbia more than one hundred miles away.

This was not the only time Sherman's army received or took credit for the accomplishments of others. When elements of his army arrived in Beaufort in January 1865 one observer remarked that they acted like they had captured the town themselves when, in fact, it had been in Union hands since 1861.[93]

Barnard rejoined Poe in Washington in May 1865 and continued working for him until 1 July 1865. One author has speculated that Barnard traveled from Charleston to Columbia in late March or early April 1865 and took the four views of the burning of Columbia that were included in his 1866 book.[94]

In March, April, and early May 1865 no Union troops occupied Columbia. Federal forces under Sherman marched through, did their work of destruction, and departed. The territory a few miles north of Charleston to Columbia was hazardous to travelers. The Charleston press reported in early April that two Germans on their way to Columbia had been attacked by "rebel bushwhackers" about twenty miles north of the city and that a group coming from Columbia had suffered the same fate. More bushwhackers were reported on farms near Charleston on 21 April 1865.[95]

Civil authority was not replaced by martial law until May 1865 and Union forces did not occupy Columbia until 18 May 1865.[96] Without the protective cloak of the federal military, Captain Poe would not have sent his employee, Barnard, into hostile territory. The newspaper, *Columbia Phoenix,* did not mention Barnard being in town and it almost certainly would have done so had a Union photographer ventured into town at that time.

The question of when Barnard came to Columbia and photographed destruction remains. In the prospectus for his 1866 book he stated his intention to visit places along Sherman's line of march and take additional photographs for his book. He included Columbia as one of the places he planned to visit. Barnard was in Augusta, Georgia, on 4 June 1866 to take photographs that the local paper reported were for his book. He probably visited Columbia about that time, just prior to going to Charleston—in other words, fifteen or more months after the city burned.[97]

If Barnard took his photographs of Columbia in early June 1866, was the city much the same as when Sherman left it? A correspondent for the *New York Times* visited Columbia

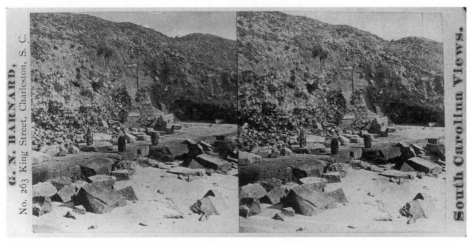

*George N. Barnard stereograph of the inside of Fort Sumter, produced after its surrender in February 1865. SCL.*

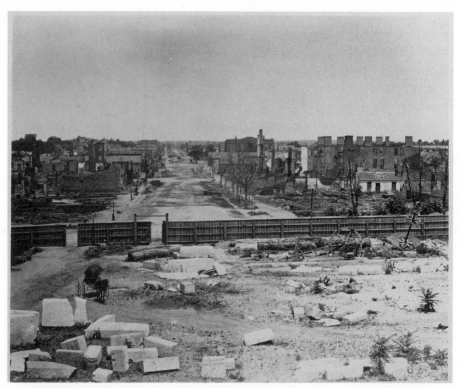

*George N. Barnard's view of Columbia's Main Street that he probably produced in June of 1866.*
*This photograph differs from a similar photograph by Wearn in that it shows Barnard's photographic*
*buggy in the foreground, men on the street, and stacks of brick that indicate some reconstruction and*
*clean up in progress. Courtesy of Library of Congress.*

on June first and has given us this "word picture" of the town that answers this question in
the affirmative:

> Columbia is beyond all doubt the most desolate looking place South of Mason
> and Dixon's Line. No one can fully appreciate the utter destruction of the city
> without seeing it. 500 buildings, not including those of a public nature, were
> burned, mostly located in the very business heart of the city. At present the city
> presents a truly heart-sickening sight, and when we take into consideration the fact
> that most of the citizens firmly believe that Sherman ordered or authorized its
> destruction, it is not hard to account for the bitter and deep-seated hatred which
> many of them exhibit toward northerners.[98]

By this time much discussion had occurred concerning the burning of Columbia and Sher-
man's role in the matter. Perhaps Barnard, not wishing to embarrass his friend General Sher-
man included only a few photographs of Columbia destruction. As already mentioned in
this chapter, Richard Wearn produced nineteen views of destruction in Columbia long
before this time.

When Barnard did take his photographs in Columbia, he produced one of the ironies of the Civil War. The ashes of Columbia contained the burned remains of Richard Wearn's studio and the remains of George Smith Cook's paintings, his studio, and many of his wartime negatives and photographs that had been shipped to Columbia to avoid Sherman's army. A Union photographer now photographed ruins that included the studios and works of two famous Confederate photographers. Perhaps all is fair not only in love and war, but in business too.

While Barnard journeyed through Tennessee, Georgia and South Carolina in 1866 taking additional photographs for his book, another photographer, James W. Campbell, accompanied him. Campbell had been one of the many northern photographers to visit Charleston after the United States flag was raised over Fort Sumter in April 1865.

Of the sixty-one photographs included in Barnard's 1866 book, only fourteen were clearly documented as being produced during the Civil War. Eleven others were produced either in 1864 or 1866. Even if these eleven were produced in 1864, the fact remains that more than sixty percent of the photographs were not wartime ones. That fact is pertinent in judging and evaluating the book as a "real time" documentation of the Civil War.

After thirteen years of study and research, Keith M. Davis published in 1990 what has been recognized as a comprehensive and near definitive biography of George N. Barnard. He had this to say about Barnard's 1866 book: "A remarkable work of great symbolic, historic, and artistic power. . . . A complex weaving of Barnard's personal career, and larger ideas about war and the American landscape. . . . The most ambitious project of Barnard's career, . . . a landmark in the history of photography. . . . One of the most extraordinary achievements in nineteenth century American art."[99] Barnard returned to South Carolina and remained for a number of years.

**J. R. Fortin.**  Fortin's name appears on images of the ruins of the Charleston Lighthouse, the U.S. Hospital on Hilton Head, and on a few others in collections at the Western Reserve Historical Society and the New Hampshire Historical Society. While serving in a New Hampshire military band, Foster had his photographic "apparatus" sent to him and produced some photographs. For a short time after the war he operated a studio in Concord, New Hampshire.[100]

## Union Photographers

The sea islands controlled by Union forces and on which Union photographers worked constituted about five percent of the total geographical area of South Carolina and the population was fewer than five percent of the state. By the end of the Civil War, at least nineteen Union photographers had been at work on Hilton Head, Beaufort, Edisto Island, Folly Island, and Morris Island. At the beginning of the Civil War the entire State had fewer than forty local photographers.

From 1861 to 1865 these Union photographers had a field day in producing photographs to supply the great demand for them in the Union. At a time when South Carolina photographers were closing their businesses due to a lack of materials, Union photographers

suffered few problems in receiving photographic equipment and supplies. In fact, their businesses expanded.

Today there exist thousands of scenes of plantations, homes, streets, stores, African Americans, forts, fortifications, ships, etc. taken in this very confined area of South Carolina. It is very doubtful that any other area of the South or, for that matter, the North received similar photographic documentation. In addition, the Union photographers took thousands of photographs of soldiers and sailors.

With the fall of Fort Sumter and Charleston in February 1865, an extremely inviting area of South Carolina became accessible to Union photographers. Several of them had been on Morris and Folly Islands practically in sight of these areas and now they could actually enter both and photograph them.

Cooley or an assistant was probably on site by late February or early March 1865. George N. Barnard was ordered there by Poe and arrived in early March. When the entourage came to Fort Sumter on 14 April 1865 and raised the United States flag that had flown over the fort when Major Anderson surrendered it in 1861, a photographer, W. E. James from Brooklyn, New York, accompanied the group. He produced a number of views of the fort and Charleston over the next several days.

### Confederate Photographers

The assessment of Confederate photographers presents a different picture. With just over forty men practicing the art in 1860, photography, by comparison, was a tiny, fragile industry. An interruption that would be insignificant in some other industries seriously affected it.

The Union blockade was the first interruption. At the beginning of the Civil War the economy of South Carolina and the South as a whole was agricultural. Most of the materials needed in the photographic industry such as chemicals and glass were manufactured only in limited amounts in the South, and had to be imported from the North or abroad. From December 1860 to 1 June 1861, South Carolina photography functioned at prewar levels. On that date the Union mails were closed to the South and commerce between the two began to slow down. This closure of the mails was a part of the land blockade of the South. When materials ran low photography in South Carolina died on the vine. By 1862 photographic ads disappeared from most newspapers and accounts with George S. Cook had ceased. Locally produced photographs dated 1863 or later are very rare.

As the Civil War progressed, the need for men in the armed forces rapidly increased. Photography was an occupation whose practitioners were not exempt from service and many enlisted or were conscripted. A much greater percent of the Southern male population served in the Confederate forces than their counterparts in the Union. This produced further deterioration of the industry.

By 1864 only two South Carolina photographers were documented as still practicing their profession, Richard Wearn of Columbia and George S. Cook of Charleston.

The majority of wartime South Carolina photographs are of soldiers in uniform and date from early in the war. Copies of many of them have frequently appeared in print or as

visuals in television programs. Most of them were cartes de visite and tintypes with ambrotypes showing up less frequently. Stereographs were produced by Millwee of Anderson, Wearn & Hix of Columbia, and George S. Cook, Osborn & Durbec, Quinby & Co., and Jesse Bolles of Charleston. These were primarily photographs of forts, fortifications, and scenes in and around Charleston. Any wartime photograph of a scene or location outside of Charleston is rare.

South Carolina photographers seldom took photographs of children as they were considered by many to be a less important subject for scarce photographic materials. African Americans in South Carolina were likewise seldom photographed.

The Civil War in and around Charleston received superb coverage by local photographers when the hardships under which they operated are considered. Military actions in other areas of the state received almost no coverage. This is not surprising since most of these actions occurred after Confederate photographers had ceased operations.

When the Civil War ended and supplies were again available, Wearn and Hix of Columbia and several of the Charleston photographers acted quickly to record wartime destruction. Again Cook was the leader in these efforts in Charleston.

As with most private enterprises, South Carolina photographers were trying to make a living. However, there is considerable evidence to support the notion that they realized the historical importance of their work. One such piece of evidence was articulated by the *Charleston Daily Courier* editor on 12 September 1863: "It being desirable to preserve a faithful delineation of the ruins of Fort Sumter, and to show future generations what Southern troops can endure in battle, Gen. Jordan sought to obtain the services of a photographic artist for the purpose." This clearly demonstrated a sense of history in the mind of photographer Cook and others as they photographed the fort.

Whether created for profit or for history, South Carolina wartime photographs today serve as an invaluable tool in the study of this period of our history. Cartes de visite of Confederate servicemen provide many details about their uniforms, arms, and accoutrements not found elsewhere. Photographs of wartime destruction provide graphic and detailed information to the historically trained eye as well as to that of the amateur. Just reading one of the many thousands of letters, diaries, or other written accounts of wartime activity does not have quite the impact as that produced by viewing Cook's photograph of destruction inside Fort Sumter in 1863. Recognition of and credit to these photographers who have provided us with these wonderful windows to yesteryear are long overdue.

# From Carte to Cabinet, 1865–80

## Recovery

When the guns of war fell silent in the spring of 1865 the Union had been preserved, but at a terrible cost. Four years of war produced enormous economic, social, and political dislocation and destruction; and for decades to come, although intact, the Union remained sharply divided.

The engines of transportation, banking, and agriculture that powered the South Carolina economy, if not completely destroyed by the Civil War, suffered serious impairment. The Union army destroyed much of the rail system and the retreating Confederate army did the same to most bridges. Confederate currency, in use for four years, was worthless and United States money was in extremely short supply. The investment in slaves as property was wiped out when the Civil War freed them. Union forces burned a thirty- to fifty-mile-wide swath from Beaufort through Columbia to Cheraw and from Georgetown to Camden, destroying homes, churches, courthouses, barns, and other buildings in large numbers. The agricultural system, the cornerstone of the southern economy, lay in ruins from four years of neglect. The problem of converting from a slave labor system to one of employed labor confronted southern planters.

The Union army remained in South Carolina as an occupying force until April 1877, during which time the military superseded or greatly curtailed civilian authority. Thus were sown the bitter seeds of resentment South Carolinians held toward the North for decades to come.[1]

The small photographic industry of South Carolina, not exempted from the effects of war, suffered along with all other segments of the economy. The Civil War closed about 90% of this small industry by mid-1862. Three years later, near the end of the Civil War, only Cook and one or two others still limped along, producing a few studio photographs.

This situation did not quickly change. Between April and December 1865 only eight South Carolina photographers were back in business. George S. Cook and J. M. Osborn of Charleston reopened their galleries in May 1865. At some point in late 1865 Jesse H. Bolles returned to the production of photographs. Quinby & Co. also returned to business at an

undetermined date in 1865. A. W. Ladd of Winnsboro reopened his gallery in August and operated it for a time. Richard Wearn of Columbia reopened for business in September and by early 1866 W. P. Hix had rejoined the firm. In October J. R. Schorb of Yorkville reopened and in November F. C. von Borstel of Anderson again produced photographs. D. L. Glen, operator of a gallery for a time during the Civil War in an unidentified South Carolina town, opened a gallery in Charleston in September 1865.[2]

Four Union photographers remained in South Carolina. H. C. Foster, operator of a studio on Morris Island during the Civil War, opened a gallery in Charleston in May 1865 and remained in business there for a year or more. Samuel A. Cooley continued at Beaufort until the latter part of 1866. Hubbard & Mix continued their wartime Beaufort business at least until June 1866. Ira C. Feather operated his Civil War studio at Port Royal until at least July 1865.

The South offered those from other sections of the nation both legitimate and not so legitimate economic opportunities. Local historians referred to those adventurers and entrepreneurs who were after a "fast buck" at the expense of a prostrate South as "Carpetbaggers." This unflattering term was employed since many of them could carry all of their worldly possessions in a carpetbag.

By the end of 1866 four more wartime photographers were back in business: Charles Kingsmore of Newberry, H. B. McCallum of Camden, J. J. Mundy of Charleston, and C. W. Davis of Sumter. Another Charleston photographer, F. E. Durbec, operated a gallery in 1868 and 1869 with R. Issertel.

Forty-six photographers had studios in South Carolina from 1865 to 1870. The 1870 United States Census did not include the figure for the number of photographers in South Carolina, but twenty-four photographers were documented in other sources as operating in the state that year. Since the 1860 census showed twenty-six photographers in South Carolina, one can conclude the industry approached prewar levels by 1870.[3]

## Expansion

As population increased and as political and economic recovery continued, these developments were reflected in the photographic industry. In 1880 the United States Census reported fifty photographers in the state, almost a 100% increase from the twenty-six reported in the 1860 census. Interestingly, while the number of photographers increased from 1860 to 1880, the number of artists fell from thirty-six in 1860 to twenty-five in 1880.[4]

Although many South Carolina photographers were itinerants, some studios operated for five, ten, fifteen, and twenty or more years. Some examples were: Aiken, J. A. Palmer, 1871 to 1896; Camden, William S. Alexander, 1876 to 1891; Columbia, William A. Reckling, 1871 to 1910; Edgefield, R. H. Mims, 1870 to 1910; Greenville, William M. Wheeler, 1871 to 1921; Orangeburg, C. M. Van Orsdell, Jr., 1880 to 1916; York, J. R. Schorb, 1853 to 1908.

## *Photographic Developments*

In 1865 local photographers primarily advertised the production of ambrotypes, ferrotypes, stereographs, and cartes de visite. In the 1870s, although a few continued to produce them, most no longer advertised the production of ambrotypes, but continued to advertise and produce cartes de visite, ferrotypes, and stereographs.

A new kind of photograph, the "cabinet," first used in England, began to replace some of the above, especially cartes de visite and ferrotypes. This photograph probably drew its name from the glass paneled cabinets in which they were often displayed in English homes. The cabinet photograph, approximately 4-by-5½ inches, was mounted on a 4¼-by-6½-inch card. This new type photograph predominated by the 1880s and remained popular for more than fifty years.[5]

The larger cabinets permitted, if not required, photographers to provide more elaborate backgrounds and scenery in their studios than the simple columns, pedestals, and draperies of the earlier carte de visite studios. They also required photographers to do a better job of eliminating flaws in their negatives since flaws became more obvious in this larger format than in the smaller carte de visite. Many cabinet prints were produced from retouched negatives that eliminated flaws.

The advent of the cabinet photograph was significant, especially for the photographic historian. On the extra inch or so at the bottom of the cabinet mount and on the reverse, there was much more space available for printing than on the cartes de visite. Photographers used this space for their names and addresses and for other pertinent advertising information. Owners of these photographs also now had more space, especially on the reverse, where they often wrote information useful to historians today. These cabinet mounts were frequently as heavily decorated with Victorian artwork and designs as were the albums that housed them.

Photograph albums for cartes de visite became a popular item in living rooms by 1860. Entrepreneurs quickly developed albums to accommodate the larger cabinet. These albums were usually ornately decorated in a style befitting the Victorian era. When the use of slightly larger cabinets began, they did not fit the standard cabinet album slots and were sometimes trimmed to fit into these albums. Many fine cabinets suffered this indignity and became less collectible or valuable to the photographic historian.

## *Photographers, 1865–1880*

### *Abbeville*

**McNight & Dodson and Dodson & Lee.**  In March 1870 McNight & Dodson located in Abbeville for a short time, producing ambrotypes and photographs in a studio over Dr. Wardlaw's office. By October they had "Returned to Camden," and were prepared to take photographs from their stand in the Workman Building. James M. Dodson returned alone in 1871, first to Camden in February, then to Abbeville in March, and

back to Camden in December. He and a Mr. A. B. Lee operated a photographic studio at Camden in the Workman Building in October 1872. By April 1873 Dodson returned alone to Abbeville, producing cartes de visite for a time. September 1873 found A. B. Lee back in Camden alone, again operating from the Workman Building.[6]

After Dodson's work in South Carolina, he moved to North Carolina in 1874, operated there from a number of towns at least until 1900, and added a new partner, Montraville P. Stone.[7]

**George A. Shillito.** Shillito advertised taking photographs at low prices next door to the *Press and Banner* office in July 1871.[8]

## Aiken

**J. C. Wright & Bro.** In July 1867 J. C. Wright and his brother operated a gallery over Wood & Co.'s drug store. They advertised single pictures from five cents to two dollars, six pictures for two dollars, and twelve for three dollars and fifty cents.[9]

**J. A. Palmer.** Palmer, a native of Ireland, came to this country as a small boy with his family and settled in Rochester, New York. While in New York Palmer married and a son, Charles, was born there in 1861. Palmer's occupation while in Rochester is not known, but he may have been engaged in photography there. In 1866 he moved to Savannah, Georgia, and apparently worked as a photographer since the 1870 United States Census recorded him engaged in that occupation. In the early 1870s he moved to Aiken, South Carolina, and began a photographic business lasting until his death in 1896. He sold his business to his wife in 1891, but continued working as a photographer. Several others may have also worked in the studio for Mrs. Palmer. For example, C. D. Hardt worked as an operator in the Palmer studio in March 1896 shortly before Mr. Palmer's death in June.[10]

From about 1871 to 1896, J. A. Palmer artistically photographed the interiors and exteriors of churches, homes, public buildings, hotels, textile mills, railroads, streets, landscapes, etc. over a wide area of South Carolina and parts of Georgia and Florida. Palmer provided sixty-three photographs in 1889 to illustrate *Aiken, South Carolina as a Health and Pleasure Resort.* He also specialized in scenes from the black community, including not only portraits, but also their cabins and "at work" scenes in cotton fields and other locations.[11]

Palmer took advantage of current events in his photographic business. As an example, when an earthquake struck lowcountry South Carolina in 1886, he was quickly on the scene with his camera recording the damage.[12]

Palmer produced many stereographs. He gave each a number and these numbers indicate he produced more than a thousand. Palmer took advantage of Aiken being a winter colony for visitors by selling stereographs and other products to them. As a result, today Palmer's stereographs are found in private hands in many parts of the nation.

Collectively, Palmer's photographic works provide historians and others with visual information not to be found elsewhere. As a result, his work enables one to develop a much more detailed and richer understanding of the life, times, and culture of a portion of South Carolina in the nineteenth century than would otherwise be possible.

*Stereograph of the Aiken Catholic Church produced by J. A. Palmer. SCL.*

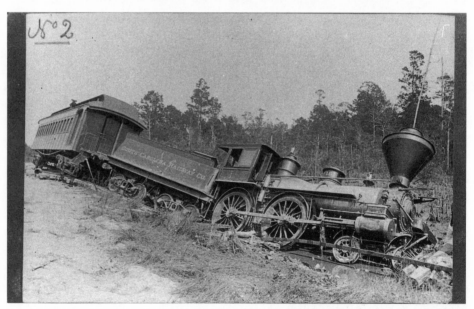

*Photograph by J. A. Palmer of a train wreck near Langley, South Carolina, caused by the earthquake of 1886. SCL.*

*Anderson*

**McLean & Trotter.** For a short time beginning in October 1870, McLean & Trotter operated a gallery over Sylvester Bleckley's Store. They advertised long experience, abundant facilities, and all the improvements in the art. A carte de visite produced in Anderson advertised them as "Watchmakers & Jewelers." McLean may have been R. B. McLean who was in Marion in 1874 and Trotter was probably H. G. Trotter who operated a gallery in Walhalla in July 1870.[13]

**John A. Reese.** Reese located in the northeast corner of the public square at the Waverly House in 1872 and touted his skylight and low prices.[14]

**John D. Maxwell, J. A. Wren, and J. Bryan Jewell.** J. D. Maxwell was listed as a photographer in 1880 and 1883 business directories. Up to 1890 other photographers occupied the Maxwell Gallery and operated there. J. A. Wren and J. Bryan Jewell operated the Maxwell Gallery intermittently until 1890—Jewell in 1884, 1886, and 1888 and Wren in 1887, 1889, and 1890. In 1890 Wren published a booklet of Anderson views.[15]

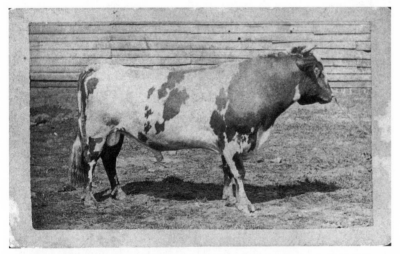

*Carte de visite by J. A. Wren of "Sir Julian," who was probably a prize bull. Collection of the author.*

*Wren placed this label on the reverse of the "Sir Julian" carte. Collection of the author.*

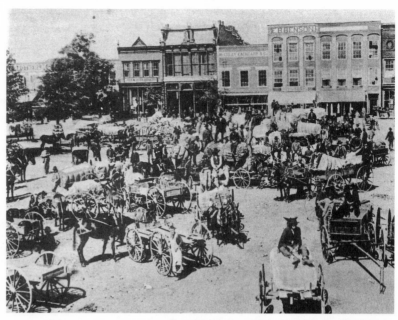

*Print showing north side of the public square in Anderson. Copied from an 1890 published booklet of photographs by J. A. Wren. SCL.*

*Ad for Burr and Lee's Columbia gallery.*
Columbia Daily Phoenix. *30 April 1867.*
SCL.

**NEW PHOTOGRAPH GALLERY!**
**Plain Street, near Main.**

BURR & LEE respectfully inform the citizens of Columbia that they have opened a PHOTOGRAPH GALLERY, on Plain street, near the store of Mr. Jas. G. Gibbes, where they are prepared to take PICTURES of all styles.

Our PRICES will be so arranged as to SUIT THE TIMES, and the work guaranteed. We respectfully ask a share of the public patronage.          H. C. BURR.

April 30 2          W. S. LEE.

## Camden

**HUGHES & BURR, H. C. BURR & W. S. LEE.** In June 1866 (W. P.) Hughes & (H. C.) Burr operated a gallery in Camden for a short time. In January 1867 H. C. Burr associated W. S. Lee of Camden in his photographic business. According to Burr, Lee had long experience in the principal cities of Germany and was recently returned from that country. By April 1867 Burr & Lee had opened a gallery in Columbia near James G. Gibbes' store on Plain Street.[16]

**McCallum & Wilder.**  H. B. McCallum operated a gallery in Camden from 1860 to 1861 and one in Sumter from 1866 to 1869. James Diggs Wilder was in business with a Mr. Wheeler in Sumter from 1869 to 1870. McCallum & Wilder apparently operated a studio in Camden for a short time in 1868. However, no products produced by this firm while in Camden are known.[17]

**William S. Alexander.**  The Alexander family of Camden maintained a long association with photography, one that began in 1842 and continued until 1891. Dr. Isaac B. Alexander, the father of William, worked as a daguerreotypist in the 1840s for a time. William opened his gallery in Camden in 1876 and produced quality photographs intermittently on de Kalb Street for the next fifteen years. Like Palmer of Aiken, he benefitted from the "Winter Colony" of northern tourists who visited Camden seasonally and who provided many customers.[18]

In 1888 Alexander and Dr. John W. Corbett compiled and published a thirty-six page illustrated pamphlet on Camden. The seventeen illustrations of Camden buildings and scenes in the pamphlet were all engravings based on photographs taken by Alexander. Several of these views later turned up as picture postcards. Only a few photographs bearing Alexander's trademark are known, but many have been otherwise identified. His work must

Alexander's Photograph Gallery, Camden, S. C.

*Albumen print of a member of the Shannon family. Courtesy of Darlene Cantey.*

*Photograph by William S. Alexander portraying a scene along the railroad. The Hermitage textile mill shows in the background. SCL.*

be ranked among the best produced by South Carolina photographers. Like Palmer of Aiken, he produced photographs of rural scenes that included African Americans.[19]

One of his descendants married a Camden antique dealer, Norman Fohl, who reported that many glass negatives stored under the Alexander home were destroyed by tenants. However, some of his photographs did survive and were in the possession of Mr. Fohl in the 1960s.

**C. M. VAN ORSDELL, JR.** In late 1879 and early 1880 C. M. Van Orsdell, Jr. produced photographs from Alexander's "stand" on de Kalb Street. He later located permanently in Orangeburg.[20]

### Charleston

**QUINBY & CO.** At some point in late 1865 Quinby & Co. reopened their Charleston gallery. A local editor reported this event and opined that before the Civil War Quinby "enjoyed a wide and well deserved reputation as a photographer and his gallery was a very popular resort." The editor encouraged patronage of Mr. Quinby's business by the local citizenry. Quinby employed Jacob F. Coonley, a friend of George N. Barnard, to manage his gallery. The business evidently flourished as Quinby added Barnard as a partner in the firm in 1868.[21]

*Two cabinet photographs by Quinby & Co. portraying phosphate mining in coastal South Carolina. SCL.*

In the 1869–70 Charleston directory Quinby & Co. advertised "a large and fine Collection of Chromos and Stereoscopic Views of Charleston and Fort Sumter for sale." At that time Louis Prang, Currier & Ives, and other similar firms produced chromolithographs for sale by photographic firms and other businesses such as bookstores.[22]

In the 1870 local fair Quinby & Co.'s display of photographs were judged the best. Not included in the display were photographs they had produced of the fairgrounds and exhibits. Quinby and Barnard sold their firm to Bertha Souder in 1871.[23]

**H. C. Foster.** The Union photographer, H. C. Foster, worked on the sea islands near Charleston during the Civil War. In May 1865 he opened the Star Gallery at the corner of King and Market Streets. A Charleston editor reported in June, "We had the pleasure of a visit to the gallery yesterday, and were shown by the polite and gentlemanly artist between forty and fifty different pictures of the principal public buildings, ruins and places in the city, besides photographs and stereoscopic views of the various fortifications in the harbor, including Fort Sumter, Fort Moultrie, Castle Pinckney, Fort Strong and Fort Putnam on James Island and Morris Island." The editor further stated that "all exhibit the same truthfulness to nature and (are) taken with a degree of precision really astonishing."[24]

The editor continued with this vivid and detailed description of Foster's photographs taken on 14 April 1865 when the United States flag was restored to Fort Sumter: "The views of Fort Sumter taken at the celebration on the fourteenth of April will be recognized by all who were present, as near perfection as the artist could possibly have made it. There is the platform, the canopy, the high dignitaries seated on the platform, including General Anderson and daughter, and Rev. Henry Ward Beecher in his white hat, the spectators seated in the centre, the gabions of the fort, the artillery on the parapet, and, just visible above all, the masts and flags of the steamers. The artist has lately received large orders for these pictures from the North."[25]

In August 1865 Foster attempted to close out his ambrotype business and concentrate on the production of other types of photographs. Foster operated a gallery in Charleston as late as December 1866. In 1867 he was not listed in the local directory.[26]

**Mrs. C. A. Bolles and J. A. Bolles.** In 1872 and 1873 a Mrs. C. A. Bolles was listed as the photographer at the King and Market Street location formerly occupied by Jesse H. Bolles. The relationship, if any, to Jesse H. is unknown, but she may have been a sister-in-law or daughter-in-law since a Mr. J. A. Bolles operated the studio after 1873 until 1876 or 1877. Probably during their last year in business the firm employed one J. F. Quinn as a photographer. After 1877 the name Bolles no longer appeared in Charleston photographic circles. Many cartes produced by Jesse H. Bolles are known, but no examples produced by Mrs. C. A. or J. A. Bolles have surfaced.[27]

**E. A. Barlow.** Barlow was listed in the 1867–68 city directory as a photographer at the corner of King and Market Streets, but not listed in the 1869 directory.[28]

**Issertel & Durbec.** F. E. Durbec, a wartime photographer, operated a gallery in partnership with R. Issertel in 1868 at 265 King Street, and in 1869 and 1870 at 235 King. Their business must have been short-lived since they were not listed in the 1872–73 directory.[29]

**S. T. SOUDER.** Quinby and Barnard sold their business, including 4,000 negatives, to Mrs. Bertha Souder in May 1871. The relationship of Stephen T. Souder to Bertha is unknown, but whatever the case, he was an accomplished photographer. Souder produced quality cartes de visite and, in 1872, advertised "Stereographs Of Fort Sumter, Magnolia [Cemetery], And All Points Of Interest In Charleston, Also Savannah And Florida Views." Souder also sold stereographs of scenes of Charleston and its environs produced from 1860 negatives by Osborn & Durbec.[30]

In July 1873 George N. Barnard returned from Chicago and purchased from Bertha Souder, for $7,000.00, the studio in which he worked and was part owner from 1868 to 1871. By 1873 Souder had produced 3,500 more negatives that were included in the sale along with the 4,000 negatives Bertha had purchased from Quinby & Co.[31]

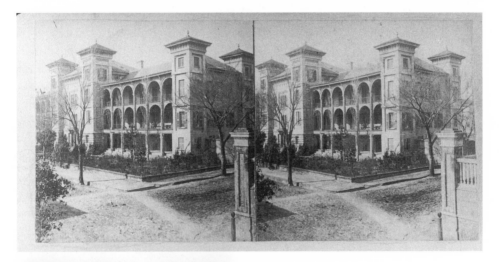

ABOVE: *Stereograph by Stephen T. Souder of Roper Hospital in Charleston, South Carolina. SCL.*

*Backmark employed by Issertel & Durbec. Collection of the author.*

GEORGE N. BARNARD, JAMES H. DEVOE AND OTHERS. Barnard's previous work in South Carolina, during the Civil War and in 1866 when he was preparing his *Photographic Views of Sherman's Campaign,* was chronicled in chapter 4. Barnard operated a Charleston business from 1868 until 1880, with the exception of the period when he operated a studio in Chicago from 1871 to 1873.

The reason for Barnard locating in South Carolina in 1868 is unknown. He certainly knew the area from his war and postwar experiences and may have been attracted by artistic and aesthetic photographic opportunities as well as the economic ones. The reputation of the Quinby firm he joined as a partner was also well-known to him. His wartime colleague, Jacob F. Coonley, had managed Quinby's gallery for a time after the war. Barnard was the type of individual who kept abreast of developments in his profession, including the reputations of other photographers.

One author suggests that, during his partnership with Quinby from 1868 to 1871, Barnard produced most of the photographs for the firm since Quinby also had an interest in a dry goods store with J. R. Read.[32] His firm was always Quinby & Co., an indication others were in the business with him. Before the Civil War he simultaneously operated three studios in New York, South Carolina, and Georgia as well as a photographic supply business located in Connecticut. In his Charleston studio in 1857 he boasted of having twenty employees. Although a photographer, he apparently was as much, if not more so, an entrepreneur.

After a successful two years in Chicago, which included his studio being burned and rebuilt, Barnard returned to Charleston and repurchased his old studio from Bertha F. Souder. Awaiting Barnard and his camera were picturesque ruins, streets steeped in history, stately mansions, rice plantations, formal gardens, a busy port, blacks at work, churches, forts, ancient live oaks draped in Spanish moss, portraits for the population of a large city of about 50,000, plus the scenes and population of the interior of South Carolina. He proceeded to capture them and, for the next seven years, competed with the long-time Charleston photographer, George S. Cook.[33]

In 1875 Barnard supplied sixty-one photographs from which engraved printing plates were made for producing illustrations for a pictorial guide to Charleston. These photographs were largely of buildings and street scenes in Charleston, but a photograph of a railroad intersection in Spartanburg County was a notable exception.[34]

Barnard's postwar South Carolina photographs mainly fall into three categories: cartes de visite, cabinets, and stereographs. In 1877 Barnard did produce some photographs by the carbon process. These photographs, although quite striking in appearance and more permanent over time, were three times more expensive and, as a result, never replaced albumen prints. Although of interest and value to collectors and historians, his cartes de visite and cabinets of individuals are not as much sought after as his stereograph and cabinet views.[35]

Barnard's stereograph and cabinet views collectively offer a pictorial cross section of lowcountry South Carolina life in the 1870s. He produced views of the docks, forts, churches, homes, and streets of Charleston. In his stereograph of "East Battery Street Looking North," he included his equipment buggy, parked on the street at the time. Printed on

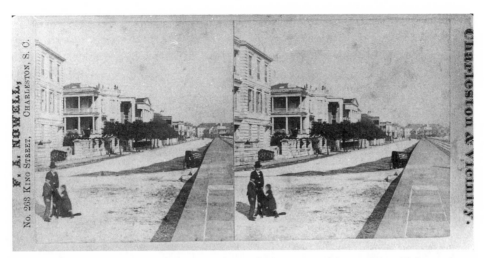

*An F. A. Nowell stereograph of East Battery Street in Charleston, copied from a George N. Barnard negative. In the foreground by the curb Barnard's portable equipment cart is shown. SCL.*

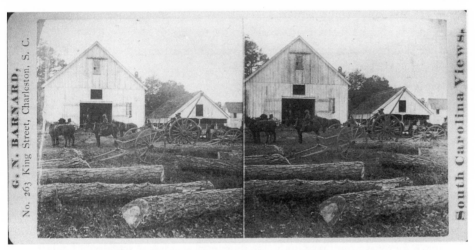

*Stereograph of a saw mill on the Alexander Knox plantation near Mount Pleasant (circa 1874), produced by George N. Barnard. SCL.*

the side of the buggy were the name and address of Barnard's studio. Probably for both advertising and ego reasons, photographers frequently took views that included their studios or studio signs.[36]

In his work Barnard included scenes not only of Charleston, but also of nearby areas. The Old Dorchester Church on the Ashley River near Summerville was an example. Another example was a series of stereographs of the Alexander Knox plantation in Mt. Pleasant. Views of Magnolia Gardens were another example.[37]

Many of his stereographs, especially the Alexander Knox Plantation ones, include blacks. Barnard was one of the very few South Carolina white photographers to provide us with nineteenth century photographs of African Americans at work or in other settings.

Barnard recognized the value of advertising and used it to a greater degree than most of his local competitors, including Cook. Cook had advertised extensively in the antebellum period, but relied on it to a much lesser degree after the Civil War. Not only did Barnard advertise locally, but, on occasion, in other areas of South Carolina as well. In September 1873 he advertised his purchase of the S. T. Souder studio in Walterboro, and in September 1877 he advertised his studio in upstate locations such as Newberry and Laurens, some 150 to 200 miles from Charleston.[38]

For a few months in 1879 he operated a branch studio in Sumter at the corner of Main and Republican Streets. Barnard photographed his subjects in Sumter and then returned to his studio in Charleston where he completed work on them, "thus assuring the very best pictures." Barnard recruited J. C. Fitzgerald from Peterboro, Ontario, but more recently of Rochester, New York, to assist him. Since Fitzgerald was documented in Sumter as a photographer in 1880, one could assume that as Barnard's assistant he may have been producing photographs for Barnard's Sumter studio in 1879.[39]

While in South Carolina Barnard's outreach sometimes extended beyond the state's borders. For example, two of his photographs of Charleston wharves appeared as engravings in *Harper's Weekly* in January 1878. He always maintained contacts and communications with others in his profession outside South Carolina.[40]

The volume of work generated by his firm required Barnard to employ others to assist him. While in Chicago he employed a Mr. Devoe, probably James H. Devoe, an operator with Osborn & Durbec in 1860. James H. Devoe also worked for Barnard in his Charleston studio from at least 1875 to 1878, if not for the entire period from 1873 to 1880. As already mentioned, J. C. Fitzgerald was employed by Barnard to assist him in 1879. Barnard earlier received much of the credit for the product of the partnership with Quinby. In all fairness to these assistants, a measure of credit is due them when the volume and quality of the product from Barnard's studio between 1873 and 1880 is assessed. Barnard followed the established tradition of the time by placing only his credits on the photographs produced by his firm.[41]

In further assessing the work of Barnard, one must take into consideration the possibility that some photographs bearing his hallmark may have been printed from negatives that were the product of other firms. The photographic views of Charleston and its environs produced by Osborn & Durbec in 1860 were the source of some later prints from Quinby & Co.(including Barnard) and S. T. Souder. In the 1880s Frank A. Nowell likewise printed from Barnard negatives and represented them as his product.[42]

In 1880 Barnard sold his business to Frank A. Nowell. The purchase price of $5,000.00 was financed by Barnard and it was 1888 before he received the final payment of $1,000.00. After leaving Charleston in 1880, Barnard continued working as a photographer until 1888. At that time he became semi-retired until his death in 1902.[43]

Of Barnard's career, which spans the forty-two years from 1846 to 1888, about one-fourth of it was spent in South Carolina with brief appearances in March and April 1865 and June 1866, a partnership with Quinby from 1868 to 1871, and sole proprietorship of a studio in Charleston from 1873 to 1880. Ten of the sixty-one views in his book published in 1866 were taken in South Carolina.

A review of the scope and quality of Barnard's work and a comparison of it to that of his contemporaries supports Keith F. Davis' assessment that few if any "had Barnard's technical expertise, artistic sophistication, pictorial originality, and broad network of professional contacts" and his further statement that "It is time that George N. Barnard step at least part way out of the shadows of historical neglect. We have much to learn from him."[44]

FREDERICK K. HOUSTON. Houston, operator of a Charleston studio by July 1871, advertised his business in the local newspaper as "Houston's Excelsior Chromo Ferrotypes! 339 King Street." He also advertised large frames and pictures for $1.50 each. He remained in business until 1875, but moved at some point to 307 King Street. Few authenticated examples of his work have been located.[45]

JAMES MOIR & CO. This firm was operated by James Moir and H. A. Cohen, who were probably in partnership. The only references found on their business were an 1874–75 city directory listing and an ad for their "National Photograph and Ferrotype Gallery, 339 King St. next North of Liberty."[46]

V. C. BROWN & FREDERICK A. SCHIFFLEY. The firm of V. C. Brown & Frederick A. Schiffley produced cartes de visite in December 1870 from a studio at 333 King Street. No city directory was available for 1871, but in the 1872–73 city directory Frederick A. Schiffley was listed at 333 King Street. Schiffley advertised his "Fine Art Gallery" at 265 King Street, opposite Hasell, in the 1874–75 city directory and promised "Photographs Of Every Style And All Sizes Finished in the Neatist Manner." He appeared at 333 King St. in the 1875 city directory. In August 1875 Schiffley was in Orangeburg for a time with his photographic tent producing "Pictures of every size and style. . . . Views of churches, residences and made in the neatest manner." Only a few examples of his work are known.[47]

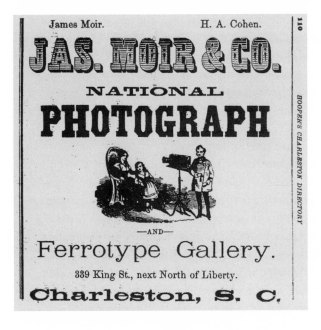

*Ad for James Moir & Co. gallery.*
Charleston City Directory,
*1874–75. SCL.*

**WILLIAM H. AHRENS.** From 1875 to 1877 Ahrens operated from 339 King Street, the address of Frederick K. Houston in 1871 and James Moir & Co. in 1874 and 1875. Ahrens' studio relocated to 232 King Street by 1878.[48]

**JOSEPH H. ANDERSON AND CARRINGTON, THOMAS & CO.** Anderson had opened a gallery by 1876 or 1877 at 267 King Street over the Carrington, Thomas & Co. Jewelry Store. Anderson advertised several times in the city directories from 1876 to 1882 boasting "The Largest and Most Complete Photographic Establishment in Charleston." During his first year in business Anderson probably employed J. F. Quinn as an operator in his studio. From 1883 to 1885 the firm located at this address was known as Carrington, Thomas & Co. The manager was Miss P. A. Steen, but it is unclear whether or not she produced photographs. In 1886 Anderson was again operator of the firm at 267 King Street and Carrington, Thomas & Co. had disappeared from the listings. Anderson likewise disappeared from the Charleston photographic scene in 1886. An interesting cabinet photograph is known that carries this wording: "The Anderson Studio, H. Leidloff, Proprietor." This caption suggests that Hermann Leidloff either worked for Anderson for a short time or was his partner. Leidloff was in Charleston by 1878 and opened his own studio in 1881.[49]

Most of Anderson's work was portrait, but on occasion he produced photographs of houses and scenes. An example is a cabinet of Fort Hill, the home of John C. Calhoun, located on the Clemson University campus more than 200 miles from Charleston.[50]

**NATHANIEL K. REED.** Reed operated a studio at 333 King Street from 1878 to 1881.[51]

**GEORGE LaGRANGE COOK.** With the departure of George S. Cook and George N. Barnard from Charleston, 1880 was a benchmark for photography in the city. Cook left his son, George LaGrange, in charge of the Charleston studio at 281 King Street. For the next eleven years, he continued the Cook tradition of quality photographic work. About 1886 George L. Cook moved to 265 King Street.[52]

George was born in 1849 while his father was an itinerant daguerreotypist in LaGrange, Georgia, and was dubbed LaGrange for the town of his birth. During his youth he was around a photographic studio and business. He obviously learned the business from his father and, in fact, was his assistant for a number of years before his father left Charleston in 1880 for Richmond, Virginia.[53]

An 1884 historical review of Charleston contains a description of the Cook studio and a comment on his work.

> The popular photographer of Charleston, is Mr. G. L. G. Cook, who as a photographic artist, has achieved a standard reputation; his pictures always showing a graceful, easy pose, a fidelity to nature, and a completeness of finish, not always obtained by those who are not thorough masters of the art. This business was established by his father, Mr. G. S. Cook, in 1849, the present proprietor having succeeded him in 1880. Mr. Cook is a thorough artist, and executes all kinds of work, from the carte de visite, to the imperial cabinet pictures which are perfect likenesses, and show the same care and perfection of finish that characterize all his efforts, which have made him celebrated, and have gained for him a great popularity

*Contact print from a glass negative of William Ravenel's house, 13 East Battery Street in Charleston, portraying 1886 earthquake damage. The negative was produced by George L. Cook. SCL.*

*Contact print from a glass negative of the Summerville Depot, produced by George L. Cook. SCL.*

and patronage, not only from the citizens of Charleston, but from throughout South Carolina. The second and third floors of No. 281 King Street are utilized in the business. The gallery, reception, and operating rooms occupy the second floor, and are neatly and handsomely fitted up. The work room is supplied with everything requisite to the business, including backgrounds of landscape scenery and others, which lend charm to the picture. Mr. Cook was born in Georgia, has resided in Charleston since he was one year old, where he is well known and highly esteemed, and merits the excellent patronage he now enjoys, and which steadily increases, purely upon the merits of his work.[54]

In early 1994 a group of more than 140 glass negatives turned up in Charleston. Most, if not all, were produced by George LaGrange Cook. These were primarily photographs of Charleston streets, homes, churches, 1886 earthquake damage, and several views of the summer resort of Summerville. One negative shows the interior of what may have been the processing or work room of the Cook studio. After the 1886 earthquake Cook produced more than two hundred views of damage in Charleston and the vicinity. These were sold individually or in sets and were also reproduced in pamphlet or booklet form for sale. The photographs of Summerville are understandable since George and his family began spending time in the summers there beginning in 1883, and moved there and made it their permanent residence in 1889.[55]

Cook left Charleston in June 1891 to join his father and brother, Huestis, in their thriving business in Richmond.

FRANK A. NOWELL. Nowell first came to Charleston in 1870 and worked as an assistant to S. T. Souder and to J. H. Anderson. In 1880 he purchased the studio of George N. Barnard, including his Charleston negatives. Nowell continued this business until 1890. A writer of an 1884 historical and descriptive review of Charleston left us a description of Nowell's studio and work.

The progress made in the photographic art in late years, is really wonderful. The popular photographer of Charleston, is Frank A. Nowell, who is pronounced one of the best. Mr. Nowell, possesses a thorough mastery of the different methods and the recent improvements in the art, and knowing how to give an easy and graceful pose to the sitter before the camera, produces soul-speaking likenesses, showing harmony in their composition, and truth in their outline.

He executes copies and enlarges pictures, in oil, crayon, India ink, water colors, etc., his skill and workmanship being greatly admired, has attracted in his handsome reception parlors, all classes of the community. His gallery occupies two entire floors of No. 263

*Advertising artwork used by Nowell on carte and cabinet photographs. SCL.*

King Street, are handsomely furnished, and thoroughly equipped, and amply provided with every convenience for the business. His studio is provided with handsome scenic backgrounds, and other necessary auxiliaries for producing effective pictures. His rooms are somewhat peculiar in their arrangement, the staircase being in the centre of the roof, its construction being such, as to have the effect of making it cooler in the summer months, and more comfortable in winter. Mr. Nowell first came to Charleston in 1870. He is a practical man, acquainted with every detail of the business, and has won distinction in the art of which he is a diligent scholar and lover.[56]

As noted earlier Mr. Nowell sometimes printed from negatives produced by Barnard and placed his name on the prints, an accepted practice at the time.

On rare occasions contemporary accounts of customer descriptions of visits to photographic studios survive. In 1941 Laura Witte Waring published this description of a visit to Nowell's studio when she was a child:

On the day that it was decided to have the six of us photographed, we were taken to Nowell's for the purpose. Our ages ranged from six to sixteen. A great deal of posing, fixing and discussion took place and two of the children quarrelled over the swing. I was seated on a box, my legs feeling scratched by the artificial straw on the floor, but I did not say a word about it. The photographer seemed to take endless time, peeping from under the black cloth, running forward to adjust our clothes and positions, and disappearing for lengthy periods. Finally the suspense was at an end, with the result of that photograph you all know and in which you find resemblances to our children.[57]

**HERMANN LEIDLOFF.** Leidloff came to Charleston in the late 1870s, married a local woman, and by 1881 operated a photographic gallery at 287 King Street. In 1884 a writer left us a description of Mr. Leidloff's business and work at that time.

The establishment of Mr. H. Leidloff is located at 278 King Street. He has had many years experience in the business, having come to the United States in 1872, and located himself first in Boston, and then in New York City, afterward in Baltimore, and during the last three years he has occupied his present location, where he has acquired distinction as being one of the leading, most accurate, and accomplished artist in the country. The studio is fitted up in an elegant manner, and is provided with every facility and specialty for the production of perfect, life-like likenesses. The operating rooms are supplied with every accessory in the way of scenery, back-grounds, etc., so that the artist is enabled to produce a picture in almost any style desired by the subject. Mr. Leidloff is a native of Berlin, and conducts a large business, extending through South Carolina, Georgia, Florida, and Alabama, and has gained a high reputation for the manner all work entrusted to him is performed.[58]

*A photograph of a bust of Robert Fulton. The photograph was produced by Herman Leidloff, using electric light, in 1883. This is the earliest example documented during research for this work of a South Carolina photographer using this method for lighting a subject. Courtesy of South Carolina Historical Society.*

In this same year (1884), Leidloff advertised the production of photographs by electric light.[59]

    Little is known of Leidloff's work in Georgia, Florida, and Alabama. William C. Darrah lists Leidloff as a publisher or producer of stereoscopic views in Atlanta, but no information has come to light concerning his work in Florida and Alabama.[60]

    From 1886 to 1906 Leidloff's studio was at a variety of King Street addresses: 1886, No. 269; 1887 to 1888, over Nos. 251 and 269; 1890, No. 267; 1892, No. 251; 1894 to 1897, No. 263; 1898 to 1906, No. 269. A cabinet photograph of Leidloff also carried his address as 249 King. During this period Leidloff's studio enjoyed a permanence and longevity experienced by only one other photographer, George S. Cook. Cook was in business for thirty-one years and Leidloff for twenty-five. Today hundreds of examples exist of the fine products from Mr. Leidloff's cameras. They usually are carte or cabinet portraits.[61]

    **JAMES H. DEVOE.** Devoe is a somewhat mysterious figure in South Carolina photography. He followed the profession for many years, but little is known of him and very few identified examples of his work exist. He first appeared in Charleston in 1860 as an operator for Osborn & Durbec. From 1867 to 1870 city directories listed him as an artist in Charleston. Whether or not the word "artist" in this case meant a photographer is not

known. Apparently he left Charleston in 1871 and worked with Barnard in Chicago until 1873 when Barnard returned to Charleston. Devoe was listed in Charleston city directories from 1874 to 1878 as Barnard's assistant. He probably remained with Barnard to 1880, but no directories exist for 1879 or 1880 to confirm this supposition. Finally in 1882 he was the proprietor of his own studio at 261 King Street, but disappeared from the scene after that year.[62]

## Chester

**JOHN R. SCHORB & SON AND GEORGE T. SCHORB.** In 1874 John R. Schorb of Yorkville opened a studio in Chester in partnership with his son George. Their studio, first located in the Bennett Building on Centre Street, relocated to the McNinch Building on Main Street in September 1874. By 1875 only George operated the Chester studio and he continued that business until at least 1881. He apparently also served as an agent for the *Yorkville Enquirer* from 1879 to 1881, as he took orders for ads and "Job Work" for that paper during this period. By 1885 he returned to Yorkville where he operated a tin store and sold stoves and household goods. Very few examples of the work produced by the Schorbs while in Chester are extant, but a number produced earlier by them in Yorkville are known.[63]

## Clinton

**J. E. HUNTER.** In September 1873 Hunter advertised he would be in Clinton "for a while." In 1876 and 1883 he operated galleries in Abbeville.[64]

**D. W. BURDETT.** In March 1874 Burdett reported he would be in town for two months.[65]

## Columbia

**HARMON & MORRIS.** H. L. P. Harmon operated a gallery in Lexington prior to opening one in Columbia in 1874. Associated in the Columbia business, presumably as a partner, was a Mr. Morris. According to Harmon, Morris was from Washington, D.C., and had "over thirty years steady practice in the art." They boasted a newly built well-equipped studio, experience, quality work, and reasonable prices. Harmon was in business until 1877, but Morris' name was not included after 1874.[66]

**WEARN & HIX AND W. P. HIX & CO.** Wearn reopened his gallery in September 1865 and Hix had rejoined the firm by early 1866. For the next eight years their studio dominated other studios in Columbia, and today there exist thousands of their cartes, cabinets, and stereographs. Best known for studio work, they produced many interesting stereoscopic views, including some scenes from the North Carolina mountains.[67]

Perhaps their next greatest contribution to South Carolina photography was the training of William A. Reckling. Beginning in 1874 Reckling (later with his sons) operated a studio in Columbia lasting nearly forty years.

*Cabinet of an unknown individual produced by H. L. P. Harmon's studio. SCL.*

When Wearn died in 1874 W. P. Hix took over the business and operated it until 1880. He associated others in the business either as employees or operators and advertised as "W. P. Hix & Co.'s Art Gallery, 124½ Richardson street." In 1875 and 1876 he boasted of "Eleven Silver and Four Gold Medals Taken at Different Exhibitions." He didn't specify the exhibitions, but they no doubt included the ones prior to the Civil War in which Wearn & Hix participated.[68]

In February 1875 Hix opened a branch of his studio in Newberry over Mrs. Mower's Store where he produced "Portraits and Photographs." One of his associates, George V. Hennies, who before 1880 had become a partner in the business, may have been the operator. In February 1880 they dissolved their partnership. That month Hix brought J. C. Fitzgerald into the business. It was not clear how long Hix remained in photography. However, in the 1883 city directory, the next one available, only George V. Hennies was listed at 124½ Richardson Street. Apparently Hennies bought Hix out or moved to the Richardson Street location after Hix had gone out of business.[69]

*Copy of a Civil War period carte de visite of Gen. Milledge Luke Bonham in full Confederate uniform, produced by Hix & Fitzgerald 1880–83. SCL.*

Throughout Hix's career, both with Wearn and on his own, he seemed to give much of his time and attention to tinting photographs or to producing paintings in oils and water colors. An ad of his in a city directory read "All the painting will be done by Mr. Hix as heretofore, and he will give special attention to the posing of the sitter."[70]

From 1874 to 1880 W. P. Hix & Co. continued the quality of work in cartes, cabinets, and stereographs that had been the tradition under Wearn & Hix. Many examples of their work exist today, including leading individuals of the time like Governor Wade Hampton. Just as Wearn & Hix should be recognized for training W. A. Reckling, so should Hix be recognized for training George V. Hennies who continued his work and tradition until 1924 or 1925.[71]

**WILLIAM A. RECKLING.** Reckling worked for and was trained by Wearn & Hix. Prior to 1874 he left their employment and operated a studio in Rome, Georgia. In 1874, Reckling returned to Columbia and opened a gallery that continued in operation until 1910.[72]

Beginning in the late 1890s Reckling began bringing his sons into the business. In 1897 his son Cliff specialized in taking baby pictures for the gallery. Shortly before 1900 his sons Thomas R. and Walter T. began working for their father, and from 1903 to 1910 the

firm was known as W. A. Reckling & Sons. Reckling and his sons were not operating the studio in 1911 and 1912, but W. A. Reckling was listed as operating the firm in 1913. In that year the elder Reckling died and his son W. T. operated the studio in 1914. After that year the name Reckling was no longer associated with photography in Columbia, thus ending a forty year era during which the Reckling name and studio were fixtures in the capital city.[73]

A writer in 1888 described Reckling's studio and work: "He began business on his own account some 15 years ago, and his work has met with such general satisfaction that many of the noted men of the State and elite of this city have been his patrons. He has some 20,000 negatives, and his rooms are filled to profusion with specimens of his work. Portraits are finished in India Ink, crayon, or any desirable style of the art. Mr. R. has taken over 100 stereoscopic views of Columbia, and these he mails at $1.50 per dozen."[74]

Reckling sought ways to expand his business. He advertised locally and in the newspapers of Aiken, Lexington, and Camden. He visited Camden, Georgetown, Greenwood, and Lexington from 1888 to 1900 and produced photographs in each location for short periods of time.[75]

Reckling developed a customer base of noted individuals, both locally and throughout the state. Senators, judges, and other leaders who lived in or visited the capital city

*Cabinet by William A. Reckling of*
*Governor Benjamin R. Tillman. SCL.*

*Group of College For Women*
*tennis players (circa 1890s) captured*
*by Reckling. Their names are Emma*
*Munnerly, Marion Green, Lucy*
*McCaughrin, and Carrie McIver. The*
*names were only listed as a group. Lucy*
*McCaughrin Collection, SCL.*

frequently made a visit to Mr. Reckling's studio. This portion of his business represented a virtual "Who's Who" of South Carolina in the period from 1874 to 1910.[76]

Over its life, the Reckling firm produced a prodigious number of photographs. In 1886 and 1888 he reported having more than 20,000 negatives. In a 1908 letter to John Gary Evans seeking to produce photographs for Mr. Evans' political campaign, he stated he had amassed more than 100,000 negatives. Today examples of Reckling's work frequently turn up in garage sales, flea markets, and antique shops. He was most noted for his portrait work produced as cartes and cabinets, but he also produced more than 100 stereographs of Columbia.[77]

**ADAM M. RISER.** Riser appeared in the city directory from 1875 to 1895. He may have operated a few years before 1875 and a few years after 1895 since directories are not available for some years to check photographic listings. His gallery was at 20 W. Plain Street through 1893, but in 1895 it was at 1112 Plain Street. In 1875 he advertised his gallery locally and in out-of-town newspapers like those in Newberry. He was in business for at least twenty years, and during most of this time he had to compete with Reckling and Hennies. A few of his cartes and cabinets have been located, but too few to form a judgment of the quality of his work.[78]

**GEORGE VALENTINE HENNIES.** George's parents were from Germany, but had located in the United States before his birth on Valentine's Day (year unknown). In the late 1870s George learned the photographic business by working as an assistant in the W. P. Hix & Co. gallery in Columbia. Shortly before 1880 he became a partner with Hix, but in 1880 the two dissolved their partnership and thereafter each operated his own studio. By 1883 Hix no longer operated a studio, however. Hennies's studio was located in 1883 at 124½ Richardson Street, the former location of Hix, and he remained there until 1888. This fact suggests Hix may have sold out to Hennies at some point between 1880 and 1883.[79]

An 1886–87 business directory listed the gallery as Hennies & Bucher, and a few cabinet photographs produced by them are known. Bucher's name appeared in these few sources, but by 1888 he was no longer listed as a resident of Columbia.[80]

Sometime after 1888 Hennies moved to 130½ Main Street, near the capitol, but about 1894 he operated from his home on Barnwell Street. He did itinerant work in nearby towns and may have been so engaged during this period. In 1889 Hennies published a picture book of Columbia containing twenty-four photographs that was sold locally for a number of years.[81]

In 1895 Hennies introduced a new feature to his business. "He has just instituted in his studio a flash light arrangement whereby pictures can be taken at night as well as in day."[82]

*Cabinet reported to be of Horatio N. Emlyn of the* Columbia Record *(circa 1885), produced by Hennies. SCL.*

He next appeared in business in 1903 at 1633 Main Street and operated from that address until 1906. From 1906 to 1911 he was listed as a photographer in city directories, but no address was listed for a studio. From 1912 to 1924 he operated at 1615 Main Street, the former location of the Rawls Brothers' studio. Sometime in late 1924 or early 1925 he apparently sold the business to J. H. Mayfield who operated a studio at 1615 Main Street for the next two years.[83]

For about forty-five years, the Hennies name was associated with photography in Columbia. Today many examples of his works are found in both institutional and private collections. Hennies primarily produced portrait work as cartes or cabinets in the nineteenth century, but moved to other types of photographs as tastes and practices changed in the twentieth century. He did produce a series of Columbia views that included home and street scenes.

Hennies employed or associated a number of individuals in his business over the years. An 1880 carte showed him as a photographer and Harry Platt as an artist in his "Photo-Portrait Gallery." In 1883 H. Cronenberg from Wilmington, North Carolina, who married into the Hennies family, worked in the Hennies studio. In 1886 and 1887 a Mr. Bucher was employed in the firm. J. L. Roane, Jr. worked in the Hennies studio in 1888 and was still listed as a photographer in 1891. In 1891 J. P. Howie worked in a Columbia studio, probably Hennies's. E. A. Mulliken likewise worked as a photographer in an unidentified Columbia studio in 1895. Eugene B. Rawl was an assistant to Hennies in 1903. In 1920 A. Escobar advertised as a professional photographer at 1615 Main Street, the address of Hennies's studio. The city directory for that year listed Aurelio Escobar as working for Hennies. J. H. Mayfield managed the Hennies Studio in 1922. A Mrs. Seets/Seats (see section on female influences in Chapter 10) and at least one of Hennies's daughters hand-tinted photographs in the gallery.[84]

Several of the individuals who worked for Hennies later opened and operated their own studios, H. Cronenberg and Rawl Brothers being examples. Hennies named one of his children, Preston Hix Hennies, for his former mentor and partner, William Preston Hix—another indication of Columbia photographic lineage and influence.

## Due West

**Joseph F. Lee.**  In 1871 Professor Joseph F. Lee built a photographic gallery in Due West and operated it successfully for a number of years. An 1871 newspaper writer referred to his "taking very handsome pictures" in his gallery. In May and June 1874 Lee was in Abbeville and took photographs of the Episcopal Church, the residence of T. P. Quarles, and a number of other subjects.[85]

## Edgefield

**G. M. Cloy.**  Cloy operated an ambrotype gallery from his rooms in the Planters' Hotel for a short time in February 1866.[86]

*Copy print photograph of by R. H. Mims of the Confederate Monument dedication in Edgefield, South Carolina, 14 August 1900. SCL.*

**The Mims of Edgefield; R. H., George F., and Eliza M.** The Mims family and name are well-known in the annals of Edgefield, but less well-known, however, are the works R. H. Mims and his family produced in art and photography.

The first reference found to Mims as an artist and photographer was a long ad in the *Edgefield Advertiser* in January 1871. R. H. Mims advertised his photographic gallery over Penn's Drug Store where he produced and hand-tinted the various types of photographs in vogue. He advertised his services as an artist who created, restored, and framed paintings. His ad also indicated others worked for him and that he had been in business for a time before the appearance of his ad. From some time in 1870 until at least 1910, R. H. Mims operated a photographic gallery in the town of Edgefield. The visual documentation, in the form of paintings and photographs, of much of the population and culture of the Edgefield area for more than forty years became the legacy of Mims and his family.[87]

His son, George F., worked with his father for a time, but also engaged in other enterprises such as selling telephones. His daughter, Eliza M., studied painting in New York and was an artist who worked in the family studio, producing paintings and tinting photographs. She taught art for many years in the South Carolina Co-Educational Institute in Edgefield.[88]

An interesting description of the division of work between the elder Mims and his children appeared in an 1895 Batesburg newspaper article titled, "The Mims Artists." Mr. Mims, according to this article, did the photographic portrait work in the gallery. His daughter produced paintings in oils and pastels, and his son was engaged in "Outdoor Photography such as Family Groups, Schools, Animals, Buildings, Machinery, etc." Further diversity of the works produced by the Mims gallery was indicated in 1906 when the elder Mims advertised the production of "The New Post Cards, etc." By 1910 Mims was operating his studio from his home.[89]

### Florence

**RUFUS H. SMITH.** Smith operated a studio in Florence in April 1866, but no examples of his work are known.[90]

**D. J. GLENN.** Glenn was listed as a photographer in an 1880-81 business directory.[91]

### Greenville

**D. W. JONES.** Several cartes de visite produced by D. W. Jones and his wife in 1867 are known. They followed the practice of hand stamping the date when each was produced on its reverse.[92]

**J. M. ZACHARY.** In May 1870 Zachary advertised his photographic gallery on Buncombe Street, over J. J. Roach's store, where he produced ambrotypes and ferrotypes at "modest prices." Zachary also advertised his services as a dentist at his gallery or wherever his services might be needed. In other words, he made house calls. He apparently left Greenville after a few months.[93]

**WILLIAM M. WHEELER.** Under "Laurens" in this chapter, the firms having any photographer by the name of "Wheeler" associated with them are discussed in some detail.

*Stereograph of Gower Bridge by William M. Wheeler. SCL.*

William M. Wheeler, one of these photographers, was an itinerant before he established a studio in Greenville in 1871. The Wheeler photographic business remained a fixture there, with only minor exception, until 1930—a period of almost sixty years.

Wheeler located his studio over Whitmire & Ferguson's Store in 1871 and 1872. Later in the 1870s and 1880s he was at the corner of Main and Washington Streets. By 1896 he had moved his studio to 111 W. McBee Avenue and remained at that location until 1910. In that year, the studio location moved to 104½ Main Street and operated from that address to 1917 or 1918. In 1918 and 1919 World War I may have interrupted the business since the firm was not listed in operation during those years. In 1921 the business was located in the Mauldin Building. No record of the firm operating from 1922 to 1925 could be found, but William M. Wheeler, Jr., who had been associated in the business since 1903, operated the business from 1926 to 1930.[94]

Over the years Wheeler associated others in the firm with him. In 1879 and 1880 Wheeler's gallery was known as the Great Southern Photo Company and William A. Clark was its manager. Wheeler advertised, "We have a Corps of the Best Artists the country affords" indicating others besides Clark worked in the studio. Clark must not have stayed with Wheeler very long since he appeared in Newberry by 1882. In 1903 William M. Wheeler, Jr. became an associate in the firm and remained so until 1930. Wheeler and an individual by the name of Steele worked together in Rock Hill in 1911. A photograph dating from about the turn of the century bears the trademark, "Wheeler-McCaw, Greenville, S.C."[95]

From his base in Greenville Wheeler journeyed to nearby towns and did itinerant work. From 25 November to 20 December 1897 he took photographs in Anderson. In 1910 Wheeler and his son were in Rock Hill and in 1911 Wheeler and Steele were there producing photographs from the Cobb Building on Hampton Street.[96]

Wheeler and his associates did portrait work in the form of cartes and cabinets, but also produced a series of scenic stereographs of northern South Carolina. Today Wheeler photographs are some of the most plentiful ones to be found in South Carolina.

**H. Murphy.** Only an 1876 business directory listing for H. Murphy documents this individual as a photographer in Greenville.[97]

**J. S. Broadaway.** John S. Broadaway produced photographs in Sumter in 1859 and may have been the same Broadaway listed in Greenville in 1876. Between 1867 and 1873 Broadaway operated galleries in Charlotte and Rutherfordton, North Carolina, and in Augusta, Georgia. In June 1878 J. S. Broadaway advertised a "new Gallery, corner Main & Washington Streets" in Greenville. He invited patrons to "Come look at the Grand Scenery of Caesar's Head, Saluda, Bridal Veil, High, Triple and Connestee Falls, also views from New York to San Francisco, but none surpassing your own grand scenery of Upper South Carolina." His ad concluded with this poem. "You who have beauty to Broadaway take it; And you who have none, go get him to make it." This verse was employed by a number of photographers in ads throughout the United States for a number of years. Broadaway last appeared in Greenville in a 1880–81 city directory listing. From the 1880s to 1900 Broadaway operated in Winston, North Carolina.[98]

## Johnston

**C. E. Sawyer.** In November 1873 Sawyer announced the establishment of his gallery over the store of Jeter W. Crim where he was "prepared to make your picture for one dollar."[99]

## Lancaster

**N. Lang.** In March 1869 this Charlotte, North Carolina, artist offered to "counterfeit" anyone's beauty at his Lancaster gallery. By June that year Lang located in Camden in the Workman Building over Baum Brothers' Store where he advertised "Photographs, Ambrotypes and Ferrotypes." Lang left Camden in November 1869.[100]

**M. M. Broadaway.** Broadaway advertised "A New Picture Gallery" in 1866 opposite the home of A. Mayer where he produced photographs ranging in cost from one to five dollars. He also advertised a copying and enlarging device.[101]

**Riddle, Marks & Bailey.** These individuals advertised a "Sky-Light Gallery" on the lot of H. H. Price, near the courthouse, where they were prepared to take "Daguerreotypes, Ambrotypes, Ferrotypes and Cameotypes in the best possible manner." This ad, appearing in July 1866, was one of the last located for the production of daguerreotypes in South Carolina. Their first names are unknown, although there was a M. W. Bailey producing photographs in Lancaster in September 1859.[102]

## Laurens, Highland Home, and Scuffletown

**Wren & Wheeler, P. H. Wheeler, W. S. Wheeler, and W. M. Wheeler.** Wren & Wheeler operated in several South Carolina towns in the late 1860s. In August 1866 they advertised from Clinton that they were late of Laurens and would be in town for a short time producing "Ambrotypes, Ferrotypes, Photographs, Gem Pictures, etc." In October they returned to Laurens and operated from a gallery in a brick building next to the post office. Since a few cartes de visite produced by them featuring Abbeville individuals and sites are known, they probably also operated a studio there during this period.[103]

In December 1867, from Newberry, they advertised being in town for only a few weeks longer. In January 1868 they moved into C. H. Kingsmore's old gallery over Mayes & Martin's Store, and likely worked in town until October when they sold out to W. H. Wiseman. The sale included more than eight hundred negatives made in Newberry. A carte de visite dating from the 1870s bears the trademark, "Wheeler and Chronenberg, Newberry, South Carolina." Cronenberg was probably H. Cronenberg of Columbia and Rock Hill. A firm by the name of Wilder & Wheeler operated in Sumter in 1869 and 1870.[104]

The first name of Wren of Wren & Wheeler has not been determined, but that of Wheeler has. A carte de visite of P. H. Wheeler with his camera, dating from 1868, taken while Wren & Wheeler were in Newberry, is illustrated. About this time P. H. Wheeler also wrote a note on the back of a carte de visite bearing a Wren & Wheeler trademark on its front.

*Carte de visite of P. H. Wheeler and his camera by Wren & Wheeler of Newberry. SCL.*

*Carte de visite of the Marshall House in Abbeville (circa 1866), produced by Wren & Wheeler. In 1857 photographer W. L. Mickle produced ambrotypes from his gallery located in this hotel and Charles H. Lanneau did the same in 1859. Courtesy of John Blythe.*

One W. S. Wheeler operated in Newberry in 1876. He was in Abbeville in 1878 selling photographs he made of Governor Wade Hampton on Sales Day there the previous March. One W. S. Wheeler trademark was found on a carte de visite produced in Mayesville, located only eight miles from Sumter, where Wilder & Wheeler operated in 1869 and 1870. In 1871 W. M. Wheeler began a studio in Greenville that operated for almost sixty years.[105] The relationships, if any, among these Wheelers are unknown.

From the late 1870s to about 1890 J. A. Wren operated a studio in a number of South Carolina towns; Walhalla in 1878, Union in 1883, and several times in Anderson from 1880 to 1890. He may have been the "Wren" of Wren & Wheeler. Also, J. Ferdinand Jacobs of Clinton stated in an 1886 ad that he received his instruction in photography from "Capt. Wren."[106]

**J. W. BEEKS.** In February 1871 Beeks followed a different practice than his predecessors when he did not locate in town, but operated his "Ferrotype Gallery" from the home of Dr. William Wright "East of Laurens Village, near Beaver Dam Church." He stated he would be there a month.[107]

**T. J. LANGSTON.** In February 1871 Langston operated from the old stand of Wren & Wheeler in Laurens, advertising photographs "of any kind." It was twelve years before Mr. Langston turned up again in the records and then in Johnston. In 1883 a local newspaper comment about "our travelling friend" may have referred to his itinerant business. Beginning in 1883, he ran a combination jewelry store and photographic gallery in Johnston until about 1890. Mr. Langston, probably T. J., was in partnership with Wiseman in Newberry for a short time.[108]

**W. H. COOPER.** Cooper opened a gallery in Laurens in September 1871, advertising quality photographs at prices "reduced to suit the times." He located in the former site of Wren & Wheeler. His ad concluded: "Think not these pictures by the sunlight made— Shades though they are—will like a shadow fade; While beauty's on the cheek, and lustre in the eye, Secure the shadow e're the substance fade and die." In 1872 Cooper returned to Laurens and briefly operated a studio. Four years later Cooper, presumably "W. H.," again produced pictures in town for a short time.[109]

**L. M. PARSONS.** In 1872 Parsons advertised in the Laurens paper a three-week stay with his "car" at Highland Home. Highland Home was a crossroads village about three miles from Laurens. After three weeks he moved to the residence of Mr. John Lanford, about three miles north of the village of Scuffletown and about eleven miles north of Laurens. In both of these Laurens District locations he advertised the production of ferrotypes.[110]

### Lexington

**H. L. P. HARMON.** Harmon opened his business on Main Street near the courthouse in July 1872 and probably operated his gallery until October 1874. At that time he advertised a new studio in Columbia, thanking the people of Lexington for their patronage. A few examples of his work produced in Columbia have turned up, but none from Lexington are known.[111]

*Marion*

**R. B. McLean.** McLean opened a gallery in Marion in July 1873, advertising seven years experience at that time. During 1875 he continued to advertise his gallery in the local paper. Later in the 1870s, a Mr. Smith joined McLean in the Marion gallery. A few cartes de visite of McLean & Smith are known.[112]

In 1905 McLean advertised his return to Dillon at Hamilton's Gallery and requested patronage, having photographed parents and grandparents of local people. In 1908 McLean operated a photographic studio and watch repair business. He guaranteed his photographs at his studio next to the Dillon post office in 1910. McLean apparently conducted a photographic business in the Pee Dee for forty or more years.[113]

**M. M. Ferguson.** By April 1866 M. M. Ferguson operated a gallery in Marion, but a carte de visite dated March 1869 is the first example found of his work. A few other cartes are known, but they do not indicate how long he operated in Marion.[114]

*Newberry*

**C. W. L. Teague.** Teague, a traveling photographer, operated in Newberry for a few weeks in 1867 with his "Ambrotype Car," producing ambrotypes and melainotypes.[115]

**M. Crine.** For a short time in June 1867 Crine produced ambrotypes and ferrotypes from a gallery over Mower's Store on Main Street, the former location of Kingsmore.[116]

**W. H. Wiseman.** By February 1868 Wiseman operated a gallery at the Mower Store location where he advertised "Good and Lasting Work." The economic conditions after the Civil War were hard, and this fact is reflected in Wiseman's offer to accept "nearly all kinds of provisions that you may bring in payment for work."

For the next nine years Wiseman advertised his gallery in the local paper. In 1870 he operated from a gallery over Mayes & Martin's. In 1875 he reported "having just returned from the northern cities, and the National Photographic Association at Buffalo, I feel better prepared to do photographic work than ever before. . . ." He produced portraits as ferrotypes and cartes and produced pictures of local buildings. Wiseman advertised not only photographs, but also "Albums, Fancy Picture Weights, etc." While in Newberry Wiseman worked for a short time as partner with a Mr. Langston, probably T. J. By 1877 Wiseman had been succeeded by J. D. Bruce.[117]

Wiseman operated for about ten years and had the next gallery, after that of Kingsmore in Newberry, that is classified as a "permanent" one. Many of his identified cartes of individuals are known, but other types of Wiseman photographs are scarce.

**J. D. Bruce, James Packer, and William A. Clark.** In March 1877 J. D. Bruce advertised himself as the successor to W. H. Wiseman. In about one year he had sold out to James Packer who continued the studio for about a year before he was succeeded by William A. Clark. Bruce, Packer, and Clark all operated from "Wiseman's Old Stand." Clark sold out to J. Z. Salter in November 1882 and moved to Florida. Ten years later he was reported in Missouri.[118]

### Oak Grove

**E. E. Tart.** In 1880 Oak Grove, in Marion County, was the location for Tart's photographic gallery. In the only example seen of Tart's work, he advertised himself as a photographic artist.[119]

### Orangeburg

**C. M. Van Orsdell, Jr.** Van Orsdell practiced photography in Wilmington, North Carolina, before appearing in Camden in 1879 and 1880. As an itinerant photographer he also visited Spartanburg and Chester. He located in Orangeburg in 1881 and advertised a gallery two years later on Russell Street. He remained in business in Orangeburg until about 1916, a period of more than 30 years.

*A selection of Van Orsdell backmarks appearing on 19th century cartes de visite and cabinet photographs. SCL.*

An 1884 account provided this description of Van Orsdell and his gallery:

> He is a Virginian, son of the well known photographer of Wilmington, N. C., just dead, and for many years Vice President of the National Photographers Association. He has been in business now ten years, having learned the profession with his father, and settled three years ago in Orangeburg. After a tour of the state, staying at Spartanburg, Chester and Camden, he returned here last fall and has furnished his studio with modern improvements, including two of the costliest operating instruments in use. The premises consist of dressing, waiting and operating room, 15 × 25 feet, with blue light, 10 × 15 feet, printing room, silver and dark rooms, etc. He has just made a purchase of handsome showcases in Baltimore. For his workmanship he has several times received diplomas at Baltimore and Philadelphia. He enjoys an increasing patronage, and callers will find him attentive to their wants.[120]

A cabinet photograph by Van Orsdell, dating to about 1890, listed his address as Amelia Street. In Orangeburg he produced thousands of quality cartes and cabinets of people from the area. He advertised in 1911 photographs of residences, animals, and family groups, but these are seldom found. Van Orsdell never completely gave up his itinerant work, but visited

*Cabinet of an unidentified man featuring an elaborate backdrop, produced by C. M. Van Orsdell, Jr. Collection of the author.*

*A cabinet by C. M. Van Orsdell, Jr. of a Miss Smith that portrays a growth on her head. Collection of the author.*

*Cabinet photograph of a couple seated in a buggy (circa 1900) by C. M. Van Orsdell, Jr. Stokes family, SCL.*

other towns such as Timmonsville in 1911 and St. Matthews in 1911 and 1916. A carte de visite in the author's collection indicates he also operated a studio in Bamberg about this time.[121]

By the early 1890s O. B. Rosenger operated a gallery in Orangeburg. A cabinet photograph from that period indicates Rosenger and Van Orsdell were in business together for a short time.[122]

### Pleasant Mound

**R. L. Fowler.** Fowler produced photographs in 1866 in Pleasant Mound, a small village located in Laurens District, South Carolina. He probably was an itinerant working in that area of South Carolina at the time.[123]

### Seneca

**W. A. Fredericks.** During the first decade after the Civil War W. A. Fredericks opened a gallery on Townville Street just below Bergen's Store and operated it to 1900 or later. Fredericks' portraits and views of homes are in collections.[124]

### Spartanburg

**S.C. Mouzon and Mouzon & Cook.** Prior to the Civil War Mouzon operated a studio in Charleston, but relocated to Spartanburg and opened a gallery there in 1865.

*Photograph of "Innisfallen" by W. A. Fredericks. Courtesy of SCL.*

An 1884 account indicated:

> Mr. Mouzon has been long engaged in the photographic business. He for some time was in the famous Kurtz gallery in New York, and before the war was established in Charleston on King Street; during the war he settled in this county on account of having been taken with typhus fever while serving as third sergeant with the Moultrie Guards. At the cessation of hostilities he started on some thirty dollars, but soon built up a large trade and improved his gallery, which is now appointed with all the latest and most expensive apparatus and conveniences for the business, in the prosecution of which he uses entirely the instantaneous process. Mr. Mouzon is also a painter, was some time apprentice with D. L. Glenn, and executes very fine sketches in both water and oil from life or from photograph. His gallery is located on the public square, and occupies 25 × 80 feet flooring. He employs two hands, the senior most promising and of marked ability.[125]

Mouzon worked in Spartanburg until at least 1894. Many cartes and a few cabinets are extant. One cabinet indicates he was in business for a time with a Mr. Cook at 38 Main Street. Cook may have been one of the "hands" referred to in the 1884 account. In 1893 He referred to his business as Mouzon & Co., indicating he had at least one other person in the business.[126]

*Carte de visite of the Spartanburg Female College Faculty (circa 1868), produced by S. C. Mouzon. SCL.*

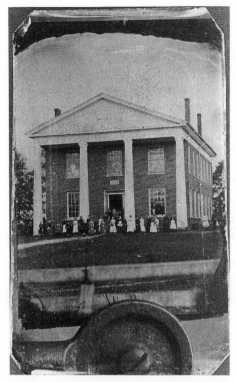

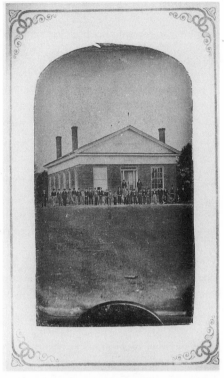

*Tintype of the Reidville Female College*
*attributed to S. C. Mouzon. SCL.*

*Tintype of the Reidville Male Academy*
*attributed to S. C. Mouzon. SCL.*

### Sumter, Mayesville, and Wedgefield

**H. B. McCallum.** McCallum, operator of a studio in Camden prior to and during the early part of the Civil War, opened a gallery in Sumter in 1866. His business lasted until 1869 when he sold out to Wilder & Wheeler. McCallum produced cartes, ferrotypes, and ambrotypes. He also advertised the production of ivorytypes.[127]

*Backmark used by McCallum.*

**Wilder & Wheeler and James D. Wilder.** The firm of Wilder & Wheeler, who purchased H. B. McCallum's studio, dissolved their partnership by June 1870, but James D. Wilder continued the business at the same location. Wilder was an accomplished photographer as witnessed by the opinion of the local press: "His nonpareil pictures are simply superb. He has one which is a perfect gem. . . ." By 1878 the studio location of Wilder was occupied by another and he had apparently left the photographic business. A number of Wilder photographs are known.[128]

**R. H. Fulghum.** Fulghum worked as an itinerant photographer and made two stops at villages in Sumter County; one at Mayesville in August 1873 and another at Wedgefield in September of that year.[129]

**E. L. SPENCER.** Spencer operated a gallery for a short time in 1878 from McCallum's old location. He advertised "Photographs, porcelains, Ferrotypes, Ambrotypes, and all other kinds of Pictures, taken in the latest styles of the art." He further advertised his services for retouching and restoring oil paintings.[130]

### Walhalla

**H. S. TROTTER.** In July 1870 Trotter advertised that he would be leaving Walhalla in a few days and those wishing a "Good Picture" should call on him.[131]

### Winnsboro

**VAN NESS & BRO.** In 1867 Van Ness and his brother operated a gallery from rooms in the Thespian Hall in Winnsboro. The Van Nesses apparently were itinerants as they appeared in other towns in the late 1860s and early 1870s. For example, in 1871 J. H. Van Ness advertised a "New Sky-Light Photograph Gallery" in a brick building near the courthouse in Chester.[132]

**A. BAUMGARTEN.** Baumgarten opened an "Art Gallery" for the production of "Photographs, Ivorytypes, Porcelains and Ferrotypes" in May 1873. In February 1874 he advertised the closing of his gallery, left for a few months, and then returned for a short time in June.[133]

**WILLIAM M. HARDIN.** Hardin purchased the gallery of A. Baumgarten in October 1874. How long Hardin remained in business has not been established, but several cartes de visite produced by him are known.[134]

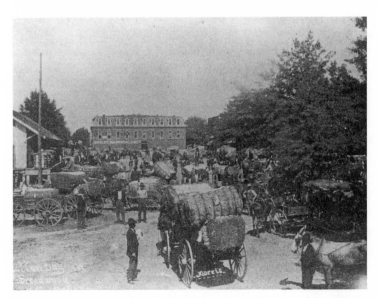

*Photograph by A. A. Morris of "Cotton Day in Greenwood," copied from* The Exposition, *vol. 1, no. 10.*

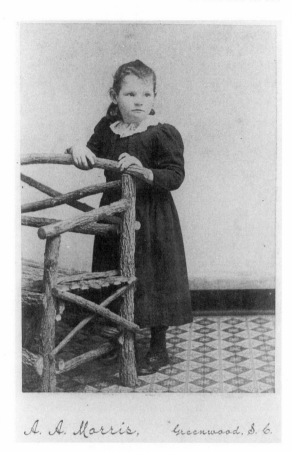

*Cabinet of Merrell Jordan (circa 1886),
produced by A. A. Morris. SCL.*

**Amos A. Morris.**  Morris opened his gallery in the Thespian Hall in February 1875 and produced cartes, cabinets, and ferrotypes for about six years. In 1877 he also operated an hotel. Although he apparently returned to Winnsboro as an itinerant from time to time, he moved to Greenwood and operated an "Art Gallery" there. In 1908 his studio was at 443½ Main, but by 1912 his son had joined the firm at 326½ Waller Avenue. Their studio was not listed after 1916, but a Paul Morris did operate a gallery in town from 1936 to 1939 at 406½ Main St. Many examples of the Morris Studio work are known both from Winnsboro and Greenwood.[135]

### Yorkville

**John R. Schorb.**  Schorb reopened his gallery in October 1865 and advertised he was "prepared to take ambrotypes and photographs at lower prices than before the war." In June 1866 he advertised "I am now devoting my whole time and attention to photography." J. R. Schorb associated his son, George T., into the Yorkville business in June 1869. They operated a gallery together in Chester for a time, but by November 1874 George had taken over that gallery and operated it on his own. In 1884 the elder Schorb sold sewing machines

*A selection of backmarks of John R. Schorb and John R. Schorb & Son appearing on 19th century cartes de visite and cabinet photographs. SCL.*

in addition to operating his photographic gallery. Schorb continued his Yorkville gallery until shortly before his death in 1908, and on his ninetieth birthday that year he worked a full day in his studio. Although a quiet man and not inclined to politics, Schorb was active in his church and community.[136]

After his father's death George T. Schorb apparently reopened his father's gallery or opened another one in York. In 1910 he advertised "satisfactory photographs at reasonable prices" and Lester pianos for sale. After 1910 Schorb disappeared from photographic production in York, ending a fifty-seven year association.

*Scenic view by John R. Schorb of a rural area near York. SCL.*

The elder Schorb and his son produced a tremendous number of photographs over sixty-four years and the thousands that survive attest to their quality. In addition to these thousands of works, one of the Schorb cameras and more than a hundred of their glass negatives have also survived.

# Halftones, Printing, "Kodakers," and Photographs, 1881–1900

Technical advances occurred during this period that affected photography. The halftone process perfected in 1880 produced a demand for more photographs, increasing the volume of business and profitability for those pursuing photography.[1] As these two decades unfolded, more and more photographs appeared in books, magazines, and other printed matter. Four books of this era contain noteworthy printed photographs of South Carolina subjects.

*Art Work of Charleston,* published in twelve parts by the W. H. Parish Publishing Co. of Chicago in 1893, was sold by subscription. No complete sets were located, but based on the number of photographic prints in five parts of one set examined, the set of twelve contained more than 100 pictures of buildings and scenes.[2]

W. H. Parish published *Art Work of South Carolina* in 1895 and, like their 1893 publication, it appeared in twelve installments, contained more than 100 pictures of buildings and scenes, and was sold by subscription. R. Means Davis, a professor at the University of South Carolina, authored the introduction.[3]

*Printed photograph of the reading room of the South Caroliniana Library.*
*Copied from* Art Work of Columbia, *1905, Part 8. SCL.*

*Government Diversification Farm no. 1.* Art Work of Columbia. *SCL*

The Gravure Illustration Company of Chicago published and sold *Art Work of Columbia, South Carolina* in 1905 and *Art Work of Piedmont Section of South Carolina* in 1920. This Company may have been a continuation of the W. H. Parish firm since these two works are similar in many respects to those of Parish—they include photographs of scenes and buildings and were sold by subscription. South Carolina newsman August Kohn wrote the introduction to the 1905 work. That work contained eighty-two photographs and the 1920 publication contained one hundred eighty-one.[4]

Another development during this period was the increased use of the gelatin dry plate process in preference to the collodion wet plate process. The George Eastman Company soon monopolized the manufacture and sale of these precoated, presensitized, dry plate negatives that possessed a long shelf life. The dry plate negative process required less preparation and less knowledge and attention to the chemistry of photography, thereby freeing photographers from a number of time-consuming tasks.[5]

When George Eastman began selling his easy-to-use, handheld "Kodak" camera in 1889, amateurs entered the world of "picture taking" in large numbers. This camera, employing a roll of film mailed to Eastman for processing after exposure, meant that photography was now open to the masses and no longer just the domain of professional photographers. Eastman advertised his camera and processing services extensively in national magazines and, before the close of the century, many families used his camera.[6]

Local photographers and others began to offer their services for processing film taken by others. By 1900 the popularity of photography reached an all-time high with family albums, school and wedding pictures, and school annuals becoming fixtures in many homes and communities.

Most people recognized that their snapshots, so easily produced, were not of the same quality as those produced by a professional. The professional was still preferred for portraits and for other subjects and purposes. The spontaneity reflected in snapshots taken by amateurs apparently influenced professional photographers as they appeared to loosen up and produce much more relaxed and natural portraits than those produced previously.

During this period cabinets, ferrotypes, cartes, and stereographs were the chief types of photographs produced by professional photographers. Albums remained in use. The need for large group photographs at weddings, for school annuals, and for various printing purposes created an increase in the number of them produced.

In the early 1880s a number of South Carolina photographers experimented with the production of photographs by electric light. Hermann Leidloff of Charleston advertised photographs produced by electric light in 1884.[7]

The 1890 census reported seventy-five photographers in South Carolina, but by 1900 the number increased to one hundred thirty-four. Recovery from the Civil War, industrialization, and population growth all contributed to this increase. Four female photographers were listed in 1890, but that statistic was not reported for 1900. The census gave no breakdown by states for African Americans in 1890 or 1900, but the national totals were one hundred eighty-six and three hundred forty-two respectively. Five African American photographers were identified who operated in the period from 1865 to 1900 .[8]

Although most studios continued to operate for only a short span of time at any given location, eighteen established during this period operated for ten to forty years.

## Photographers

### Abbeville

**E. T. Hill.** In December 1885 Hill opened a gallery in town and, according to an 1886–87 business directory, continued operating his studio that year. An L. T. Hill operated a studio in Darlington at the turn of the century.[9]

**W. C. Gallagher, Gallagher Brothers, and Gallagher's Studio.** For more than two decades the above listed firms operated in at least six different South Carolina towns. Whether or not these were the same firm or three different ones is not clear, but they probably were the same. The evidence indicates that W. C. Gallagher was one of the Gallagher brothers.

In 1908 Gallagher's Studio advertised in Chester that they "have had 25 years experience in the making of photos," suggesting that W. C. and his brothers had started in business in 1883. In 1890 a newspaper editor in Aiken provided several details about the Gallaghers and their work.

> Aiken is fortunate in having one of the best photographic establishments in the South, conducted by Messrs. Gallagher Bros., formerly of Canada. At their gallery at the corner of Chesterfield Street and Richland Avenue may be seen some speci-

mens of as good work as can be found anywhere. Their pictures are carefully arranged, carefully taken and highly finished, so that they do credit to the most pretentious gallery anywhere. We are endebted to the Messrs. Gallagher Bros. for the photographs from which several of the cuts in this paper were made, and our readers can thus judge of their good work.

In December 1888 W. C. Gallagher advertised he had just returned to Union and was prepared to make Christmas photographs. He apparently visited Union prior to 1888. A cabinet photograph produced by Gallagher Brothers in the early 1890s indicates they operated studios at Abbeville and Union simultaneously. Yet another cabinet indicates Gallagher Brothers simultaneously operated galleries at Abbeville and Spartanburg. They left Abbeville in 1895 and were succeeded by M. V. Lomax who advertised he had Gallagher's negatives. Their time of departure from Union and Spartanburg is unknown.[10]

For at least six months in 1896 W. C. Gallagher operated a studio near J. R. Tolleson in Gaffney that he called the Iron Gallery. Just before Christmas that year he offered his gallery for sale.[11]

By 1898 and 1899 Gallagher Brothers were in Laurens and operated for a few months from L. A. McCord's old stand. By June 1899 Miss Cora Frances Holroyd had succeeded Gallagher Brothers at McCord's old stand.[12]

A. J. Gallagher produced cabinet photographs in Clifton in the late 1890s and may have been the other Gallagher brother. This Gallagher also operated for a time in Rutherfordton, North Carolina.[13]

A number of their works produced at Aiken, Abbeville, Laurens, Gaffney, and Union are known, but no examples produced at Chester have surfaced.

**M. V. Lomax.** In 1893 Lomax opened an Abbeville gallery and two years later bought the Gallagher Brothers studio located over Haddon's Store. He advertised that he would supply photographs from Gallagher's negatives. In 1910 he sold his studio to Orr & Hays and moved to Atlanta, Georgia. While in Abbeville Lomax also operated a studio in Cokesbury.[14]

## Aiken

**Benjamin F. Gunter.** Gunter advertised in the local paper in 1886, "Photographs, Ferrotypes, Groups, Views, Goat Carts, Ox-teams, Negro Babies, Pug-dogs, Pinestraw, and every other kind of picture, corner of Carve & Newberry Sts., Aiken, S.C." Gunter also operated a studio in North Augusta from 1895 to 1897. To date very few examples of his work have surfaced.[15]

**C. D. Hardt.** Hardt was an operator in Palmer's Gallery in March 1896, but by June of that year he advertised his own studio independent of Palmer. He may have taken over the business since Palmer died on 18 June 1896. He remained in Aiken at least until 1900, producing cabinets and group photographs. He also advertised enlarging and copying and that there was no need to go to Augusta for photographs.[16]

*Photograph of members of the Stokes family, produced by M. V. Lomax. SCL.*

BELOW: *Cabinet portrait of Dr. B. H. Teague combining two photographs taken at different stages of his life. Produced by C. D. Hardt. SCL.*

O. N. C℞ipps. Beginning in about 1900 Cripps operated a gallery in Aiken and remained there at least until 1905. A number of his cabinet portraits have surfaced. [17]

### Anderson

A℞fred W. Humph℞eys. Humphreys located a gallery near the Anderson post office in 1887 and operated there for a short time. From 1899 through 1917 he was frequently listed in Augusta, Georgia, city directories as operator of a studio in Hamburg, South Carolina. A small photo of an African American woman named Mittie, dating to about 1910, produced by the "Miniature Portrait Co., Hamburg, S.C.," probably was the work of Humphreys. Several cabinet photographs dating to about 1900 carry the name Humphreys and Piedmont, South Carolina. Apparently Humphreys was an itinerant photographer who maintained a base in Hamburg.[18]

*Photograph of Mittie by the Miniature Portrait Co. of Hamburg, South Carolina.*
*Collection of the author.*

**J. H. COLLINS.** Collins, a native of the Belair community in Lancaster County, first appeared in Rock Hill in July 1888 and advertised "Photographs! In All The Latest Styles and Finish." In September 1890 the firm of Sanborn & Francis advertised they were "Successors to J. H. Collins" in Anderson. Apparently Collins had been in Anderson for a time in early 1890 or late 1889, but had moved on by September 1890. He returned at some point and remained for several years or periodically visited the town. In 1900 Collins operated from a studio on the public square. He advertised in the local papers in 1901 the production of "Oval, Round, Oblong or Square Shapes-or will make you a Picture in any distinctive or particular style you wish. . . . In the first place my photographs are correct likenesses, but they are more than that-the Retouching and Finishing gives them an art value which you can appreciate, and my prices will suit you."[19]

**SANBORN & FRANCIS AND W. K. SANBORN & T. A. BOLT.** Sanborn (presumably W. K.) & Francis were successors in September 1890 to J. H. Collins and apparently operated in Anderson until 1893. By 1893 Francis disappeared from the scene and T. A. Bolt

*Ad for the J. H. Collins Studio.* (Anderson) People's Advocate, *1901. SCL.*

joined W. K. Sanborn. Both businesses also sold books, picture frames, and stationery. By 1899 T. A. Bolt operated a studio in Piedmont where he produced cabinet and card photographs, framed pictures, and processed Kodak film.[20]

**E. M. Snipes.** In February 1892 Snipes operated from a tent on Anderson's South Main Street near the Public Square. He appeared again in 1900, operating from his home near the Orr Cotton Mill, and advertised that he would "continue to make 6 of those nice small card pictures for 30 cents-Just five cents each or 4 cents each by the doz. Other sizes at the lowest figure." In 1905 he hailed from 105 ½ Depot and operated from that location until 1908. In 1909 and 1910 he was at 105½ E. Whitener. Only a few examples of his work are known.[21]

*S. M. Pearson used this backmark and changed the town name when his studio location changed to another town. SCL.*

### Bamberg

**S. M. Pearson.** Several cartes and cabinets produced by Pearson at Bamberg and Leesville dating from the late 1890s are known.[22]

### Barnwell

**Warner.** In 1900 Mr. Warner billed his studio as a temporary one where he would provide a quality product on the spot.[23]

### Beaufort

**Penn School Photographers.** Individuals from the North with concerns about the education and general welfare of freedmen founded the Penn School on, St. Helena Island near Beaufort, in 1862. Operating continuously since that date, the school has educated and improved the lives of thousands of African Americans.

Early on Union photographers Samuel A. Cooley and Hubbard & Mix took photographs of the school, its activities, and its teachers. Beginning in the 1890s and through the 1940s a number of visitors and Penn School personnel took about 3,000 photographs that constitute an historical record of school activities, students, teachers, and school buildings. These photographs remained at the school until they were placed on deposit in the Southern Historical Collection, University of North Carolina, Chapel Hill.

Although the subjects of these photographs were black or black related, all were produced by Northern whites. The majority were produced by twelve individuals, six of whom were women (see p. 310).[24]

### Bennettsville

**W. L. Frambo.** Frambo was listed as a photographer in an 1886–87 business directory.[25]

**J. B. Taylor.** In May 1894 Taylor advertised a new gallery on Depot Street and the production of cabinets at reduced rates. He also offered to enlarge portraits in "Crayon, Water Colors and India Ink."[26]

### Blacksburg

**Daniel Audley Gold.** In 1895 Gold established a studio in Blacksburg that he operated for about five decades. If not from the beginning of the business, at some future point in time he named his business the Piedmont View Company. The South Caroliniana Library collection contains two images produced by the American View Company of Blacksburg, one dated in 1895 and the other with the date missing.

Gold specialized in studio portraits, developing and printing kodak pictures, framing and mounting photographs, and producing photographs of the Blacksburg area. These local subjects included barns, houses, rural farm scenes, African Americans at work or in home settings, street scenes, and picture postcards. During the period from 1906 to 1910 he developed a business in the college community large enough to justify the services of B. F. Massey, Jr. as his agent.

*Photograph of Lemon family and home, located in the Jackson Creek section of Fairfield County. Produced by D. Audley Gold. Courtesy of Tim Lord.*

*Members of the Gold family, SCL.*

*A 1918 invoice of D. Audley Gold for developing, enlarging, and mounting photographs. Collection of the author.*

About four hundred of his glass negatives of Blacksburg and Cherokee County subjects have survived and are presently in the Gold collection at the Historical Center of York County. In 1995 Marion Manheim, through Winthrop University, produced prints from many of these negatives that were subsequently included in an exhibit in Rock Hill.[27]

### Blackville

**Green B. Rich and C. T. Johnson.**  From 1884 to 1886 Rich operated a combination jewelry store and photographic studio in Blackville. C. T. Johnson succeeded Rich in 1886 and operated the studio into 1887, but by 1888 Johnson was in business with Arthur F. Baker in Chester.[28]

**Arthur F. Baker.**  By 1890 Arthur F. Baker operated studios in Blackville, South Carolina, and Hendersonville, North Carolina, and continued them at least until 1900. Probably due to Baker being a native of England, he called his studio the London Art Gallery. A number of Baker's cartes, cabinets, and other photographs are extant.[29]

### Celestia

**E. J. Waits.**  In the late 1880s E. J. Waits billed himself, on the paper holder of one of his tintypes of an elderly man, as a "Travelling Photographer, Celestia, S.C." At that time Celestia was a community in Edgefield County and Waits apparently operated an itinerant photographic business from there.[30]

### Charleston

**Henry C. Searles.**  Henry C. Searles appeared in Charleston at 339 King Street in 1882. From 1886 to 1890 he was at 303 King Street. In 1898 he was at 251 King and was

*Stereograph of Caesar's Head by Arthur F. Baker. SCL.*

listed at that address until 1904. In 1906 he was at 591 King Street in the residential listings of the city directory, but was not listed as the operator of a studio. It is not known if Searles operated a studio from 1891 to 1898 or from 1905 to 1908. However, from 1882 to 1909 he was documented as the operator of a studio for fifteen of those twenty-six years. During this period he produced many photographs, usually portraits, and a number are known from his years at 251 King Street.[31]

**J. A. Calvery.** Calvery was at 174½ Meeting Street in 1888.[32]

**W. T. Johns.** Johns was a photographer at 621 King Street in 1888, but had no other city directory listings. One of Johns's cabinet photographs indicates he operated from 303 King Street—the same location from which the African American photographer J. B. Macbeth worked in 1892, and William P. Dowling, Jr. and W. P. Dowling worked from 1895 to 1914. Johns probably worked at the 303 King Street location from 1889 to 1891 or from 1893 to 1894. Another W. T. Johns cabinet photograph dating circa 1890 bears only his printed name on the reverse, but is accompanied by this manuscript notation: "Photographer from Allendale." Johns may have done itinerant work in Allendale circa 1890.[33]

**William B. Austin.** From 1887 through 1889 Austin apparently worked in one of Charleston's photographic galleries. From 1890 to 1914 he operated a photographic gallery at 310 King Street and at 251 King from 1916 to 1919. Austin called his business Vandyke Studio. One of his 1892 employees, W. D. Clarke, would soon establish and operate a gallery in town.

In 1901 this description of Austin's gallery appeared:

> It is located at 310 King Street and occupies most eligible apartments on the second floor, 20 × 175 feet in area, handsomely furnished. Mr. Austin has been identified with the business for thirty years and is a superior artist of great talent. His gallery is supplied with all modern improvements and appliances and the latest improved methods are brought into requisition in the execution of his artistic work. He does all kinds of photographic work, including portraits, landscapes, interior and exterior of buildings for engraving, etc. He also does crayons, pastel, oil and water color work, and in his studio many fine examples of his work can be seen. He is a dealer in kodaks, photographic apparatus and supplies, being also agent for the Eastman Kodak, the best on the market. Mr. Austin also develops, prints and finishes for amateurs.

Austin produced a photograph some time in 1891 or shortly before of an African American servant named Aleck that justified his advertisement of himself as an "artistic photographer."[34]

**Andreas Savastano.** Savastano, from Naples, Italy, opened and operated a gallery in Charleston from 1892 to 1893 at 269 King Street. He chiefly produced cabinet portraits and stereographs. He advertised children's photographs as one of his specialties. Savastano must have been a teacher since a Professor Savastano was recorded setting up a photo gallery in the Tech School part of Thornwell Orphanage at Clinton in April 1892.

In Charleston, Summerville, and probably other South Carolina towns, Savastano gave stereographically-illustrated lecture "tours" of various United States sites, as well as sites

*Cabinet of William J. McGrath by William B. Austin. SCL.*

*Interior of C. H. Quackenbush's store in Summerville by Andreas Savastano. Copied from the* Pine Forest Echo, *15 July 1892. SCL.*

of Europe, Egypt, the Holy Land, and Japan. While in Charleston he photographed a number of local subjects, including several in Summerville.[35]

The editor of the Summerville *Pine Forest Echo* described Savastano's work in these terms:

> Mr. Savastano is a photographer par excellence, with the soul of a true artist, not merely satisfied with the reflected image of the object in the photograph, but determining to obtain a perfect mastery over the lights, shadows and the entire technique of the pictures, which, to come up to his standards, required many tedious trips during the hot days, but the very beautiful results repaid his labor and trouble. If [Sullivan's] Island residents or visitors desire souvenirs, they will be delighted to purchase some of these lovely views, which Mr. Savastano has mounted prettily. Some of these were taken from the steamer. Just a single flash from the Kodak, occupying a second of time, and behold! a beautiful, sharply outlined and perfect photograph. The views from the steamer are particularly attractive, showing a graceful sea gull fluttering over the waving waters.[36]

**R. ACHURCH (AMATEUR PHOTO SUPPLY COMPANY).** This description of Achurch's business appeared in 1901:

> The leading establishment of its kind in Charleston is the well known Amateur Photo Supply Co., the popular headquarters for photographic requisites on this city. The business was established some eight years ago by Mr. R. Achurch, a native of England, and one of the most skilled engravers in this country. The premises occupied consist of the entire second floor at 251 King Street and are admirably fitted for all requirements of the business. Herein is contained a most complete line of photographic supplies, Kodaks, camera, Vive Camera Co., Cyclone Camera Co. and the Ray Camera Co., all standards of excellence. He makes a specialty of developing and painting for amateurs and also does all kinds of general engraving. He is enterprising and honest and has gained success by meriting it.

Although not his primary business, Achurch also produced photographs.[37]

**WILLIAM D. CLARKE.** Clarke was born in Scotland, but little is known of his life and activities before he came to Charleston. He first appeared photographically in Charleston as an employee of William B. Austin, but by 1894 operated his own studio. From 1894 to the beginning of World War II his studio was a fixture in town. He began at 265 King Street, but had moved to 301 King by 1897 and remained at that location for the next forty-four years.

In 1895 Clarke advertised "I make every desirable picture known to photography and invite critical inspection of my work." He advertised portrait and landscape photographs. In an 1896 Confederate veterans' reunion guide to the city of Charleston, Clarke invited veterans to "Go to Clarke, The Peoples Popular, Pushing, Progressive Photographer. Photographic Views of Charleston, Fort Sumter, Fort Moultrie, etc." Many fine Clarke cabinet portraits and other types of photographs are found in South Carolina albums and collections today.

A 1912 account perhaps best described Mr. Clarke's work:

> For artistic and general excellence the studio of Clarke, at 301 King Street, near Liberty, cannot be surpassed anywhere. This studio, handsomely and elaborately fitted up is equipped with the most modern instruments of the photographers art, and the general excellence of the work turned out is doubtless due in some measure to this as well as to the cleverness of the directing manager. Clarke has been called on to do some of the most important work ever done in this city, his outdoor efforts being especially commendable. He has had marked success also in photographing babies, the surest test of an artist's skill, and his character studies have won wide applause. Appointments can be made by telephone, number 338, in person, or by letter. There is no better photographic studio in the South than Clarke's.[38]

**WILLIAM P. DOWLING, JR.** Dowling was first recorded producing photographs in 1895 at 303 King Street, the address of H. C. Searles' gallery in 1894. A sketch of Dowling in the late 1890s referred to him as "The Baby Taker" and gave the following description of his work:

> Charleston's own photographer is one of the best, if not the best, that we have ever seen, and in all work requiring the greatest skill he is always selected. His studio

W. P. Dowling, Jr.

**303 KING ST.**

**THE BABY TAKER**

Charleston's own photographer is one of the best, if not the best, that we have ever seen, and in all work requiring the greatest skill he is always selected. His studio is called "**The Electric**," because it is the finest equipped of any in the South. Fans to keep you cool in summer, and well heated in winter. The operating room is furnished with everything that a thoroughly up-to-date atelier requires; lenses from the highest grade European manufacturers, carefully selected, to do every special work demanded from them is only used by him. Being a thorough artist, he creates backgrounds and special effects adapted best to the sitter.

*Picture and ad of William P Dowling, Jr. copied from* The Resources & Attractions of Charleston, S. C. *SCL.*

*Photograph of the Administration Building under construction at the South Carolina Inter-state and West Indian Exposition, produced by William P. Dowling, Jr. The Exposition, vol. 1, no. 3. SCL.*

*Dowling often applied this red and green advertising sticker on the reverse of his photographs. Collection of the author.*

is called the "*The Electric*," because it is the finest equipped of any in the South. Fans to keep you cool in summer, and well heated in winter. The operating room is furnished with everything that a thoroughly up-to-date atelier requires; lenses from the highest grade European manufactures, carefully selected, to do every special work demanded from them is only used by him. Being a thorough artist, he creates backgrounds and special effects adapted best to the sitter.[39]

In 1901 and 1902 the South Carolina Inter-State and West Indian Exhibition was held in Charleston. Dowling was the "Official" photographer for this event and published a souvenir pamphlet containing photographs of the buildings and grounds. Other Dowling photographs of building interiors showing exhibits are also known.[40]

After 1904 Dowling dropped the "Jr." He operated from 303 King Street until 1914 when he was shown at 315 King. He was not listed in the 1916-17 local directory, but showed up at 267 King in 1918.[41]

William P. Dowling next appeared in Greenville in the Vickers-Cauble Building in 1923 and continued at that address until 1928. From 1930 to 1945 the Dowling studio was listed at 320 N. Main, but by 1937, Mrs. Julia A. Dowling had succeeded her deceased husband in the business.[42]

*Photograph reported to be of
William P. Dowling. Coxe Collec-
tion. Courtesy of Greenville
County Historical Society.*

In 1928 and again in 1931 William Preston Dowling advertised "over 25 years experience" in photography. These ads could reasonably support a 1904 beginning date for Dowling, but would be a stretch for an 1894 one. Perhaps William P. Dowling was the son of William P. Dowling, Jr.[43]

Information on Dowling in Greenville is somewhat spotty, but an ad in 1931 provides some interesting details about his career. "Mr. Dowling is recognized as an artist on three continents, and his works have been exhibited over the entire civilized world." [44]

In 1934 Dowling wrote:

> The nearest approach to one's self is a portrait-that is, a composite representation of the best expression, made from the advantageous view point, properly lighted to produce the roundness, character and texture differing in persons. A picture to take the place of anyone who is absent, to be satisfying, should be a portrait.
>
> Those of the highest intelligence realize the difficulties in producing such a counterpart by any art or process, and see how few really good pictures exist; therefore, they appreciate their value sometimes beyond the sentiment expressed.
>
> It will pay everyone to have the best picture produced, rather then a "cheap" photograph made by someone ignorant of the fundamentals of good portraiture. There are literally thousands who have realized the above mistake too late to correct their mistake.

*Photograph of a 1923 college football team, probably Furman's, taken by W. P. Dowling. Coxe Collection. Courtesy of Greenville County Historical Society.*

It may be better to have a poor epitaph on one's tombstone than to leave a bad representation purporting to be your portrait.[45]

**DAVID H. BAHR.** From 1898 to 1917 Bahr was a photographer at 75 Columbus Street.[46]

**HARPER & CO.** In 1898 this national firm located one of their many studios in Charleston at 251 King Street and placed Herbert B. Hermann in the position of manager. Hermann was probably the photographer and manager. Only a few cabinets produced by this studio are known since they apparently operated for only one year.[47]

**FRANKLIN FROST SAMS.** In the 1890s and the early 1900s this Charleston physician and amateur photographer produced several hundred photographs of places in Charleston and the vicinity. More than 500 of his glass negatives are in the Charleston Museum collection today.[48]

**GEORGE W. JOHNSON.** Operating a hat business and, later, manufacturing and repairing umbrellas were the primary sources of income for Johnson. However, as a hobby, for about fifty years he produced photographs of local buildings, streets, doors, gates, walls and scenes characterized by a Charleston reporter as a "Living Record of the Past." Johnson did on occasion sell copies of these photographs to tourists visiting Charleston. Several years

after his death in 1934 about 1,000 of his glass negatives were given to the Gibbes Art Gallery by members of the Johnson family, and in March 1964 the gallery presented an exhibition of photographs made from them.[49]

### Cheraw

**L. H. FEASTERMAN.** Feasterman was listed as a photographer in an 1890 business directory.[50]

### Chester

**A. F. BAKER & D. T. JOHNSON.** These two gentlemen appeared in a business directory as photographers in Chester in 1886. Several good quality cartes produced by them, one dated in 1886, are in the Knox-Wise family album at Winthrop University.[51]

**W. H. RIGGSBEE.** Riggsbee exhibited photographs in competition in the Chester fair in 1881.[52]

**J. B. DeHERRADORS(DORA).** In 1882 DeHerradors took the honors for the best display of photographs in the Chester fair. It is not clear that he operated a gallery in Chester at the time, however. This becomes even more problematical when we find a Mr. DeHerradora listed in Winnsboro in 1886 as a photographer.[53]

**O. J. RADER.** Rader advertised closing his Chester gallery in March 1898. He advertised his Charlotte, North Carolina, gallery in 1900 and 1902 newspapers from Fort Mill, South Carolina. Apparently his base was Charlotte, from which he periodically traveled to nearby South Carolina towns and took photographs.[54]

### Chesterfield

**(A. W.) W. A. DAVIS.** In their 1900 business directory Young & Co. listed A. W. Davis in Chesterfield. This may have been a reference to W. A. Davis of Lancaster.[55]

### Clifton

**S. U. USSERY.** A circa 1900 cabinet portrait bears the wording "S. U. Ussery, Photographer, Clifton, No. 3, S.C." Clifton No. 3 was a textile mill in that town.[56]

### Clinton

**J. FERDINAND JACOBS.** "Jacobs has opened his art gallery and is fully prepared to make you any kind of a picture you may desire, from the cheap ferrotype to the most artistic photograph. It is only necessary to say that he learned the art from that veteran, Capt. John Wren."[57]

In August 1887 Jacobs opened a gallery in the Fowlers Block of Laurens that he called the Elite, but advertised his departure in August that year.[58]

*Columbia*

**J. P. HOWIE.**  At an early age J. P. Howie came to Columbia from North Carolina. Because he was listed as a photographer in 1888 and 1891, but had no studio address listed, he probably was employed in a local studio such as Reckling or Hennies. By 1895 Howie established his own gallery at 1511 Main Street and remained there until 1915. W. H. Lyles, Jr. operated from this address in 1916 and probably had bought out Howie.[59]

Howie, an energetic businessman, sought customers locally and in other towns by advertising in the newspapers. For example, in 1898 he advertised his Columbia studio in the *Kingstree County Record.* In 1899 Howie advertised photographs and portraits in "Aristo,

*Cabinet by J. P. Howie of Herbert Dunlap in his cadet uniform. SCL.*

*Photograph by J. P. Howie of the Coca-Cola Bottling Plant in Columbia. Copied from "Columbia, 1912, Special Souvenir Number," Columbia Daily Register. SCL.*

Platinum Carbon, Crayon and Pastel." He further stated he had been "Awarded a prize by the Photographers' Association of America in convention at Celoron, New York, July, 1897." A picture of Howie's studio appeared in the 1899 *Garnet and Black*.

In 1900 Howie journeyed to Greenwood to assist A. A. Morris in his studio for a short time. Morris advertised in the local paper: "A very rare opportunity is offered the people of the city and county to have their picture made by The Best Photographer in South Carolina. . . . Mr. Howie seldom finds time to leave his business in the city, but kindly consented to help me during Reunion Week and I trust the people of Greenwood will appreciate the opportunity, as it cost something to induce him to come. See specimens of his work at the gallery."[60]

A description of Howie's Studio and work was contained in a magazine titled "Columbia, 1912, Special Souvenir Number, Columbia Daily Record."

> Among the masters of the photographic art in Columbia, one of the best known is J. P. Howie, whose studio is located at 1511 Main Street, under the name of Howie's Studio. This business was founded sixteen years ago, and in that time he has won a reputation second to none in the state. His present quarters, consist of a handsomely furnished reception room, dressing room, operating room and two work rooms, with necessary dark rooms, etc. They are fitted with the latest and most approved appliances for the conduct of his art, including retouching desks and the latest cameras. He does a general photographic business, including slide construction, and commercial work. A specialty is made of Sepia work. Mr. Howie, the proprietor, is a native of North Carolina, who moved to this city when quite young. He has spent the greater part of his business life in this line, and is in every way a splendid workman. Believing that the satisfied patron is one of the best

advertisements in any business, Mr. Howie never allows poor work to leave his studio. As an example of his work, most of the photographs for this magazine were taken by him.

Howie's photographs in this magazine included dozens of portraits, street scenes, buildings, and interiors of businesses. In 1904 Howie also provided a number of the photographs appearing in an illustrated book on Columbia.[61]

The volume of business Howie generated required him to employ other photographers. In 1899 and 1903 Albert L. Rawls worked for Howie and Frank P. Scully was employed by him in 1904.[62]

**L. L. WATERS.**  Waters was listed as the operator of a studio at 180½ Main Street in 1893.[63]

**RAWLS BROTHERS.**  Albert L. Rawls first appeared in Columbia in 1899 as an assistant to J. P. Howie and was again so listed in 1903. His brother, Eugene B. Rawls, was an assistant to George V. Hennies in 1903. By 1904 the brothers had opened a studio at 1615 Main Street. In that year the following description of their business appeared in a Columbia publication:

> The proprietors of this beautiful studio are messrs. E. B. & A. L. Rawls. Mr. E. B. Rawls, operator for the firm, has gained his artistic experience with Northern artists, in whose studios he has been previously employed. Though but a new firm here, the artistic merits of their work has attracted unusual attention. Their studio includes six rooms, all of which are handsomely furnished and equipped with the most modern appointments. A visit to their studio will convince any one of this fact, and as Portrait Photographers they are unsurpassed. Their trade is derived from among the best classes of people, not only in the city, but the surrounding country as well, all of whom are enthusiastic in their praise, and express genuine satisfaction at the good results obtained in every instance.

Rawls Brothers continued at 1615 Main Street until 1912 when they operated from 1435 Main Street, remaining there until about 1915.[64]

*Artwork used by Rawls Bros. on their photographic envelopes for storing negatives. Collection of the author.*

*Cabinet by the Radcliffe Studio of the Nolan family. SCL.*

**GEORGE B. RADCLIFFE & LEWIS J. RADCLIFFE.** Since these two men occupied the same residence it is assumed they were brothers or father and son. George B. Radcliffe was listed as an assistant to W. A. Reckling in 1891 and 1895, but probably worked for him the entire time. In 1898 the Radcliffe Photographic Studio operated from 1434 Main Street. Louis J. and George B. Radcliffe were both listed as photographers in 1899, but without a studio address. A circa 1900 cabinet portrait of a man, woman, and child, bearing the inscription "Radcliffe, Columbia, S.C.," survives.[65]

### Crosbyville

**W. W. CROSBY.** Crosbyville was a small village located near the Fairfield County line about ten miles south of Chester. A cabinet photograph of a woman and four children dating from around 1900 and a few other photographs produced by W. W. Crosby are known.[66]

### Cowpens

**INGRAM & WILLIAMS.** In December 1894 these two gentlemen advertised galleries in both Cowpens and Gaffney.[67]

### Darlington

**MR. MOSS.** A "Mr. Moss" was reported to have done "a good business" in Darlington in late October and early November 1889. He was in Sumter in November 1889. He apparently was an itinerant at that time.[68]

**EARNEST A. SMITH.** Smith's dates of operation are unknown, but a number of cabinets he produced suggests the 1890s. One cabinet is of J. W. Kennedy, a delegate to the South Carolina Constitutional Convention of 1895. This photograph is one of a large collection of photographs of delegates to this convention assembled by the newspaper editor August Kohn. The cabinets produced by Smith that have survived indicate he had a first rate gallery.[69]

**E. W. SUTTON.** In April 1892 Sutton encouraged those who want "High-Class Photographs" to go to his studio in the Hewitt Block. He advertised the production of both portraits and landscapes and was listed in a business directory with a studio in Darlington in 1900. For a time Wilcox was in partnership with Sutton. A number of Sutton's cabinets are known.[70]

**L. T. HILL.** By 1900 Hill was operating what appeared to have been a first class studio as witnessed by a photograph made of it in late 1900 or early 1901. A description of his studio was also carried in *The Exposition,* a publication of the Charleston Inter-State and West Indian Exposition. "Mr. L. T. Hill's Photo Studio is the best of its kind that has ever been situated here. Mr. Hill has a natural aptitude for the business and he has equipped himself fully with modern facilities. His studio is neat and tasteful in its arrangement and he sends out good work always. All the cuts for this article were made from photographs by Mr. Hill and they show that he knows his business."[71]

**DARLINGTON ART GALLERY.** A number of cabinets, one of which is dated 1898, carry the wording "Darlington Art Gallery, Darlington, S.C.," but do not mention the photographer's name. This gallery could have been that of Smith, Sutton, or Hill.[72]

*Photograph of a Darlington business block, produced by L. T. Hill. Copied from* The Exposition, *vol. 1, no. 1.*

*Copy print of photographer
Warren K. Hamilton at his
retouching table. Courtesy of
Mrs. H. R. Wyman.*

## Dillon

**WARREN K. HAMILTON.**[73] Hamilton's first introduction to photography occurred in 1884. He had graduated in dentistry from Campbell College and was working in his uncle's dental office located across the hall from a photographic studio. As he observed this photographer at work he became enthralled with the art of "picture making," gave up dentistry, opened a Dillon studio, and worked as an itinerant photographer for at least twenty years. During this time he processed film other photographers brought to him. He married Jessie Gasque of Marion in 1888 and became the postmaster of Dillon in 1895, serving in that capacity until 1897. He moved to Marion in 1904 and opened a studio there, but maintained the Dillon studio until at least 1906.[74] From 1909 to 1912 he operated a gallery in Conway, but presumably continued his Marion gallery during this time.[75]

In 1918 Hamilton opened a studio in Florence. His daughter, Jessie Gasque Hamilton, continued the Marion gallery until she graduated from high school in 1919. He operated his Florence studio from several locations: 6 Barringer Building from 1918 to 1923, 121 Gregg Avenue in 1923, 150 A West Evans from 1924 to 1925, and 106 N. Dargan from 1929 to 1937.[76]

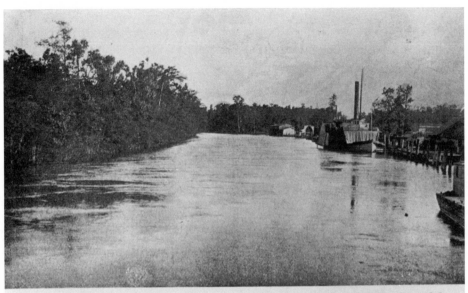

WACCAMAN RIVER AT CONWAY S. C., HORRY CO.                    Pub. by W. K. Hamilton, Conway, S. C.

*Copy print from a 1909 picture postcard, published by photographer Warren K. Hamilton, showing a docked steamboat on the Waccamaw River at Conway. Note the word "Waccamaw" is misspelled. In the flood of 1999 this entire area was under water. Collection of the author.*

*The original camera used by many of the Hamilton family photographers. Courtesy of Mrs. H. R. Wyman.*

Warren Hamilton hired itinerant photographers who photographed in the area but brought their film to him, usually on a Friday, for processing. He also developed a business arrangement with local drug stores who accepted film from amateurs and shipped it to him for processing.

Warren Hamilton operated his Florence studio until suffering a stroke in 1937. His son, Hubert S. Hamilton, took over the studio until his sister, Jessie, bought him out in 1947 and combined his studio with another she began in Florence in 1944. Hubert concentrated on commercial photography and Jessie on portrait work. The senior Hamilton died in 1938.

W. K. Hamilton was a photographer for fifty-two years in at least four towns: Dillon, Conway, Marion, and Florence. Other photographers worked for him and he processed their film as well as film taken by amateurs. His firm was continued by family members until 1985, creating a one hundred year photographic legacy in the Pee Dee. By the time the studio closed in 1985, at least three daughters, a son, a son-in-law, a niece, and a granddaughter had worked in the business.

## Duncan

**J. R. THOMAS.** Thomas was listed as a photographer in the 1896 Spartanburg city directory in a section for the village of Duncan.[77]

## Earhardt

**J. B. JONES.** A single Jones cabinet dated August 1896, of a group of about thirty individuals, was the only evidence found of his gallery.[78]

## Florence

**FARRELL & EDWARDS** A few cabinet portraits from the 1890s constitute the only record of their gallery. Andrew J. Farrell and William D. Edwards (Farrell & Edwards) did operate galleries in North Carolina from 1886 to 1900.[79]

**T. M. ROYALL.** Royall advertised his gallery over Gregg and Lynches Drug Store in January 1895. He touted "Fine fancy scenery for all positions. Copying and enlarging a Specialty. Crayon, Pastelle, Water Colors, Enameled Bromide, life-like from locket size up to life-size portraits." At some point in the 1890s, probably prior to 1895, he operated a gallery in Marion.[80]

**S. N. DAVIS.** A 1900 business directory listed S. N. Davis.[81] Perhaps this was the son of the Lancaster daguerreotypist of 1854, S. N. Davis.

**MERENE D. HARLLEE.** Harllee began his business in Florence in 1900 and operated it from his Evans Street studio for the next quarter of a century. For many years his was the preeminent gallery in town and produced the photographs for the *Florentine,* the Florence High School annual. In 1914 a New York City magazine carried a detailed description of Harllee's Studio, including a photograph of it.

On the fashionable and much frequented thoroughfare of West Evans Street, at No. 40½ is located the studio of one of the most eminent photographers in South Carolina. The Harllee's Photographic Studio, of which M. D. Harllee is proprietor, which was founded in 1900, has always displayed a keen sense of competitive energy, and has constantly added to its resources and producing powers, keeping pace with the increasing demands of a fashionable and truly critical patronage. In this way Mr. Harllee has obtained a degree of success that is, however, only consistent with his enterprise, and the high standard of perfection to which he has bought the art of photography. The premises occupied are commodious, being 25 × 100 feet in dimensions, artistically arranged, and admirably equipped in every respect. Photography in all its branches is here executed with consummate skill and in carte-de-visite, cabinet, panel work, water colors, pastel, crayon and sepia work, the productions of this gallery are unrivalled for beauty and superior workmanship. Mr. Harllee was awarded the silver medal at the Charleston exposition in 1902, for excellence of work. Outdoor and commercial photography also constitutes a most important item in the operation of the establishment, and some splendid specimens of group work can here be seen. Portraits in oil, water colors, pastel, crayon and India ink are also executed in perfect manner, together with picture framing, and while the charges are moderate, the satisfaction to be obtained by an artistic and accurate portrait is guaranteed. Enlargements of prints are also a specialty. Mr. Harllee is a native of South Carolina and a member of the Jr. O. U. A. M.[82]

*Photograph by Merene D. Harllee of Florence High School. Copied from the 1918 high school annual, the* Florentine. *SCL.*

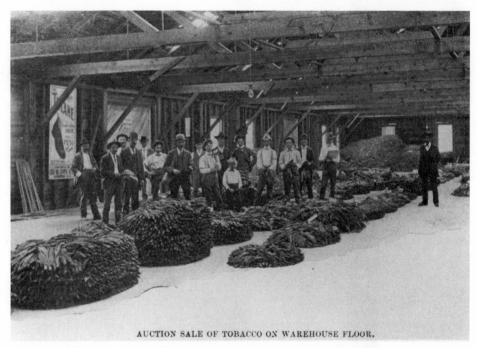

AUCTION SALE OF TOBACCO ON WAREHOUSE FLOOR.

*Photograph by Merene D. Harllee of Auction Sale of Tobacco on Warehouse Floor. Copied from* The
Exposition, *vol. 1, no. 1.*

### Gaffney

**D. A. W. McCANDLESS.** In the early 1880s McCandless, a traveling photographer
from North Carolina, photographed in Gaffney at Limestone College.[83]

**WILLIAM ARCHER.** Archer was listed in 1886 and 1890 in a South Carolina business
directory.[84]

**MILLS.** A photographer named Mills photographed at Limestone College in 1893.[85]

**WILLIAM E. WILSON.** In March 1894 Wilson, late of Savannah, advertised that the
Gaffney City Photographic Studio "Is now permanently reopened." He stated "The Studio
is equipped with new Back Grounds and Accessories. Also a ladies posing robe. Especially
prepared for Landscape Work of every description, such as Residences, Factories (interiors
and exteriors), Horses and Live Stock." His stay must have been short since he tried to sell
his studio in late July.[86]

**J. E. HELLAMS.** Hellams advertised his studio in the "Carroll & Carpenter brick
block" in late 1897. He apparently left town after a short stay. In 1899 and 1900 J. E. Hel-
lams was at Greenville at 306 S. Main, but was not listed there in 1902. Before working in
South Carolina Hellams operated a gallery in Waynesville, North Carolina.[87]

**JOHN GREEN.** In August 1899 Green advertised his tent studio next door to W. F.
Thomas. His August 1899 ad featured baby pictures and new cameras and lenses, in 1900
he advertised a free cabinet to anyone over seventy years of age, in 1901 the feature was a

*Ad for the Green Gallery.* Gaffney Ledger, *30 June 1902. SCL.*

new gallery, and in June 1902 Green offered "Photos in all those new and popular styles, Oval, Oblong, Square Shapes." A number of examples of cabinets and these "new" types of photographs of Green are known. For a few months in 1902 he and June H. Carr operated simultaneously in Gaffney. Carr's arrival may have been a factor in the departure of Green. The studio of a J. I. Green in Gastonia, North Carolina, was bought by Mrs. M. H. Curry in 1911. This may have been John Green.[88]

### Georgetown

**B. S. MATTOCKS.** In March 1882 Mattocks set up a tent on Inman's Lot and began taking photographs. He stated that "Owing To The Number Of Visitors, it has been necessary to assign special days. Visits from the whites will be received on Monday, Tuesday and Wednesday of each week, colored people on Thursday, Friday and Saturday."[89]

### Greer Depot

**C. W. GRACE.** Grace operated a gallery in 1898 at Greer Depot, now called Greer, a few miles from the city of Greenville.[90]

### Greenville

**J. C. FITZGERALD.** Fitzgerald formerly worked in Canada, Rochester, New York, and with Barnard in Charleston and probably in Sumter in 1879. In 1880 he joined Hix in a Columbia gallery and, in that same year, briefly operated a gallery in Sumter. He remained with Hix until 1882.

From 1882 to 1909 his gallery was a fixture at 104½ S. Main Street, at the corner of Washington and Main Streets, over Westmoreland's Drug Store. Although there were a number of Greenville galleries during those years, two of them stood out: Fitzgerald's and William M. Wheeler's.[91]

An 1884 account stated Fitzgerald's gallery was

fitted with the latest and most modern improvements, including two lenses, unfailing in their action, plates from the best makers, etc. The premises are neatly

*Engraving of photographer J. C. Fitzgerald.* His-
torical & Descriptive Review, *1884, p. 119. SCL.*

furnished, making the gallery quite a pleasant one, and the whole is fitted up with
the view of carrying on business with expedition. His pictures, in the various show
cases and adorning the walls of the establishment at once make it evident that the
proprietor is not only an expert in his business but has devoted much time and
attention to the posing of subjects and arrangement of groups. He is assisted by a
competent lady retoucheure. He established the institution in January, 1882 and
although he found a good light already here, he has improved it so as to give full
advantage to the camera, in the cloudiest and sunniest days alike.[92]

In 1888 Tom Rector, a black man, worked in some capacity for Fitzgerald. In 1899 Fitzger-
ald advertised "A complete series of Camp Wetherill Scenes, Views of Greenville, Paris and
Blue Ridge Mountain Scenery. See them while the sets are complete." In 1900 he offered
enlargements in "Water Color, Oil, Ink, Crayon and Pastel."[93]

By the early 1900s Fitzgerald had a substantial business in school annuals. In 1901,
1904, and 1905 he produced the photographs for the Furman University annual the *Bon-
homie,* and in 1904 he also produced annuals for Davidson, Chicora, Clemson, and Wof-
ford Colleges.[94]

**H. P. Johnson, Jr.** Johnson was in Greenville in 1883 and 1884 with a gallery at W.
S. Main Street near Washington Street.[95]

**Frank Jantzon.** Jantzon worked in Greenville in 1890.[96]

**Earle Turpin.** Turpin first appeared in 1886 with a studio at 214 Washington
Street. That year he produced a series of stereographs of the home of former governor Ben-
jamin F. Perry. On the reverse of these photographs, and one of the First Baptist Church of
Greenville produced in 1891, he advertised himself as an "artistic Landscape Photographer,
Photos of Buildings, etc., etc., either Single Views or Stereoscopic, to order instantaneous
Process."[97]

**S. A. Howard.** In 1886 Howard Brothers had a gallery in Westminister. One of the
brothers was probably "S. A." who was listed in 1888 as a photographer in Greenville, but

*Stereograph by Earle Turpin of the garden at San Souci, the home of Gov. Benjamin F. Perry. SCL.*

without a studio address. In 1896 and 1898 he operated from 402 S. Main and in 1901 and 1902 at 306 S. Main.[98]

**L. L. ALLEN.** Allen was at 402½ S. Main in the 1899-1900 local directory.[99]

**J. C. BRAZWELL.** His gallery was listed on Buncombe Street beyond the city limits in the 1899-1900 local directory.[100]

**LABORATORY OF FURMAN UNIVERSITY, W. F. WATSON.** This studio name appears on a cabinet dating from the 1890s that portrays two children outside of a building, holding a tea party, using a tomato box as a table. W. F. Watson taught chemistry at Furman University in the 1890s and may have included the chemistry of photography in his courses. This cabinet photograph, however, bearing his name and address printed on the card, gives it the appearance of a commercial photographer product.[101]

### Greenwood

**GREER.** In December 1897 a photographer named Greer placed a stark, or one might say "naked," ad in the local paper whose wording in large letters was "Greer Photographer." One photograph from his Greenwood gallery recorded his last name and indicated he also operated a studio in Atlanta.[102]

**GREENWOOD ART GALLERY.** This gallery was in Greenwood in 1898.[103]

### Lancaster

**W. A. DAVIS.** A 1924 Lancaster newspaper announced that T. F. Shoemaker from Statesville, North Carolina, took over the W. A. Davis Photo Studio, and that "Mr. Davis has been in operation for 43 years in Studio of Moore Building." Shoemaker operated the

*Remains of Haile Gold Mine Stamp Mill after its boiler exploded in August 1908. Photograph attributed to W. A. Davis. Courtesy of Inez Cassidy.*

*Cabinet of William R. Richey, Jr., by Luther A. McCord. SCL.*

studio for the next ten years. Davis appeared in Fort Mill in 1903, in Kershaw a number of times, and may have been in Chesterfield about 1900.

Several cartes and cabinets produced by Davis while in Lancaster are known. A photograph of the Haile Gold Mine Stamp Mill taken after its boiler exploded in August 1908 is attributed to Davis.[104]

**J. T. Amos & M. B. Billings.**  These two men were listed in a 1900 South Carolina business directory.[105]

## Lanford Station

**S. R. Moore.**  In 1898 S. R. Moore operated a photographic gallery at this small village in Laurens County.[106]

## Laurens

**J. R. Glazener.**  In 1885 Glazener was at Laurens in the Fowler Block with a studio over the store of John D. Sheahan. By 1886 he advertised "I have again opened out my photograph gallery on the lot next to the *Messenger* office" in Easley, South Carolina. This ad indicates he operated from a tent. He apparently made Easley his base as 1898 and 1900 business directories indicate he operated his gallery there.[107]

**C. A. Warner.**  A cabinet portrait dating from the 1890s produced by C. A. Warner is known.[108]

**Luther A. McCord.**  Luther McCord, a Laurens entrepreneur, operated a photographic studio and a number of other businesses. He opened his studio in the mid-1890s

*Cabinet of a boy and horse by G. A. Warner. Wil Lou Gray Papers, SCL.*

on the public square. In 1899 he rented it to Cora Frances Holroyd whom he wed in 1904. After their marriage, Luther again operated the studio. Luther and a few other businessmen established the Laurens Glass Works in 1911. After his death a few years later, his wife resumed operation of the studio and continued it for several decades.[109]

### Lexington

**LEXINGTON PHOTO GALLERY.** This gallery advertised in October 1890 "Portraits, Family Groupes or Views" and "the best enlargements in the United States for the least money." A George C. Smith was listed in 1900 with a gallery in Lexington and may have been the proprietor of this gallery.[110]

### Liberty

**J. T. BOGGS.** Boggs was listed in 1886 and 1890 business directories as the operator of a studio in Liberty.[111]

### Lowndesville

**W. H. HUGHES.** Hughes operated a studio in 1898 in this village in Abbeville County.[112]

### Marion

**M(ARION) CARLISLE.** Several excellent cabinets dating from the 1890s produced by M. Carlisle in Marion are known. Marion Carlisle operated a studio in Rock Hill from 1904 to 1909 and one in York in 1905. A group photograph taken in front of a church, photographs of a flood, photographs of train wrecks, and portraits taken during his Rock Hill days are known.[113]

### McCormick

**PITTS.** In December 1885 Pitts came to town and took pictures for a time. According to the newspaper account, he had worked in the small town of Troy.[114]

### Newberry

**JESSE ZEBULON SALTER AND FIVE OF HIS CHILDREN.** In November 1882 Jesse Zebulon Salter bought out the studio of William A. Clark, who operated in Newberry during the previous two years. Included in the buyout were negatives produced by Clark while in Newberry. Thus began a fifty-year photographic business in Chester, Anderson, Spartanburg, Newberry, and Athens, Georgia. The head of this business was J. Z. Salter who

*Photograph by Marion Carlisle of a group at Fishing Creek Presbyterian Church, Chester County. SCL.*

*Photograph by J. Z. Salter of a textile mill in Newberry. SCL.*

operated his Newberry studio for more than 25 years. Five of his children gained experience in the art from him and operated studios in Newberry and five other towns between 1904 and the 1930s. Their family papers indicate there was cooperation and dedication to the purpose of creating a large family business with studios in several towns.[115]

In 1884 J. Z. Salter's gallery was over Leavell's Furniture Store, but for most of his career his studio was listed at 943 Main Street. He called his studio Old Reliable Photo Studio. In 1908 he advertised "Come Along, Bring thy face wi's thee, An'it be plain or it be bonnie, We'll work it a wee An will make it sweet an' make it sunnie, For the ane sma' price of love, An' a wee sma' sum of monie."[116]

Hundreds of J. Z. Salter carte and cabinet portraits exhibit an exceptional understanding of photography as an art form. A number of Salter building photographs demonstrate a similar mastery of his craft.

Reginald Otwey and sister Temperance Elizabeth became the first of Jesse Zebulon's children to set up and operate an independent studio. They opened their business in 1902 and dubbed it the "Elite Photo Studio." They continued this studio until 1921 when Otwey dropped out and T. Elizabeth operated alone for about a year. The building housing this studio for much of its period of operation stood in Newberry until the 1950s. A masonry panel at the top of the building was inscribed "1911, O. & T. E. Salter."[117] They also operated a studio in Chester from 1906 to 1912. In July 1906 they apparently bought out J. C. Patrick, who had succeeded Miss Sallie Kennedy a few months earlier. Reginald Otwey also operated a third studio in Spartanburg in 1908 and 1909.[118] Mamie Elaida Salter and her brother Jesse Sheppard Salter continued the family legacy by operating a studio in Athens, Georgia, from 1904 to 1906.

From 1920 to 1923 Leroy and Mamie Salter operated a photo and art studio at 945 Main Street in Newberry. They also owned a combination music store and photographic gallery in Anderson from 1920 to 1925. By 1925 Mamie left the business and Leroy entered a partnership with Lucy Speer in photo and music stores in Newberry and Anderson. They too were still pursuing the family dream.[120]

Salter and six family members operated a total of eight studios from 1882 to the 1930s. Some Salter cameras and other equipment are in the Nichols studio in Newberry, South Carolina.[121]

T. W. PRICE. In 1898 T. W. Price operated a gallery in Newberry in competition with that of Salter.[122]

ANDREW CHAPMAN. In the 1892 edition of *Annals of Newberry* O'Neall and Chapman state that Andrew Chapman practiced photography in Newberry for a time.[123]

### North Augusta

JOHN T. BATEMAN. Bateman was listed in Augusta, Georgia, city directories of 1899, 1903, and 1907 as a photographer in North Augusta, a town across the Savannah River in South Carolina.[124]

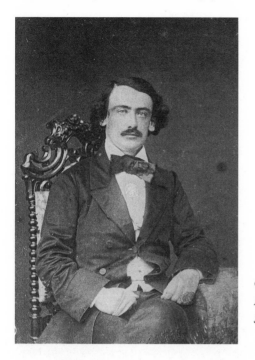

*Copy print by O. B. Rosenger of a daguerreotype of Henry Timrod originally produced by Tyler & Co. SCL.*

## Orangeburg

**O. B. ROSENGER.** Cabinet portraits show Rosenger in business with C. M. Van Orsdell, Jr. and for a time with a gentleman named Cummings. The first documentation of Rosenger's business was in late 1891 and early 1892 at Georgetown. He made return visits to Georgetown in 1893, 1895, and 1897. In 1896 Rosenger worked in Florence for a week and was described as a photographer from Orangeburg. His "Portable" gallery was on a lot next to the Central Hotel. Young & Co. listed him with a studio over Lowman's Drug Store on Russell Street in Orangeburg in 1900. Most surviving Rosenger photographs were produced in Orangeburg where he worked at 3 W. Russell Street as late as 1921 and 1922.[125] Judging from existing information, Rosenger apparently was an itinerant photographer from 1891 to 1922, who visited other South Carolina towns while maintaining a base in Orangeburg.

## Pelzer

**ROBERT LUTHER SNIPES AND HARDY P. FENNELL.** The earliest reference to Snipes and his gallery in the small Anderson County town of Pelzer was a cabinet photograph of an African American family dated 1893. In *Memories of Pelzer* Cobb & Weldon state Snipes came to Pelzer in 1895 and followed his father into photography. His father may have been E. M. Snipes of Anderson. In his early years in Pelzer he operated from a tent, but eventually moved into permanent quarters.

ABOVE: *Photograph of Robert Louis Snipes in 1899. Courtesy of Foundation for Historic Preservation in the Pendleton Area.*

*Photograph of a boy standing on a wicker chair with his toy bear on a wicker stand behind him. Produced by Robert L. Snipes (Snipes Studio) in 1919. SCL.*

Unlike most photographers of the time, Snipes generally dated his photographs on the reverse. Dated photographs record Snipes working in the town of Pelzer until 1925, the year of his death. His photographs also indicate his gallery was well equipped with drapery, background scenery, chairs, couches, toys for children's photographs, and other props.

Some time after World War I Snipes associated with Hardy P. Fennell. According to Cobb & Weldon, Fennell learned the trade in the military and while working for Kodak and for Snipes. When Snipes died in 1925 Fennell continued the business.[126]

## Piedmont

**JAMES L. DAVENPORT.** According to city and business directories, Davenport operated a studio in this small Greenville County town from 1900 to 1904. In newspaper ads he

touted his expertise in producing pictures of children and babies. Davenport produced picture postcards of Anderson, South Carolina, around 1912.[127]

### Rock Hill

**R. F. STEELE.** Steele located in Rock Hill, over J. Johnson's Drug Store, for a short time in January 1882 and produced photographs and ferrotypes. He may have been the father or brother of Susan N. Steele who operated a studio in town from 1911 to 1913.[128]

**C. S. MOORE.** In 1890 Moore operated a gallery in Rock Hill producing cartes, cabinets and tintypes.[129]

**E. A. & H. F. MORLEY.** In the spring of 1894 these men from Warr Wick (Warwick), New York, engaged Dr. Crawford to construct a two-story photographic gallery for them on Main Street opposite the home of Mr. S. L. Reid. They were described by a reporter as two good artists who engaged in photography in all its branches and who made "a specialty of enlargements of pictures from photographs, daguerreotypes, etc." The Morleys chose Rock Hill due to the "push and energy of the people." The Morleys' tenure must have been rather brief as few examples of their work are found.[130]

**C. W. ROCHELLE.** From 1898 to 1900 Rochelle advertised in the local paper. In 1898 he offered to barter photographs for wood and country produce. During 1899 and 1900 he advertised "You furnish the subject, Rochelle does the rest. Baby pictures made between kicks." He also advertised the production of views.[131]

### Spartanburg

**M. COOPER.** An 1890 business directory listing tells us of Cooper as a photographer in Spartanburg.[132]

**ROBERTSON & JENNISON.** By 1883 W. T. Robertson and his assistant, N. S. Jennison, simultaneously operated studios in Spartanburg and Asheville, North Carolina. In addition to portrait work, they advertised the publication of "Stereoscopic Views of Southern Scenery." One of their works lists them as Robertson & Jennison in the Archer Building engaged in "Photography in all its branches."[133]

**JEROME HALL.** An 1884 account described Mr. Hall and his studio in these terms:

> He was more than seven years in Bunkerhoff's gallery on Broadway, and for five more conducted an establishment of his own on 8th Avenue. He came south in October last and bought out Robertson, his predecessor in these premises, and fitted up the various rooms of the establishment with that taste and neatness which displays his adaptation to an artistic profession. His rooms occupy two floors, on the first of which is a pretty reception room with dressing room attached, and also working and finishing departments quite removed from visitors eyes. Up stairs is the operating gallery with adjustable light, and dark and printing rooms. Mr. Hall has the best and most improved instruments and facilities for carrying on business,

his establishment in every respect a model one, and can teach a lesson to the other galleries. He turns out a superior class of all kinds of work. His pictures are distinguished for an accurate and just conception of the requirements of the subject, which enables him to force the beauties and attractions into prominence. The gallery is hung with samples of his conception, photographs, landscapes and also oil paintings. Mr. Hall is a native of Syracuse, N. Y., passed as before mentioned most of his life in the city. In following his profession he has a bright future before him.[134]

**FREEBURGER & CO., NAT. W. TAYLOR, AND ELITE ART GALLERY.** A few cartes and cabinets that date from around 1880 to 1900 represent the only information located on these three galleries. Taylor simultaneously operated studios in both Spartanburg and Asheville, North Carolina.[135]

**RICHARD F. PETERSON, PETERSON & BERNHARDT, AND PETERSON & FERRELL (FARRELL).** In June 1893 Peterson advertised in the *Wofford Journal* his gallery at No 28, East Main Street. Peterson must have taken on an associate in 1893 or earlier as a cabinet portrait dated that year was produced by Peterson and Ferrell. Peterson & Bernhardt were listed as partners in 1899 but not in 1900.

Peterson operated from a number of addressees: 28 East Main Street in 1893, opposite New Windsor Hotel in 1894, Morgan Square in 1896, 26 East Main Street from 1899 to

*Photograph by the Peterson Gallery of Robert Lee Meriwether while he was a student at Wofford College from 1908 to 1912. Meriwether later became a history professor at the University of South Carolina and director of the South Caroliniana Library. SCL.*

1905, 140½ Magnolia and 119½ West Main in 1908, 118½ E. Main in 1910, and 141½ E. Main from 1911 to 1920. He maintained a close working relationship with the two colleges in town, Converse and Wofford, and over the years college annuals and other photographic business came his way from both students and school administrators.

Peterson operated an up-to-date gallery and the historical value of his work is significant. At some point between 1908 and 1912 he produced an excellent photograph of Wofford student Robert Lee Meriwether, who founded the South Caroliniana Library and Society and became one of the state's outstanding historians.[136]

**HENRY BERNHARDT.** Thirty-three Morgan Square became the location for Bernhardt's studio in 1895. For twenty years, he owned a studio in the city. Over the years he operated from a number of locations: Morgan Square from 1895 to 1898, 25 E. Main Street (with Peterson) in 1899, 33 W. Main from 1903 to 1905, 137½ Morgan Square from 1908 to 1909, and 212 W. Main from 1911 to 1924.

Bernhardt worked with Peterson in 1899. Although she did not appear in city directories as an active participant with her husband until 1920 through 1924, Mrs. Bernhardt had been described in advertisements as an active operator or photographer in the business as early as 1906.[137]

In 1955 Sammy Atkinson photographed Mr. Bernhardt, when he was 85 years of age, in a setting that evoked Spartanburg, Wofford College, history, and art. During his youth,

*Photograph by Sammy Atkinson taken on 12 January 1955 of photographer H. Bernhardt with his hand on the sculptured bust he created several years earlier of James H. Carlisle, longtime president of Wofford College. Courtesy of Wofford College Library.*

Bernhardt was an amateur sculptor and had created a bust from one of his photographs of James H. Carlisle, President of Wofford College, from 1875 to 1902. As the story goes, Bernhardt wished to portray the back of the beloved president's head since photographs did not do so. In 1955 he presented his Carlisle bust to Wofford College. Atkinson captured the cherished moment, the 85-year-old photographer with his hand on the piece of sculpture and Dr. Carlisle looking benignly down from his frame on the wall as if to bless the event.[138]

**JOHN D. OWEN.** Owen was listed as a photographer in 1899 at the corner of E. Main and Liberty Street. His next listing was in 1908 at E. Main and S. Liberty and he remained there through 1913.[139]

**McKNIGHT & EDWARDS.** These two men operated a photographic studio at 33 Morgan Square in 1899.[140]

*Sumter*

**GEORGE H. LEWIS.** Lewis was listed in an 1886–87 business directory with a studio in Sumter. In 1894 he had a gallery in Florence at 222 Dargan Street and in 1900 at 206 Evans

*Photograph by G. H. Lewis of "Sophia," featuring an elaborate backdrop. Collection of the author.*

Street. In 1909 one George V. Lewis took photographs in Sumter. Perhaps he was George H. Lewis. A few cabinets produced while George H. Lewis operated in Florence are known.[141]

**JAMES H. WINBURN.** Winburn was an experienced photographer in 1887 when he arrived in Sumter from Conyers, Georgia. He began a photographic career in Sumter destined to span 33 years. By 1889 the local press called him a proven artist whose "gallery is crowded with work." Although Sumter was his base, Winburn was an itinerant photographer in his early years in South Carolina. The fact that he operated out of a mammoth tent as late as 1896 suggests that was the case. In 1895 a reporter from the *News and Courier* of Charleston visited Winburn's gallery and saw "specimens made from various sectors of the state." He operated from his tent in Georgetown on Front Street in 1896.[142]

Apparently Winburn had moved out of his tent into more permanent quarters by 1897, probably to 10½ South Main Street. In 1904 he moved from the 10½ South Main location to 108½ South Main over Stubbs Brothers Clothing Store. From this location he advertised his gallery many times over the next twenty-two years. Beginning in 1913 he advertised portraits that were modern and natural: "Your family and friends want pictures of you as they are accustomed to seeing you—a natural intimate likeness. This is modern photography. Such portraits are a pleasure for us to make and you to have made."[143]

In 1924 a fire destroyed Winburn's studio. He saved some equipment and other materials and continued in business until his death on November 2, 1926. *The Sumter Herald* editors described Winburn as "one of the best in the state in his chosen profession. For

*James H. Winburn behind his camera. Photograph copied from 1914* Game-cock. *Sumter County Museum.*

many years he has enjoyed the friendship of the people of Sumter and the surrounding communities."[144]

The volume of work produced by Winburn's studio required the employment of assistants. Over the years he employed at least three women in his studio: his daughter, Mrs. Diedrick Werner; Miss Irma L. Roberts; and Miss Juanita Lawrence. Miss Lawrence succeeded Winburn after his death and successfully operated the studio for several years thereafter.[145]

**BOSTON PHOTO COMPANY.** This itinerant company set up for a short time in Sumter in May 1897. They claimed to have made 40,000 photographs in Florida the previous winter. Apparently when they stopped in Sumter they were working their way back to Boston.[146]

**J. W. RHODES.** Rhodes was from England and located on Main Street in Sumter in 1897. He was listed as a photographer by Young & Co. in 1900 along with James H. Winburn.[147]

### Trenton

**J. W. M. COURTNEY.** In the town of Trenton, near Edgefield, Courtney opened a gallery in January 1882 and produced "Photographs and Ferrotypes" for a short time.[148]

### Unionville

**H. T. YATES.** A few photographs dating from around 1900 to 1910 produced by Mr. Yates are known.[149]

**ATWOOD & UNGER.** A cabinet portrait produced by these men dating from the 1890s is known. Another cabinet portrait produced in Winnsboro from this same period by E. Jay Atwood is known.[150]

**UNION PHOTO CO.** A cabinet portrait exists of an unidentified lady dating about 1900 produced by the Union Photo Co.[151]

**W. W. COLE.** A cabinet portrait dating from around 1900 was produced by Cole in Union.[152]

**J. E. SQUIRE.** Young & Co. listed J. E. Squire's gallery in Union in 1900. Several photographs dating in the early 1900s show a Squire's Studio in Union, and in Roxbury and Fleishman's, New York.[153]

### Walterboro

**J. R. HALFORD.** Based on photographs in the Hudson family collection this studio may have begun in the 1880s. In 1914 Halford operated from his home and apparently went out of business that year since he advertised the sale of his furniture and household goods that October.[154]

### Winnsboro

**W. W. Kuser.**　Several cabinets produced by W. W. Kuser dating from the late 1890s to the early 1900s are known.[155]

### York(ville)

**T. B. McClain.**　For a time around the turn of the century McClain produced cabinet photographs in York.[156]

*Photograph by J. R. Halford of members of the Stokes family with their African American nurse. SCL.*

# Of Postcards and War, 1901–20

South Carolina's industrial revolution continued during this period. Textile production, valued at thirty million in 1900, increased by about 900 percent to more than 286 million by 1920. Unfortunately, this increase carried with it one rather negative element, child labor, found in the industry throughout the nation. Various efforts were mounted to pass and enforce child labor laws. The National Child Labor Committee employed documentary photographer Lewis Wickes Hine to record child labor practices in the South. He visited South Carolina in 1908 and produced very compelling images. His photograph of children doffers at a long line of textile machines in a Springs textile mill in Lancaster, South Carolina,

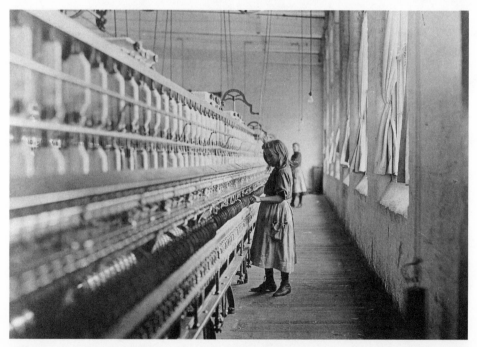

*Photograph portraying child labor in a textile mill in Lancaster, South Carolina. Taken by Lewis Hine in 1908. Courtesy of The National Archives.*

was later chosen and exhibited as one of the most memorable photographs in United States photography.[2]

An improving economy made more funds available for South Carolinians to purchase photographs. Agriculture, the continuing mainstay of the local economy, also grew during this period. Agricultural growth over these two decades was due in part to the leadership of Clemson College and the coming of World War I.

World War I profoundly affected a few communities when army training bases were located in or near them. During this period Columbia secured Camp Jackson; Greenville, Camp Sevier; and Spartanburg, Camp Wadsworth. Servicemen had always been good customers of photographers by securing photographs to send to loved ones.

Columbia's five photographic firms in 1917 increased to 12 by 1918. Spartanburg firms, totaling only three in 1916, increased to eleven in 1918, but by 1920 the number was back to three. In Greenville nearby Camp Sevier produced similar results as in Columbia and Spartanburg. One studio operator in Greenville called his business the Camp Sevier Studio.

Photographs first appeared in South Carolina newspapers shortly before 1900, but were used sparingly until the second decade of the twentieth century. Publishers of books and magazines increasingly used photographs as illustrations after 1900. Pictures books appeared in greater numbers. More schools, including some high schools, began to print annuals. Chambers of commerce, civic and fraternal organizations, colleges, cities, churches, hotels, and governmental agencies published pamphlets and promotional materials that relied heavily on photographs. The printing and collecting of picture postcards reached its zenith in this period. All of these activities augured well for local photographers who secured a large share of this business, although out-of-state firms captured some business, especially school annuals and picture postcards.

Another development of the period from 1901 to 1920 was the inauguration by the federal government of Rural Free Delivery (RFD) of mail. Although experimented with before 1900 in a few areas of the United States, RFD service in most areas of the country, including South Carolina, began between 1901 and 1910. This meant that for the first time many of South Carolina's rural citizens did not have to journey to a post office for their mail. The picture postcard was now delivered to each RFD mailbox for one penny. What rural South Carolinians began to experience visually through their mailboxes began to change as more printed matter included photographs catering to rural citizens.

Between 1900 and 1920, when South Carolina's population increased by about 340,000, there was an accompanying increase in the number of photographers. By 1910 there were 168, thirty-four more than in 1900. The 1920 census did not report the number of photographers by states, but there likely were 200 operators in South Carolina by that year.

Improvements in photographic equipment and film continued. Styles of mounts and albums changed as photographs of varying sizes became the rule instead of traditional cartes and cabinets. As electricity became more available, photographers began to illuminate their studios. Airplanes made aerial photography possible which, although used during World War I, had little use and impact locally until after 1920.

## *Photographers*

### *Abbeville*

**ORR & HAYS.** In 1910 these men bought out the Lomax studio, including his negatives. By 1 February 1914 Franklin S. Hays was operating alone, and he was still in business in 1949. Orr was probably James H. who opened a studio in Greenville in 1913. Several hundred of Hays's glass negatives exist and indicate he produced the full range of photographs popular during this period. For about four decades he enjoyed the patronage of the town and surrounding area.[3]

### *Anderson*

**EUGENE T. ANDERSON.** On 1 January 1904 Anderson began advertising his studio at 110½ Court Square with engravings of beautiful women whom he stated he would pose gracefully and double their charm. By June his ads featured a photograph of himself. In July 1904 he invited citizens to come by and "see what we have from St. Louis," probably indicating he had been a visitor to the world's fair there.

The next year he began to sell clothing in his establishment as well as producing photographs and framing pictures. He was a staunch segregationist, stating in his ads, "No Coons allowed." By 1907 he called his business "Eugene T. Anderson & Co" and had added cameras, films, photographic papers, and chemicals to his line. In 1909 he operated a business at 110½ Main Street named "The Grand Novelty Studio." From 1909 to 1916 he also operated a studio at 1136 S. Main Street.[4]

*An advertisement for Anderson's Studio that pictures the photographer and indicates his attitude toward African Americans. Anderson City Directory, 1909–10. SCL.*

The Voice of Praise for Anderson's Studio
1136 SOUTH MAIN STREET

BEAUTIFUL PICTURES
LIFE SIZE,
COPIED,
ENLARGED,
FRAMED,
ON POST CARDS,
FOR WATCH,-
LOCKET, ETC.

Anderson's Studio
FOR WHITE PEOPLE ONLY
OUR EXPERIENCE IS AT YOUR SERVICE

*Photograph attributed to Franklin S. Hays of an Abbeville School group. Courtesy of John Blythe.*

**ABOVE:** *Advertisement by M. E. Allen that pictures the photographer.* Anderson City Directory, *1909–10. SCL.*

*Photograph by M. E. Allen of the Central Presbyterian Church copied from* Autumn Leaves, *1907. SCL.*

Photo by M. E. Allen.
Central Presbyterian Church

**J. W. Ballenger.** Ballenger's studio was listed in local directories in 1905-06 at "B R Ry beyond Bleckley," and in 1909-10 at 229 Clinkscales Street.[5]

**J. P. Worstman.** Worstman was listed in the 1905-06 Anderson local directory with a studio at 131½ N. Main Street.[6]

**Elwood W. Jones.** Jones had a studio at 124½ E. Benson Street in 1909 and 1910, but operated from 105½ E. Whitener the next year. Jones also advertised copying and enlarging portraits in 1911 and 1912. A postcard postmarked in 1912 and produced by Jones & Trimpy indicates these two men were in business together that year. By 1913 Jones disappeared from the Anderson photographic scene.[7]

**E. Burt Trimpy.** Trimpy operated a studio in Anderson at least from 1908 to 1911 whose location was probably 1201 Fant Street, but that location was confirmed for only 1909 and 1910. A couple of postcard views produced by him between 1908 and 1911 and a 1912 Jones and Trimpy postcard view are the only known examples of Trimpy's work.[8]

**M. E. Allen.** Allen operated an Anderson studio from 1907 to 1921 at 131½ N. Main Street.[9]

**Green & Haynes and W. E. Haynes and John I. Green.** John I. Green likely also operated a studio in Gaffney from 1899 to 1901, but was listed only as John Green in his advertisements. The Anderson listings for Green are found in city directories.

John I. Green operated Green's Art Shop at 105½ W. Benson Street by 1915. H. E. Haynes joined the studio in about 1920. For the next ten years they continued as a partnership, but apparently ended this relationship around 1930. In that year Haynes was listed alone with a studio at 110 S. Main Street, but did not appear in Anderson with a photographic business in ensuing years. John I. Green operated from 128 N. Main Street in 1930, but was at 132 E. Benson Street from 1934 to 1940. Many examples of their work survive.[10]

**Harry E. Wallace.** By 1914 Harry E. Wallace produced photographs from his studio listed at 110½ S. Main Street and for the next sixty years photographed in Anderson. In 1916 he was located at 124½ N. Main Street and remained there until 1934 when he was listed at 132 N. Main with a combination studio and gift shop.

*Photograph of Harry E. Wallace being interviewed late in life. Courtesy of Foundation for Historic Preservation in the Pendleton Area.*

*Photograph by Green & Haynes of Opportunity School at Anderson College (circa 1927 or 1928). Wil Lou Gray Papers. SCL.*

*Photograph by Harry E. Wallace of Anderson Female College girls on an Anderson street car. Foundation for Historic Preservation in the Pendleton Area.*

In addition to his portrait work, Wallace produced many photographs of local sub-
jects such as streets, businesses, and homes. In 1913 and 1917 he produced all the illustra-
tions for the Anderson College publication, *The Sororian*.[11]

## Bamberg

**PATRICK PHOTO SUPPLY CO.** In 1903 this firm enlarged and copied photographs
and produced picture frames of all sizes. They also advertised in the *Lexington Dispatch*
newspaper seeking business beyond Bamberg.[12]

## Batesburg

**J. B. WHITTLE.** Whittle began a photographic business in Batesburg around 1901
that lasted until 1907 or 1908. He advertised several times in 1901 and 1902 and again in
1906. That year he advertised his studio over Dr. Harris' Drug Store as specializing in
"Children & Babies. Kodak Finishing Good Work and low prices." A photograph pro-
duced by him in 1907 or 1908 is known, but samples of his work are rare.[13]

**POND & ETHEREDGE.** In August 1901 this firm advertised enlarging pictures and
producing portraits in "Crayon, India Ink, Sepia, Water Colors, Pastel and Oil."[14]

## Beaufort

**J. A. WILLS.** Wills located in Beaufort for a short time on Charles Street, one door
from Bay, in March 1905. By April he had reduced his prices by fifty percent and advertised
his departure soon after Easter.[15]

**M. E. WILSON.** Wilson of Savannah produced a number of photographs of the
Beaufort and Port Royal area that appeared in a *Report of Port Royal Naval Station By The
Citizens Committee of Beaufort and Port Royal, S.C.* He also advertised his Savannah studio
in the Beaufort newspapers.[16]

**C. C. CARTWRIGHT.** According to a 1918-19 Beaufort directory, Cartwright then
operated a photographic studio in town.[17]

## Bennettsville

**J. P. EASON.** Eason produced postcards in Bennettsville in 1905.[18]

**JOHN E. SPENCER.** Spencer operated a gallery in Bennettsville at 214 E. Main
Street from about 1913 to the 1950s. He did portraits, produced dozens of postcard views,
and processed Kodak film at his studio. William Kenny, editor of the *Marlboro Herald*,
recalls Spencer taking his photograph when he was a young child. He also recalls that Mrs.
Spencer operated a gift shop in Bennettsville during much of the time her husband oper-
ated his studio.[19]

## Bishopville

**ANONYMOUS.** In 1904 an unknown individual advertised the production of photographs from the Opera House.[20]

**A. K. KHOURY.** In 1907 Khoury advertised "Views of Bishopville and river scenes at Steel Bridge in neat postal Cards. Kodak films finished at low prices; also pictures enlarged at A. K. Khoury's Art Gallery."[21]

## Camden

**E. T. START.** During most of the last quarter of the 19th century William S. Alexander was the preeminent photographer in Camden. Among his products during this time were photographs of the winter colony and their activities.

In 1903 T. Edmund Krumbholz, owner of the Kirkwood Hotel, brought E. T. Start to Camden and provided him a room in his hotel for a studio. Start quickly became the Winter Colony photographer.

Start was born in London, but came to this country at an early age. While operating a studio in Providence, Rhode Island, in 1875 he visited Lake Saranac, New York, and there met T. Edmund Krumbholz. Start was offered a position as hotel photographer at Lake Saranac during the summer tourist season. In 1903 he added the Kirkwood Hotel as the winter location for photographing northern tourists and their activities. In November 1945 the *Camden Chronicle* reported that "Mr. Start's pictures of Camden winter life, featuring

OLE SWIMMIN' HOLE
Bennettsville, South Carolina

SPENCER - PHOTO.
211 E. Main Street

*Copy print from a picture postcard, Bennettsville, South Carolina. SCL.*

*Photograph by E. T. Start of a scene at the Woodward Airport dedication in Camden in 1929. SCL.*

*The front of a film and print envelope from E. T. Start's Lake George, New York, and Camden, South Carolina, studios from the early 1900s. Collection of the author.*

the horse shows the Camden Hunt, polo games, Carolina Cup races and hunting scenes have appeared in magazines for many years."

Start was an award winning, accomplished photographer. The local paper in April 1932 reported the following:

> In 1931–32 Mr. Start won seven prizes in open competition with professional and amateur photographers—four firsts and three seconds. His pictures of Lake Saranac, by-way scenes, and mountain views have been used in many of the leading papers which carry photogravure sections. Many of them have been in demand and decorate many homes in the north. He also has in his collection photographs taken over this long period of time of such nationally known celebrities as the late

President William McKinley, Vice President Hobart, Admiral W. S. Schley, Victor Herbert, President Taft, President Coolidge, General John J. Pershing, John D. Rockefeller, Sr., the Vanderbilts and scores of others."[22]

Start bought a home in Camden and maintained a residence there until late in World War II when he sold it to Mr. and Mrs. William Claude West. In later years, when Start journeyed from New York state to Florida, he often stopped in Camden and stayed with the Wests. Two of the West children and a son-in-law related that Start left a trunk full of photographs in their basement and after his death their parents asked Start family members whether they wanted the trunk or not. When they declined, the trunk and its contents were discarded.[23]

Start's business was not confined to the winter tourists, but included the usual local portraiture and scenes.[24]

**H. L. MUNSON.** In December 1909 Munson opened a gallery in the Man Building and solicited patronage from the local citizenry.[25]

**SNYDER GALLERY.** Dated photographs indicate Snyder operated a gallery in Camden as early as 1902 and continued in operation until succeeded by the Camden Studio on 22 July 1910. In May 1914 E. C. Zemp advertised taking over the Snyder Gallery formerly

*Cabinet copy by the Snyder Gallery of an engraving of Grace Episcopal Church in Camden. SCL.*

*Cabinet copy by the Snyder Gallery of a painting of Abram Blanding. SCL.*

operated by Miss Bessie Roberts. Although Snyder may have no longer owned or operated the gallery, it apparently continued to bear his name for several years. A few examples of his work are among the holdings of the South Caroliniana Library and the Camden Archives & Museum.[26]

**JOE B. GASKINS.** From his base in Camden Joe B. Gaskins, an itinerant photographer, produced school pictures and others at a variety of locations in South Carolina. In 1908 he located upstairs over Park's Drug Store in Fort Mill. A 1914–15 Camden city directory listed him at 1011 6th. Avenue and in 1925–26 at a Haile Street extension address. In November 1926 he advertised the building of an up-to-date home studio at 1340 Haile Street.[27]

In the 1930s Gaskins photographed the author when he photographed school pictures for Midway School in Kershaw County, South Carolina. He continued in business into the 1940s.

### Charleston

**E. N. TILTON.** Tilton's credits appear on the reverse of an image of a Charleston High School class that was taken in the early 1900s.

**CAMPBELL & BROOKS.** Albert E. Campbell and Joseph R. Brooks were listed in the 1902 Charleston directory with a studio at 296 King Street. They had disappeared from Charleston by 1903.[28]

**JOSEPH H. MAYFIELD.** Mayfield first appeared in Charleston in 1903 with a studio at 411½ King Street. From 1904 to 1906 he operated from 445 King Street, but had moved to 401 King Street by 1909. After 1910 he did not advertise in Charleston. In January 1915 Mayfield purchased the Zemp Studio above the Bank Of Camden and advertised producing photographs "in the studio or at homes." By 1922 he managed Hennies' Studio in Columbia. He opened his own studio at 1515 Main Street the next year. He apparently bought out Hennies in 1925 as 1615 Main Street, the former address of Hennies' Studio, was now that of the Mayfield studio. He continued his Columbia business until 1926.[29]

**W. BARNEY WHALEY.** Whaley appeared on the Charleston scene in 1906 with a studio at 413 King Street, but did not appear in the 1910 city directory.[30]

**HUBERT S. HOLLAND.** From 1910 to 1916 or 1917 Hubert S. Holland operated a Charleston studio at 297 King Street. By 1918 he moved to Columbia and operated a studio at 1435 Main Street. Camp Jackson may have enticed him to the capital city. Fred Toal(e) became the proprietor of this studio in 1918 and Holland disappeared from the scene. Toal retained and used the Holland name for his business until 1921. The Holland name was also retained in Charleston from 1918 to 1932 by Mrs. G. E. Grant (Rosa S. Grant) for her studio.[31]

**WALTER L. HARRELL.** Harrell operated a studio at 332 King Street from 1912 to 1926. His studio in 1921 and 1922 city directories was listed as "Harrell's Cute Studio."[32]

**H. R. JACOBS.** Jacobs began his photographic association with Charleston as a clerk in Lanneau's Art Store in 1910. By 1912 he was listed in the directory as a photographer, but no studio address was given. In 1913 he opened a studio at 9 Liberty Street. The next year he established the Charleston Photograph Co., moved to 286 King Street, and remained in business until the end of World War II. In 1914, 1919, and 1921 he advertised in the city directory the production of "Panoramic Views, Kodak Finishing, Interior and Architectural Photography." Over the years he frequently advertised in the city directories; in 1932, "Commercial Photography"; in 1939, "Weddings-Banquets-Conventions-Panoramic Views"; in 1940, "Commercial Photography, Photostats."[33]

**ST. JULIEN MELCHERS.** St. Julien Melchers called his business at 244 King Street the "Graflex Studio" in 1914 and advertised "Photographic Work of All Kinds, Home Portraiture a Specialty, Copying, and Enlarging from Plates, Films or Photographs." By 1918 he called his business Melchers Studio at 281 King Street. By 1921 the studio incorporated with W. S. Lanneau as president, St. Julien Melchers as vice president, and R. O. Wittington as secretary-treasurer. That year the studio operated from 238 King Street and remained there until 1938. From 1938 to 1940 the studio was listed as Melchers-Weaver.

In the late 1920s and early 1930s Frank Melchers was an assistant in the studio, managing the production of photostats. By 1934 St. Julien Melchers does not appear to be active in the business since T. Walton Worthy was employed as manager. Beginning in 1938, Max Furchgott worked as an assistant in the studio. The Furchgott name continues to be prominent in Charleston photographic circles.[34]

*This is one of the Cheraw streets. Am having a lovely time. Am at Mary's now.  LLd.*

*Postcard photograph of a street in Cheraw by Bland. SCL.*

**LLOYD & KERSH AND HARRY W. SMITH.** Jackson Lloyd and a Mr. Kersh operated a studio for a time in 1919 at 370½ King Street. Harry W. Smith also operated for a time that year at 588½ King Street.[35]

### Cheraw

**BLAND.** Picture postcards of Cheraw scenes were produced by Bland in 1906.[36]

**J. C. PATRICK.** Patrick rented Miss Sallie Kennedy's studio in Chester in 1906, but relinquished it to two of the Salters from Newberry after a few months. Soon thereafter he showed up in Cheraw where he operated for several years. Picture postcards by Patrick while in Cheraw are known. He also went to nearby towns to produce photographs. For example, in 1913 he accompanied a group of Patrick, South Carolina, picnickers to the nearby Sugar Loaf Mountain and photographed them.[37]

### Chester

**JOHN A. WENTZ.** Wentz operated a studio over Lindsay's Store in Chester at 147½ Gadsden Street from 1907 to 1909.[38]

**T. Y. JOYNER.** Joyner's gallery was located on Gadsden Street from 1908 to 1915. In 1915 Joyner invited local citizens to give "For Christmas Your Photograph, The simple gift that lends the touch of friendship without the embarrassment of an obligation."[39]

**T. C. FALEY.** While Martin F. Ansel was governor of South Carolina, from 1907 to 1911, he received a photograph from Mr. & Mrs. Reed produced by Faley that showed about

*Photograph by T. C. Faley described in the text. SCL.*

a dozen people on the front porch of their Chester home decorated with Confederate flags with a carriage in the foreground. This is the only example presently known of Faley's work. Since Faley was not listed in the 1908–09 Chester directory, the production of this photographs dates from 1907 or between 1909 and 1911.[40]

### Clinton

**R. H. MCADAMS.** In the early 1900s McAdams did itinerant photographic work in the southeastern states, specializing in college annual photographs. In 1904 he was in Clinton plying his trade.[41] About 1916 McAdams was in Due West. He visited the Harbison Agricultural College in Irmo and produced photographs for some of their publications.[42]

### Columbia

**JAMES L. WEST.** West is listed as a Columbia photographer in 1904, but without a studio address. He probably was an assistant in one of the local studios.[43]

**WALTER L. BLANCHARD.** In 1906 Walter L. Blanchard opened Columbia Photographic Studio at 1438½ South Main Street over Owings Drug Store. For three decades Blanchard and his assistants journeyed far and wide throughout the state capturing places, people, events, disasters, etc.

Although the address occasionally changed, Blanchard's Studio was a Columbia fixture for more than thirty years. In 1911 he began listing his studio in his name. By 1913 he had relocated to 1441 Main; 1917, 1435 Main; 1921, 1528 Main; 1923 and 1924, 2734 Devine;

*Postcard photograph by Walter L. Blanchard of W. E. Love's Columbia, South Carolina, business. SCL.*

1925, 2713 Devine; 1926, 1641 Main; 1929, 1322 Main, where he remained until his death in 1939.[44]

By 1911 Blanchard's Columbia Art Store and Studio at 1438 Main Street occupied a three-story building. His photographic gallery occupied the first and second floors and his art store the third floor. In his art store he stocked such assorted items as stationery, pens, ink, paper, mirrors, chinaware, vases, and jewel cases.[45]

"Photo by Blanchard" became a common credit line found on photographs in South Carolina newspapers and periodicals from 1906 to 1940. In 1907 he supplied most of the photographs for a Seaboard Air Line Railway publication that featured Columbia. Blanchard included some of his World War I era photographs of soldiers and Camp Jackson and Columbia in a book. He produced many postcard views of Columbia such as the Congaree Bridge during the

*Photograph of a baby with bottle by Walter L. Blanchard. Copied from the* Mercantile and Industrial Review. *SCL.*

*Photograph by Walter L. Blanchard of Wappaoolah School House. Harold Tatum Volume. SCL.*

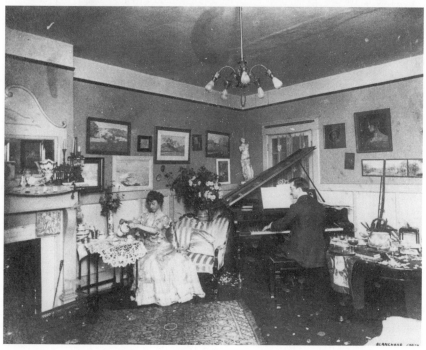

*Photograph of the interior of artist Blondell Malone's Columbia home, produced by Walter L. Blanchard. Blondell Malone Papers, SCL.*

flood of 1908. In the early 1930s Blanchard produced a series of photographs of historic sites and buildings for a proposed publication. Although never published, a manuscript copy including Blanchard's photographs survives.[46]

Blanchard was an innovator and experimenter. In 1914 an interesting account appeared in a Lancaster newspaper concerning one of these activities. "A Lancaster moving picture made by Mr. Sargeant of the Blanchard Studio at Columbia will be shown here at Amuse-U-Theater (Midway)-It will show scenes of Uncle Hardy Montgomery, 116 years old, eating a watermelon. Also Col. Leroy Springs and his entire office and Cotton Mill Force."[47]

Exactly what type of "motion picture" this was is not clear, but it may have been the kind a Camden reporter described Blanchard producing in January 1923 while he made school photographs in town and in the mill schools. "Blanchard is doing the work with a camera of his own make, and on which he now has a patent pending. It is known as the 'Movie Turn Camera' and is so constructed that the films are made from celluloid, the same as motion picture films, and has a capacity of 800 pictures without reloading."[48]

Blanchard returned to Camden in June 1923 and set up a temporary studio in the Chamber of Commerce office. The Camden reporter who described these activities also gave us what is probably the best description of Blanchard and his work, "W. L. Blanchard of Columbia, widely known as 'Johnny-on-the-Spot.'"[49]

From 1907 to 1918 Lella Lindler assisted him in his Columbia studio. John A. Sargeant appeared in the 1817 local city directory as an assistant to Blanchard. From 1932 to his death in late 1939 his daughter, Mildred A. Blanchard, worked in the studio as an assistant. By 1940 his wife, Emma R. Blanchard, and daughter, Mildred, operated the studio.[50]

**G. P. McKinstry.** McKinstry was listed with a studio at 1435 Main Street in a 1911 city directory. He was also listed as a photographer from 1912 to 1914, but without a studio address.[51]

**Harry Smith.** In 1911 Smith was listed with a Columbia photographic studio at 1013 Gervais Street.[52]

**John Victor May.** From 1912 to 1919 May was a photographer, but only in 1917 was a studio address given. In that year he operated from a 206 Richland Street location. May probably worked out of his home for most of this period or was employed in another studio in town.[53]

**P. B. Barnes.** In 1912 Barnes operated a Columbia studio at 1633 Main Street.[54]

**William H. Lyles, Jr., Deaver C. Blackwell, and the Escobars.** Lyles opened a studio in 1914 at 1438 Main Street and remained there until 1916, when he moved to 1511 Main Street, the former location of J. P. Howie's studio. He continued his business at 1511 Main through 1930.

In 1931 the studio name was changed to Blackwell's Studio. Apparently Deaver C. Blackwell and William H. Lyles, Jr. went into a partnership at that time. After 1931 both Lyles and Blackwell disappeared from the Columbia photographic scene.[55]

From 1914 to 1927 members of the Escobar family worked as assistants in the Lyles studio: Aurelio C., from 1914 to 1916 and 1919; Ignatio H., from 1917 to 1927; and Enrique

(Henry), 1918. Aurelio occasionally independently advertised his services to take birthday photographs.[56]

### World War I Columbia Studios

The location of Camp Jackson near Columbia in preparation for World War I enticed several photographers to open studios in town. Soon after the war ended and the troops departed most closed their businesses. However, a few photographers, such as Lella Lindler, Fred Toal, Plase A. Lollar, and John A. Sargeant, established studios that operated for years to come.

### Short-term Studios, 1918–21

The short-term operators of photographic businesses during the war and shortly thereafter were: Adams & Hinson, 1917 and 1918, National Loan and Exchange Building; Otto W. Elsner, from 1918 to 1921, Columbia Art Co., 1225 and 1219 Taylor; Harry Rudolph, 1918, The Electric Studio, 1211 Gervais; John Spillman, 1918, 1538½ Main; Charles E. Mills and A. Dean Thrasher, 1918, The Camp Jackson Studio, 1423 Main; Robert W. Shepherd, 1919, Shepherd's Studio, 1423 Main (same location as Mills and Thrasher); Barney Smith, 1919, 1716 Gadsden; H. C. Bruns, 1920, Cola. Photo Finishing Co., 1112 Taylor; J. G. Tegu, 1921, Blue Light Photo Studio, 1204 Main; Louis Marino, 1919, 1225 Main.[57]

### Long-term Studios

**JOHN A. SARGEANT.** Sargeant worked as an assistant to Blanchard as early as 1914, but by 1918 had opened his own photographic business. Sargeant operated at several locations; 1918–19, 1921–24, 1623 Main; 1920, 1615 Main; 1925–40, 1528 Main. In 1940, when he sold out to the Reeves Studio of Atlanta, Reeves dispatched Curtiss Bartlett Munn to Columbia and he operated the business for a few years under the Sargeant name.[58]

Sargeant did not confine his work to Columbia, but engaged in photographic activities in many areas of the state. In 1914, while working for Blanchard, he photographed textile mill scenes in Lancaster. When the Cleveland School near Camden burned in 1923, killing seventy-seven men, women, and children, Sargeant recorded the burying of the bodies and other aspects of the tragedy. In the 1930s he photographed Cheraw State Park for the Work Progress Administration (WPA). In 1928, 1929 and 1932 he was in Newberry taking photographs for the Newberry College annual. Sargeant took the short trip to Camp Jackson during World War I and later where he produced many photographs of soldiers and the camp. In 1928 he joined briefly with Raymond A. Lecoq in a studio in Sumter. Lecoq continued the business alone for several years thereafter. In 1930 Charles W. Old joined the Columbia firm and worked there until 1937.[59]

Sargeant's work included such varied subjects as studio portraits, panoramic views of Columbia, convention groups, press photographs, photographs taken for the WPA, postcard

*Photograph of the ruins of Cleveland School, taken by John A. Sargeant on 18 May 1923, the day after the school burned to the ground, killing 77 men, women, and children. Courtesy of the Camden Archives and Museum.*

*Photograph of the mass grave being dug at Beulah Methodist Church for about 70 of the Cleveland School fire victims, taken by John A. Sargeant on 18 May 1923. Courtesy of the Camden Archives and Museum.*

views, school annuals, and school pictures. Like those of Blanchard his photographs may be found today as illustrations in newspapers, periodicals, and postcards.

**PAUL F. BAUKNIGHT AND FRED TOAL.** Bauknight first appeared in Columbia photographic listings in 1916 as proprietor of The Columbia Portrait Co. By 1917 Fred Toal had joined him. The directory gave a residential address for their business. By 1918 Bauknight had dropped from sight and Fred Toll (Toal) was listed as a photographer in Olympia, but with only a residential address. From 1919 to 1920 Toal was proprietor of Holland's Studio at 1435 Main Street. In 1921 Toal and Plase A. Lollar worked together, but by the next year each had gone his separate way. Toal continued his studio at 1435 Main until 1955, after which time it was continued by the family for several years.

Many political and civic leaders of the period were visitors to Toal's gallery and were rewarded with a well-done portrait. He also competed with Sargeant and others for the school annual business.[60]

**R. R. BEATTY AND PLASE A. LOLLAR.** From 1918 to 1921 Beatty operated a studio at 1647 and 1647½ Main Street. Plase A. Lollar joined him in their "Kodak Studio" in 1920 where they processed film and produced portraits. In 1921 he and Fred Toal worked together for about a year. By 1922 Lollar had opened his own studio at 1423 Main, producing portraits and other photographs there for the next ten years. Lollar attempted to attract out-of-town customers by advertising in Camden and Bamberg. In Columbia photographic circles he never received the patronage or achieved the stature accorded to Blanchard, Sargeant, Lindler, and Toal.[61]

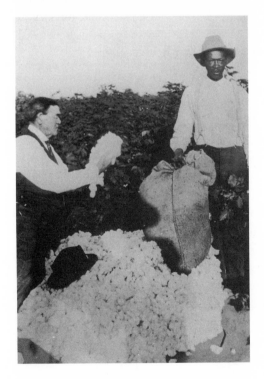

*Photograph of a cotton field by Lollar Studio. Copied from a slide from the History of South Carolina Slide Collection by Dr. Constance B. Schulz. Courtesy of the Calhoun County Museum.*

*A mailer used by Lollar in his Columbia studio in 1927. Collection of the author.*

## Darlington

**W. G. Graham.** This studio, begun in 1913, was described that year in these terms: "The gallery, The Graham Studio, located over T. E. Sligh's store, is one of the most attractive places in Darlington, and there is every facility for the execution of the finest class of work. This business was established in November-1913, and since its inception has met with a gratifying success. Since his establishing himself in business here, he has been actively identified with the business life of Darlington and is one of the most progressive citizens."[62]

**Satchwell's Photo Gallery.** This gallery was in operation in 1904.[63]

**Angus Gainey.** Beginning around 1914 Angus Gainey established a bicycle and furniture store, but soon branched out to other merchandise. Included was the production of "Penny pictures, Post Cards And Larger Photos." Gainey called his business the Old Barn. Some of his photographs and a few of his glass negatives have survived.[64]

## Denmark

**E. E. Burson.** In the early 1960s Mr. Nyles Rowell of Denmark was dismantling an old building when he noticed small oblong pieces of glass in one room of the building. At first he thought these may have been scrap glass from a glass cutter, but on closer examination, he noticed each carried a "picture" on its surface. He saved them, and in the process, preserved some of the work of local photographer, E. E. Burson. In 1995 Rowell gave about 300 glass negatives to the South Caroliniana Library for conservation, cataloging, and use by scholars and others. Included in Mr. Rowell's bequest was the small, hand-lettered, wooden sign Burson used over his studio door.

Burson operated in Denmark and the surrounding area from about 1905 to 1920. In 1915 he produced views for postcards of the nearby town of Bamberg. Burson produced many portraits of the local citizenry and views of Denmark and its environs. Of particular note were about 100 portraits of African Americans and of their nearby college, Voorhees.[65]

Burson's work in Denmark in capturing local scenes compares to that of D. Audley Gold of Blacksburg and June Carr of Gaffney. However, Burson's work does not possess the

same artistic quality as that of Carr and Gold. Gold and Burson appear to have documented African Americans to a greater degree than Carr.

### Dillon

**J. M. BRIDGMAN.** In February 1914 Bridgman advertised producing photographs with family groups a specialty.[66]

### Easley

**N. D. TAYLOR.** In the Easley newspaper of 30 July 1902 Taylor stated he could now provide even better work than that of the past, indicating previous work in Easley. In 1902 his studio was over Ellison Brothers' store. In February 1905 he boasted of having produced more than five thousand photographs the previous year. Later that year and in 1906 he advertised adding a skylight to his studio.[67]

**J. ADGER SMITH.** The *Easley Progress* in October 1933, some twenty-four years after J. Adger Smith came to town and set up his photographic studio, carried this brief history of the business:

*In the 1960s Mr. Rowell removed and saved this wooden hand-painted sign from above the room where E. E. Burson had his Denmark studio. SCL.*

*Photograph by E. E. Burson of the Bank of Denmark. SCL.*

Mr. J. Adger Smith, owner of Smith's Studio, was born and reared in the upper section of Anderson County. When a young man he went to Belton, S.C., and established a studio, remaining there for six years. Leaving Belton he went to Conway, Arkansas and worked as a photographer for three years. Then in 1909 he moved to Easley and established Smith's Studio. His office was located over what is now the City Market and at that time the postoffice was also in this building.

In 1920 Mr. Smith built his present studio and moved into it. He purchased new equipment throughout, took a special course in oil coloring, and set up a modern studio.

Smith has for a number of years had an average of 3,000 sittings during a twelve month period. Besides photographs he carries picture frames, kodaks and other photo supplies. He makes picture frames to order, enlarges kodaks or photographs and finishes pictures in color.[68]

Smith often advertised in the local press between 1920 and 1940, and the papers often illustrated feature articles and news accounts with Smith photographs. Smith's advertisements provide us with a description of his work: "Post Card Photographs," "Graduation Photographs," "One sitting during the Fair," "Christmas Photographs," "Dollar Day and Trade Festival Week Photographs," "New Year Greetings To All," "The True Gift, Your Photograph," "Spring Time, Kodak Time," "Enlargements," "Frames."[69]

One of his ads provides much more, an insight into religious beliefs in the Piedmont of South Carolina during the Depression years. "Visit Your Church Each Sunday and on Monday Get Our Prices On Photos, Smith Studio."[70]

### Fort Mill

**Z. E. SCOTT.** Scott advertised a photographic business scheduled to operate for a week in October 1906 on the second floor of the Massey Building. He indicated it was a branch studio, but did not indicate where his main studio was located, perhaps Rock Hill, York, or Charlotte.[71]

### Gaffney

**JUNE H. CARR.** June Carr became interested in photography as a teenager and photographed family members. He studied photography at the Illinois Institute of Photography at

# Graduation
# Photographs

Essential as the diploma itself is a photograph of your boy or girl at graduation.

In a few short years it will become a priceless treasure to you—cherished for its faithful record—your child at the dawn of a new era in life.

Our new process printing on special toned paper is the highest development in photographic art.

## Smith's Studio
### Easley, S. C.

*Ad for J. Adger Smith's Gallery.* Easley
*Progress, 30 April 1924. SCL.*

**Construction of Electric Power Co.'s main dam across Broad River, near Gaffney, S. C.**
June H. Carr, Photographer

*SCL Photographic Collection.*

Effingham, Illinois, and did his first work professionally in Otto Billig's studio in Liberty, New York. While there he became interested in architectural and landscape photography and met his future wife. In 1902 Carr journeyed South in search of a suitable location for a studio and settled on Gaffney.[72]

On 18 March 1902 he advertised his plans to open a Gaffney gallery and opened it three days later. From that time until early 1904 Carr advertised repeatedly in the local press. His ads touted "expert photographer," "Best equipped studio," "High-Class Photography," "Art and Nature Photography," "Christmas Sittings," "Pleasant Visions," "Pleasing Prospects," "Visionary." After 1904 he seldom advertised, indicating he was probably well-established by then.[73]

During these early years his studio was in the 500 block of North Limestone Street. About 1907 he moved his studio to the Baker Building and maintained a studio there until his retirement in 1950.

For more than forty-seven years Carr artistically recorded the faces and places of Gaffney and Cherokee County. A book featuring seventy photographs printed from glass negatives of Carr in the Cherokee County Library collection was published in 1975.[74]

According to Callison and Moss in their 1975 work on Carr, he participated in a first in American photography: "Carr's photographs of a nursing home in Cherokee destroyed by fire was the first ever transmitted by wire, a feat scarcely known in this community that was his home for better than half a century." Their reference was to the first transmission over the Associated Press Wirephoto Service and not to the first ever transmission of photographs by wire.[75]

*Photograph by D. C. Simpkins of a building in Georgetown, sent as a compliment to Governor Martin F. Ansel. SCL.*

*Copy print of photographer D. C. Simpkins from an original photograph in the possession of a family member.*

## Georgetown

**D. C. Simpkins.** Simpkins came from New Bern, North Carolina, to Georgetown in late 1901, set up a gallery on Front Street over O. B. Lawrence's Store, and became Georgetown's first long-term resident photographer. In the summers for several years he also operated a studio on Pawleys Island.[76]

Scenes of hunting, farming, fishing, parades, street work, fire company rallies, buildings, churches, and portraits of people were the products of Simpkins's camera. A large sample of this work was collected by the Georgetown civic leader, William Doyle Morgan, and today is in the Georgetown Public Library and the South Caroliniana Library. These photographs were the major portion of photographs used by the Georgetown Public Library in their 1992 pictorial work on Georgetown covering the period, 1890–1910.[77]

Simpkins married Emily Jane Hurcomb, a local girl, raised a family, and engaged in a number of pursuits. Over the years he was owner of an amusement parlor, owner of the first movie theater in Georgetown, and was a commercial fisherman.[78]

## Greenville

**Lewis & Hartzog.** These men produced postcards of Greenville scenes in 1908.[79]

**L. A. Bernhardt & Co.** Bernhardt first appeared in a Greenville city directory in 1910 at 211 W. Washington Street. In 1911 Bernhardt advertised "The Very Latest" photographs produced in his studio and that many of the Furman University *Bonhomie* illustrations were his work. In 1912 this firm operated a gallery at 4–5 Mauldin Building and in 1913 at 130½ Main Street.[80]

**O. L. Collins.** Collins was listed with a studio at 1415 Buncombe Street in 1912.[81]

**Charles E. De Mulder & Son.** De Mulder first appeared in Greenville in 1909 at 402½ Main Street; in 1912, at 110½ West Coffee and 402½ South Main; in 1915 through 1917 and 1921, at 219½ N. Main; in 1919, 317 South Main opposite post office. In 1910 De Mulder advertised in the Furman University *Bonhomie* as frame makers at 402½ Main and producers of "Pictures day and night over Williams & Woodside grocery store on Coffee Street." In 1919 he advertised his gallery as an "Art Shop."[82]

**L. F. Long.** In 1912 Long had a gallery at 17 McPherson Building. A Furman L. Long served in the South Carolina House of Representatives in 1918 and 1919 and a biographical sketch listed him as a photographer.[83]

**W. C. Moore Art Co.** In 1912 they operated from 13–23 Vickers-Cauble Building in Greenville.[84]

**A. G. Sands.** His studio was located at 216½ N. Main Street over the Lyric Theater in 1912. After 1912 Sands operated a gallery in Greenwood called the "Gem Shop."[85]

**James H. Orr.** The first listing located of Orr's photographic studio in Greenville was in 1913 at 216 N. Main Street. Orr advertised himself as the successor to A. G Sands who operated at that address the previous year. From 1913 to 1947 the Orr studio was a fixture in Greenville: from 1913 to 1918 at 216 N. Main, from 1921 to 1924 at 125½ S. Main, from 1926 to 1937 at 23–A S. Main, and from 1938 to 1947, 23½ S. Main.[86]

*A copy print of a photograph of the Reedy River Falls, taken by the Orr Studio and included in the 1915* Bonhomie. *Courtesy of the Furman University Library.*

Probably from the outset of the business in 1913 Mrs. Orr actively participated as a photographer. The Orrs specialized in portraiture, although they produced other kinds of photographs. From 1915 to 1920 the studio produced all of the photographs for the Furman University *Bonhomie*. These photographs included buildings on the college campus. Today many families of Greenville have examples of the Orrs' work in their albums.[87]

After her husband's death, Mrs. Orr became the sole operator of the studio in 1935 and continued the business to its close in 1947.[88]

**J. R. PEDEN.** Peden operated a studio at 402½ S. Main by 1901 and worked at that location until 1904. He dropped from sight photographically until 1917 when he operated a studio at 107½ N. Main. World War I and Camp Sevier probably were the chief factors in his returning to business at that time. On a photograph of the 220 Field Signal Battalion he took at Camp Sevier, he listed himself as "Post Photographer." After 1924 Peden may have departed Greenville.[89]

**CAMP SEVIER AND PHOTOGRAPHY.** In 1903 Greenville was served by three photographic studios. Between that date and 1917 a number of short-lived studios located in town. In 1917 only the studios of Charles De Mulder & Son, Wheeler & Son, and Mr. & Mrs. James H. Orr were long-term ones. Between 1917 and 1919 a total of ten different studios located in town, but five of them disappeared by 1921.

The five short-term studios were: John R. Shelkett, from 1917 to 1918 at 25½ S. Main and from 1919 to 1921 at 1214 Vickers Cauble Building; P. A. Merrell, from 1917 to 1918 at 125½ S. Main and in 1919 at 118½ S. Main; Cling M. Bawgus, 1919 on Pendleton, near W.

Side Avenue; Luther C. McCurry, 1919 at 117½ S. Main; D. W. Scalf and George D. Sherrill, 1919 at 122½ N. Main. The residence of Scalf was listed as La Follette, Tenn. The remaining four studios established during World War I that continued after 1921 are next described. The studio of J. R. Peden also falls into this latter category, but was treated earlier.[90]

**J. WOODFIN MITCHELL.** By 1919 Mitchell operated the Camp Sevier Studio at 211½ W. Washington Street. He probably opened this studio in late 1917 or early 1918. By 1921 he had given his name to his studio at 209–211 W. Washington Street. In 1922 he and W. M. Wheeler, Jr. worked together and were the photographers for the Furman University *Bonhomie* that year. Mitchell was listed alone at his Washington Street studio in 1923 and 24.

The city directory of 1921 listed Mitchell as vice president of the Southeastern Photographic Association.[91]

**B. A. CULBERSON.** Culberson's Portrait Studio at 118½ S. Main operated by 1919 and continued at that location until late 1924 or early 1925.[92]

**HENRY T. CHASTAINE.** The Greenville Studio at 201½ S. Main Street was operated by Chastaine by 1919. In 1921 he operated from 107½ N. Main; in 1923, 216½ N. Main; in 1924, 218½ N. Main; in 1926, 118–A N. Main; in 1928, 116–A N. Main; in 1931, 24–A N. Main. He did not appear as a Greenville photographer after 1935.[93]

**WISTER H. McKITRICK.** McKitrick's Studio was in operation at 122½ N. Main by 1919. Scalf and Sherrill also operated from that same address, but their studio seemed a separate business to that of McKitrick. In 1923 and 1924 McKitrick operated at 4 Mauldin Building. In 1930 he operated the Cut Rate Studio at 528 S. Main Street and from 1935 to 1940, the New Studio at 10–A North Main Street.[94]

*Greenwood*

**JAMES HENRY NICHOLS AND HIS FOUR SONS.** In the period from 1900 to 1935 James Henry Nichols became the first of five Nichols studios in South Carolina, his studio

*Photograph of the four Nichols brothers who were photographers. Left to right—Leon Dupont, J. Horace, C. Eston, Henry Orion. Courtesy of Mr. and Mrs. Murphy Hall.*

*Portrait by Henry O. Nichols of an unidentified woman. SCL.*

*Photograph of Presbyterian College by C. Eston Nichols. Copied from the 1936 Pac Sac. SCL.*

*Nichols Studio photograph of the Salter camera that was used by the Salters and Nichols to take tens of thousands of photographs. This camera is now owned by the present day Nichols Studio in Newberry. Courtesy of Mr. and Mrs. Murphy Hall.*

and one for each of his four sons. The Nichols became the rival of the Salters of Newberry as the premier South Carolina "photographic" family.

James Henry first operated his studio in Laurens. By 1902 he had moved to the Bailey-Barksdale Building in Greenwood. In 1906 a Nichols studio in Chester was probably that of James Henry. By 1908 he relocated his Greenwood studio to 326 Waller Avenue and continued there until his son, J. Horace Nichols took over in 1936. During this period of time he apparently also operated a Laurens studio at 103 ½ Main St. from 1911 to 1917, and for a time on Wednesdays in 1910, operated a studio in Clinton. Although the Greenwood studio once burned, destroying negatives and prints from its earlier period of operation, today David Nichols, a grandson of James Henry and son of J. Horace continues the business.[95]

From 1918 to 1990 Henry Orion Nichols, the eldest son of James, operated a studio in Chester. He learned photography from his father and from study at Effingham College. For a short period of time he practiced his profession in Cuba before locating in Chester. Today his negatives and many prints are a part of the collection of the Chester County Museum and provide an extensive documentation of this area of South Carolina.[96]

Another son of James Henry, C. Eston, operated a studio in Clinton. From 1933 to 1936 he produced the photographs for the *Pac Sac,* the Presbyterian College annual.[97]

*Photograph of Leon Dupont Nichols and his camera on an outdoor shoot. Courtesy of Mr. and Mrs. Murphy Hall.*

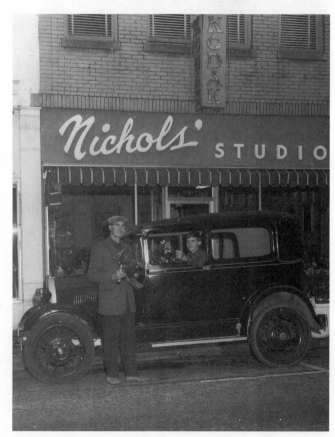

*Photograph taken of Leon Dupont Nichols and his son Leon, Jr., standing by a Model A Ford parked in front of the Nichols Studio (circa 1965). Courtesy of Mr. and Mrs. Murphy Hall.*

For a few months in 1933 Leon Dupont, the youngest of James Henry's sons, produced "penny pictures" in Marion, but by September opened a studio in Newberry that he operated until 1987. Today his daughter and her husband, Mr. & Mrs. Murphy Hall, operate the studio. Soon after Leon Dupont began his Newberry studio he purchased one of the Salter cameras and some other equipment. This camera is still used occasionally today. Over the course of its life, the Salters and Nichols probably shot more than a quarter million photographs through its lenses. Today the Halls have more than a quarter million negatives on file dating from 1933, but of course many were not shot on the "Salter" camera.[98]

Currently the photographic tradition of the Nichols family continues through studios in Greenwood and Newberry plus a studio in Rock Hill operated by Joel Nichols, grandson of James Henry and the son of J. Horace. For a century from their studios in Rock Hill, Chester, Newberry, Clinton, Greenwood and Laurens the Nichols family has recorded more of the faces and places of upcountry South Carolina than that of any other family.

**W. H. Hughes, Jr.** Hughes operated a gallery at 429 Main St. from 1912 to 1913. He did not appear in any other listings for Greenwood although a Mrs. E. Hughes operated a studio at 205 National Bank in 1916 and 1917. She may have been his wife.[99]

**J. V. & E. R. May & M. G. McDowell (Southern Art View Co.).** This company had a studio at 14 Masonic Temple in 1912 and 1913. J. V. & E. R. May and M. G. McDowell were listed as the photographers for the company. They may have produced postcards.[100]

**Peden's Studio.** In 1920 this studio advertised "High Class Portraits" in a Lander College literary magazine. Their business was located at 501–503 National Bank Building. During this period a J. R. Peden operated a studio in Greenville and may have had a connection with this Greenwood gallery. Extant city directories for Greenwood that are closest to 1920 are 1917 and 1923 and neither mention Peden.[101]

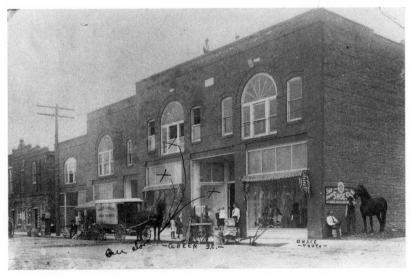

*Postcard photograph of downtown Greer, produced by C. W. Drace. SCL.*

*Photograph of members of the Stokes
family, produced by W. A. Hatchell.
SCL.*

### Greer

**C. W. DRACE.** From 1901 to 1911 Drace operated a photographic business in Greer. His scenes of Greer and picture postcards are extant from this period.[102]

### Hartsville

**W. A. HATCHELL.** Hatchell advertised a "permanent" studio on Avenue B. in Hartsville in June of 1908. By September he added an enlarging service to his studio. Hatchell apparently took his studio on the road as he was in Bishopville in November 1908 for a few days during the time the local carnival was in town. His ad stated, "Everybody knows me," indicating previous visits to the area.[103]

### Honea Path

**CLYDE CAMPBELL.** Campbell operated a business in Honea Path from his home taking photographs of local subjects including school pictures during the decades before and after World War I.[104]

*Miles O'Reilly mailed material from his studio to Mrs. G. W. Whetstone in this envelope. Collection of the author.*

## Montmorenci

**ROBERT LEE CLELAND.** Cleland (1874-1950) grew up in Hampton county near Brunson and learned photography at some point. After his marriage to Lillian Phillips, the couple located in the small community of Montmorenci, a few miles from Aiken. Here he practiced photography for a time in the early 1900s, but, due to the illness of a daughter, moved back to Hampton County near his home place. For a number of years he practiced photography in Varnville and Hampton and his photographs are found on picture post-cards. He produced noteworthy photographs of fires in Varnville and of tornado damage in the area in 1918.[105]

## Mullins

**J. C. WEBB.** Webb produced postcard scenes of Mullins c. 1920.[106]

## North

**MILES O'REILLY.** In the early 1900s Miles O'Reilly, Sr. opened a gallery he called the North Studio and for the next fifty or more years he and later his son, Miles O'Reilly, Jr. produced photographs and provided film processing for "Kodakers." A camera from this studio was given by the family some years ago to South Carolina State College at Orangeburg, South Carolina. The senior O'Reilly also served as mayor of North for several years.[107]

## Norway

**M. P. HUFF.** A single small photograph dating c. 1910 and bearing an M. P. Huff photographic studio trademark, serves as the only evidence of Mr. Huff's Norway studio.[108]

## Orangeburg

**G. E. Smith.** In 1920 and 1921 Smith produced portraits, enlargements, Kodak developing, and hand coloring at his 33 W. Russell Street studio.[109]

## Rock Hill

**Vale & Hemphill.** In 1902 these men operated a gallery opposite St. John's Church on Main Street. They offered special prices to summer school teachers attending Winthrop College. They advertised group pictures and Kodak developing and printing.[110]

**R. M. London.** London produced picture postcard views of Rock Hill in 1908.[111]

**Thomas W. Joyner.** The first Joyner ad located, a 1906 one, referred to him as "J. W.," but subsequent ones used the initials, "T. W.." In 1906 he claimed a business experience of eight years and the capability of producing any picture desired at his 206 East Main Street studio. He remained in Rock Hill at least to 1909.[112]

**Gem Photo Company.** For a short time prior to Christmas 1907 this company produced 28 photographs for 25 cents from the Old Armory Hall over Bailey's Stable. After Christmas they dropped their price to 28 photographs for 15 cents.[113]

**Wheeler & Steele & S. Steele.** Steele first appeared in Rock Hill in business with Wheeler on Hampton Street in 1911. By 1913 she apparently operated a studio on Hampton Street as its sole proprietor. Additional information is presented in chapter 10 on Miss Steele.[114]

**Thackston Studio.** From at least the early twenties to the 1940s this studio operated in town: 1925 and 1926, 100½ E. Main; 1936 to 1940, S. Trade, corner E. Main. The studio placed ads in the Winthrop College annual and appeared to benefit from Winthrop College student business. Lillian F. Thackston managed the studio for a time in the 1930s.[115]

## St. Matthews

**Boeckman.** From 1907 to 1912 this man came to St. Matthews for short periods of time and produced photographs. As an itinerant photographer working this area of South Carolina, he apparently did not venture very far since he did not show up in other areas of the state.[116]

## Spartanburg

**McLean's Photograph Gallery.** McLean operated his gallery at 38½ Magnolia Street in 1901. In the 1870s an R. B. McLean worked in Marion and may have been the same individual.[117]

**Hugh T. Hart.** Hart first appeared in photography in Sumter in 1904 with a studio located over Bultman Brothers' shoe store at 33 North Main Street. By 1905 he had

moved two doors to 31 North Main Street. While in Sumter Hart employed an assistant named Wiltse Glick.[118]

For most of the period from 1905 to 1930 Hart operated a studio in Spartanburg. He was proprietor of the Magnolia Studio at 38½ Magnolia Street in Spartanburg in 1905. By 1911 he turned up as proprietor of Hart's Studio at 156½ E. Main. In 1914 and 1915 Hart was joined by Volley W. Cole in the Electric Photographic Studio at 165 W. Main Street, but operated a studio alone at 165 E. Main the next year. From 1916–30 the Hart Studio, although in town and operating, moved about: from 1918 to 1920, 164 E. Main; from 1922 to 1924, 141½ E. Main; 1926, 147½ E. Main; 1927 and 1928, 110½ N. Church; and from 1928 to 1930, 121½ E. Main.[119]

**VOLLEY W. COLE.** Cole first appeared at 127½ W. Main in 1911, but joined with Hart by 1914 in the Electric Photographic Studio at 165 W. Main. By 1918 Cole operated a studio at 21½ N. Public Sq. in Darlington, South Carolina and that year produced the photographs appearing in the *Echoes,* the St. John's High School annual.[120]

**WILLIAM J. B. STILES.** Stiles operated a gallery for a time in 1913 at 187 N. Liberty Street.[121]

**J. T. GILBERT.** According to the 1914-15 local directory, Gilbert operated a studio for a time at 127½ W. Main Street.[122]

**S. A. MASSEY.** According to the 1914-15 local directory Massey operated a gallery on Whitney Rd. for a time.[123]

**CAMP WADSWORTH AND LOCAL PHOTOGRAPHY.** With the establishment of Camp Wadsworth near Spartanburg during World War I, thirteen additional studios located in town by 1920. Only two of these thirteen remained after 1920. During the World

*Photograph by Boeckman of a St. Matthews group. Courtesy of the Calhoun County Museum.*

War I period directories for only the years 1916, 1918 & 1920 could be located. Most of the eleven short-term studios first listed in 1918 were gone from the area by 1921.

The eleven short-term studios were: W. J. Armstrong, 1918, 117½ E. Main; Wm. Cummings (Cummings Studio), 1918 149½ W. Main; A. J. Cunningham, 1918, 131½ W. Main; Doc Henry (Doc Henry's Picture Shop, 1918, 127½ W. Main; J. M. & S. A. McCandless (McCandless Brothers), 1917 146½ Magnolia; Robert McKernan, 1918, 106½ W. Main; Princess Palace, 1918, Sam Loef, Pres., Max Green, V. P., Jack Robin, Sec. & Treas.; Julius Gordan (New York Bazaar), 1918, 150 W. Main; H. W. Pelton, 1918, 31–32 Lee Building; C. H. Schlecter, 1918, 35 Lee Building; C. W. Robinson, 1920, 106½ W. Main.[124]

**George F. Donnahoo and J. D. Owen.** Donnahoo established a studio at 113½ E. Main by 1918. J. D. Owens worked there as an operator in the beginning years of the business. For at least the next twenty-two years the Donnahoo Studio operated in town, although it changed locations a few times: from 1918 to 1924, 113½ E. Main; 1926 and 1927, 115½ E. Main; from 1928 to 1940 147½ E. Main.[125]

**John F. Manning.** Manning began his business by 1920 at 115½ W. Main, but operated from 222 E. Main from 1927 to 1934. In 1920 Utley was listed as a partner or business associate.[126]

*Sumter*

**Fletcher R. Simpson.** Simpson worked out of his home located at 331 West Hampton Avenue in 1909 and 1910.[127]

**George V. Lewis.** Lewis was an itinerant photographer from Indiana who worked in the Sumter area in 1909.[128]

**Vernon D. Glover.** In 1917 Glover worked as a photographer from his residence at 10 E. Hampton Avenue.[129]

**Daniel Ernest Williams.** Williams' first recorded studio in South Carolina was in Charleston at 401 King Street in 1912, but by 1913 he had departed the city. By 1917 he operated Williams Cute Studio at 28 North Main Street in Sumter. He relocated his studio to 17½ Main Street over DeLorme's Pharmacy by 1923 and remained there for a number of years. Williams frequently advertised his framing, finishing and film processing services in the local papers. He often linked his ads to holidays such as Christmas or to a Mother's Day observance.[130]

Williams expanded his business in 1938 by opening studios at 1417–a Main and 1115½ Washington Streets in Columbia. The manager of these studios was G. Doyle Rutland. By 1940 Williams operated only the Main Street studio and had discontinued the Washington Street one.[131]

Williams employed others to help operate these studios. During World War II two sisters, Vivian and Ophie Hyatt, took photographs of servicemen in these studios as the expanding military populations of Camp Jackson and Shaw Air Force Base brought in new customers. Vivian remembers long lines of soldiers on Main Street in Columbia waiting for the studio to open in order to secure pictures of themselves for loved ones.

Another female, Helen Rowe, also worked for Williams during World War II. Williams married her after the death of his wife and the two moved to Morehead City, North Carolina, after the war where they opened a photographic studio.[132]

**ASHBY NEWELL.** Newell operated an itinerant business from his home in Sumter County from about 1910 to 1925. Most of his customers were located in the rural areas of Lee and Sumter counties.[133]

## Union

**ANSON TRAIL.** Trail operated a Union photographic gallery in 1911 and 1912 at 20 W. Main Street. Very few examples of his work have survived.[134]

**W. A. WHITE.** White operated a gallery in Union in 1911 and 1912 at 36 W. Main Street.[135]

**N. C. OLIVER.** Oliver produced postcard views of Union in 1917.[136]

**WILLIAM F. HENDRICKS.** According to the 1920-21 local directory, Hendricks operated a Union gallery in the Foster Bldg. that he named "Studio De Luxe."[137]

## Varnville

**W. H RENTZ.** About 1910 Rentz produced photographs appearing on postcards of Varnville and surrounding area subjects.[138]

## Walhalla

**SMALLS.** Smalls produced a number of Walhalla postcard views and street scenes from about 1908 to 1910.[139]

## Walterboro

**POSTAL STUDIO.** This studio located on Main Street next to the Walterboro Drug Store in 1909 and produced postcard views of local subjects. According to Howard Woody, this studio was operated by the Foltz Studio of Savannah, Georgia.[140]

## Ware Shoals

**MILES F. STEVENSON.** 1910 postcard views of Crows Hill and the residence of James F. McEnroe in Ware Shoals are known with photographic credits to Stevenson.[141]

## Westminister

**WESTMINISTER STUDIO.** The names of the proprietors of this studio did not appear in their 1909 ads. Westminister produced portraits, sold supplies and processed film.[142]

*Williamston*

**L. L. WALLACE.**  Several photographs dating from the early 1900s contain the backmark, "L. L. Wallace, Photographer, Williamston, S.C."[143]

*York(ville)*

**S. W. WATSON.** In 1902 Watson operated a gallery in Yorkville on Cleveland Avenue. A carte de visite of an old man, a baby and a young boy dating c. 1900 produced by him while in Yorkville is known.[144]

**HARRIS.** A fragment of a 1912 publication contains a number of photographs of buildings and scenes in York that contain an "Harris, Photographer" credit line on them.[145]

# Between the Wars, 1921–40

Earlier in this work the rural and agricultural characteristics of South Carolina's economy and culture were described in general terms. During the 1920s and 1930s this picture did not change, but with the coming of the depression economic forces began to bear more directly on the agricultural character of the state and, in the process, directly affect almost every South Carolinian.

In 1930 most of the state's 1,738,765 citizens lived and worked on farms. In that year only two South Carolina cities, Charleston and Columbia, boasted populations of more than 50,000. The populations of Greenville and Spartanburg ranged from 25,000 to 30,000, and those of Rock Hill, Anderson, Greenwood, Florence and Sumter from 10,000 to 15,000. Twelve towns contained populations between 5,000 and 10,000. In towns and small villages, many non-farm families demonstrated their agrarian roots by growing a garden, keeping a few chickens and in some cases a cow and hogs. This was often the case with textile workers who comprised most of the manufacturing labor force.[1]

Farmers grew and preserved most of the meat, vegetables, and corn and wheat their families needed. Farmers and textile workers bought from merchants clothing, shoes, furniture, gasoline, spices, sugar, coffee, and mules. They sparingly purchased photographs.

Although some large farmers employed tractors to pull mechanized farm machinery, most farmers from 1921 to 1940 used mules as a source of power and purchased mule-drawn plows, wagons, and other equipment. Large farmers usually employed tenants and sharecroppers to cultivate their farms. Tenants and sharecroppers and small farmers who owned or rented land relied to a great extent upon their families for labor.

The nation emerged from World War I with a robust, booming economy, but by 1921 one segment of the national economy, agriculture, entered a depression that lasted to the beginning of World War II. South Carolina's agriculturally-based economy suffered to a greater degree than those of many other states. Agriculture in this state largely depended on cotton as the cash crop. The destruction by 1921 of more than fifty percent of this crop by the boll weevil was a serious blow. Crop failures, accompanied by low cotton prices, sank the local economy into a serious depression. By the time the Great Depression began in October 1929, the agricultural depression had ravaged the state for eight years.

The Great Depression administered a severe blow to textiles, the mainstay of South Carolina manufacturing. Many cotton mills closed and others severely reduced workers' hours and wages.

The United States censuses of 1920 and 1940 did not enumerate the number of photographers in South Carolina, but did so for 1910 and 1930. The 1910 census reported 168, but by 1930 economic conditions had reduced the number to 137. Although the population of the state increased by more than 200,000 during this twenty year period, the state had thirty-one fewer photographers, about an eighteen percent decline. Actually the reduction in 1930 from 1920 was probably even more pronounced since the number of photographers in South Carolina steadily increased in each census from 1880 to 1910, and by 1920 probably numbered about 200. On that basis, by 1930 the depression produced a one-third reduction in the number of photographers in the state.

Although conditions in many quarters were desperate, there were signs of vitality in some and a willingness to work for recovery. A number of positive programs were initiated and substantial progress made on several fronts.

The state improved its transportation system by creating a department of government to oversee the construction of roads and bridges and adequately funded these initiatives. This made it possible for all travelers, including photographers, to move more quickly from town to town.

Consolidation of schools into more efficient districts and increased funding of education occurred during these decades. However, the South Carolina literacy rate remained at or near the bottom of the nation; and, statewide, illiteracy served as a damper on many cultural and economic activities, including photography.

Gaffney photographer June H. Carr's involvement in the early transmission of photographs by wire in 1935 has been mentioned. By the late 1930s the United States Forestry Service and the United States Department of Agriculture used aerial photography in their work. Photographs began to occupy an increased percentage of space in many forms of print, especially in newspapers.

In the late 1930s the author's first encounter with "picture making" occurred at the age of eleven when Joe B. Gaskins, using a flash pan for light, took school pictures in Kershaw County from behind a camera he focused from beneath a black cloth hood. This camera very probably was the same one in use by him thirty years earlier in Fort Mill.

Financial circumstances prevented purchases of photographs until the late 1930s for many rural children of the Great Depression. In other words, today many have no baby pictures, but do have family pictures from earlier and more prosperous times.

During the Great Depression Franklin Delano Roosevelt was elected President and, after taking office in 1933, inaugurated many public works programs. Two of these programs, the Works Progress Administration (WPA) and the Farm Security Administration (FSA), contained important photographic components.

## Farm Security Administration Photography

In 1936, under the direction of Roy Stryker, the Historical Records Section of the FSA began to create a photographic archives documenting agriculture in the nation and the work of the agency. Stryker dispatched Walker Evans and other FSA photographers across the

nation with instructions that included ones to produce photographs showing "sub-marginal areas, cut-over land, old estates, decay, erosion and bad mill towns, the relationship of land to cultural decay."[2] The pictures resulting from such instructions are picturesque and artistic and do document these aspects of South Carolina society. However, they do not, nor should one expect them to, present a balanced documentation of the state's society in the 1930s.

Due to shifting governmental priorities produced by international developments, in 1941 Stryker secured the transfer of the Historical Records Section of the FSA to the Office of War Information (OWI). By 1943 Stryker's governmental photographic work came to a close. The large photographic archives of about 77,000 photographs created by Stryker and his photographers were transferred to the Library of Congress.

About 800 of these 77,000 photographs portray South Carolina subjects, but a large percent of the South Carolina photographs were created after 1940, the last year covered by this study. By the end of 1940, FSA photographers Walker Evans, Carl Mydans, Dorothea Lange, and Marion Post (later Wolcott) produced photographs in several areas of the state.

**WALKER EVANS.** Prior to becoming an employee of the FSA, Evans gained some knowledge about South Carolina as he traversed the state on his way to and from Florida. In 1934, on a return trip to New York, he apparently stopped and spent some time with Pulitzer Prize winning author, Julia Peterkin, at Fort Motte, South Carolina, but no photographs are known from this stop-over. In 1936 Evans photographed in the Beaufort and Charleston areas of the state, producing a relatively small number of photographs that primarily featured architecture.

Peter Sekaer assisted Evans while they were in South Carolina and later became the chief photographer for the Rural Electrification Authority. He continued his photographic career after his governmental work and today is recognized as one of the noteworthy photographers of the twentieth century.[3]

**CARL MYDANS.** In 1936 Mydans visited South Carolina as a part of a mission to photograph the Southern cotton industry. He traveled widely and produced images in Anderson, Cheraw, and Lady's Island near Beaufort.[4]

## *WPA and Federal Writer's Project Photography*

The Federal Writers' Project, a division of the WPA, employed historians, writers, editors, and others who, among their many activities, developed historical guides to various states. These guides relied heavily upon photographs.

In South Carolina the Writers' Project was housed on the University of South Carolina campus. Miss Mabel Montgomery directed the project with Louise Jones Dubose ably serving as her assistant. These two, with the assistance of others such as editor Walter Connelly, developed a number of publications, one of the most significant being *South Carolina: A Guide To The Palmetto State*. This 539-page book contains 102 photographs taken by Montgomery, Dubose, and Connelly or secured by them from others.

It is unclear whether Montgomery employed and paid professional photographers to produce photographs for her or bought selected photographs from them and others.

*Photograph of the railroad draw-*
*bridge over the Intracoastal Water-*
*way at Myrtle Beach, produced by*
*Mabel Montgomery. SCL.*

However, she apparently engaged in some of these activities, since the Writers' Project archives contain dozens and dozens of photographs produced by photographers such as Carl T. Julien (Columbia), Marion Post Wolcott of the FSA, Howard R. Jacobs (Charleston), John A. Sargeant (Columbia), W. Lincoln Highton, Walter Connelly (an editor), Hart Studio (Hartsville), Warren Studio (Orangeburg), Wilson (probably of Savannah), Carlisle Roberts (Columbia), The Pryors (Falls Church, Va.), plus many more. Actually thirty-eight individuals and agencies supplied photographs used to illustrate the guide. Miss Montgomery departed from current practices by giving every photograph in this guide a credit line and in most instances named the photographer.[5]

The securing and selecting of photographs for publications was left to local officials. George W. Cronyn, Associate Director, Federal Writers' Project, on 13 July 1936 informed Miss Montgomery: "We have no absolute rule about photographs except that we do want them to be as fine as possible. If you get a good selection we would like to see the whole lot and offer suggestions as to which ones seem most appropriate, leaving the final decision, of course to your judgment."[6]

After the Writers' Project folded in 1941 their files were turned over to the South Caroliniana Library. Included in these files are hundreds of photographs and picture postcards. In fact, for a number of years the Library followed the Writer's Project filing system for photographs of People, Places and Things. The postcards form the nucleus of the Library's collection today.

*Hauling cotton to market. Copied from* Handbook of South Carolina. *SCL.*

*Kaolin mining near Aiken, South Carolina. Copied from* Handbook of South Carolina. *SCL.*

Due to the integration of the Writers' Project photographs into the Library collection, in order to study them for source, number, content, and quality, it became necessary to identify and separate them. This study revealed that the Writer's Project left a South Carolina photographic archive larger than the South Carolina section of the FSA and the OWI. Furthermore, the Writer's Project archives include the work of a large number of predominantly local professionals and amateurs whose photographs more diversely illustrate South Carolina society in contrast to the more narrowly focused FSA and OWI archives produced by a few individuals from outside the state.

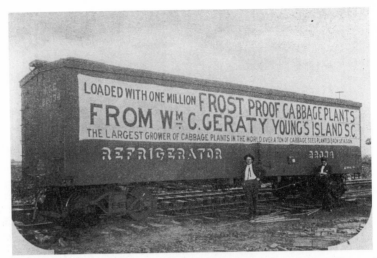

*Cabbage plants on freight car for shipment, produced by William C. Geraty of Young's Island.* Handbook of South Carolina. *SCL.*

FSA, OWI, and WPA are but three examples of photographic work resulting from governmental activity. Wartime photographs produced in South Carolina from 1861 to 1865, also resulted from governmental activity, in that case, the United Stated military. As the twentieth century unfolded state, county, and municipal governments employed photography on a regular basis in many aspects of their work. The 616 page *Handbook of South Carolina,* produced in 1908 by the South Carolina Department of Agriculture, Commerce, and Industry, contains 447 photographs as illustrations.[7]

## Motion Picture Film Footage of South Carolina Towns

In 1911 motion picture film footage produced by the Ad Club of Columbia featuring town scenes was shown at the Corn Exhibition, and in 1913 some footage of the Exhibition was produced and shown. In 1914 John A. Sargeant filmed some Lancaster scenes. In 1925 the *Columbia Record* began production of a motion picture titled "Columbia's Hero." A few scenes for "Gone With the Wind" were shot at Boone Hall Plantation near Charleston and similar scenes appeared in a few other films. But prior to World War II, little motion picture film was shot of South Carolina subjects in the state. Some motion picture footage was produced by a North Carolina photographer in South Carolina towns.[8]

**HERBERT LEE WATERS.** From 1937 to 1942 Herbert Lee Waters of Lexington, North Carolina, shot motion picture film footage of streets, churches, and businesses in several towns in Virginia and North and South Carolina. After shooting film in a town, he would then make arrangements with the local theater owner to show his film footage as a short subject on the weekends for a share of admissions resulting from local people coming to see themselves "in the movies." Waters undertook this endeavor to subsidize his "depression strapped" photographic studio. Sometimes he earned as much as $150.00 a weekend.

In the course of his work he produced film footage of Great Falls, Winnsboro, Hartsville, and Camden. Some years ago the South Carolina State Museum acquired the South Carolina portion of Waters' work.[9]

## Photographers

### Aiken

**FRUEDY.** This New York City based studio operated a branch gallery in Aiken in the 1920s and 30s. In 1935 this studio produced most of the photographs appearing in Harry Worchester Smith's *Life and Sport in Aiken and Those Who Made It.*[10]

**CATOE.** This studio operated in the 1930s and produced photographs of local sporting events and scenes.[11]

**KIRKLAND.** The Kirkland Studio produced portraits and other types of photographs in the 1930s.[12]

### Aynor

**WILLIAM VAN AUKEN GREENE.** About 1930, Green, a one-armed, 60-year-old itinerant photographer from Minnesota, located in Aynor, a few miles north of Conway,

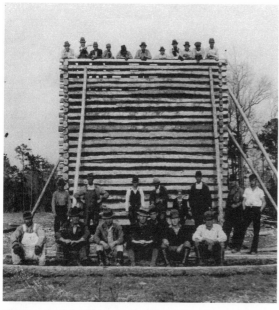

*Photograph of the "Raising of a Tobacco Barn" near Aynor, South Carolina. Produced by William Van Auken Greene. Courtesy of the Horry County Museum.*

*Picture of photographer William Van Auken Greene. Courtesy of Horry County Museum.*

and produced photographs. For the next two decades he captured the local citizenry in their rural, agricultural, work, and social settings.

His documentation of the Depression years in this small South Carolina community portrays many "happy" faces and a much less grim and desolate view of the times than the work of FSA photographers. His work is a more realistic picture of the times than theirs.

The Horry County Museum owns about sixteen hundred Greene negatives that may soon serve as the basis for a book featuring Greene and his work.[13]

## Batesburg

**W. G. McMANUS.** In 1924 McManus offered "Kodak Finishing," home portraits, and copying, enlarging, and framing services from his Batesburg Studio over the Fair Drug Co.[14]

## Beaufort

**SAM KOSINER (PALMETTO STUDIOS).** Kosiner opened this studio in 1937 and operated it until 1943 when he sold out to Lucillle Hasell Culp. She began working for Kosiner in 1941 and, after becoming the owner, continued the business for forty more years. In 1940 this studio produced the photographs appearing in the *Beaufortonian,* the Beaufort High School annual. They advertised the production of portraits and commercial photographs. During World War II thousands of U.S. Marines visited the Palmetto Studios for their likenesses to send to loved ones.[15]

## Camden

**BERT CLARK THAYER.** In the late 1930s Thayer produced photographs of Camden sporting events and activities such as horse racing and fox hunting. An album of his photographs may be seen in the Camden Archives and Museum.[16]

## Charleston

During a part of, or in some cases all of, the period from 1921 to 1940 the long-term galleries of Howard R. Jacobs, Elizabeth Dawson (Marion Studio), St. Julien Melchers, Herbert S. Holland, William D. Clarke, Walter L. Harrell, and Michael F. Blake continued in operation in Charleston. Two other studios joined this long-term category in the period from 1921 to 1940.

The J. F. Short Co. operated a studio at 269 King Street from 1922 to 1930. Joseph W. Short was listed as a photographer for the firm. Charles C. Hunt operated a gallery at 247 Meeting Street from 1929 to 1942.[17]

There were nine galleries operating from 1921 to 1940 for three or less years. They were: Nick Saclarides and Mike James (People's Studio), 269 King Street, 1921 to 1923; Peter

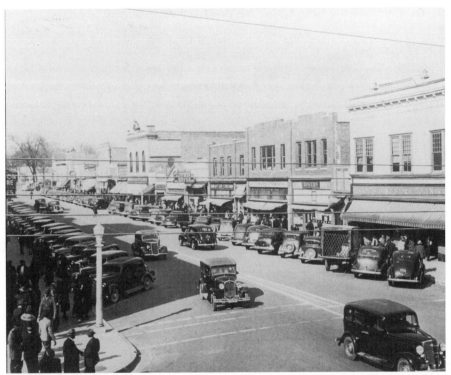

*Photograph of downtown Camden in 1939 by Bert Clark Thayer. Courtesy of the Camden Archives & Museum.*

*Photograph of "Behind the Scene at the Carolina Cup" taken by Bert Clark Thayer in 1939. Courtesy of the Camden Archives & Museum.*

Leleces (N. Y. Studio), 317 King Street, 1922; Leon Ortner (Charleston Studio), 513 King Street, 1934; Jerald Hirshman, Mgr. (Florian Studio), 317 King Street, 1934; Wesley A. Jackson, 146 King Street, 1934; Eugene D. Sassard, 35 Cumberland Street, 1938; Bert Elam (Picture Box), 320 King Street, 1940; James A. Beales, Mgr. (Tu Layne Studio), 320 King Street, 1940; F. P. Marron (Warner Studio), 309 King Street, 1940. Six of these galleries began their operation during the depression, but apparently soon fell victim to the economic vicissitudes of the time.[18]

## Columbia

During part of, or in a few cases all of, the period from 1921 to 1940 the long-term galleries of Walter L. Blanchard, Miss Lella Lindler, William H. Lyles, Jr., John A. Sargeant, Fred Toale, Plase A. Lollar, Joseph H. Mayfield, Daniel Earnest Williams, and Richard Samuel Roberts continued in operation in Columbia. A few other galleries opened and operated during the period.

J. G. Tegu operated the Blue Light Photo Studio at 1204 Main Street in 1921. Charlton H. Griffin managed the Cut Rate Studio at 1417–A Main Street in 1937. Both Tegu and Griffin apparently operated their galleries for about a year. In 1939 Kennedy & King operated a studio at 1201 Lady Street for a short time. The St. John's Studio managed by Mrs. Laura Hefner and the Olan Mills Studio managed by Mrs. Frances Sanders, operated briefly during this period.[19]

**CHARLES W. OLD.** The only studio to open and also to operate on a long-term basis during this period and later was that of Charles W. Old. As indicated in the previous chapter, he was employed in Sargeant's studio until 1937. For a time in 1937 Sargeant and Old seem to have been in a partnership, but by 1938 Old operated his own studio at 1641 Main Street. He moved a block away the next year to 1726½ Main Street and operated from that location for more than thirty years.

During those years Charles Old and his wife, Caroline, produced thousands of portraits of Columbians. However, several panoramic views of various Columbia scenes are the most memorable photographic works produced by the Olds. In 1996 the Columbia Museum of Art exhibited prints by Hunter Clarkson made from Mr. Old's original negatives.[20]

## Conway

**WARREN JOHNSON.** Beginning in the early 1920s Johnson created a variety of photographs of local subjects. A notable example of his work was a photograph taken in 1927 of the famous multiple murderer from Pamplico, Edmund Bigham.[21]

## Darlington

**GRAGG'S STUDIO AND PORTER'S STUDIO.** Gragg's Studio operated in 1924 and 1925 over Sligh's Store on the north side of Public Square. In January 1925 Gragg sold out to Porter's Studio.[22]

**JOHN A. JAMISON.** Jamison operated a studio in Darlington in the mid-1930s. Like many studios of the day, Jamison offered a processing service to amateurs from the area. Jamison was a member of the Photographer's Association of America.[23]

**W. F. LEWIS (TONE ART STUDIO).** W. F. Lewis operated this studio in the mid- to late 1930s. Among his works were photographs of dead bodies taken for the local coroner. He may have operated a studio in Timmonsville for a short time.[24]

### Easley

**ANONYMOUS.** On 21 February 1935 a "Photo Studio" located in the Old Bakery Building on Main Street advertised "4 Photos Finished in 4 Minutes for Ten Cents."[25]

**NELSON'S STUDIO.** In 1939 Nelson's Studio located on Main Street next door to Couch's Market and advertised enlargements, tinting, and "3 Photos-10 cents."[26]

### Florence

**QUARLES STUDIO.** In 1926 Robert E. Quarles began a gallery that he operated for about three decades. Fred Scott, the studio manager in 1926, and Quarles produced the photographs for that year's *Florentine,* the Florence High School annual. Over the years the studio specialized in portraits and processing for local amateurs.[27]

*Photograph of Lovers' Lane at Muldrow's Mill, produced by Robert E. Quarles. Copied from the 1927 Florentine. SCL.*

**Grantham's Studio.** Wiley Grantham operated a Florence studio in 1938 at 163–a Dargan Street and Ethel M. Grantham, presumably his wife, served as assistant manager.[28]

### *Greenville*

During the period between the World Wars, from 1921 to 1940, at least seventeen Greenville studios were established, a larger number than in either Charleston or Columbia. Five of these studios operated for a year or less: R. F. Shelby, 201½ S. Main Street, 1923; J. F. Manning, 501–503 Wallace Building, 1930; Ansel Shoaf, 206 A. Main, R 212, 1933; Frank Redd, Green Avenue, Extn. near City limit, 1935; Thelma L. Caldwell (Thelma's Studio), 2 Lois Avenue (W. Greenville), 1937.

J. R. or J. W. Brown operated a studio for about four years, from 1923 to 1926, at Easley Bridge Road (Judson Mills). J. D. McHaffey also operated a studio for about two years, from 1937 to 1938, at Green Avenue extension near Walnut. This may have been the same location used by Frank Redd in 1935.[29]

**James Huntington.** Huntington opened a studio at 401½ S. Main in 1921 and operated from that location to 1924. By 1926 he moved to 301–A S. Main Street, but from 1928 to 1940 and later he operated from 219–A S. Main Street. Local directories from 1931 to 1940 list him as a "Commercial Photographer."[30]

*James Huntington's photograph of the Kiwanis Club and cast members of their charity minstrel show at the Greenville Women's College. Coxe Collection. Courtesy of the Greenville County Historical Society.*

**W. B. COXE.**  By 1930 Coxe was operating a studio at 4 Washington Street and continued in business for about four decades. At some point he came into possession of some negatives and prints from the William P. Dowling and James Huntington Studios. Negatives produced by him and those from these two studios are at Bob Jones University. This collection provides a pictorial archive of Greenville from the early 1900s to the 1970s.[31]

*Photographer W. B. Coxe and the camera he used to produce many of the negatives in the present day Coxe Collection. Courtesy of the Greenville County Historical Society.*

*Photograph of the Furman University campus, taken by W. B. Coxe. Coxe Collection. Courtesy of the Greenville County Historical Society.*

**JAMES E. FOSTER.** Foster opened his gallery in 1930 at 116–A N. Main Street and continued in business to at least 1938.[32]

**L. R. HAWKINS.** Hawkins opened Hawkins Photo Service in 1930 at 2 Lois Ave, and operated there to 1935. In 1937 Thelma Caldwell operated from that address and was followed at this location the next year by James O. Childers.[33]

**JAMES E. GILLIAM.** Gilliam managed the Ivey-Keith Department Store studio in 1937. Mrs. Carol Gilliam managed the studio the next year. James E. Gilliam, Jr. operated the Gilliam Studio at 104 S. Main Street during World War II and for a number of years thereafter.[34]

**MILLS F. STEELE.** Steele opened a gallery at 18½ S. Main Street in 1937 and continued a local gallery for a few years.[35]

**JAMES O. CHILDERS.** Childers operated a gallery at 2 Lois Avenue in West Greenville from 1938 to at least 1940.[36]

**ARTHUR L. COOK.** Cook managed the Hollywood Studio, located at 534 S. Main Street, from 1938 to 1940.[37]

**JOHN MINOR.** Minor opened a gallery at 6 Woodlawn in 1938 and operated it to 1940.[38]

## *Hartsville*

**CLAUDE HART.** Claude Hart, a native of Clarkston, North Carolina, operated his studio in Hartsville during the 1920s and 1930s. He usually placed a heart-shaped sticker on the back of his photographs containing the wording, "The Hart Studio, Hartsville, S.C." He produced photographs that were used in WPA publications.[39]

*Photographer Hart used this heart shaped logo on the reverse of many of his photographs. SCL.*

An undated newspaper clipping provides this description of Mr. Hart's studio:

> His studio is located on Avenue B., near the Post Office, and includes a well equipped operating room, provided with every new appliance and artistic scenic designs for background. Mr. Hart is a gentleman whose thorough knowledge of the photographic art has drawn around him a liberal patronage and gained him a standard reputation, which places him in the front rank among the artists of acknowledged skill and ability in this section. Pictures of every style and all sizes are made, and particular attention is given to copying. Likenesses are taken by the instantaneous process, thus effecting satisfactory results in the cases of children and babies. Mr. Hart is a native of Clarkston, N. C. and is a thorough lover of his art, and those who desire correct likenesses should not fail to visit his studio and examine the many beautiful specimens of his handiwork exhibited in his reception rooms. The collection is the finest in this section.[40]

**H. KLASK.** In mid-July 1926 the (Florence) *Times-Messenger* reported "H. Klask Dies in Florida City. Former Hartsville Photographer Dies Under Mysterious Circumstances. Police Investigate." At this time Klask had been living in Kissimmee, Florida. When he practiced photography in Hartsville is unknown.[41]

In his fictionalized reminiscences, *Plum Tree Lane,* Lodwick Hartley recounts a story about a German photographer names Herman Klask who left Batesburg in 1917 under mysterious circumstances just prior to the United States' entry into World War I. After his departure the people of Batesburg suspected him of being a spy or saboteur and even took steps to guard their water supply. If this "Herman Klask" was the same man as the Hartsville "H. Klask," then the mystery surrounding him deepens.[42]

## Orangeburg

**WARREN STUDIO.** Kistler B. Warren operated a studio at 78 E. Russell Street during the 1930s. A number of his photographs are in the South Carolina Federal Writer's Project files.[43]

**WILLIAMS STUDIO.** Williams operated a studio at 82 E. Russell Street in the 1930s. J. Lackey managed this studio from 1938 to 1940.[44]

## Spartanburg

**ALFRED T. WILLIS.** By 1924 Willis operated a photographic business in Spartanburg that was probably located in his home. In 1926 and 1927 he operated a studio at 115½ E. Main Street and from 1928 to 1930 at 147½ E. Main Street. By 1934 he moved to 153½ N. Church and remained there for a number of years.[45]

**W. H. COFER.** In 1927 Cofer operated a studio at 147½ E. Main, the location of the Hart studio in 1926 and the location of the Alfred T. Willis studio in 1928.[46]

STREET SCENE, SPARTANBURG, S. C.

*Photograph by Alfred T. Willis of a Spartanburg street copied from "Omar's Spring Pilgrimage to Spartanburg, 1915." Although this printed photograph is dated 1915, the earliest date found for a Willis studio in Spartanburg was 1924. Mendel Smith Papers. SCL.*

**Norwood Studio.** From 1934 to 1936 Girard J. Lang operated this studio located at 121½ W. Main Street.[47]

**Van Dyke Studio.** Charles A. Gerrell managed this studio located at 124½ E. Main Street from 1936 to 1940.[48]

**Hollywood Studio.** S. Telford Grubbs operated the Hollywood Studio located at 121½ N. Church Street from 1938 to 1940.[49]

### Sumter

**Joel E. Brunson.** Beginning in 1940 Brunson operated the Sumter Photo Shop in the rear of 306 S. Sumter Street.[50]

### Union

**P. B. Barnes.** Barnes operated a studio in Union in the Foster Building from 1925 to 1927. He did school annual photography in the local area.[51]

### Unknown[52]

**J. S. Broadaway.** Two cartes de visite of J. S. Broadaway c. 1870 turned up that indicate he opened and operated a gallery over Nesbit & Brother, but no date, town or state was listed on these cartes. He may have been the same J. S. Broadaway who operated a gallery in Greenville in the 1870s.

**R. L. Steele.** A carte de visite of an unidentified female bearing the inscription "R. L. Steele, Photographer, S.C." is known.

**Peeler's Studio.** One of the more interesting miscellaneous items to surface was a cabinet photograph from "Peeler's Studio on the Road." As Peeler indicated, he was "on the road," hence he never bothered to indicate any town or state on his products. The Peeler name is prominent in the Cherokee County area of South Carolina.

**Willie A. Beach & J. R. Preacher.** The itinerant nature of two photographers' business apparently prompted them to omit a town name from their photographic mounts. Both, however, indicated their base was South Carolina. Beach printed his name and "Photographer, (blank space) S.C." and Preacher printed his name and then "Artist (blank space), S.C."

**S. M. Pearson.** Pearson operated galleries in Bamberg and Leesville. An extant carte de visite does not indicate a location.

**James T. Winburn.** Two cartes de visite of photographer J. T. Winburn carry some information about him. One indicates he had twelve years experience and the other that he specialized in producing cabinets. One of these cartes is of a member of the O'Bear family of Winnsboro.

**Humphreys.** Two cabinets among the holdings of the Spartanburg Historical Association bearing the wording "Humphreys, Photographer," indicate he may have operated a gallery in Spartanburg. Alfred W. Humphreys did operate a gallery in South Carolina.

*A photograph of exceptional quality produced by the itinerant Moose's Art
Car studio. Chester County Historical Society.*

CROSBY JACKSON. A cabinet photograph surfaced of a female about twenty years
of age produced by Crosby Jackson, Palmetto Photo Co., South Carolina.

MOOSE'S ART CAR. A single photograph from this itinerant photographer's cam-
era informs us of his studio. Although the time, date, state, and town of its origin are
unknown, the photograph is included since it turned up in a South Carolina museum and
serves as an exquisite example of the quality of the creations of some itinerants.[53]

# Emancipation and Images

### African American Photography, 1865–1940

When Europeans settled in South Carolina in 1670, across the river from present day Charleston, five black slaves from Africa were brought to the settlement by their owners. From that point to the end of the Civil War slavery continued as an integral part of South Carolina society. Between 1670 and September 1839, when Daguerre's photographic process was unveiled in the United States, the African American population of South Carolina rose from five to 335,591 (1840 Census). Of this number 8,276 were free African Americans. A total of 3,201 free African Americans dwelled in Charleston District alone with 1,558 of them actually living in the city.[1]

Although possessing many freedoms not accorded slaves, free African Americans suffered severe restrictions in their activities and never enjoyed full participation in political processes. By 1860 their rights became so restricted that a few sought to become slaves. Regardless of the restrictions placed on them before and during the Civil War, some of them became leaders of the black community after the war.[2]

Slaves in South Carolina legally were property and, as a result, did not enjoy citizenship status through which civil rights flowed. The situation was not markedly better in most

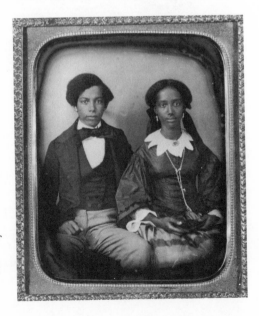

*Sixth-plate daguerreotype by George S. Cook of two unidentified free blacks from Charleston. Courtesy of George S. Whiteley, IV.*

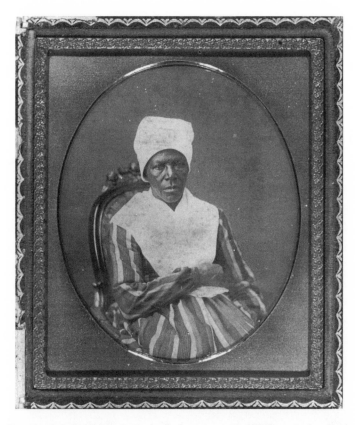

*Daguerreotype by George S. Cook of a house servant of William Seabrook who lived at Oak Island Plantation on Edisto Island. Courtesy of Becky Hollingsworth.*

states outside the South before the Civil War. In Oregon blacks could not make a contract. Most states, including the populous states of New York and Pennsylvania, did not allow blacks to vote. Ohio, Illinois, Indiana, Iowa, and California forbad blacks to appear in court as witnesses against whites.[3]

Since Lincoln's Emancipation Proclamation of 1 January 1863 freed only slaves in areas of the country in revolt and not under Union military control, South Carolina's 400,000 plus slaves did not receive full emancipation until the South was defeated in 1865.[4]

At the end of hostilities, more than 400,000 African Americans were free. The Freedmen's Bureau, established at the end of the Civil War to assist recently liberated African Americans, provided some assistance and direction, but African Americans by and large were left to their own devices. Before and during the Civil War it was illegal to teach slaves to read and write. White communities sought to pass laws to regulate these recently freed Africans Americans. These laws, called the Black Code, were so restrictive that the North perceived them as a continuing effort by the state to enslave African Americans. This code in South Carolina and similar ones in other southern states contributed to the establishment of Radical Reconstruction.[5]

*This manuscript "Wanted Poster" dated in April 1863 contains the upper half of a carte de visite portraying "Dolly," a runaway slave. This carte probably was done by a Charleston photographer. It is noteworthy that this poster was issued over three months after Lincoln's Emancipation Proclamation. Manigault Family Papers, SCL.*

Radical Reconstruction and the South Carolina Constitution of 1868 placed freedmen in authority over their former masters, often with disastrous results. White southerners turned to organizations such as the Ku Klux Klan to restore white control and their version of orderly government. Reconstruction ended in South Carolina in 1877 when the last of the occupying Union troops departed. The white ruling class again governed the state under the leadership of former Confederate general, Wade Hampton, III.[6]

The enactment of a new state constitution in 1895, for all intents and purposes, disenfranchised African Americans, a condition they suffered under until well after World War II.[7]

In the decades after the Civil War almost all facets of South Carolina society became segregated and remained so until well after World War II. Churches, schools, hospitals, insane asylums, jails, militia or national guard units, movie theaters, beaches, state parks, restaurants, buses, housing, social clubs, swimming pools, water fountains, lunch counters, marriage, waiting rooms, fairs, and the legal system all reflected racial segregation. Segregation affected most professionals such as teachers, doctors, lawyers, undertakers, preachers, and photographers in South Carolina. Segregated professional organizations sustained double standards in employment, education, and salaries. Throughout society whites practiced a different set of attitudes toward blacks.

In 1882 photographer B. S. Mattocks advertised a schedule for patrons to visit his tent studio in Georgetown. "Visits from the whites will be received on Monday, Tuesday and Wednesday of each week, colored people on Thursday, Friday and Saturday."[8] In 1896 W. C. Gallagher apparently did not accept African American customers for he advertised his Gaffney gallery as a "White People's gallery."[9] From 1905 to 1910 Eugene T. Anderson's advertisement stated, "No Coons allowed" and "For White People Only."[10] In 1906 Z. E. Scott of Fort Mill advertised Saturday afternoons from "1 to 6 O'clock will be reserved exclusively for colored people."[11]

In photographing African Americans, white photographers often reflected the position of African Americans in South Carolina society and the stereotypical attitudes held toward them. J. A. Palmer of Aiken and George N. Barnard of Charleston each posed African Americans eating watermelon and picking cotton. Palmer posed and photographed an African American boy dressed in a suit of clothes looking at a "voo doo" or face jug sporting a sunflower in its neck that he titled, *An Aesthetic Darkey.* A. F. Baker of Blackville photographed an African American dancing in the street titled *Coon Dancing* and a similar photograph titled *Another View of the Coon.*[12]

After 1900, when collecting postcards from different parts of the country became popular, African Americans were represented on them in many unflattering settings or poses in both sketched caricatures and in real photographs. From early times in most areas of the United States presentation of African Americans in sketches and cartoons appearing in various forms of print, in photographs, and later in the movies often reflected stereotypes.[13] Perhaps none did this with quite the lack of taste or meanness as a sketch located at the end of a 1927 South Carolina private school annual that portrayed an African American hanging from a tree by a noose around his neck. This sketch was titled *The End.*[14]

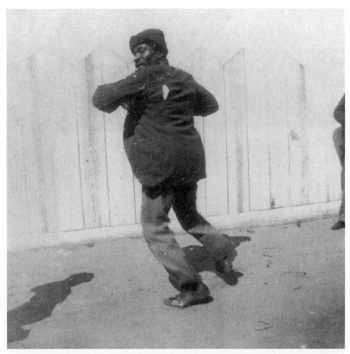

*Photograph by Arthur F. Baker titled* Coon Dancing. *Courtesy of the South Carolina Historical Society.*

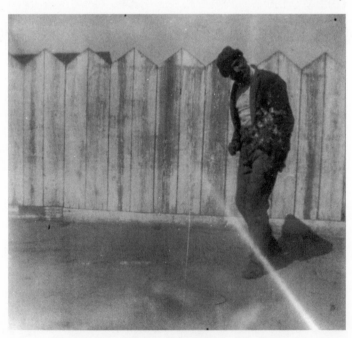

*Photograph by Arthur F. Baker titled* Another View of the Coon. *Courtesy of the South Carolina Historical Society.*

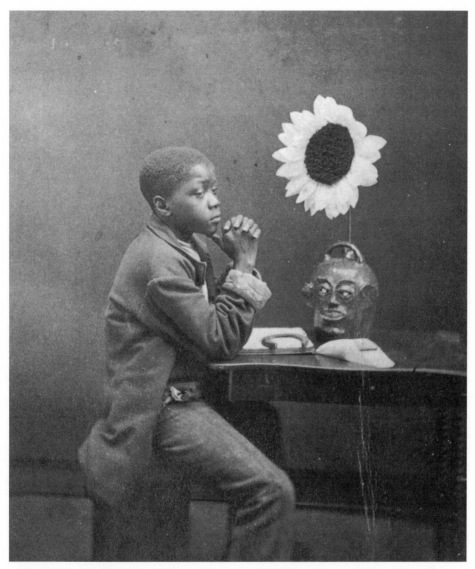

*One half of a stereograph by J. A. Palmer of a young African American boy looking at a "face" jug sporting a sunflower from its neck. Palmer titled his creation,* The Aesthetic Darkey. *Courtesy of Pria Harmon.*

Most African Americans in South Carolina lived on farms, both before and after the Civil War. After the war, their population grew in Charleston, Columbia, Greenville, Sumter, Orangeburg, and Anderson. An African American middle class composed of businessmen, craftsmen, teachers, preachers, undertakers, and others developed in these cities. Although segregated from whites, the values and attitudes about family, property, church, and other areas of their society closely mirrored those of middle class whites. Most African American photographers appeared to have few white customers, being primarily limited to a customer base from their own race.[15]

White photographers generally did accept black customers, but their economic plight limited their abilities to buy photographs even to a greater degree than poor whites. Consequently, various institutional or individual collections of photographs are heavily weighted toward portraits of white people. Even non-portrait photographs including people usually portray whites. Most of these collections on occasion will have one or two African American portraits and a similar number of photographs portraying African Americans in street scenes. Quite clearly African Americans and subjects related to them constituted a minor part of most white photographers' business. Consequently their culture was never documented photographically to any extent approaching that of whites.[16]

Some white photographers were exceptions to the rule and produced noteworthy numbers of photographs of African Americans and related subjects. Since these photographs document African American culture, a description of them deserves inclusion in this chapter.

## White Photographers of African Americans

**JOSEPH T. ZEALY.** In 1850 Joseph T. Zealy of Columbia photographed slaves from B. F. Taylor's Edgehill plantation near Columbia and selected slaves from a few other owners for an anthropological study by Louis Agassiz. At the time Agassiz was visiting Robert W. Gibbes and some of the faculty of South Carolina College. These fifteen Zealy daguerreotypes are a part of the holdings of the Peabody Museum of Archeology and Ethnology at Harvard University. Zealy photographed these slaves in nude and semi-nude poses to show their physique and facial features. Agassiz sought to demonstrate his false thesis that humans are composed of more than one specie.[17]

**OSBORN & DURBEC.** In the summer and fall of 1860 James M. Osborn and Frederick E. Durbec photographed plantation scenes near Charleston that included slaves, slave quarters, cotton picking, etc. Some examples of this photographic project are prints made after the Civil War by S. T. Souder from pre-war Osborn & Durbec negatives or prints. Few other antebellum photographs of South Carolina slaves in home and work settings are known.[18]

**SAMUEL A. COOLEY, HUBBARD & MIX, AND HENRY P. MOORE.** These Union photographers produced some photographs of African Americans on the South Carolina sea islands during the Civil War.

**GEORGE N. BARNARD.** During George N. Barnard's third sojourn in Charleston, from 1873 to 1880, he produced a number of photographs of African Americans in home and work settings. Stereographs produced in 1874 at the Alexander Knox plantation in

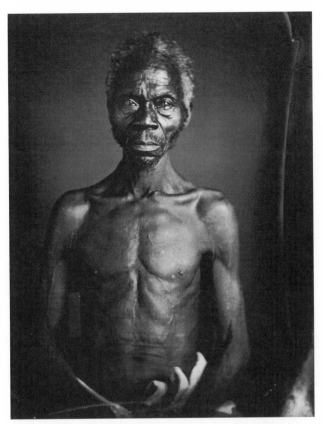

*An 1850 daguerreotype by Joseph T. Zealy of Renty from the Congo, a slave on B. F. Taylor's Plantation. Harvard University, Peabody Museum of Archaeology and Ethnology. Photograph by Hillel Burger.*

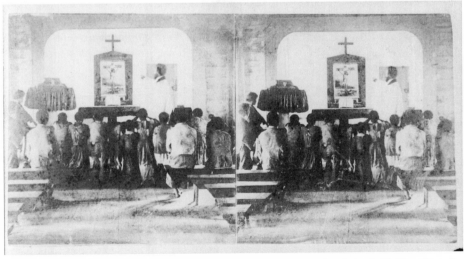

*Photograph by Osborn & Durbec taken in 1860 of the inside of a slave church (probably Zion Chapel) in Rockville, South Carolina. Courtesy of the South Carolina Historical Society.*

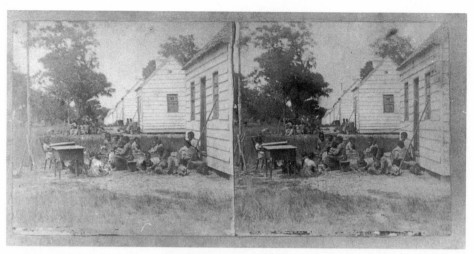

*Stereograph by S. T. Souder produced from an 1860 Osborn & Durbec negative. The scene is the rear view of a row of slave quarters on a South Carolina plantation. SCL.*

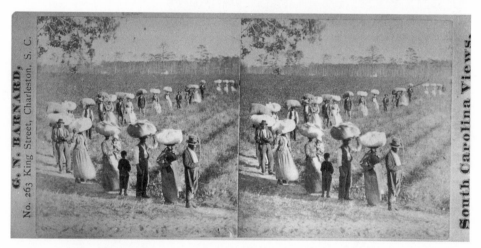

*Stereograph by George N. Barnard of African Americans returning at day's end from the Alexander Knox plantation cotton fields carrying their pick on their heads. Barnard artistically arranged these twenty-six "cotton pickers" in a sweeping curved line that gives the image depth and perspective. Courtesy of George S. Whiteley, IV.*

Mount Pleasant near Charleston included African Americans at work. His stereograph of cotton pickers coming home from the fields at sunset bearing the day's cotton on their heads artistically presents them in a work setting.

He also photographed African Americans in his studio and in various settings in Charleston. Although Barnard occasionally produced stereotypical photographs of African Americans for sale to customers who may have viewed them in that light, his work as a rule portrayed African Americans in a realistic manner in real-life settings. Consequently, many of his photographs may be viewed today as non-contrived historical documents.[19]

The aesthetic aspect of Barnard's photographic work featuring African Americans is most clearly demonstrated by his stereograph titled *South Carolina Cherubs* posing two young black children in a manner similar to the cherubs in Raphael's painting *Sistine Madonna*. In his 1990 book on Barnard, Keith F. Davis presents a well-written analysis and interpretation of the artistic and historical symbolism represented by this work.[20]

**J. A. PALMER.** Palmer documented African Americans in Aiken and the vicinity. Among his photographs are examples of his subjects cutting wood, picking cotton, washing clothes, working at a turpentine still, and sitting and standing on back porches, as well as children playing and family portraits.

An Aiken, South Carolina, doctor in 1888 reported another aspect of Palmer's documentation of black culture.

> October 5th. Palmer, the photographer met me and said he had taken several views of the negro cemetery which I had suggested and asked me to look at them. I bought a set to send to the Smithsonian Institute in Washington as I had been reading in one of their works by Major Powell on the burial custom of the Indians and I had a vague idea of calling his attention to the strange customs of our negro race. Oct 19th. Received a letter from O. T. Mason thanking me heartily for the photographs of the negro cemetery sent to the Smithsonian Institute and begging me to prosecute further inquiries in this direction as it is a new field. I replied last night giving him Harriett's graphic description of the funerals of colored people and their benevolent societies referring to negro customs on large coastal plantations in localities where they have been less mixed with whites than in our county.[21]

Palmer's work from 1871 to 1896 exceeds in amount and scope Barnard's portrayal of African Americans. Palmer worked in a town that served as a winter colony for northern visitors

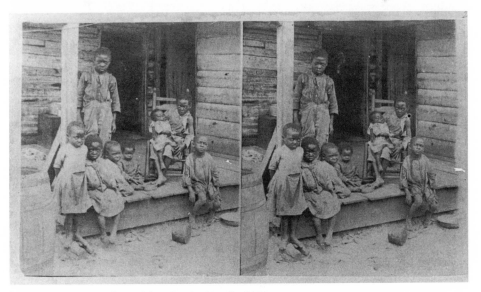

*Stereograph by J. A. Palmer of the Whitaker Family. SCL.*

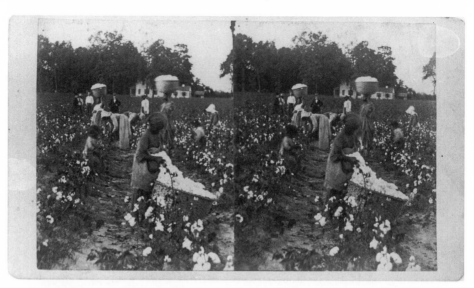

*Stereograph produced by J. A. Palmer in 1876 of cotton picking on a farm owned by Robert Rowell,
rented by Walter Kubler, and located between Aiken, South Carolina, and Augusta, Georgia. SCL.*

who may have had a greater desire for these kinds of photographs than most of Barnard's
customers.[22]

**WILLIAM S. ALEXANDER.** Alexander produced a number of photographs of
African Americans and their activities in the Camden area in the late 1880s and early 1890s.[23]

**ANONYMOUS CAMDEN PHOTOGRAPHER.** A few years after Barnard and Palmer
photographed African Americans in the Charleston and Aiken areas, a "Winter Colony"
visitor to Camden, or someone employed by him/her, produced similar photographs of
Camden and vicinity in 1901. At Mulberry and nearby plantations, this photographer cap-
tured African Americans in a variety of real life settings: a coachman, hauling cotton, a black
public school, slave quarters and blacks at Mulberry plantation, hauling wood, a golf
"caddy," basket weaving, wash day, a grandmother teaching her grandchild, tending cows,
breaking a steer, going to market, plowing, preparing a cotton field, stirring the pot (cook-
ing), planting corn, carrying home the laundry, carrying water, and portraits of blacks. This
work constitutes one of the more comprehensive treatments of African Americans by a
white photographer.[24]

Unfortunately the visitor's identity is confined to the initials "C. A. B." or just "B."
He/she was probably from the northeast and produced or secured the production of about
100 photographs of local subjects in early 1901.[25]

**C. M. VAN ORSDELL.** In 1888 Van Orsdell produced a series of photographs of
Claflin College buildings, faculty, and students.[26]

**JULIAN DIMOCK.** In 1904 and 1905 Julian Dimock photographed black scenes in
Columbia and along the state's southern coast. According to Nina J. Root, Dimock "cap-
tured their grinding poverty, evidenced by their threadbare and much-mended clothes, care-
worn faces, and much-hardened hands as well as their extraordinary dignity and strength of

*Photograph of slave quarters at Mulberry Plantation taken in 1901 by an anonymous photographer. Mulberry was the home of Mary Boykin Chesnut, the famous Civil War diarist. SCL.*

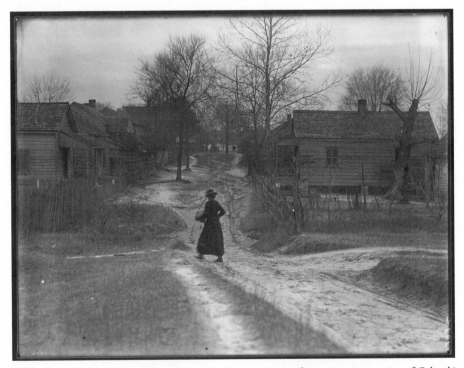

*Photograph by Julian Dimock created in 1904 of a street in an African American section of Columbia. Dept. of Library Services, American Museum of Natural History, New York.*

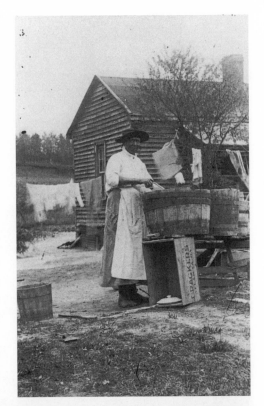

RIGHT: *Photograph by D. Audley Gold portraying a backyard "Wash Day" scene. Note the cracker box propping up the wash tub. Courtesy of the Historical Center of York County.*

*Photograph by R. H. McAdams of Harbison Agricultural College's main building. SCL.*

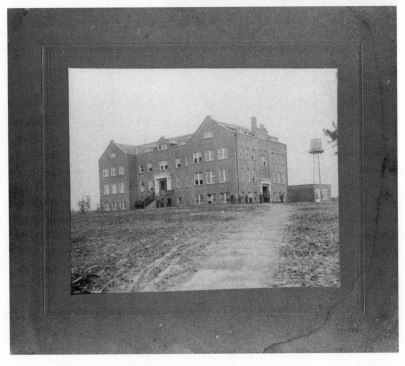

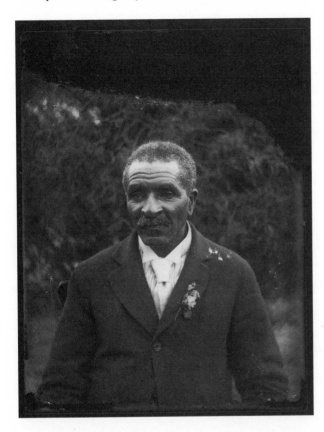

*Print of George Washington Carver produced from a glass negative by E. E. Burson. SCL.*

spirit." Dimock and his father, Anthony, wrote about and photographed African Americans in South Carolina and Georgia, and in 1910 did the same for the Seminole Indians in Florida. In 1917 Julian Dimock donated some six thousand negatives to the American Museum of Natural History in New York City, including the one hundred or more photographs he produced of African American subjects in South Carolina.[27]

**Daniel Audley Gold and June H. Carr.** In the Blacksburg area of Cherokee County Daniel Audley Gold produced several photographs of African Americans during the period from 1895 to 1940.[28] Some twenty miles away in Gaffney June H. Carr produced similar photographs.[29]

**R. H. McAdams.** In 1916 and 1917 McAdams of Due West, South Carolina, produced photographs of Harbison Agricultural College near Irmo, South Carolina.[30]

**E. E. Burson.** Burson of Denmark produced a number of photographs of Voorhees College and Voorhees students from about 1905 to 1920. Included in Burson's work is a photograph of George Washington Carver taken when Carver was visiting Voorhees.[31]

**Doris Ulmann and Julia Mood Peterkin.** Julia Mood Peterkin wrote articles and books that sensitively portrayed blacks. In 1929 her novel *Scarlet Sister Mary* won a Pulitzer Prize.

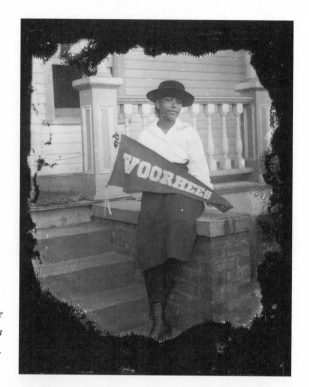

*Contact print of a Voorhees College coed produced from an E. E. Burson glass negative. SCL.*

*Photograph by Doris Ulmann of an African American female living on Julia Mood Peterkin's Lang Syne Plantation. Courtesy of South Carolina Historical Society.*

In 1933 she teamed with Doris Ulmann to produce *Roll, Jordan, Roll,* an illustrated work also portraying African American life. Peterkin's writing in this work met her usual standard of literary excellence, but with photographs of matching excellence by Doris Ulmann. Ninety Ulmann photographs presented blacks in a great variety of situations and activities, but always with an eye for art and realism. Most of the individuals portrayed lived on Lang Syne, Julia Mood Peterkin's plantation near Fort Motte, South Carolina.

Her work captures the character, the spirit, and the soul in the faces of her black subjects; young faces, happy faces, old, wrinkled, time-worn faces. The use of a soft focus lens, which produces photographs sharply focused in the center with less definition on their borders, probably contributed to their almost spiritual quality.[32]

While in college in 1902 Doris Ulmann studied nature and photography with Lewis W. Hine. In 1914 she enrolled in a photography course taught by Clarence W. White of Columbia Teachers College. Classmates at the time were Margaret Bourke-White, Ralph Steiner, and Laura Gilpin. In 1918 she became a photographer by profession.

Between 1919 and 1925 she and her husband produced three limited edition photographic works, two on doctors at Johns Hopkins and Columbia University and one on American editors. Her best work documented Southern handicrafts and African Americans from 1925 to 1934 and included *Roll, Jordan, Roll.*[33]

**PENN SCHOOL PHOTOGRAPHERS.**[34] Individuals from the North with concerns about the education and general welfare of freedmen founded the Penn School on St. Helena Island near Beaufort in 1862. Operating continuously since that time, the school has educated and improved the lives of thousands of African Americans.

During the Civil War Union photographers took some photographs of the school, its activities, and its teachers. From the 1890s through the 1940s visitors and Penn School personnel took about 3,000 photographs that constitute an historical record of school programs, students, teachers and school buildings. These photographs remained at the school until a few years ago when they were placed on deposit in the Southern Historical Collection, University of North Carolina, Chapel Hill.

Although these photographs were of African Americans and related subjects, all were produced by Northern whites. The great majority were produced by twelve individuals, six of whom were women, Helen C. Jenks, Rossa B. Cooley, Grace B. House, Isabella Curtis, Mary Isobel House, and Margaret Moyes.

**FRANCIS R. COPE.** Cope, a school trustee and chairman of Penn's board for a time, was an avid amateur photographer and photographed Penn School and St. Helena Island from 1901 to 1944. "He took many striking compositions of island scenes which reveal a very proficient photographer with a flair for the dramatic."

**LEIGH RICHMOND MINER.** Miner grew up in Cornwell, Connecticut, and received his early schooling there. A gifted artist as a youth, Miner graduated from the Academy of Design in New York City and became an instructor in drawing at Hampton Institute in 1898. Photography, a love of his for many years, lured him back to New York City in 1904 where he opened a photographic studio. In 1907 he gave up his studio, returned to Hampton Institute, and spent the remainder of his life teaching there.

A number of Hampton Institute graduates taught at Penn School and when Miner visited them between 1907 and 1923 he took photographs of the school and area. He used a view camera for his photographs, making a total of about 150 plates, most of which were printed in a book by Edith M. Dabbs titled *Face of an Island: Leigh Richmond Miner's Photographs of Saint Helena Island.*[35]

LEWIS W. HINE. This photographer, who earlier produced documentary photographs of child labor in South Carolina, worked for the *Survey Graphic* in the years 1910 through the 1920s. He took photographs on a visit to Penn School and two were published in the *Survey Graphic.*

## African American Photographers

From 1820 to 1920 more than half of South Carolina's population was African American, but by 1930 the white population, for the first time in a century, rose to slightly over 50 percent.[36] Migration of African Americans from the South helped produce this shift in population. From 1840 to 1940 more than six hundred South Carolina photographers were identified who served the South Carolina population. Only twenty-seven of the six hundred plus photographers were African Americans, and more than half of the state's population was African American. This brings into sharper focus the lack of economic, social, and political standing of African Americans, both under slavery and segregation. It is little wonder that photographic collections largely represented white people and white culture and were produced by white photographers.

Prior to or during the Civil War no African American photographers were identified, a not surprising fact when the restrictions of slavery are factored in. Many antebellum itinerant photographers were one- or two-man teams from the North and, although white, owned no slaves who could have been operators in their studios. In fact, no record could be found that George S. Cook owned a slave or had any working for him. Cook occasionally photographed free blacks or house servants with their white children charges.

This work identifies slightly more than two dozen African American photographers in South Carolina between 1865 and 1940. Photographs produced by only nine of the twenty-seven African American photographers have been identified. The number of extant photographs from only four of these nine are of sufficient quantity to base an opinion on the scope and quality of their work, and only the large number of surviving Richard Samuel Roberts photographs provide the basis for an in-depth study of his work.

Although few in number, African American photographers captured and preserved the faces and places of their race, documented their culture and helped preserve their heritage through photographs. In several instances their photographic efforts reflected an understanding and mastery of photography as an art form on a par with their white counterparts. To describe their photographic work in this separate and discreet chapter has been done *not* to continue segregation of African Americans, but rather as a means of rescuing them from obscurity, publicizing their work, and giving them long overdue credit.

### Anderson

**EDGAR L. THOMAS.**  The first reference found to Thomas listed him as a teacher in 1905. By 1909 he had opened a photographic gallery at 1201 Fant Street and continued in business there until at least 1923.[37]

In 1982 James and Juanita Artemus developed a publication on African Americans who operated businesses on East Church Street in Anderson from 1907 to 1980. Included in this work are many photographs of Anderson African Americans and scenes including them. Thomas likely produced many of these photographs. Thomas certainly would have known the men who operated businesses from 1909 to 1923 and been given their photographic business.[38]

**D. P. HARLEY.**  Harley appeared in the 1925 Anderson directory with a photographic studio at 208 E. Whitener Street.[39]

### Brookland

**PAUL D. MITCHELL.**  In 1891 or 1892 P. E. Rowell published a book describing the towns of Lexington County, South Carolina, that contained advertisements of various businesses in those towns. P. D. Mitchell of Brookland (later called New Brookland and now West Columbia), across the river from Columbia, advertised as a "Photographer and Clock and Watch Repairer." By 1899 he had moved his business to Columbia and was operating a photographic gallery at 1112 Plain Street. He advertised as a photographer, but also sold cigars, tobacco, and "Summer Drinks." In 1903 through 1905 he was a grocery store operator. In 1905 he operated a cigar and tobacco store at 1102 Washington Street, but in 1906 he was a photographer at 801 Lady Street. He may have been a part-time photographer during this entire period, from 1891 to 1906. By 1907 he disappeared from local directory listings.

*P. D. Mitchell ad featuring an engraving of the photographer.* Towns of Lexington County. *SCL.*

Only a few Mitchell photographs are known. One shows Mitchell's studio at 1326 Market Street, an address not reported in local directories.[40]

*Charleston*

**KNIGHT & RANDOLPH AND HENRY KNIGHT.** Beginning in December 1865 a firm by the name of Knight & Randolph opened a gallery in Charleston at 339 King Street and continued there at least through 1866.[41] By May 1867 Henry Knight was advertising a gallery at the 339 King Street location. Knight continued in business to 1870 and several times advertised himself as an ambrotypist and a "photographist" with a studio "Where All Kinds Of Photographs Are Taken Cheap."

Henry Knight was listed several times as a black in Charleston directories, but no listing for Randolph's race could be found.[42]

Knight & Randolph secured a very small portion of the local photographic business in Charleston. From October to December 1866 they grossed $100.00 while George S. Cook was grossing $1660.00. The combined gross for all photographers during this three-month period was $3776.00. Knight & Randolph secured less than a 3 percent share of the market.[43]

The origins of Knight & Randolph are unknown, but they were probably from the northeast. Under slavery it would have been difficult for them to have become proficient enough to operate a gallery as early as 1865. Although images by them are unlocated, Knight & Randolph are important as an example of African Americans who operated a business soon after the end of slavery. Their studio is the first African American one on record in South Carolina.

**CLARENCE E. CHAFFEE.** From 1878 to 1881 Chaffee operated a gallery at 339 King Street, the former location of Henry Knight.[44]

**ARTHUR LAIDLER MACBETH.** Macbeth advertised in the 1901 city directory that his business in Charleston was established in 1886. The 1886 directory lists him as a printer, presumably of photographs, in J. H. Anderson's studio. In 1882 Macbeth was an artist in Anderson's studio, perhaps a hand-tinter of photographs. He apparently worked for Anderson's studio from 1882 to 1886.

The first Macbeth studio address on record was at 557 King Street in 1890. He worked at 529 King Street from 1894 to 1899 and at 186 Calhoun Street from 1900 to 1906. Macbeth's studio locations were in the heart of Charleston's business districts, the same area of the city chosen by most white photographers.[45]

Macbeth was born in Charleston and attended Avery Normal Institute there. He may have received formal training in photography, but likely learned his craft in J. H. Anderson's studio in the 1880s.[46]

**HENRY KNIGHT,**
**PHOTOGRAPHIST**
AND
**AMBROTYPIST,**
Rooms. 339 King Street,
**CHARLESTON, S. C.**

*Ad for Henry Knight's Gallery.* Charleston
*Advocate, 11 May 1867.* SCL.

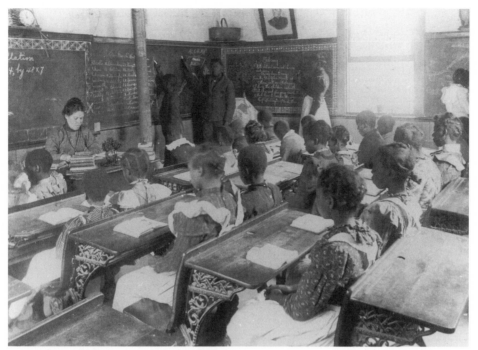

*Photograph of Class Room No. 2 at Laing School produced in 1900 by Arthur L. Macbeth. SCL.*

Arthur L. Macbeth,

Photo-Artist.

———

STUDIO:

529 King Street.

———

Superior Work
at Low Prices.

———

All the
Latest Effects
and
Improvements

*Ad from* Autumn Leaves, 1895, *featuring a picture of Macbeth. SCL.*

ABOVE: *Photographic backmark sometimes employed by Macbeth. SCL.*

*A bill from Macbeth to Principal Abbey D. Munro for photographing the Laing School in 1900. Macbeth's letterhead suggests a prosperous gallery. Abbey D. Munro Papers, SCL.*

Macbeth's work in Charleston was quite varied. In addition to portraiture, he advertised as a landscape and architectural photographer. Copying and enlarging photographs were two other services he provided. He produced several dozen images of the Laing School buildings and students near Charleston. The Laing School had been established in 1866 by the Friends Association of Philadelphia for the purpose of helping freedmen. Although most of his customers seem to have been drawn from the African American community, he also had some white ones.[47]

Macbeth's volume of work cannot be judged accurately, but there was a sufficient quantity to justify the employment of Miss S. J. Macbeth in 1892 as a clerk in his studio. Macbeth left Charleston in 1906 and worked for the Jamestown Exposition in 1907. He later operated studios in Norfolk and Baltimore.[48]

His work won awards in the 1890 South Carolina State Fair, the 1895 Cotton States Exposition in Atlanta, the 1901–02 South Carolina Inter-State and West Indian Exposition, and the 1907 Jamestown Exposition. His photographs, studio furnishings, photographic card mounts, and even his stationery all reflect a modern, thriving, photographic business and indicate his work was on a par with or excelled that of many of his white competitors. Of the twenty-seven known South Carolina African American photographers from 1865 to 1940, Macbeth had no equal except Richard Samuel Roberts of Columbia, who operated from 1920 to 1935.[49]

**J. B. Macbeth.**  The 1892 Charleston city directory lists James B. Macbeth with a photographic studio at 303 King Street. It is not known whether he was a relative of Arthur L. Macbeth.[50]

**Michael Francis Blake.**  Blake first appeared in a Charleston city directory in 1906 as a fruit dealer at 12 Sumter Street. From that date to 1910 he was listed as a "waiter" or dealer in "fruits, etc." The 1912 directory listed him as a photographer and repeated that listing in 1913. He ran a woodshop at 12 Sumter Street in 1914. From 1916 to 1932 his occupation is consistently listed as a photographer. His residence and place of business from 1919 to 1932 were at 384 Sumter Street.[51]

Examples of his work are in the Duke University collections. These photographs are chiefly printed photographs on postcards of African Americans and related subjects in the Charleston area. The Charleston Museum presented an exhibition of his works in 1994.[52]

**Elise Forrest Harleston.**  In September 1919 Elise Forrest enrolled in the E. Brunel School of Photography in New York City and began her training in photography. After finishing this course, she took graduate training in photography at Tuskegee Institute in 1921 with C. M. Battey. She married the African American artist, Edwin A. Harleston,

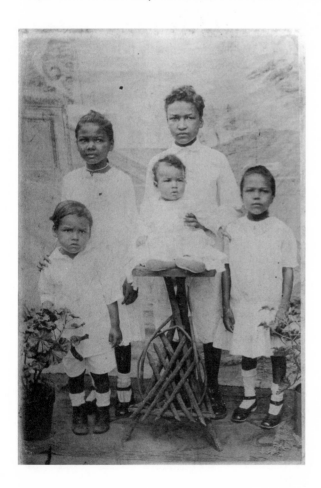

*Postcard photograph by Michael Francis Blake of an African American family. Duke University Library Special Collections.*

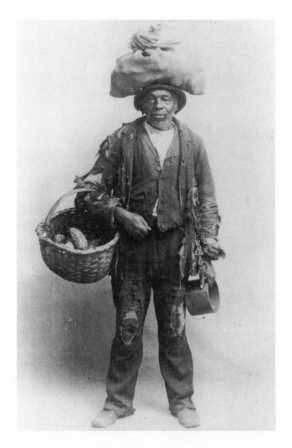

*Photograph by Elise Harleston of a Charleston street vendor with his products in a basket and in the bundle on his head. In his left hand he carries what appears to be a quart measure for berries, beans, or some other items. SCL.*

and from 1922 to 1932 she and Edwin operated a studio at 118 Calhoun Street where he painted portraits and she produced photographs. Frequently Edwin got Elise to make a photograph of an individual for whom he was painting a portrait so that he could continue painting when the subject was not present. Mrs. Harleston also produced and sold a series of photographs portraying African American street vendors in Charleston.

To Mrs. Harleston belongs the honor of being the first known African American female photographer in South Carolina.[53]

**CORNELIUS GLOVER.** In 1940 Cornelius Glover opened a gallery at 46 Spring Street, but was no longer in Charleston by 1942.[54]

## *Chester*

**IDA R. MASSEY.** Ida R. Massey served as a cook in homes and hotels before becoming the long-time cook for the Judge J. Lyles Glenn family of Chester. Ida's interests and activities beyond cooking included painting and photography. During the depression she received training in photography from Henry O. Nichols before opening a photographic studio in town. Her studio burned after a year and no examples of her work are located. She published *Ida Massey's Cook Book* in 1976 when she was in her late eighties.[55]

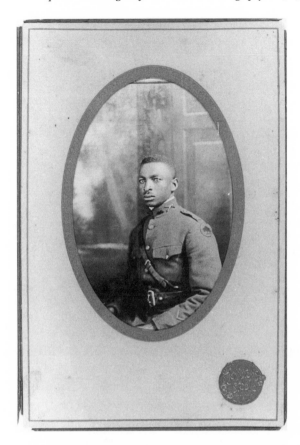

*Photograph by J. W. Johnston of a World War I African American soldier. Harbison Agricultural College Collection. SCL.*

## Columbia

**J. W. JOHNSTON.** Johnston had located a photographic gallery in Columbia at 1109 ½ Washington Street by 1918. He was a photographer until 1921, but disappeared thereafter. Perhaps the opening of a gallery in town by Richard Samuel Roberts prompted Johnston to depart town.[56]

**THE JOYCES OF COLUMBIA AND CHARLESTON, GARFIELD J. AND JOHN D.** The first evidence of Garfield J. Joyce in Columbia was a listing of him in the 1919 Columbia city directory as a porter in Lella Lindler's photographic studio. In 1920 he went into the photographic business for himself at 1029 Washington Street under the name Joyce's Art Studio. In 1921 and 1922 Garfield is listed as a laborer and not a photographer. At that time his place of employment was not given.[57]

In 1921 and 1922 John D. Joyce is listed as a finisher in Lindler's Studio. John D. and Garfield J. Joyce resided in the Waverly Community at 1406 1–A Taylor Street, suggesting they were related, perhaps brothers or father and son.[58]

Sometime in 1922 Garfield J. Joyce moved to Charleston. He set up the Joyce Art Gallery at 218 St. Philip Street and operated from that location through 1927. The 1929 Charleston city directory, the next year available, shows no residential or business address

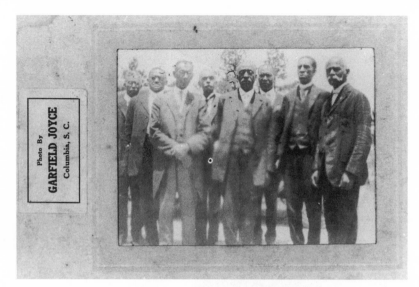

*Photograph by Garfield Joyce of Harbison Agricultural College faculty. Harbison Agricultural College Collection. SCL.*

for Garfield J. Joyce. John D. Joyce did not accompany Garfield to Charleston, but had left Columbia by 1923.[59]

Both Garfield J. and John D. Joyce were employed by Lella Lindler in her photographic studio. She may have employed them because they had previous experience in the photographic business, but they may have gained experience and training from her since she had thirteen years of experience in the photographic business by 1920.

The names employed by Garfield for his studios in Columbia and Charleston suggest that he may have been involved in handling art supplies or paintings. However, the city directories of the two cities show only photographic work. Very few examples of Joyce's work have surfaced to date and most of them are studio portraits. Three photographs of Harbison Agricultural College, including a panoramic view, have recently surfaced. Like Blake, he produced postcard portraits, but also did other kinds of portrait work.[60] For a time in 1920 there were three African American photographers in business in Columbia and a fourth worked as a photo finisher in a white female photographer's studio.[61]

RICHARD SAMUEL ROBERTS. During the hundred years covered by this study authors have chosen fewer than a dozen from the more than six hundred South Carolina photographers to use as a basis for a book, one being the African American photographer Richard Samuel Roberts. Beginning in 1977, a chain of events lead to the rediscovery of about 3,000 glass negatives produced by Roberts, about one-third of his estimated total work. From that year to 1986 a variety of activities lead by Thomas L. Johnson and Phillip C. Dunn, with cooperation and in-put from the Roberts children, led to the publication of *A True Likeness, The Black South of Richard Samuel Roberts, 1920–1936*.[62]

In *A True Likeness* Johnson and Dunn devoted ten pages to a description of Roberts' life and work and reserved the remaining 187 pages to print 196 well-chosen examples of his work.

Roberts came to Columbia in 1920 from Fernandina, Florida, and for the next fifteen years worked from four a. m. to noon in the United States Post Office. For the remainder of the day he worked in his photographic studio, first located at 1717 Wayne Street and then at 1119 Washington Street. Roberts was a self-taught photographer who constantly studied trade journals and manuals published by photographic suppliers such as the Eastman Company. Limited resources often forced Roberts to improvise in his studio, but throughout his working years as a photographer he enhanced his product with better equipment, studio furnishings, and techniques.

Roberts, like most photographers of the time, earned a large percentage of his income from studio portraits. He also produced portraits and other photographs at various locations around the midlands of South Carolina. He has been documented plying his profession in Florence, Orangeburg, Winnsboro, Johnsonville, Irmo, Hopkins, Charleston, and settings such as churches, schools, clubs, homes and cemeteries. Roberts produced some photographs of street scenes, houses, and businesses, and for several years he also produced most of the photographs for the *Palmetto Leader*, an African American Columbia newspaper. In 1925 he produced the pictures for the first South Carolina State College annual.

Estimates vary, but the figure of 10,000 images produced over fifteen years might be an accurate figure for Roberts' work. To help with this work load, Roberts' wife, Wilhelmina, and his son, Gerald, worked in the studio when necessary. Roberts employed others including Janie Paris of Irmo who worked as a receptionist, clerk, assistant photographer,

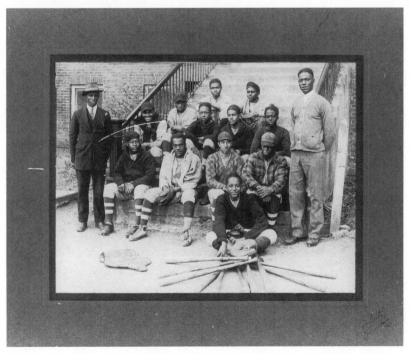

*Photograph by Richard Samuel Roberts of the Harbison Agricultural College baseball team (circa 1920). Harbison Agricultural College Collection. SCL.*

and dressing room attendant for about ten years. Although these individuals produced some of the product of Roberts' studio, his training and his direction were represented in all of these images.

The Roberts collection of some 3,000 images provides comprehensive documentation of urban, middle class, South Carolina African Americans and their culture in the two decades prior to World War II. No other known photographic collection produced by either African American or white photographers does this, leaving Roberts to rest alone today on this pinnacle of uniqueness.

Roberts, although self-taught, having fewer photographic resources than many others, and handicapped by segregation, rose above all these obstacles and produced artistic work of the highest quality. Johnson and Dunn state Roberts' work represents "beauty and clarity, grace of form, studies in proportion and clarity," and a combination of "attractive simplicity and a subtle complexity."

**HARRY SALLOWS.** In the last page of the 1938 Allen University annual, the *Allenite,* appreciation was expressed to "Our photographer, Harry Sallows, without whose labor the annual could not have been done." This credit line suggests that he was an African American photographer.[63]

*Photograph by Harry Sallows of Eugene Howard McGill, Allen University president. Copied from 1938* Allenite. *SCL.*

EUGENE HOWARD McGILL, B. D., D. D., A. B., A. M.
President

*Photograph by S. W. Williams of 1919 Harbison Agricultural College group. SCL.*

### Gadsden

**S. W. WILLIAMS.** From about 1915 to 1925 S. W. Williams of Gadsden produced photographs of Harbison College.[64]

### Greenville

**MERATT & MACKEY.** In 1923 Meratt & Mackey operated a studio at 14 Working Benevolent Temple.[65]

**SULLIVAN FRANKS.** By 1924 Franks had succeeded Meratt & Mackey at 14 Working Benevolent Temple, but had disappeared by 1925.[66]

**MELVIN OLIVER.** Oliver operated a photographic studio at 224 Young Street in 1926, but was not listed in 1928. No other black photographers were recorded in Greenville between the listing for Oliver in 1926 and 1940.[67]

### Orangeburg

**JAMES ANDERSON.** Anderson appeared in the 1920–21 city directory with a studio at 20 North Broughton Street.[68]

**SMALLS.** A few references were found to this photographer's presence in Orangeburg, but no details as to dates or length of time there or even his first name.[69]

### Sumter

**ANTHONY FRANCIS.** By 1910 Anthony Francis was working in Sumter as a photographer.[70]

*Photograph by Marion Farmer of a small
African American boy who is all "dressed up"
for his photograph. SCL.*

**MARION M. FARMER.** In 1912 Farmer operated a photographic studio at 212 South Main Street and continued at that address at least until 1916.[71]

**A. J. LEWIS.** Lewis operated a studio at 102½ North Main Street by 1912.[72]

**CHARLES SPEARS.** In 1934 Charles Spears operated a studio at 112 W. Bartelle Street. His studio had closed by 1937. Spears is better known as a painter.[73]

## Observations and Conclusions

When the information compiled from this one hundred year study is examined in its totality, a clearer picture emerges concerning the extent to which African Americans and their culture and heritage were documented photographically compared to whites, and the extent their photographs have survived.

Only a few African American South Carolina portraits are known that date before 1865 and all of them were taken by white photographers. In the period from 1870 to 1900 some of the white photographers and all of the African American Charleston photographers photographed blacks in that area. White photographers also photographed African Americans in the areas of Aiken and Camden. In the remainder of the state a few African Americans were photographed by various white photographers, but the vast majority of them and their activities were not being photographed.

Eighteen of the twenty-seven African American South Carolina photographers practiced their profession between 1909 and 1932. Only Charles Spears in Sumter for the year 1934, Ida R. Massey in the mid-thirties, Richard Samuel Roberts for the years 1933–36, and Cornelius Glover in Charleston for the year 1940 are documented as having practiced

photography. The depression almost wiped out the budding expansion of photography into the African American community during the 1920s. Nine of the twenty-seven worked for only a year.

African American photographers located in eight South Carolina towns: Anderson, Charleston, Chester, Columbia, Gadsden, Greenville, Orangeburg, and Sumter. Large areas of the state were not served by any African American photographer. Some African American photographers left their bases of operation and went to nearby communities and photographed there, but, except for Macbeth and Roberts, this was done to only a minor degree.

Based on examination of the major photographic collections and most of the minor ones, the quantity of African American photographs compared to those taken by whites is very small. The Roberts collection and the Penn School collection are the only noteworthy exceptions.

In all likelihood there are sizeable numbers of African American photographs not in collections. Field work in African American communities should identify many family albums dating from 1900 to 1940 that have not been viewed by historians. Hopefully institutions and others will identify, collect, and preserve these photographs of African Americans so researchers and writers of the future can present a clearer and more complete picture of South Carolina African Americans.

## South Carolina African American Photographers and Known Working Years

(LISTED CHRONOLOGICALLY)

1865–66—Knight & Randolph—Charleston
1866–70—Henry Knight—Charleston
1878–81—Clarence E. Chaffee—Charleston
1882–06—Arthur Laidler Macbeth—Charleston
1892—J. B. Macbeth—Charleston
1899–06—Paul D. Mitchell—Columbia
1909–22—Edgar L. Thomas—Anderson
1910—Anthony Francis—Sumter
1912–32—Michael Francis Blake—Charleston
1912–16—Marion M. Farmer—Sumter
1912—A. J. Lewis—Sumter
c. 1915–25—S. W. Williams—Gadsden
1918–21—J. W. Johnston—Columbia
1920–21—James Anderson—Orangeburg
1920–36—Richard Samuel Roberts—Columbia
1920—Garfield J. Joyce—Columbia
1922–27—Garfield J. Joyce—Charleston
1921–22—John D. Joyce—Columbia
1922–32—Elise Harleston—Charleston

1923—Meratt & Mackey—Greenville
1924—D. P. Harley—Anderson
1924—Sullivan Franks—Greenville
1926—Melvin Oliver—Greenville
1934—Charles Spears—Sumter
Mid-thirties—Ida R. Massey—Chester
?—Smalls—Orangeburg
1938—(Harry Sallows)—Columbia

# Female Photographic Artists, 1840–1940

Over the years authors have portrayed the role of women in the professions in hundreds of magazine articles and books, but few have treated in depth women's role in photography, and none the role of South Carolina women in that profession. During the one hundred years covered by this study, of the more than six hundred photographers who operated in South Carolina, more than sixty were women.

## Female Photographers, 1840–80

During the first forty years, from 1840 to 1880, only five women were identified who operated or owned studios: Mrs. Fletcher, a daguerreotypist in Charleston in 1842; Mrs. D. W. Jones, operator of a Greenville studio in 1867; Mrs. J. A. Bolles, operator of a Charleston studio in 1872; Bertha F. Souder, owner of a studio operated by S. T. Souder in Charleston from 1871 to 1873; and Miss Georgia C. Parks, operator of a gallery in Greenwood in the 1870s and 80s.

MRS. FLETCHER. Mrs. Fletcher first advertised her gallery in February 1842 at 149 Meeting Street, but her ads were discontinued after a few weeks. Those for Mr. Fletcher's phrenology business also ceased after a few more weeks, indicating the Fletchers' stay in Charleston was probably three months or less. Mrs. Fletcher's was the first female-operated gallery in South Carolina.[1]

According to an undated manuscript attributed to Albert Sands Southworth, Mrs. Fletcher apparently began her career in Cambridgeport, Massachusetts, in 1840.[2] This manuscript refers to her experiments in photography there. Prior to coming to Charleston she and her husband also operated their businesses for a brief period in Canada.[3]

MRS. D. W. JONES. Two cartes de visite surfaced from the studio of Mrs. D. W. Jones of Greenville with circular dated stamps of October and December 1867. The Greenville Public Library collection contains an 1868 printed advertisement card for Mrs. Jones' studio. A carte de visite of her husband, D. W. Jones, also came to light.[4]

MRS. J. A. BOLLES. The next female-operated gallery to be identified was that of Mrs. J. A. Bolles in 1872. She was likely the sister or sister-in-law of Jesse H. Bolles. His gallery had the same location as hers, the corner of King and Market Streets. She only operated the studio for a year or less because a J. A. Bolles, presumably her husband, operated it the following year.[5]

**MRS. D. W. JONES**

INFORMS her friends and patrons that she has opened a
NEW GALLERY on Pendleton Street, (first building on
the left above DAVID & STRADLEY'S,) where, with a newly-
constructed Side and Sky Light, unobscured by neighboring
walls, as heretofore, and with many improvements and con-
veniences in Photography, she hopes to retain the patronage
hitherto extended to her.

She hopes that persons residing in the eastern part of
Town will, in the longer walk, be cheered with the prospect
of better pictures under circumstances so much more favor-
able for securing them.

Frames of different sizes, and Cases of various qualities,
for sale at low rates.

December 1st, 1868.

*Mrs. D. W. Jones used this hand bill in advertising her Greenville gallery. Courtesy of the Greenville County Public Library.*

**BERTHA F. SOUDER.** Bertha F. Souder purchased Quinby & Co's gallery in 1871, but sold it to George N. Barnard after two years. The relationship, if any, between S. T. Souder, the operator of the studio, and Bertha is unknown, but she probably was his sister, wife, or mother.[6]

**MISS GEORGIA C. PARKS.** The only evidence of Miss Georgia C. Parks' gallery in Greenwood are some cartes de visite of members of the Klugh-Hartley family of Abbeville that date from around 1870 to 1880. It is assumed she owned this gallery, although these cartes only list her as the photographer.[7]

## Female Influences on South Carolina Photography, 1840–80

During the period from 1840 to 1880, although few women owned or operated studios, they influenced photography in a variety of other ways.

Travel for the itinerant photographer or others was difficult, sometimes hazardous, and almost always uncomfortable. These factors inhibited wives from accompanying their husbands. The added factors of homemaking and caring for children meant very few women probably traveled with them. Scant records exist concerning wives who accompanied their itinerant husbands, but most were usually active in the business when they did.

Mrs. Adam Libolt serves as a splendid example of an active wife in the family business. A Columbia newspaper reporter in 1845 described her role in this manner: "Dr. Libolt's personal worth and gentlemanly deportment, can scarcely do less than his success as an artist, to commend him to the favorable consideration of our citizens; while the very pleasing reception and attention given to his lady visitors by his suitable and intelligent lady,

*A carte de visite by Miss Georgia C. Parks of a member of the Klugh/Hartley family. The hand-tinting on this carte may have been added by members of the family after its production by Miss Parks. Courtesy of Mrs. Cathy Hartley.*

*Backmarks appearing on cartes de visite produced by Miss Georgia C. Parks. Courtesy of Mrs. Cathy Hartley.*

may well render his room, combined with its plentiful attractions, a place of frequent and favorite call with them."[8] As a hostess, Mrs. Libolt unquestionably was an important factor in the success of their business.

Augusta Wilde, the daughter of Dr. J. W. F. Wilde, provided valuable assistance in her father's galleries in North and South Carolina. In Yorkville in 1853 she was advertised as a colorer "unsurpassed anywhere, and unequalled in the South." In Greensboro, North Carolina, this ad appeared in March 1851: "To ladies, our advantage present strong claims, as they are assisted (in a separate apartment) in their toilette, and prepared for sitting by Miss Wilde, whose experience and success with children produce gratifying results and whose style of coloring is unequaled;-both of which duties are exclusively within the province of a female."[9]

Many females hand-tinted photographs and otherwise participated in the arts. Mrs. E. M. Link, a Charleston female artist, gave photographer D. L. Glen assistance in 1856. A local editor opined: "We were much pleased yesterday with a colored photograph we had an opportunity of inspecting, which exhibits a new and most effective mode of adding the advantages of color and hue to the photograph without destroying the peculiar delicacies of the original impression. The coloring was executed by Mrs. E. M. Link, whose ingenious and highly meritorious skill in Grecian painting, leather work, and other branches of ornamental elegance we have had previous occasions to notice, and who occupies rooms at the S. E.

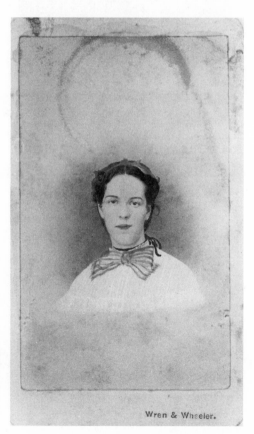

*Carte de visite with P. H. Wheeler's hand-
tinting instructions to Mrs. O'Bear. SCL.*

corner of King and Hassell Streets (over the store of Calder, Brown & Co.) for the purpose of giving instruction in these arts. The photograph in this case was taken by Glenn, in the usual excellent style of his gallery."[10]

The editor's use of the term, "in this case," suggests Mrs. Link colored photographs for other Charleston photographers. Mrs. Link's coloring at that date probably would have been confined to daguerreotypes and ambrotypes since paper photographs were yet to come into vogue in Charleston.

A Wren & Wheeler carte de visite, probably produced by them while in Newberry in 1867 and 1868, contains directions on its reverse to the hand colorer, a Miss O'Bear. "Miss O'Bear, Please col. these first. Please not to col. eyes so blue quite & the lips not so red. Very respectfully, P. H. Wheeler."[11]

Hand-tinting and coloring photographs by women continued in the post-1880 period as well. Anna A. Weir was a "retoucher" in J. C. Fitzgerald's gallery in Greenville in 1883 and 1884. George V. Hennies employed at least one of his daughters and a Mrs. Seats/Seets (see Hennies in Chapter 5) to hand-tint photographs in Columbia.[12]

Before, during, and after the period from 1840 to 1880 women were engaged in similar pursuits in other fields. Ladies were frequently employed to hand paint china and, in many instances, to execute drawings and paint backgrounds for well-known artists. When we examine some works of art produced by men, we may also be viewing the paint strokes of female hands.

Such a case occurred when Thaddeus Mason Harris, the son of Harvard University Librarian Dr. T. William Harris, visited in the Charleston home of the famous South Carolina scientist and naturalist, John Bachman. At the time Bachman's house guests were the most famous of all American naturalists, John James Audubon and his wife. Harris observed Maria Martin, Bachman's sister-in-law, executing drawings for Audubon and wrote that her "talent is scarcely less in its accuracy & finishing than that of Audubon himself."[13]

*P. H. Wheeler's hand-tinting instructions to Miss O'Bear.*

Antebellum photographers J. S. Wear, Dr. Adam Libolt, J. Hervey, and Joseph T. Zealy recognized women as customers in their ads by inviting "Ladies & Gentlemen" to visit their studios. Sterling C. McIntyre recognized female customers when he gave directions to them in his ads concerning the kind of clothing they should wear when visiting his gallery.[14]

Although not enjoying political and economic power during much of the time covered by this study, women possessed and used other resources that probably influenced photography to a greater degree than most other professions. Women obviously had much control and influence in the matter of visiting studios for photographs of their children and other family members—photographs destined for albums or to be sent to relatives, or to be carried off to war when loved ones answered the call.

Photographers knew the advantages of considering female needs and tastes in the conduct of their business. As studios became more permanent during this time period, the influence of female clientele produced changes in studios such as the addition of dressing rooms, reception rooms, improved backdrops and scenery, and more props for use with children.[15]

## Female Photographers, 1881–1900

The activities of women in South Carolina photography from 1881 to 1900 closely paralleled that of the first forty years. Seven women owned and operated photographic studios: Miss P. A. Steen, Charleston, 1883–85; Miss Sallie Kennedy, Chester, 1889–1906; Cora F. Holroyd (Mrs. Luther A. McCord after 1904), Laurens, 1899–1950s; Misses Nora and Corra Carver, Seneca, c. 1900; Miss Eva LeConte, Columbia, 1900–04. The women who operated or owned galleries from 1840 to 1880 did so for brief periods of time while four of the six women photographers operating from 1881 to 1900 had established studios for long periods of time. For two towns, Chester and Laurens, the female-operated galleries were the predominant ones. Although not operating a studio, Chansonetta Stanley Emmons engaged in significant photographic work in the state in 1897 and 1926 and has been included.

### Charleston

**Miss P. A. Steen.** During the period from 1883 to 1885 Miss Steen managed the Carrington, Thomas & Co. firm located at 267 King Street in Charleston.[16]

**Mrs. Leidloff.** Hermann Leidloff's wife assumed an active role in the operation of the family studio in Charleston. In 1884 a report stated that Leidloff "is ably assisted by his wife, Mrs. Leidloff, who attends to the reception room and financial part of the business. This excellent lady is a native of Charleston, and has made many friends in the community."[17]

**Chansonetta Stanley Emmons.** On visits to North Carolina and to Charleston and vicinity in 1897 and 1926 Chansonetta produced more than 200 photographs of buildings, street scenes, and African Americans on plantations near Charleston. Included in this work produced in the Carolinas are 168 lantern slides and 122 exhibition prints.

Chansonetta was also an accomplished painter and specialized in miniatures on ivory. She apparently did no paintings while on her two trips to the Carolinas. Her work both as a painter and a photographer was primarily confined to the northeast and to her home state of Maine.

Chansonetta's work remained unappreciated and almost unknown until Marius B. Peladeau produced a book in 1977 containing a biographical sketch and more than ninety examples of her work, including ten of South Carolina subjects. Of her Carolina work Peladeau wrote, "Chansonetta showed the rural South and rural New England as it had been for generations, because she knew this reality was disappearing and that another generation of photographers would not be able to document what she was seeing. Yet this was more than documentary photography. It was done with the eye of an artist."[18]

### Chester

**MISS SALLIE KENNEDY.** In her Chester studio in December 1889 Kennedy offered "Photographs Taken By The Instantaneous Process." In May 1895 she advertised that "Now is the Time To Get Good Work Cheap. Pastels 14x17—$4.00, Crayons, 14x17—$3.00." In 1900 hers was the only Chester studio listed in Young & Co's directory. She operated her studio successfully until her death in 1906, producing thousands of cartes, cabinets, and other types of photographs.[19]

*Cabinet by Sarah (Sallie) Kennedy of Mrs. Mary Barber. McFadden, White, Macaulay Papers. SCL.*

On 6 February 1906 photographer J. C. Patrick rented her studio and operated it until Reginald Otwey Salter of Newberry took over in July of that year. Salter had his eye on Miss Kennedy's studio before her death, but she would not sell. When discussing the establishment of a studio in Chester in a letter to his sister in September 1906, he described visits with Miss Kennedy: "I know those to be *facts* for I've been over there twice and looked into it—the first time, when Miss Kennedy—a sweet old maiden lady—loved by all the town—had charge and had no intention of disposing of the studio. She was very sweet and nice to me while I was there— made me at home in the studio and during the hour I spent there there were some 6 or 8 young lady clerks and others 'just droped in' to have a min-utes chat with her—and she would always introduce Mrs. Salter to them individually."[20]

When Kennedy died from pneumonia on 13 January 1906, the local paper carried a one-third column obituary that gave details about her family, especially the male members, about her Christian character and service in the Baptist Church, and, finally, details for the funeral service. What was missing from the obituary demonstrates the overall societal atti-tude at the time toward women working outside the home and perhaps toward the profes-sion of photography. Her work as the owner and operator of a studio in town for at least seventeen years went unrecognized.[21]

## Columbia

**MISS EVA LECONTE.** She was first listed in the 1900 city directory with a studio at 1316 Main Street and in 1903 and 1904 as a photographer living at 1707 Pendleton Street. No address was given for her studio in 1903 and 1904. She may have worked out of her home or been employed in another studio. Only a few examples of her work have surfaced to date.[22]

ABOVE: *Photograph attributed to Eva LeConte of "Allwehave," the Gibbes plantation home in lower Richland County. Courtesy of A. Mason Gibbes.*

*Photograph of Eva LeConte by an unknown photographer when she was a young lady. Courtesy of A. Mason Gibbes.*

## Laurens

**CORA FRANCIS HOLROYD.** In the annals of South Carolina photography, a significant event occurred in Laurens in June 1899. Cora Frances Holroyd rented the gallery of Luther A. McCord. McCord, who earlier had established the gallery and operated it until late 1898, rented it to the Gallagher Brothers. When they left Laurens Miss Holroyd succeeded them.[23]

Holroyd's parents, of English origin, were living in North Andover, Massachusetts, when her mother became ill. For Mrs. Holroyd's health, the family moved to Tallapoosa, Georgia, where Cora finished school and studied photography with family friends. After locating in Laurens she operated a studio until 1904, when she married her landlord, Luther A. McCord. After her marriage she devoted full time to being a homemaker and Luther took over operating the studio. When he died a few years later, Mrs. McCord resumed operation of the gallery and continued as its proprietor for the next fifty years.[24]

From 1899 to post-World War II times the McCord Studio was preeminent in the Laurens area. The McCords recorded the faces of thousands of Laurens county citizens.

## Seneca

**NORA AND CORRA CARVER.** Somewhere around the turn of the century the Carver sisters, Nora and Corra, began a studio in Seneca. They operated it for several years.[25]

*Photograph by the Carver studio of "Aunt Julia." Henry William Ravenel papers. SCL.*

## *Female Photographers, 1901–20*

During the first two decades of this century, twenty-three women either owned or operated photographic studios. More women were now entering the profession.

**PENN SCHOOL FEMALE PHOTOGRAPHERS.** While serving as principals, teachers, and trustees, or while visiting the Penn School on St. Helena Island near Beaufort, six women produced photographic work worthy of note.[26]

Helen C. Jenks, a trustee and amateur photographer, took photographs at the school from 1890 to 1912. Rossa B. Cooley and Grace B. House were teachers and principals of the school from 1904 to 1944. Rossa B. Cooley took the great majority of the 3,000 photographs now in the Penn School collection. She deserves most of the credit for creating this exceptional photographic archive of the Penn School, its surroundings, and lowcountry African Americans' culture. Isabella Curtis served as a school trustee and was a friend of the school principals. She produced photographs while on visits to the school in 1915 and 1930. Mary Isobel House, a sister of Penn school principal, Grace House, took photographs. Margaret Moyes, another friend of the principal, produced a large number of photographs when she visited the school in 1937.

### *Blackville*

**LEONARD KELLY.** Kelly began her business in 1905 after study in Atlanta and training sessions in photography at the Eastman School in Charleston. She said that she learned much about photography by demonstrations of photographic products from salesmen.[27]

For more than sixty years Kelly's studio was the chief one in that region. A 1954 *State Magazine* article indicated that "there is hardly a family in Barnwell, Aiken, or Bamberg counties, and as far as Brunson and Walterboro, which does not list several Kelly pictures among its cherished possessions. Miss Kelly has always done excellent baby pictures and she says: 'I am now doing the grandchildren of the babies whose pictures I made when I first started.'"[28] Conversations with the staff at the Barnwell, South Carolina, Public Library in 1993 also verified the widespread patronage Miss Kelly enjoyed. In fact, from 1905 to the late 1940s, Barnwell, the county seat, had no photographic studio. Everyone either patronized Miss Kelly or went to Augusta, Georgia, for photographs.[29]

Miss Kelly remained active in her studio until shortly after 1970, a period of more than sixty-five years. Today many local townsfolk recall Miss Kelly, her studio, and trips there for photographs. Isabella Murphy Meaney, a native Blackvillian, described trips she took to Miss Kelley's as a young child, a mother, and a grandmother. She recounted Miss Kelly's careful attention to lighting and posing her subjects and the facility with which she photographed babies and young children. She remarked that Miss Kelly usually printed extras of such pictures that, as a rule, were also purchased by loving parents or other relatives. She recalled that Miss Kelly enjoyed an average standard of living and did not become wealthy from her business. She remembered that Miss Kelly did not drive, but was frequently taken by family members to their reunions to photograph them.

*Photograph of Miss Leonard Kelly. Courtesy of Wyatt B. Pringle.*

*Baby photograph of Marion Imogene Still by Miss Leonard Kelly. SCL.*

Mrs. Meaney invited me to see the "rogues gallery." Her daughter then led the way to a room with ceilings about 12 feet high and, with a sweep of her hand, presented a wall covered by photographs of her family largely created by Miss Kelly over more than sixty years.[30]

Two of Kelley's pictures were accepted in 1926 for the International Exhibit in Chicago. They were a study called *Old Man with Pears* and a baby picture.

In 1954 her studio was described in this manner: "Kelly's Studio today still occupies the one-story brick building just off Main Street of Blackville where she began work 50 years ago. Its entire north wall is one gigantic skylight. The front or show room is attractively decorated with samples of her work, hand-tinted by Miss Kelly herself, but it also includes some of the oil paintings done by her mother, the late Mrs. Kelly. Most eye-catching, too, are the colorful flower 'prints' by Miss Kelly's sister-in-law, Mrs. Pauline Kelly, a talented artist in her own right."[31]

## Camden

**BESSIE M. ROBERTS.** In the second decade of this century Bessie M. Roberts operated a studio in Camden. The 1914-15 Camden city directory listed her at 1003 6th Avenue. This was apparently her home address. She was succeeded as owner of her studio over the Bank of Camden in May of 1914 by E. C. Zemp. The Bank of Camden was located on DeKalb Street.[32]

When she began her business is unknown. A studio called the Camden Studio was established in town in July 1910 and was a successor to the Snyder Gallery. This may have been Roberts's studio since Zemp referred to her business in 1914 as the "Snyder Gallery." If this is the case, she operated in Camden for about four years. The Camden Studio in 1910 advertised taking portraits, enlarging photographs, and Kodak finishing.[33]

## Charleston

**ELIZABETH A. DAWSON.** Dawson began her photography career in Charleston in 1901 as a clerk in the well-established studio of William D. Clarke. For the next eighteen years she continued in this capacity with her position being variously described as clerk (1901), retoucher (1903), and, for several years, assistant.[34]

No directory for 1920 was available, but in 1921 she was not listed as being in town. In 1922 she operated the Marion Studio at 251 King Street, the former location of William B. Austin's studio. From that year to the middle of World War II she continued the operation of her studio there.[35]

Her former employer, William D. Clarke, continued in business and the two were competitors for more than twenty years. Clarke had once worked for Austin whose location she occupied with her Marion Studio.

Dawson had the good fortune to have worked for a first rate studio where various types of photography such as studio and outdoor work were practiced. She learned her lessons well as she successfully competed with not only her former employer Clark but also with a host

of others. Her career as a photographer in Charleston spanned more than forty years and may best be summed up by a quote from one of her 1938 ads, "Photographs of Quality."[36]

**Rosa S. Grant.** In 1917 or 1918 Rosa S. Grant, widow of G. E. Grant, became proprietor of Holland's Studio at 297 King Street in Charleston. Hubert S. Holland had moved to Columbia and opened a gallery there. Mrs. Grant retained the name Holland's Studio and, for the next fourteen years, continued to produce portraits for her clients. Since she was listed as the proprietor and photographer of Holland's Studio, it is assumed Holland did not retain a financial interest in the business. For about ten years one of Rosa's photographic neighbors and King Street competitors was Elizabeth A. Dawson.[37]

**Elizabeth Gibbon Curtis.** This lady produced a series of photographs that were incorporated in 1926 into a book titled, *Gateways and Doorways of Charleston, South Carolina in the Eighteenth and the Nineteenth Centuries.* In about 1912 or 1913, "she studied professional photography and devotedly recorded the gates and doorways that she knew so well." Although there is no record indicating she ever operated a photographic studio professionally and this work is primarily devoted to chronicling the work of professional photographers, the historical importance of this endeavor by Curtis justifies its inclusion here.[38]

## Columbia

**Lella Lindler.** In 1906 Walter L. Blanchard began what was to become one of the most outstanding studios in the history of Columbia. Within a year, he employed a young lady by the name of Lella Lindler as his assistant. From 1907 to 1918 Lella worked in Blanchard's Studio and contributed much to the success the studio enjoyed during this period.[39]

*Portrait by Lella Lindler of an unknown girl (circa 1925). SCL.*

During and after World War I the growing economy of Columbia increased the number of photographic studios. Lella Lindler decided it was time to leave Blanchard and to open a studio. The studio she established in 1918 at 1306 Main Street remained a Columbia fixture for the next three decades.[40] She competed with Blanchard, Sargeant, Toal, Lollar, and Charles Old—all first class studios.

In 1919 she advertised her business in Camden and St. Matthews, inviting those coming to the State Fair in Columbia to visit her gallery. In 1922 her ad in the Columbia city directory indicated Lindler's Studio was "Just a Little Different" and that she provided "Artistic Photography and Copying."[41]

Records in 1919 and 1922 indicate Lindler employed two African American assistants, Garfield J. Joyce and John D. Joyce. Later these two owned and operated a studio in Columbia.[42]

## Gaffney

**EUNICE TEMPLE FORD.** Although not a professional photographer, as a student and faculty member of Limestone College Miss Ford produced a significant number of photographs of Limestone students, faculty, and college from 1904 to World War I.[43]

## Greenville

**MISS SHARP.** In 1907 Sharp operated a studio at 213 W. Washington Street. She was not listed in the 1903, 1904, or 1909 city directories. Hence, she could not have been in business for more than three years. One example of her work is a head and shoulder shot of a girl in her graduation cap.[44]

**MRS. JAMES H. ORR.** The Orr Studio in Greenville dates from 1913 and was probably a husband and wife business from the outset, although documentation for Mrs. Orr's involvement in the business as a photographer dates from 1915. From 1915 to 1920, a period of six years, the two produced the photographs in the Furman University annual, the *Bonhomie*. By 1935 Mrs. Orr had succeeded her husband and operated the studio alone until 1947.[45]

## Greenwood

**MARY E. HUGHES.** Hughes operated a studio in Greenwood from 205 National Bank in 1916 and 1917 and may have been the wife of W. H. Hughes, Jr., operator of a Greenwood Studio in 1912 and 1913.[46]

## Halsellville

**MRS. E. D. WELLS.** In the early 1900s Wells worked for the Sunny South Picture Concern as a photographer and produced stereoscopic views for them. According to the backmark on one of her stereographs, the company operated simultaneously out of Ohio

*Stereograph of a girl in Georgetown. Produced by Mrs. E. D. Wells, titled "Sweet Sixteen." SCL.*

*Photograph of downtown Lancaster produced by Miss Isabella Michaux Davis.*
*Courtesy of Lindsay Pettus.*

and South Carolina. Mrs. Wells of the Halsellville community in Chester County served
as the South Carolina agent, and E. C. Brownson of 632 Hicks Street in Toledo, Ohio,
served as the Ohio agent. The three examples located of Mrs. Wells work are of George-
town subjects.[47]

## Lancaster

**MISS ISABELLA MICHAUX DAVIS.** According to historian Louise Pettus, Isabella
Michaux Davis was producing photographs in Lancaster by 1908. She may have been the
daughter of photographer W. A. Davis.[48]

## Marion

**JESSIE GASQUE HAMILTON (MRS. JENNINGS BLACKMON).** Warren K. Hamilton's daughter, Jessie Gasque, very early in life took an interest in her father's business and was a competent photographer by her high school years. In fact, he left the Marion studio in her charge in 1918 when he opened his Florence gallery. Jessie took photographs in Marion and sent the film by train to Florence where her father processed it and mailed the finished photographs back by train to her. Charlotte Stevenson related the occasion of Jessie taking her sister's picture in Marion at the Hamilton Studio.[49]

Jessie continued the Marion studio until her graduation from high school in 1919. Her father then sent her to take a one year training course in photography. Her experience and this training stood her in good stead later. After marriage to Jennings Blackmon she opened the Blackmon Studio in Sumter in 1941 and operated it until 1944. The Blackmons moved to Florence that year and Jessie opened the Blackmon Studio there. In 1947 she bought out her brother Hubert and combined that studio with hers. In 1950 she moved the studio from the downtown location to their home at 1508 W. Evans Street and built a lab on the back of the property. From this location she continued the Blackmon Studio until 1985.

Jessie's sisters, Bruce and Esther, also worked in their father's studio and for a short time Bruce operated a studio of her own. Jessie's sisters, children, husband, and a niece all provided valuable assistance as they performed the various tasks necessary in a studio such as developing, printing, mounting, and tinting.

Warren Kenneth Hamilton began and developed the family business to its successful position and standing during the firm's first fifty-two years. Jessie (Mrs. Jennings Blackmon) directed the fortunes of the family business for the last forty-eight years of its operation. She continued the gallery until 1985.

*Copy print of photographer Jessie Gasque Hamilton Blackmon (circa 1980). Courtesy of Mrs. H. R. Wyman.*

That she was an artist is borne out by the many Blackmon-produced portraits in family albums of the area or photographs in school annuals or wedding pictures. The Blackmon studio won many awards over the years for outstanding work. Although she never painted portraits or scenes for commissions, a number of her family portraits, still lifes, and landscapes further demonstrate her talents.[50]

## Newberry

**MAMIE ELAIDA SALTER.** Mamie Elaida Salter operated a studio with a brother in Athens, Georgia, from 1904 to 1906. From 1920 to 1923 she and a brother operated a photo and art studio in Newberry and from 1920 to 1925 they operated a combination music store and photographic gallery in Anderson.

**TEMPERANCE ELIZABETH SALTER.** She and a brother operated a studio in Newberry from 1902 to 1921. From 1922 to 1932, and perhaps longer, she operated the studio alone. From 1906 to 1912 she and a brother also operated a studio in Chester.

*Copy print of photographer Warren K. Hamilton with his two daughters, Jessie on the left and Esther on the right (circa 1916). Courtesy of Mrs. H. R. Wyman.*

## North Augusta

**SARAH POTTER.** The Augusta, Georgia, city directory of 1912 listed Sarah Potter on Carolina Avenue in North Augusta, South Carolina, as a photographer.[51]

## Rock Hill

**S. N. STEELE.** In 1911 a photographer named Steele worked with Wheeler from Greenville in a studio on Hampton Street in Rock Hill. In 1913 S. Steele advertised locally and in the 1913–14 city directory was listed under "Photographers" as Miss S. N. Steele at 119½ Hampton Street, but in the alphabetical listings as Susan N. Steele. She was probably the Hampton Street photographer with whom Wheeler worked in 1911.[52]

## Spartanburg

**TACCOA SANDERS.** In Spartanburg a photographic firm by the name of Ray & Sanders advertised in the June 1902 *Wofford Journal.* Whether Ray was male or female remains a mystery, but Miss Taccoa Sanders operated a studio at 10 W. Main Street from 1903 to 1908.[53]

*Photograph of a young man (circa 1902) by Ray & Sanders. Note the names of the photographers at the lower right of the image. Collection of the author.*

**MRS. W. S. GRAHAM.** In September 1906 a Mrs. W. S. Graham of Spartanburg advertised that "the Magnolia Studio On Magnolia Street is the place to go for good photographs and Low Prices." In 1905 H. T. Hart was the proprietor of the Magnolia Studio and in 1908 and 1909 R. F. Peterson was listed as the proprietor.[54]

**MRS. HENRY BERNHARDT.** Although Spartanburg city directories did not list Mrs. Henry Bernhardt as a partner in the studio until 1920, she was advertised in a 1906 Spartanburg almanac as an active partner in the business and in a newspaper for giving special attention to women. The Bernhardts were pictured in the *Bohemian* of Wofford College in 1908 as owners and operators of their studio, and, so far as is known, she was an active partner in the business from 1906 to 1924.[55]

*Sumter*

The successful photographer James H. Winburn of Sumter owed a measure of his success to three females, Irma L. Roberts, Juanita Lawrence, and to his daughter, Mary, who later became Mrs. Max Diedrick Werner.

**MRS. MAX DIEDRICK WERNER.** Mary, or "Jack" as she was known, began assisting her father in the early 1900s. Much of the work she did for her father is unidentified, but in 1924, after a tornado swept through a part of neighboring Lee County, she visited the area and recorded the damage in a set of photographs bearing a backstamp containing her name and Winburn's studio name.[56]

**IRMA L. ROBERTS.** The length of service and the exact role Miss Irma L. Roberts played in Winburn's studio is not clear. She may have been a receptionist and general assistant and not have actually taken pictures.[57]

*Photograph by Mrs. Max Diedrick Werner of Dubose Fraser's home in Lee County that had been destroyed by a tornado in 1923. Courtesy of W. C. Smith.*

**Juanita Lawrence.** Juanita Lawrence had been an assistant to Winburn for a number of years before his death in 1926. After his death she operated the studio for a couple of years. In 1927 she advertised she was trained by Winburn and guaranteed "the same high grade Photography that was the Winburn reputation." The continuance of the Winburn quality was borne out by the picture of a fire in Sumter she took in 1928 that appeared in the local paper.[58]

**India Graham.** In addition to the ladies working for Winburn, there was a wife and husband team who operated a studio for a short time in Sumter. India Graham worked with her husband in a studio from 1908 to 1910, taking photographs and processing film for amateur photographers.[59]

### Yorkville

**Rosa J. Lindsay.** On 27 November 1903 Rosa J. Lindsay advertised the opening of her photographic studio above the Opera House in Yorkville, a studio she operated for at least the next nine years. She related her completion of a photographic course under a competent master and the possession of the finest equipment available. She advertised frequently in the local paper–especially around Easter, Confederate Memorial Day, Christmas, and school graduations–her services that included photographing cattle and stock, producing picture postcards, developing film, and working on location.

Lindsay left her studio for a few weeks in 1905 to take a photographic course in Buffalo, New York, and in 1907 she attended a convention of photographers in Norfolk, Virginia, with other photographers from Virginia and the two Carolinas. By February 1911 Rosa joined into a partnership with Mrs. M. H. Curry in a Gastonia, North Carolina, studio. She advertised that her Yorkville studio would remain open on Mondays and Tuesdays until further notice.[60]

**Daisy B. Williams.** Williams operated a studio from the Bratton Building in Yorkville in 1904 and 1905. In addition to the production of cabinet photographs, she advertised oil painting or crayon drawings and tatted table covers.[61]

## Female Photographers, 1921–1940

During the period from 1921 to 1940 thirty-four female photographers were identified who either worked in studios as photographers or were owner/operators. Eleven of these females going into business prior to 1921 and continuing thereafter were discussed earlier in this chapter. The remaining twenty-three were entrepreneurs during this period.

### Anderson

**Emma Holland.** By 1922 Emma Holland operated the Anderson Studio located at 131½ N. Main Street. For almost two decades Eugene T. Anderson owned and operated this studio, but the studio was not listed in the local city directory after World War I until

1922 and 1923. Mrs. Holland may have opened a studio and used the old, well-established Anderson name, or she may have had a business relationship with Mr. Anderson.[62]

### Bennettsville

**EDNA L. SPENCER.** In the 1920s Mrs. Spencer, the wife of photographer John L. Spencer, worked in "The Right Now Shop," assisting him in their Bennettsville studios.[63]

### Charleston

**ELISE FORREST HARLESTON.** Harleston operated a studio in Charleston from 1922 to 1932. She was a prominent African American photographer and wife of the artist Edwin A. Harleston.

### Columbia

**MRS. WALTER L. BLANCHARD AND MILDRED BLANCHARD.** Walter L. Blanchard employed his daughter Mildred in 1932 to work in his studio and from then until his death in 1939 she was clerk, artist, and assistant. Blanchard's wife took over the Columbia studio in 1939 and, with her daughter Mildred, continued its operation until the late 1940s.[64]

**LAURA HEFNER.** In 1936 the St. John's Studio first appeared in Columbia at 1501 Main Street with Laura Hefner as manager. She remained the manager until 1943 when Harriet St. John of Charlotte, North Carolina, took over its management. Apparently the St. John's studio was a North Carolina-based business with a branch in Columbia.[65]

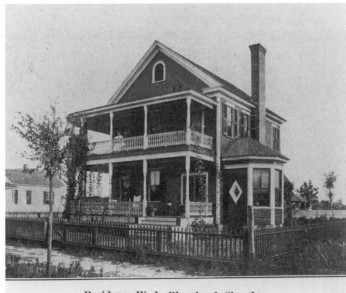

Residence W. L. Blanchard, Shandon.

*From a printed photograph.* Mercantile and Industrial Review of Columbia and Richland County South Carolina. *SCL.*

**MRS. FRANCES SANDERS.** By 1939 the Olan Mills Studio listed a branch in Columbia at 1327½ Main Street under the management of Mrs. Frances Sanders. It is assumed that Mrs. Sanders produced photographs for them.[66]

### Florence

**ETHEL M. GRANTHAM.** In 1938 Ethel M. Grantham served as assistant manager of the Grantham Studio located at 163a W. Dargan Street. Presumably this was a husband and wife studio as Wiley Grantham was listed as manager.[67]

**ETHEL RATTERREE.** She was listed as manager of the Williams Studio located at 109a S. Dargan Street. Presumably as manager she took photographs.[68]

### Fort Motte

**DORIS ULMANN.** Ulmann produced photographs of African Americans on Lang Syne plantation near Fort Motte for Julia Mood Peterkin's book *Roll, Jordan, Roll,* published in 1933.

### Gaffney

**MABEL WOOD MILLER.** She was listed in 1928 as the official photographer of Limestone College in Gaffney. She advertised "Portraits For Christmas, Beautiful Work; Reasonable Prices."[69]

### Greenville

**MRS. L. M. MARKER.** In 1930 Mrs. Marker operated the Venus Studio at 119–A North Main Street in Greenville.[70]

**MRS. JULIA A. DOWLING.** By 1937 Mrs. Dowling had succeeded her deceased husband in the Dowling Studio that had been in business in Greenville since 1923. Whether or not she was an active participant in the business before 1937 is unknown, but since she successfully operated the business until 1945 or 1946 she must have been previously active in it.[71]

**THELMA L. CALDWELL.** This lady operated a studio called Thelma's Studio at 2 Lois Avenue in West Greenville in 1937.[72]

**LUCILLE B. ECKERT.** In 1937 Warner's Studio, at 228–A N. Main Street, was operated by Lucille B. Eckert.[73]

**MRS. CAROLYN COURSEY.** From 1938 to 1940 Mrs. Carolyn Coursey managed the Preston Studio located at 204 N. Main Street. As manager it is assumed she produced photographs.[74]

**MRS. CAROL GILLIAM.** In 1938 Mrs. Carol Gilliam was a photographer for the Ivey Keith Co. located in Greenville.[75]

## Newberry

**LUCY SPEER.** She was in partnership with Leroy Salter in photo and music stores in Newberry and Anderson from 1925 to 1927 or later. The two also produced the photographs for the *Newberrian* in 1927. Some time later she opened and operated her own studio in town at least until 1932.[76]

## Rock Hill

**MRS. JAMES M. RAUTON.** Edward M. Rauton operated the Brownie Studio at 149½ E. Main in Rock Hill beginning in 1936. Between 1939 and 1940 Mrs. James M. Rauton became the proprietor of this studio. The relation she had to Edward, if any, is unknown.[77]

**LILLIAN THACKSTON.** By 1938 Lillian Thackston managed the Thackston Studio on South Trade Street. She probably played an active role in the studio from its inception in the early 1920s, but the extent of her involvement remains to be documented.[78]

## Spartanburg

**DEVIOLETTE BERNHARDT.** By 1935 Deviolette Bernhardt of Spartanburg followed in the footsteps of her parents with a photographic studio at 582 W. Main Street and for many years hers was one of the premier studios in town.[79]

## Various South Carolina Towns

**BAYARD WOOTTEN.** Born in New Bern, North Carolina, in 1875, Bayard Wootten was the daughter of Rufus Morgan and Mary Devereaux Clarke. Morgan operated several

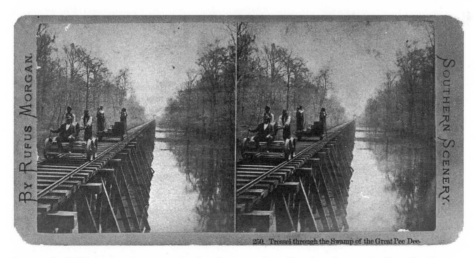

*Sterograph of African Americans running hand carts on the railroad trestle over the Great Pee Dee east of Florence. Produced in the 1870s by Rufus Morgan.*

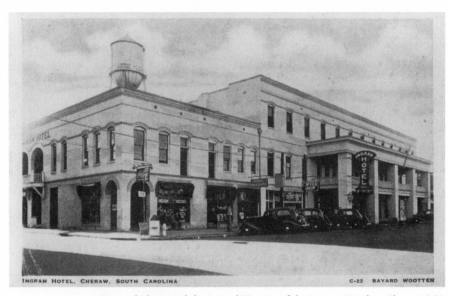

*Postcard photograph by Bayard Wootten of the Ingram Hotel in Cheraw. SCL.*

North Carolina photographic studios and on occasion came to South Carolina. Sometime before 1879 he produced a stereograph set of Columbia views, as well as a set of views of the railroad over the Great Pee Dee River. He died in 1880 when Bayard was only five years old.

Bayard was originally trained as an artist and did not take up photography until the early 1900s. Over the course of a long, productive career from her North Carolina base she produced tens of thousands of portraits, landscapes, and photographs of various subjects such as hotels, churches, homes, and courthouse squares in several states. She also produced illustrations for a number of books. In 1998 Mrs. Wootten and her work appropriately became the subject of a book when Jerry W. Cotten authored *Light and Air: The Photography of Bayard Wootten,* a comprehensive and profusely illustrated biography of her.

Some of her picture postcards feature scenes from Camden, Cheraw, Lancaster, Bennettsville, Marion, Mullins, Chester, Myrtle Beach, Murrells Inlet, and Charleston. In 1937 Bayard produced the photographs for Samuel G. Stoney's book, *Charleston: Azaleas and Old Brick.* In the 1930s she produced a number of photographs in the Charleston, Murrells Inlet, and Myrtle Beach areas that feature portraits of African Americans.

Wootten developed a friendship with Columbian Dr. Chapman J. Milling and exchanged letters with him over the years. In a 1948 letter she revealed a number of facts about her studio and work. "About two years ago I took my youngest son into partnership. He really runs the business now, and takes the hard end of things. —I am glad my three mountain women holds good through the years. This and pictorial landscapes are the types of work that I have made my reputation on, but I have done very little of it in the last year. We are going strictly to portrait work. There is much more money in it though it requires much less skill. —In the old days I used to do most everything myself. Now I have an operator that is on the road most of the time."[80]

*Photograph by Beulah Glover of an African American baptism in lowcountry South Carolina. SCL.*

### Walterboro

**BEULAH GLOVER.** Beginning around 1937 Miss Beulah Glover operated a photo duplicating shop in Walterboro that she continued for a number of years. In her business, called the Photo Nook, she also produced and sold photo postcards whose subjects were usually historical. Glover photographed lowcountry topics that struck her fancy and either sold her photographs or used them to illustrate the many articles and books she authored over the years.[81]

## Female FSA Photographers

Two of Roy Stryker's Farm Security Administration photographers were females who produced photographs in South Carolina in the late 1930s.[82]

**DOROTHEA LANGE.** Lange came to South Carolina in July 1937 and photographed sharecroppers and their families in Gaffney and Chesnee.

**MARION POST (LATER WALCOTT).** Post photographed the FSA resettlement community of Ashwood Plantation near Bishopville in May 1938. In June she took photographs of two families, one in Manning and another in Summerton. That same summer she documented a Fourth-of-July celebration at Frogmore on St. Helena Island. During her stay in South Carolina she produced almost 200 images portraying rural poverty and economic depression.

*FSA photograph by Marion Post (Walcott) of a black church in a cornfield near Manning. SCL.*

*FSA photograph by Dorothea Lange of a mother of 14 children and grandmother of 56, who lived near Chesnee, South Carolina. SCL.*

# South Carolina Stereographs and Panoramic Photographs

## Stereograph

A stereograph may be described as two photographs of the same subject taken at slightly different angles, mounted to appear three dimensional when viewed through two lenses located or focused at the proper distance from the mounted photographs. The viewing lenses and apparatus is called a stereoscope or stereoscopic viewer.

The optics involved in viewing images stereoscopically were understood by the scientific community before photography was invented and an early version of the stereoscope had been perfected by 1838. After 1839, with the pioneering work of Daguerre and Talbot, individuals began to experiment, seeking to discover methods for applying the stereoscope to photography. By the early 1850s daguerreotypes had been combined with viewing lenses into a single frame or case for stereoscopic viewing, and a few years later the same approach was used with ambrotypes. In the late 1850s, when paper photographs became the standard, photographs could easily be mounted side by side on a piece of cardboard for viewing in a stereoscope. Poet and essayist Oliver Wendell Holmes invented in 1859 a simple handheld device containing two lenses and a focusing bar for viewing these stereographs. With only minor improvements, this stereoscope became a fixture in many homes. Photographers and publishers began to produce stereographs in large numbers for these modestly priced and easy to use viewers.[1]

Under the topic "Victorian Articles," Laura Witte Waring described the stereoscope in her Charleston home: "There was a sort of stereoscope of black wood, into which you put pictures and turned a handle to focus them. Among the pictures was the Lion of Lucerne, the British Royal Family, St. Paul's Cathedral, Notre Dame, and many more."[2]

In South Carolina photographers were aware of both the optical and photographic developments concerning the stereoscope. *Graham's Magazine,* subscribed to by many South Carolinians, carried a five-page treatise on the stereoscope in the November 1853 issue that detailed its history and state of perfection.[3] Charleston merchants Courtney & Co. and F. Von Santen sold stereographs by late 1858 and early 1859. In fact, Von Santen advertised for sale more than 1,000 views of American scenery and foreign cities as well as various viewers and related materials.[4] By 1860 George S. Cook and a few other Charleston photographers produced and sold stereoscopic views.

*Ad by Von Santen for stereoscopic views and other items.* Charleston Courier, *30 November 1858.* SCL.

Stereographs continued in popularity well into the twentieth century and photographers and publishers worked vigorously to supply this demand. The creation of views and scenes covering almost all aspects of American and foreign society as well as many portraits of individuals resulted from these endeavors. Today these stereographs collectively continue to document our history and preserve our heritage.

Due to the format of the stereograph and the requirement of an apparatus for proper viewing, it is unique among photographs. This uniqueness, in part, may account for the popularity the stereograph enjoys today among collectors. A number of approaches have been taken by both individuals and institutions as they seek to collect these images. Collections are built around themes such as a state, county, city, or photographer and others around the themes of blacks, nudes, firearms, etc. As might be expected, a national society has been created with an accompanying newsletter and today stereograph exhibits, dealer bourses, sales catalogs, and auctions are commonplace.

Additionally, many books by scholars and others have been devoted to this topic. William Culp Darrah's *The World of Stereographs,* published in 1977, has become the standard work on stereographs. The work of Darrah and others who have studied and written about stereographs enables one generally to date a stereograph by its card mount. From the 1850s to 1867 mounts had square corners and were composed of flat thin stock. After 1868 corners on mounts usually were rounded, and after 1879 mounts were curved instead of being flat.[5]

The colors of card mounts are also indicators of their age. From the 1850s to about 1862 mounts were ivory, green, pale-blue, white, cream, brown, and lavender. From about 1862 to 1876 various shades of yellow were used for mounts. From the end of the Civil War to 1876 mounts also appeared in ivory, green, cream, blue, purple, pink, and orange. After 1876 mounts were usually dark-grey, orange, yellow, beige, cream, black, and tan.[6]

From the 1850s to 1940 millions of stereographs were produced and today are in ample supply in dealer stocks, antique shops, and flea markets. However, stereographs with South Carolina subject matter or those produced by South Carolina photographers are not

plentiful. Charleston scenes or those produced by Charleston photographers dating from the 1860s to the twentieth century are available and stereographs from Aiken, Columbia, and Greenville turn up occasionally. Other South Carolina stereographs are uncommon.

## South Carolina Stereographers

Darrah listed by state the known publishers and photographers who produced stereographs.[7] Research for this work has confirmed all but one he listed for South Carolina and identified many others. Newly identified stereographers are indicated by an asterisk. Many of these new stereographers were discovered through their advertisements. For some of these new stereograph producers, examples of their work have not surfaced.

While Darrah included both the photographer and publisher of stereographs, the thrust of this chapter has been the identification of photographers who produced stereographs. When found, however, information on "new" local stereograph publishing houses is included.

In previous chapters the matters of negatives changing hands and lack of credit being given to the producers of negatives have been discussed. In the production and reproduction of stereographs these same conditions and practices prevailed, making it often difficult to identify the original producer of a given stereograph.

*A. F. Baker—Blackville and Hendersonville, N. C.
George N. Barnard—Charleston
*Jesse Bolles—Charleston—1861
*J. S. Broadaway—Greenville—1877–81
*June H. Carr—Gaffney—1902
*W. A. Clark—Manager of Great Southern Photo Company—Greenville—1880
George S. Cook—Charleston
Samuel A. Cooley—Hilton Head
*Charles W. Davis—Sumter—1858
Haas & Peale—Charleston
*William P. Hix—Columbia—1875–77
*Hubbard & Mix—Beaufort—1864
*H. C. Jennison,—Spartanburg—1883–Ass't to W. T. Robertson
Hermann Leidloff—Atlanta (Although based in Charleston, no record was found indicating he produced stereographs in South Carolina.)
*Millwee's Gallery—Anderson—1861
*S.C. Mouzon—Spartanburg—1880s
F. A. Nowell—Charleston
J. A. Palmer—Aiken (also Savannah, Georgia)
*Osborn & Durbec—Charleston—1861
Quinby & Co.—Charleston
William A. Reckling—Columbia (also Rome, Georgia)

*W. T. Robertson—Spartanburg—1883
*John R. Schorb & Son—Chester—1869
*Edward Sinclair & Co.—Beaufort—1864
S. T. Souder—Charleston
B. H. Teague—Aiken (No record was found of Teague as a photographer or publisher of stereographs.)
*Earle Turpin—Greenville—1886
F. Von Santen—Charleston (Von Santen only published or sold stereographs and was not a photographer.)
*Richard Wearn—Columbia—1859
Wearn & Hix—Columbia
*Mrs. E. D. Wells—Halsellville—c. 1900
P. H. Wheeler—Greenville, Laurens, Newberry
*Wilder & Wheeler—Sumter—1870
Wren & Wheeler—Newberry

## Panoramic Photograph

Before the advent of photography, painted panoramas depicting scenes and locations were created and exhibited in the larger cities. In the early years of photography, panoramic views were created by joining together several photographs taken of a scene. Eventually panoramic cameras were developed that enabled the photographer to pan a scene and record it on a single, long, horizontally-oriented, paper photograph. These photographs today are called panoramas or panoramic photographs.

Although their production dates from the early years of photography, all of the known South Carolina panoramas were produced in the twentieth century. Many views of troops in training during World War I were produced by Sargeant, Blanchard, and others. Occasional photographs of college campuses and students, such as Joyce's view of Harbison College and Charles De Mulder & Son's 1912 view of Greenville Female College, are known. Charles Old produced a number of panoramic views of Columbia scenes. H. R. Jacobs of Charleston advertised his production of this type of photograph. In 1920 Peden produced a view of downtown Greenwood. Melchers of Charleston produced a view of a group in Branchville.

No large collection of South Carolina panoramas are known and most institutional collections include only a small number of them. This may be due in part to the difficulty their size and shape create for storage and retention. An individual may retain a panorama in a rolled up, rubber-banded state for a few years, but will have discarded it before he donates his papers and photographs to an institution. Even if retained and donated, the institution must then make special provisions for the conservation and filing of these odd shaped photographs.[8]

All of these factors notwithstanding, these views today are quite valuable in studying the streets and architecture of an area.

*Panoramic view by the Melchers Studio of the South Gate Club of Charleston while on a stop-over at Branchville, South Carolina. SCL.*

*Panoramic view by John A. Sargeant of cotton ready for shipping in Columbia. SCL.*

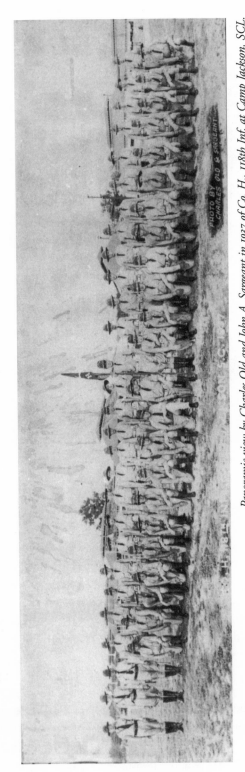

*Panoramic view by Charles Old and John A. Sargeant in 1937 of Co. H., 118th Inf. at Camp Jackson. SCL.*

# The "Lowly" Picture Postcard

The use of cards for mailing brief personal or business messages became an established practice by the early 1870s. For this purpose the United States Post Office Department in 1873 issued what became known as the "penny" postcard. The amount of postage was printed on one side with space allowed for addressing, and the other side was left blank for a message. For decades these cards remained a penny, but today (2000) inflation has pushed their price to twenty cents. All of these cards are technically "postal cards," that is, government issue cards that contain postage, but by postal regulation cannot carry a picture or advertisement on the side of the card containing the postage.

Picture postcards are cards produced by private entrepreneurs that contain no postage. Within legal bounds, anyone may print or write on these cards any information they wish. The halftone printing process made it possible to print pictures or photographs on cards. Such picture cards dating before 1898 today are known as "pre-pioneer" cards and those dating from 1898 to 1902 as "pioneer" cards. Since their inception in the late 1890s, picture postcards have continued in use.

A few known pre-pioneer South Carolina cards depict Charleston subjects. Most extant South Carolina pioneer cards are scenes from the South Carolina Inter-State and West Indian Exposition held in Charleston in 1901 and 1902. Although some of these cards are very rare, all are scarce and highly collectible.

Photographers, foreign and domestic printing and publishing houses, and drug stores were quick to supply a growing demand for these cards. They apparently became popular in South Carolina after 1905. For example, June H. Carr in 1903 advertised for sale a set of six 8 x 10 photographs, not a set of picture postcards, of the flood along the river at Clifton. Carr did produce picture postcards at a later date.

Almost from their inception picture postcards were popular with the public, and individuals in large numbers began to collect them. Many companies supplied albums similar to those used for photographs to house postcards. Card-filled albums became a fixture in many homes and often turn up at estate sales.

In supplying images for cards, local photographers and others employed by national firms photographed almost every scene or object in sight for printing on these cards. Old negatives refurbished and printed. Old photographs were retaken and published. For these reasons it is difficult to appropriately attribute photographers to picture postcards.

Publishing houses printed many cards in color and sometimes added features to a view that were not present in the original negative or photograph. As a result, many cards

*A postcard printed in blue with a yellow border portraying the Cotton Palace at the South Carolina Inter-State and West Indian Exposition. Collection of the author.*

*Photograph of a typical postcard album, c. 1905–1920. Collection of the author.*

ABOVE: *Drug store ad for sale of postcard albums.* Yorkville Enquirer, *24 August 1906. SCL.*

*Ad by D. C. Simpkins for his postcards.* (Georgetown) Sunday Outlook, *1906.*

carry factually incorrect information. Many cards were produced cheaply, hurriedly, and, on occasion, with incorrect information; but others were outstanding examples of both the photographic and printing arts.

Many South Carolina photographers from the early 1900s to 1940 participated in the production of picture postcards. Almost all of them produced photographic portraits on cards that an individual could mail. These portrait cards were left blank on the reverse for an address and a brief message. Other photographers produced sets of cards or individual ones portraying buildings, street scenes, factories, floods, fires, and activities. Unfortunately most of these cards from this era bear no photographic credits.

In years past historians and archivists did not attribute much historical value to picture postcards. However, opinions concerning their historical worth have changed, and they now have been elevated to positions of respectability and desirability. As early as the 1930s in South Carolina the Federal Writers' Project, a part of the Works Progress Administration (W. P. A.), collected South Carolina picture postcards, and today these cards are a part of the collection of the South Caroliniana Library. The Library and most similar state or regional institutions now constantly search for postcard scenes to add to their collections.

*Ad by the Postal Studio for their post-cards.* (Walterboro) Colleton News, *19 May 1909.*

Collectively these cards today are a record of our society in all its variety. They portray the state's splendor and color, breathtaking vistas, picturesque countryside, mountains, beaches, farms, factories, railroads, country stores, courthouse squares, churches, schools, home activities of its people, and the state's "warts" of slums, poverty, child labor, and racism.

In 1991 Dr. Howard Woody, art professor at the University of South Carolina, with the aid of the University South Caroliniana Society, the University of South Carolina Art Department, and a grant from the South Carolina Humanities Council, completed a cataloguing project titled, *Forgotten Images: South Carolina Postcards from the Golden Era.* This catalogue was developed through a process that identified card collections in South Carolina and elsewhere. Photocopies of cards were then made and, later, pertinent information abstracted and a catalogue prepared that represented these combined collections. This catalogue is a starting point for serious study of South Carolina postcards.

Dr. Woody's project identified fewer than two dozen South Carolina photographers whose photographic works appeared on postcards. In the research for this work all of the South Carolina photographers identified by Woody were verified and a number of others unearthed. A list of local photographers who produced picture postcards was developed from these sources. However, when examining South Carolina picture postcards today, one undoubtedly will view cards produced by South Carolina photographers who are not identified. Potentially, any photographer from 1905 to 1940 could have produced picture postcards.

## South Carolina Photographers Who Produced Picture Postcards

Eugene T. Anderson—Anderson—1910
(Unknown)—Walterboro—1910
Walter L. Blanchard—Columbia Photographic Studio—Columbia—1908
[     ] Bland—Cheraw—c. 1906

June H. Carr—Gaffney—1908

(James L.) Davenport—Anderson—c. 1912

J. P. Eason—Bennettsville—1905

J. B. Gaskins—Fort Mill and Camden—1908

Beulah Glover—Walterboro—c. 1937

D. Audley Gold—Blacksburg—1918

John I. Green—Green's Art Shop—Anderson—1916

W. A. Hatchell—Hartsville—1908

Warren K. Hamilton—Conway—1909

Howard R. Jacobs—Charleston

Elwood W. Jones & E. Burt Trimpy—Anderson—1912

Miss Leonard Kelly—Blackville—1920s–30s

A. K. Khoury's Art Gallery—Bishopville—1907

Lewis & Hartzog—Greenville—1908

Rosa James Lindsay—Lindsay's Studio—York—1910

Luther A. McCord—Laurens

N. C. Oliver—Union—1917

J. C. Patrick—Chester and Cheraw—1906–12

Richard Samuel Roberts—Columbia—1920s

Otwey and Temperance Elizabeth Salter—Newberry—c. 1912

Jesse Zebulon Salter—Newberry—1907

John A. Sargeant—Columbia—1917

D. C. Simpkins—Georgetown—1909

[　　] Smalls—Walhalla—1908–10

J. Adger Smith—Easley—1922

J. E. Spencer—Bennettsville—1913

Miles F. Stevenson—Ware Shoals—1910

Anson Trail—Union—1917

E. Burt Trimpy—Anderson—1910

J. C. Webb—Mullins—1920s

Alfred T. Willis—Spartanburg

Bayard Wootten—Charleston—c. 1936

# Businessmen/Artists/Recorders
# of History

From many sources this work has identified more than six hundred photographers. It has chronicled the towns where they worked, the length of time they operated a studio, and the types and quality of their products and has presented other information about them.

The majority of this information was gleaned from news accounts, editorials, and advertisements in newspapers and other publications. With the exceptions of George S. Cook, Samuel A. Cooley, George LaGrange Cook, Solomon N. Carvalho, June H. Carr, the Salters of Newberry, George N. Barnard, Timothy H. O'Sullivan, Bayard Wootten, and John R. Schorb, business or personal papers were not available to provide a closer and more detailed look at these men and women. Only in the cases of George S. Cook, Samuel A. Cooley, John R. Schorb, and the Salters of Newberry were their business or personal papers examined. For a few other photographers, books written about them, whose authors examined personal and business papers in the process of writing their books, were consulted.

In the absence of personal or business papers for use in creating *individual* biographical sketches, the sources identified and used in the development of this work were combed for bits of information to create a *collective* picture of these men and women as businessmen, artists, and recorders of history.

### Businessmen

ITINERANT. Statistics based on the length of time various studios operated indicate 9.4 percent operated for twenty or more years, 15.3 percent for ten or more years, 24.2 percent for five or more years, and 60 percent for one year or less.

Quite clearly itinerant or short-term is an apt term for describing these photographic firms. To a degree the term accurately describes long-term studios as well. This work is replete with examples of long-term firms such as Winburn, Reckling, Wearn, Cook, Barnard, Wheeler, Van Orsdell, and many others doing itinerant work in towns other than their home base.

For the first six years of photography all photographers who worked in South Carolina were itinerant or short-term. From 1840 to 1860 about one hundred and eighty photographers practiced in the state and of this number, only eighteen or 10 percent worked from one location for as much as a year. They were: Charleston, Charles L'Homdieu, Sterling C. McIntyre, George S. Cook, Osborn & Durbec, Solomon N. Carvalho, Daniel L. Glen,

*"Peeler's Studio On the Road." This inscription appearing on the bottom of a cabinet by photographer Peeler typifies the itinerant status of many who followed the profession. Collection of the author.*

Solon Jenkins, Jr., Albert George Park, Jesse H. Bolles, and C. J. Quinby; Columbia, Joseph T. Zealy, Richard Wearn and William Preston Hix; Chester, E. Elliott; Newberry, Charles H. Kingsmore; Sumter(ville), Charles W. Davis; Winnsboro and Yorkville, John R. Schorb.

During the entire 100 years covered by this study the picture did not change to any great degree. By the period from 1921 to 1940, however, the South Carolina system of roads, bridges, and railroads developed to the extent that a photographer could travel by car or rail some distance from his home, record a scene or event, and return in a day or so. A good example of this practice was John A. Sargeant's coverage of the Cleveland School fire, near Camden, in May 1923. The fire occurred in the early evening and the next day Sargeant traveled the forty miles there in time to record with his camera the burial of the more than seventy fire victims.

Technological changes in photography permitted a photographer to take pictures more easily in one location and return home for processing and printing. These developments reduced the need to engage in itinerant work that involved setting up a branch studio in a town and operating it for several weeks or months. In other words, a photographer could be itinerant with a camera while his studio remained stationary.

Itinerant status prevented photographers from becoming integrated into the society of a town. When working in a town for only two or three months, joining and participating in churches and civic clubs was not feasible. Also, the development of long-term personal and business relationships with individuals in a town was curtailed, if not prevented, by "itinerancy."

Itinerant photographers apparently were not perceived in the same manner as itinerant drummers who came to towns and sold everything from patented medicines to axes and tin pans. To announce their presence in towns, drummers usually had to generate their own publicity by placing ads in the local papers. In the case of photographers, on a number of occasions, local papers carried news accounts or editorials about a photographer and his studio. Local itinerant artists who painted portraits frequently received similar treatment by local presses.

Photographers who remained in town for a year or more usually joined the local society with church membership, local bank accounts, civic or fraternal club membership, and long-term personal and business relationships. Many became active in local organizations such as Masonic lodges, fire companies, and town governments. Few seemed to be very active in politics, however.

*George T. Schorb ad for both producing photographs and selling pianos.* Yorkville Enquirer, *8 July 1910.*

PART-TIME. During the century covered by this study instances surfaced of photographers' involvement in other ventures in combination with photography. At least 10 percent of the more than six hundred South Carolina photographers earned income from sources other than photography. Ten photographers painted portraits and other subjects, seven engaged in the jewelry business, and five operated gift shops. Others were mail clerks, fruit dealers, town clerks, piano salesmen, telephone salesmen, dentists, doctors, and teachers. Some operated general stores, bicycle repair shops, movie theaters, glass factories, hotels, cigar stores, boarding houses, and furniture stores. One unusual example involved the Fletchers in 1842 who produced daguerreotypes and gave phrenological readings in a joint venture.

Many photographers took on side lines directly related to photography such as picture framing, selling art and photographic supplies, and in later years, processing film for others. At the turn of the century Achurch's business in Charleston was primarily that of selling photographic supplies and processing film, with photography providing his secondary source of income. A number of photographers sold necklaces, brooches, and bracelets in which they placed photographs. George S. Cook recorded the sale of such jewelry in his account books a number of times. Occasionally the jewelry cost more than the photograph placed in it.

LOCATION OF STUDIOS. Businessmen today employ sophisticated market surveys to determine the best location for a business. These were not available to early photographers. Some sized up the business potential in a town with visits and discussion with local people. In 1906 Reginald Otwey Salter visited Chester to gauge the photographic business potential there.

Photographers generally located their studios in business districts. They correctly reasoned that a location successful for other businesses should be successful for them. In their ads photographers often described the location of their studio relative to a well-known landmark or site. These descriptions create vivid, concrete images of these towns. Descriptions such as "near the depot," "at Spann's Hotel," "at Winyah Hall," "over the Masonic Hall," "at the courthouse," "next door to the bank," "over the Apothecary Store," "over J. R. Archer's Saddle Shop," "at the Thespian Hall," "opposite the Mammoth Boot," "Sign of the American Flag," "next door to the sign of the Negro and Mortar," "over Bailey's Stable," "at

Odd Fellow's Hall," and "opposite Kennedy's Tin Factory" have an immediacy not found in city directories and telephone books.

Before the ready availability of electricity, photographers procured buildings in which windows or skylights offered sufficient light for photographic purposes. Sometimes existing buildings were remodeled to add skylights—improvements that photographers touted in their ads. Suitably-lighted rooms in a building were frequently used successively by a series of itinerant photographers. Examples were the Thespian Hall in Winnsboro, the Workman Building in Camden, and the Maxwell Gallery in Anderson.

Because many photographers were itinerants and short-term occupants, they leased or rented quarters for their studios. Several long-term photographic firms constructed their own buildings, Barnard of Charleston, the Morleys of Rock Hill, Reginald Otwey and Temperance Elizabeth Salter of Newberry, and J. Adger Smith of Easley being examples.

Illustrations on pages 342–349 portray showrooms and processing rooms, equipment, signs, and exteriors of permanent and temporary studios.

Word descriptions of seventeen other photographic studios, the studios of Dr. Adam Libolt, Solomon N. Carvalho, Jesse H. Bolles, George L. Cook, Frank A. Nowell, Hermann Leidloff, J. C. Fitzgerald, C. M. Van Orsdell, S.C. Mouzon, Jerome Hall, R. Achurch, William D. Clarke, William P. Dowling, J. P. Howie, Rawls Brothers, Claude Hart, and Leonard Kelly help delineate the physical characteristics of studios as they changed over time.

Many itinerant photographers operated from portable studios or tents, situated temporarily in business districts on a vacant lot or some other available spot. In the antebellum era some advertised "Daguerreotype Cars" or "Ambrotype Cars," wagons outfitted as portable studios. During the Civil War photographers employed field wagons that became known as a "What is It?" Occasionally a photographer included one of these carts, buggies, cars, tents, field wagons, or studio signs in one of his photographs. Several illustrations document this practice.

*Photograph of present day Thespian Hall by Tim Lord. Over the years this building served various purposes from a Thespian Hall, a newspaper office, and several restaurants, to photographic studios in the 1950s to 1970s.*

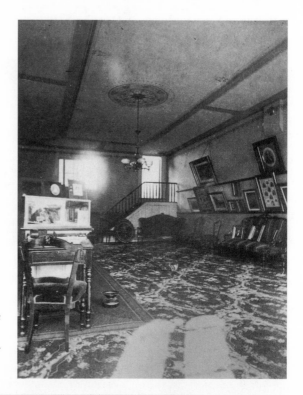

*Half of a stereograph by George N. Barnard of the interior of his Charleston studio. Onondaga Historical Society, Syracuse, N.Y.*

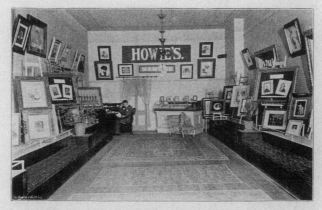
*An interior view of his studio by Howie. 1899 Garnet and Black, SCL.*

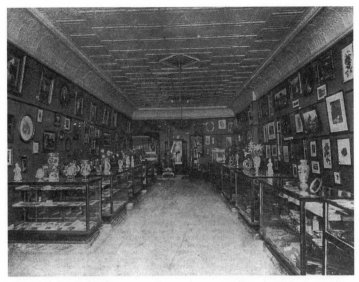

*An interior view of his art store and studio by Blanchard.* The American Journal of Commerce, *vol. 21, no. 37, March 1911, page 26.*

*You are most cordially invited to visit the*

## "ELITE"
## PHOTO STUDIO

EAST END MAIN STREET NEWBERRY, S. C.

*We will take pleasure in showing you our Photo display*

*Hours from nine a. m. to six-thirty p. m.*

# OTWAY & T. E. SALTER

*Copied from the 1906* Newberrian. *SCL.*

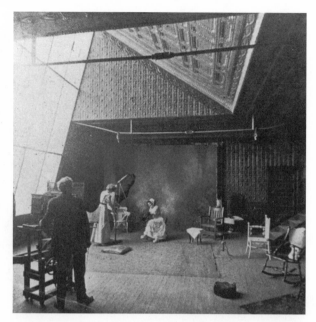

*Interior of Otwey & T. E. Salter's studio. The* Newberrian, *1912. SCL.*

*Processing room of George L. Cook's Charleston gallery. Contact print from a Cook glass negative. SCL.*

ABOVE: *Photograph of Broad Street in Camden showing William S. Alexander's studio sign. SCL.*

*An enlargement from a view of East Battery Street in Charleston that shows George N. Barnard's equipment cart parked on the street. SCL.*

*Carte de visite of Erastus Hubbard's photographic gallery. SCL.*

*Stereograph by Cooley of the exterior of his Beaufort studio. Courtesy of the Beaufort County Library.*

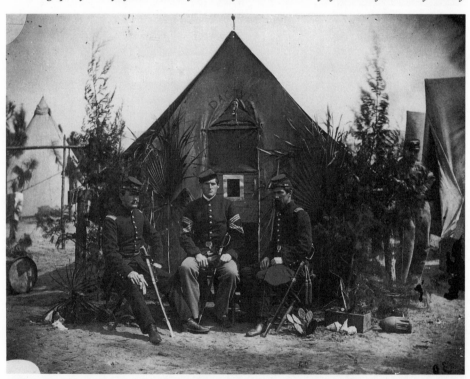

*Albumen print showing H. P. Moore's makeshift tent studio on Hilton Head Island. Moore added local flora and other interesting items to this image featuring a group of 6th Conn. soldiers. The term "Dagtyps" was a generic one often employed at the time to describe all types of photographs. Courtesy of New Hampshire Historical Society.*

*Photograph of Arthur F. Baker's "London Gallery" in Blackville. Courtesy of the South Carolina Historical Society.*

THE PLACE WHERE THESE PHOTOS WERE MADE.

*Exterior view of Otwey and T. E. Salter's studio in Newberry. Note their names appear in the masonry panel at the top of the building. The* Newberrian, *1912. SCL.*

ABOVE: *Winburn's photographic gallery (circa 1900). Courtesy of Sumter County Museum.*

*Photograph by Rawls Brothers showing the entrance to their studio in the Lever Building in 1904.* Illustrated Columbia, South Carolina, *1904. SCL.*

LEVER BUILDING

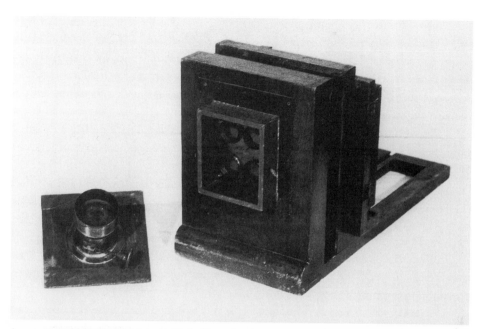

*A camera used by J. R. Schorb in his Yorkville studio. Courtesy of the Historical Center of York County.*

*Photograph of a portable studio in use in the Myrtle Beach pavilion (circa 1940). The studio, two cameras, various equipment, and the studio sign are in the South Carolina State Museum.*

**ADVERTISING.** Up until about 1900 photographers' advertisements appeared regularly in local newspapers, but appeared less frequently thereafter. Ads also appeared in city directories, school annuals, and other publications where ads were sold. Most ads contained studio locations, prices, and variety of products. Some ads used poetry, fashionably dressed women, some payment practices, awards, endorsements, or information about new and up-to-date equipment.

Photographers built much of their advertising around holidays, especially Christmas. Other holidays or events touted were Labor Day, Easter, Thanksgiving, Fourth of July, sales day, court week, and graduation day.

Some photographers did little advertising beyond passing out hand bills and placing a sign over their studio. However, after paper photographs became prevalent in the late 1850s, most photographers used photographic card mounts to advertise their studios. They also used displays of their products and photographs of national figures as a means of advertising.

Some advertisements reflected economic conditions with statements such as "hard times prices," "Wood and Country Produce taken for Photos," "accept nearly all kinds of provisions that you may bring in payment for work."

**PAYMENT PRACTICES.** Most photographers operated their businesses on a cash basis. A two-week to three-month stint in a town did not permit or encourage credit work. A few required cash up front, but, at least for the itinerants, it was usually a cash and carry business when the customer was satisfied with the photograph. Many photographers made no charge when the customer was not pleased.

**PRODUCTION INFORMATION.** Account books of South Carolina photographers George S. Cook and Samuel A. Cooley were discovered during research. They were not a complete record for their studios, however. A few production figures were gleaned from photographic ads and news accounts. A record of photographic production in Charleston for three months of 1866 was obtained from Internal Revenue records in the National Archives. Production figures listing either gross revenue for a period of time or the number of photographs produced over a period of time were located for sixteen photographers.

For fifteen of these sixteen (Cook excepted), these figures are insufficient to form conclusions about the number of photographs produced. The entries of Tyler & Co. and Quinby & Co. are perhaps promotional hyperbole with little basis in fact. Reports from Internal Revenue records, from Cook's account books, and from the account book of Samuel A. Cooley should not be subject to much question.

This production information provides a poor basis for judging the amount of product generated by South Carolina photographers for one hundred years. However, based on this information, the examination of most of the major and many of the minor collections of South Carolina photographs, the examination of the number of South Carolina photographs used in pictorial or other works, and the examination of the length of time photographers operated studios, it is likely that several million photographs were produced during this one hundred year period. Using the production figure for Reckling of 100,000 negatives in 1908 as a basis, one can identify twenty or more photographers who produced a similar number. The total for these twenty would amount to two million or more photographs. A conser-

vative estimate for the state over this 100 year period would be twenty million photographs produced.

**PROFIT.** Production statistics unearthed during this study include a few entries indicating the gross revenue for a few photographers for specific periods of time, but they do not address the amount of profit earned by photographers. Profits could be earned from photography, but it was a very competitive business. No photographer grew wealthy from their labors. Most worked hard, produced a quality product, and secured a decent living. A citizen of Blackville remarked that Miss Leonard Kelly, the long-term photographer there, enjoyed an average standard of living. Reginald Otwey Salter in 1906 expressed a similar opinion about the profitability of Miss Sallie Kennedy's studio in Chester.

Based on the Cooley account book, the number of surviving photographs, and an article in the *New South* by editor J. V. Thompson, Union photographers' studios were quite profitable in occupied South Carolina, Georgia, and Florida. Over four months in 1864 Cooley grossed $3,552.04 in a Jacksonville studio. His account book indicates he netted $1,609.00 from this studio, one of four, the others being at Beaufort, Hilton Head, and Folly Island. If all four were equally profitable, his annual net income would project to be $19,508.00.

George S. Cook was more successful than most. He required payment in gold or silver during the Civil War and would not accept Confederate money. Throughout his career he increased his income by selling photographic supplies. According to Keith F. Davis, George N. Barnard's net worth while in South Carolina approached that of Cook.

## Artists

Photography emerged from both the scientific and art communities. It involved chemicals and scientific processes and the production of a likeness of a subject. Many "brush and paint" artists explored this new art from its beginning, and before very long many became practitioners of it. Some South Carolina artists were George S. Cook, Solomon N. Carvalho, Christian Mayr, Charles H. Lanneau, R. H. Mims, and Isaac B. Alexander. A number of examples are known of South Carolina portrait painters using photographs in the absence of the sitter. The artistic service of hand-tinting photographs was available at most studios. Some photographers provided so many artistic services that they emulated Jesse H. Bolles' description of his studio in the 1850s as a "Temple Of Art."

From the antebellum era to about 1900 photographers almost always used the term, "brother artist," when writing to or referring to another photographer. In fact, in the early years they called photography "The Art." The United States censuses of 1850 and 1860 occasionally used the terms "artist" and "photographer" interchangeably. For many years entries for daguerreotypes, ambrotypes, and photographs in South Carolina fair catalogs were placed in the arts section. As late as 1867 the Charleston city directory listed photographers under the category of "Artists." Local art museums today regularly include photographic exhibits in their yearly calendar of events. In the final analysis, the quality of his/her work should be the basis for determining whether or not a given photographer should wear the mantle of "Artist."

**PROFESSIONALS.** Numerous examples abound in this work of photographers holding memberships in their professional organizations, attending professional meetings, seeking and receiving training in their profession, and competing in fairs or exhibitions with each other. Obviously some were more diligent than others in staying abreast of developments in their field, but the overall quality of their product suggests they employed a professional approach to their work.

### Recorders of History

Seven years of research and examination of tens of thousands of photographs raised the question of the value and the significance of what photographers had captured. In answering this question, as if projected on a screen, the faces of thousands of individuals appeared; textile workers, farmers, college students, babies, old time-worn and wrinkled faces, sad faces, cold faces, stern faces, dead faces, loving faces, happy faces, the faces of South Carolinians for one hundred years.

A one hundred-year fashion parade of clothing and accessories worn by South Carolinians passed in review, uniformed Confederate soldiers and the doughboys of World War I with their buttons, buckles, insignia and side arms. A one hundred-year sweep of pins, medals, brooches, bracelets, combs, rings, and other jewelry adorning the person and clothing of individuals in these photographs caught the eye.

Interiors and exteriors of studios came into focus, showing a great variety of backdrops, posing chairs, couches, toys for children, showrooms and processing rooms, and their evolution over time.

There appeared many types of architecture—homes, churches, livery stables, country stores, taverns, town squares, forts, bridges, monuments, courthouses, and other public and private buildings.

Images of South Carolina beaches, her coast, her rivers, the midlands, the rolling hills of the Piedmont, and the Blue Ridge Mountains showcased geographic diversity.

Civil War destruction, effects of the Charleston earthquake of 1886, the hurricane of 1893, a lynching in York County, tornado damage in 1924, floods, fires, wars, picnics, funerals, weddings, school dedications, and inauguration of governors, all passing in a kaleidoscopic review.

South Carolinians laboring in rice and cotton fields, ginning cotton, shrimping near Edisto Island, mining phosphate in the lowcountry, and digging kaolin near Aiken all materialized on the screen.

These photographers recorded South Carolina history using a different medium, but with as powerful effect as Simms, McCrady, Snowden, Wallace, Lander, Jones, Edgar, and other South Carolina historians. If a picture is worth a thousand words, then these photographs represent a thousand times more words than all South Carolina historians have written. Photographers were not historians because they were confined by their creations to a precise moment in time. They could not easily synthesize and interpret events over time, but they recorded the immediacy of events.

Since their photographs are unquestionably an historical record, the question remains whether or not they viewed themselves as recorders of history. The answer is yes for some photographers and no for others.

In February 1861, when George Smith Cook crossed Charleston harbor in a small boat to Fort Sumter and photographed Major Anderson and his staff, he knew that he was creating a pictorial record of a significant event. He and others appreciated the historical significance of the photographs he took on 8 September 1863 of a bruised and battered Fort Sumter. In 1886 his son, George LaGrange Cook, knew that he was creating a pictorial and historical record when he produced more than 100 photographs of Charleston earthquake damage. When Greenville photographer William P. Dowling, Jr. wrote in 1934 that "it is better to have a poor epitaph on one's tombstone than to leave a bad representation purporting to be a portrait," he alluded to the historical value of his work.

These businessmen and women, these artists and recorders of history deserve recognition, respect, and acclaim as the creators of South Carolina's visual heritage. The time has come for professional historians and others to recover photographs and their creators from neglect and obscurity and mix them with their metaphors to create a more appealing and understandable history of South Carolina.

# *Notes*

**NOTES TO CHAPTER 2**

1. Beaumont Newhall, *The Daguerreotype in America* (n.p.: Duell, Sloan and Pearce, 1961). Floyd Rinhart and Marion Rinhart, *The American Daguerreotype* (Athens: University of Georgia Press, 1981).

2. David Duncan Wallace, *South Carolina: A Short History, 1520–1948* (Chapel Hill: University of North Carolina Press, 1951), 1 and 710.

3. Maximilian, LaBorde, *History of the South Carolina College* (Columbia: Peter B. Glass, 1859). In 1859 LaBorde was completing this history of the college when Ellet died. At that point he wrote an eight-page biographical sketch of Ellet, 262–69, for inclusion in his history.

4. Ibid., 266–67.

5. *(Columbia) South Carolina Temperance Advocate,* 8 October 1840.

6. Francis Lieber, letter to his son, Oscar, 22 September 1839, Lieber Collection, South Caroliniana Library, University of South Carolina (hereinafter referred to as SCL).

7. May 1839, board of trustees minutes of the South Carolina College, SCL.

8. Manuscript account, 28 August 1839, treasurer's records of the South Carolina College, SCL.

9. Robert Taft, *Photography and the American Scene* (New York: Macmillan, 1938), 8–17. Newhall, *Daguerreotype in America,* 22. Rinhart and Rinhart, *The American Daguerreotype,* 25–26.

10. Rinhart and Rinhart, *The American Daguerreotype,* 25–26.

11. Ibid., 13.

12. Ibid., 13.

13. *Charleston Daily Courier,* 19 February 1841.

14. *(Columbia) South Carolina Temperance Advocate,* 4 March 1841.

15. *Charleston Daily Courier,* 10 March 1841.

16. James R. Chilton, receipt for chemicals, 20 September 1836; Chilton receipt, 21 September 1837; Chilton receipt, 23 February 1839; F. & L. Root receipt, 10 March 1839; 27 November 1839 accounts summary; 18 March 1840 G. W. Prosch receipt; month of August 1840 accounts; 25 September 1840 Cornelius & Co. receipt; 15 September 1840? G. W. Prosch receipt; 24 December 1840 voucher, all from treasurer's records of the South Carolina College, SCL.

17. Samuel Irenaeus Prime, *The Life of Samuel F. B. Morse, LL.D., Inventor of the Electro-Magnetic Telegraph* (New York: D. Appleton & Co., 1875), 439–40.

18. LaBorde, 668–69.

19. *Charleston Daily Courier,* 18 February 1840.

20. John D. Legare, ed., *Southern Cabinet of Agriculture, Husbandry, Rural and Domestic Economy, Arts & Sciences, Literature, Sporting Intelligence, etc.* (Charleston: A. E. Miller, 1840), February, 127; July, 448; September, 576.

21. *Charleston Daily Courier,* 12 May 1840.

22. Ibid., 29 July 1840.

23. Mary C. Oliphant, Alfred Taylor Odell, and T. C. Duncan Eaves, *The Letters of William Gilmore Simms* (Columbia: University of South Carolina Press, 1952), Vol. I, 178–79.

24. *Charleston Daily Courier,* 29 and 30 December 1840.

25. Rinhart and Rinhart, *The American Daguerreotype,* 411.

26. *Charleston Daily Courier,* 6 January 1841. *Augusta Chronicle and Sentinel,* 20 February 1841.

27. *Charleston Daily Courier,* 19 February 1841.

28. *Abbeville Banner,* 6 July 1849.

29. *Camden Journal,* 3 April 1843. Rinhart and *Rinhart, The American Daguerreotype,* 380.

30. *Camden Journal,* 10 April 1845; 10 March 1848.

31. Thomas J. Kirkland and Robert M. Kennedy, *Historic Camden,* part 1, *Colonial and Revolutionary* (Columbia: The State Company, 1905), 342.

32. *Camden Journal,* 14 November 1848. Stephen E. Massengill, "'Portraits by the Sunlight Made': Daguerrean Artists in North Carolina, 1842–1861," *Carolina Comments* 41, no.5 (September 1993) (Raleigh, North Carolina: Division of Archives and History, Department of Cultural Resources), 147.

33. *Charleston Daily Courier,* 15 and 17 December 1841; 7 January 1842.

34. *Charleston Daily Courier,* 19 February 1842. Rinhart and Rinhart, *The American Daguerreotype,* 386.

35. *Charleston Daily Courier,* 19 February 1842. Rinhart and Rinhart, *The American Daguerreotype,* 386.

36. *Charleston Daily Courier,* 14 February 1842.

37. M. Susan Barger and William B. White, *The Daguerreotype: Nineteenth Century Technology and Modern Sciences* (Washington and London: Smithsonian Institution Press, 1991), 79.

38. *Charleston Daily Courier,* 12 July 1842. *Charleston Mercury,* 17 November 1849.

39. *Charleston Daily Courier,* 7 January 1843.

40. Ibid., 11 July 1843.

41. *Charleston Daily Courier,* 2 February and 7 June 1844.

42. *Charleston Mercury,* 1 July 1844.

43. Newhall, *Daguerreotype in America,* 41–43. Joan Sturhahn, *Carvalho, Artist-Photographer-Adventurer-Patriot: Portrait of a Forgotten American* (Merrick, N.Y.: Richwood Publishing Co., 1976), 6.

44. *Charleston Daily Courier,* 21 August, 1845. Rinhart and Rinhart, *The American Daguerreotype,* 382.

45. *Charleston Daily Courier,* 10 October 1845. *(Columbia) Southern Guardian,* 31 December 1845. This ad showed a 24 December 1845 placement date.

46. *Charleston Daily Courier,* 20 April, 2 October, 7, and 27 November 1846; March 1 and 18 October 1847; 21 and 31 January 1848. *Charleston Mercury,* 1 January and 17 November 1849. Rinhart and Rinhart, *The American Daguerreotype,* 401.

47. *Greenville Mountaineer,* 16 June 1847; 7 July and 8 September 1848. *Laurensville Herald,* 23 November 1849. *Sumter Banner,* 23 May 1849.

48. *Charleston Daily Courier,* 4 February and 30 October 1847; 25 January , 17 and 21 July 1848; 28 July 1851. *Charleston City Directory,* 1849.

49. Rinhart and Rinhart, *The American Daguerreotype,* 188–190, 427.

50. *Charleston Daily Courier,* 6 August 1853.

51. *Catalogue of the Articles on Exhibition at the Fair of the South-Carolina Institute, November 15, 1851* (Charleston: Walker & James, 1851), 11.

52. *Charleston Daily Courier,* 7 March and 5 June 1847; 20 January, 16 March and 2 June 1848. Account books of George S. Cook, George Smith Cook Collection, Manuscripts Division, Library of Congress.

53. *Charleston Daily Courier,* 24 January 1848. *Charleston City Directory,* 1849.

54. *Charleston Daily Courier,* 25 January 1848. Rinhart and Rinhart, *The American Daguerreotype,* 70–71, 445.

55. *Charleston Daily Courier,* 7 May and 23 July 1849. *Charleston City Directory,* 1852.

56. Lawrence A. Kocher and Howard Dearstyne, *Shadows in Silver* (New York: Charles Scribner's Sons, 1954), 3–4. Jack C. Ramsay, Jr., *Photographer. . . under Fire: the Story of George S. Cook, 1819–1902* (Green Bay: Historical Resources Press, 1994), 23–24.

57. Kocher and Dearstyne, *Shadows in Silver,* 5–6.

58. See Thomas J. Peach, *George Smith Cook: South Carolina's Premier Civil War Photojournalist* (master's thesis in journalism, University of South Carolina, 1982). Ramsay, *Photographer. . . under Fire.*

59. Laurie A. Baty, "'And Simons.': Montgomery Pike Simons of Philadelphia (ca. 1816–1877)," *Daguerreian Annual* (Pittsburgh, Pa.: Daguerreian Society, 1993), 183–200.

60. *Charleston Daily Courier,* 12 November 1849. *Report of the Committee on Premiums of the South Carolina Institute, 1849,* 43, SCL. *Charleston Daily Courier,* 13 March 1850.

61. *Charleston Daily Courier,* 8 December 1849. Rinhart and Rinhart, *The American Daguerreotype,* 110–11. Baty, *Montgomery Pike Simons,* 186–87.

62. *Charleston Daily Courier,* 12 and 20 November, 8 and 19 December 1849; 1 January and 8 February 1850.

63. Ibid., 24 December 1855; 31 March 1856.

64. Ibid., 13 March and 17 September 1850; 6 May 1851; 14 July, 11 September, and 20 November 1851.

65. Louis Ginsberg, *Photographers in Virginia 1839–1900: A Checklist* (Petersburg, Va.: n.p., 1986), 55. R. Lewis Wright, *Artists in Virginia before 1900* (Charlottesville: University Press of Virginia, 1983), 178. Rebecca Norris, "In Praise of Scratched Daguerreotypes," *Daguerreian Annual* (Pittsburgh, Pa.: Daguerreian Society, 1998), 34.

66. *Farmers' Gazette & Cheraw Advertiser,* 26 May 1841. *(Columbia) Southern Guardian,* 16 February 1842.

67. *Charleston Daily Courier,* 21 December 1843; 11 January 1844; 19 November 1844. *(Columbia) South Carolinian,* 8 December 1842. *(Columbia) Southern Chronicle,* 31 December 1845. On that date a Mr. Broadbent advertised he was occupying the rooms Dr. Libolt had the previous summer (1845).

68. Rinhart and Rinhart, *The American Daguerreotype,* 399.

69. *(Columbia) South Carolinian,* 3 and 17 April 1845.

70. *(Columbia) Southern Chronicle,* 21 December 1842.

71. Genealogical records of Zealy Family, SCL. *(Columbia) Daily South Carolinian,* 16 December 1846.

72. *(Columbia) Daily South Carolinian,* 22 December 1848; 9 February 1849. *(Columbia) Daily telegraph.* 7, 10, 26 November 1849. *(Columbia) Daily South Carolinian,* 4 July and 1 December 1851; 5 August and 2 December 1852; 24 January and 15 February 1853. *Columbia Banner,* 26 April 1853. *(Columbia) Examiner,* 10 February 1856. *Farmer & Planter Advertiser,* January–June, 1859.

73. Barger and White, *The Daguerreotype,* 72. Ambler, Louise Todd Ambler and Melissa Banta, *The Invention of Photography and Its Impact on Learning* (Cambridge, Mass.: Harvard University Library, 1989), 28. Eleanor Reichlin, "Faces of Slavery," *American Heritage* 28:4 (June 1977), 4–11.

74. Louis Perrin Foster, letter to his sister, 16 October 1856, James Rion McKissick Collection, SCL.

75. Photographic collection, SCL.

76. Massengill, "Portraits by the Sunlight Made," *Carolina Comments* 41:5, 28.

77. *(Columbia) Daily South Carolinian,* 21 August 1847. *(Sumter) Black River Watchman,* 24 September 1854. *(Georgetown) Winyah Observer,* 15 December 1852.

78. *(Winnsboro) Tri-Weekly Register,* 24 September 1857.

79. *(Columbia) Daily South Carolinian,* 8 March 1849. Rinhart and Rinhart, *The American Daguerreotype,* 416.

80. *(Columbia) Daily Telegraph,.* 8 March and 10 November 1849.

81. *Edgefield Advertiser,* 24 April 1844.

82. *Edgefield Advertiser,* 22 March 1848.

83. *(Georgetown) Winyah Advertiser,* 2 March and 13 April 1842.

84. Ibid., 22 and 29 November 1843.

85. Ibid., 18 March 1846.

86. Ibid., 2 February 1848.

87. *Greenville Mountaineer,* 6 August 1847.

88. *Laurensville Herald,* 11 May 1846.

89. *Laurensville Herald,* 13 July 1849. Account books of George S. Cook, George Smith Cook Collection, Manuscripts Division, Library of Congress.

90. *Pendleton Messenger,* 17 August 1848.

91. Letter, 9 July 1848 from John C. Hudson to his sister, June H. Hudson, Historical Center of York County, York, South Carolina.

92. John R. Schorb's autobiographical account recorded by L. M. Grist in 1908.

93. Letter, 15 March 1983 from Frank K. Lorenz, curator of archives and special collections at Hamilton College, to Ronald J. Chepesiuk, Archives and Special Collections, Winthrop College, Rock Hill, South Carolina. Lorenz included with his letter pages 69–71 of a typed copy of Professor Avery's diary describing his daguerreotype activities.

94. *Yorkville Enquirer,* 14 June 1866.

95. Ibid., 22 June 1853.

96. In arriving at the number of daguerreotypists who practiced their art in the state, when a firm listed "& Co." as a part of its name, the assumption was made that the firm had more than one photographer. In the three cases where the "& Co." appeared, those firms were credited with two photographers.

### Notes to chapter 3

1. Rinhart and Rinhart, *The American Daguerreotype,* 190. Sturhahn, *Carvalho,* 65–66.

2. Rinhart and Rinhart, *The American Daguerreotype,* 148.

3. Ibid, 147.

4. Newhall, *Daguerreotype in America,* 148.

5. Rinhart and Rinhart, *The American Daguerreotype,* 148.

6. Newhall, *Daguerreotype in America,* 109.

7. Rinhart and Rinhart, *The American Daguerreotype,* 191–207. *Charleston Courier,* 2 December 1858; 13 and 18 January, 29 October and 21 December 1859.

8. William Gilmore Simms, "Charleston, The Palmetto City," *Harper's New Monthly Magazine* 15:85 (June 1857), 20.

9. *Abbeville Banner,* 21 April 1851. *Unionville Journal,* 20 January and 23 April 1852.

10. *(Abbeville) Independent Press,* 22 February 1852. *Laurensville Herald,* 18 and 25 April 1856.

11. *Abbeville Banner,* 20 August and 17 October 1856. *(Abbeville) Independent Press,* 11 June 1857.

12. *(Abbeville) Independent Press,* 7 April 1856.

13. *Abbeville Banner,* 15 January 1857.

14. Ibid., 30 July 1857.

15. *(Abbeville) Independent Press,* 28 September 1858.

16. Account books of George S. Cook, George Smith Cook Collection, Manuscripts Division, Library of Congress.

17. A Works Progress Administration (W. P. A.) transcript of Anderson town minutes located at the South Carolina State Archives and History Department, Columbia, South Carolina.

18. *Camden Journal,* 15 March 1850. *Darlington Flag,* 5 March 1851. *(Macon) Citizen,* 28 June 1851.

19. *(Georgetown) Winyah Observer,* 15 May 1850. *Sumter Banner,* 12 March 1851.

20. *Sumter Banner,* 12 March 1951. *(Sumter) Black River Watchman,* 15 March 1851. *Camden Journal,* 14 March 1851. *(Sumter) Black River Watchman,* 26 May 1854. *Chester Standard,* 6 January 1856 (this ad ran all year). For additional information on Squier in Sumter consult Renee Marie Stowe, "The Development of the Commercial Photographic Industry in Sumter, South Carolina" (master's thesis, University of South Carolina, 1991), 10–12.

21. *Camden Journal,* 23 December 1854. Thomas J. Kirkland and Robert M. Kennedy, *Historic Camden,* part two, *The Nineteenth Century* (Camden: The State Company, 1926), 409–410.

22. *Camden Weekly Journal,* 6 November 1854.

23. *Yorkville Miscellany,* 7 December 1853. Massengill, "Portraits by the Sunlight Made," *Carolina Comments* 41:5, 148. *Camden Weekly Journal,* 12 January 1858. Private collection of Shannon family photographs. *Camden Journal,* 23 January 1868.

24. Kocher and Dearstyne, *Shadows in Silver,* 6–7. Charles Hamilton and Lloyd Ostendorf, *Lincoln in Photographs: An Album of Every Known Pose* (Norman: University of Oklahoma Press, 1963), 30. According to Hamilton and Ostendorf, Cook asked Lincoln to sit for this photograph and stated in 1865 that "Mrs Lincoln pronounced (it) the best likeness she had ever seen of her husband." Ramsay, *Photographer. . . under Fire,* 45.

25. *(Macon) Citizen,* 28 June 1851.

26. Rinhart and Rinhart, *The American Daguerreotype,* 404. *(Chester) Palmetto Standard,* 23 June 1853. *Charleston City Directory,* 1856. Letters from A. McCormick to George Smith Cook, 9 and 20 April, 17 May and 2 June 1861. George Smith Cook Collection, Manuscripts Division, Library of Congress. *Charleston City Directory,* 1859. Ramsay, *Photographer. . . under Fire,* 133.

27. Account books of George S. Cook, George Smith Cook Collection, Manuscripts Division, Library of Congress.

28. *Charleston City Directory,* 1852, p. 6.

29. *Charleston City Directory,* 1852, p. 6. *Charleston Courier,* 28 February 1854. See Ramsay, *Photographer. . . under Fire.*

30. *Charleston Courier,* 27 March 1855. Letters from W. H. Hunt to Cook, 8 April and 29 June 1861, George S. Smith Collection, Manuscripts Division, Library of Congress.

31. *Charleston Courier,* 12 January 1856.

32. Ramsay, *Photographer. . . under Fire,* 36, 55.

33. *Charleston Courier,* 21 October 1853; 14 February 1861.

34. *(Georgetown) Winyah Observer,* 15 May 1850.

35. Sturhahn, *Carvalho,* xv–xvi, 9–18.

36. Ibid., 41–43.

37. *Charleston Courier,* 3 February, 10 April and 7 July 1851. *Charleston City Directory,* 1851, p. 188.

38. *Third Annual Fair. Catalogue at the Fair of the South-Carolina Institute, November 18, 1851* (Charleston: Walker and James, 1851), 4, 9.

39. *Charleston Courier,* 3 February 1851.

40. *Boston Daily Evening Transcript.* 14 February 1852.

41. Sturhahn, *Carvalho,* 60–62.

42. Ibid., 67–69.

43. *Charleston Courier,* 23 December 1851; January 1852.

44. *Charleston City Directory,* 1852, p. 188. *Charleston Courier,* 9 November 1853; 30 August 1855; 21 February 1856.

45. *Charleston Courier,* 25 April 1856. *The South Carolina Jockey Club* (Charleston: Russell & Jones, 1857), 147–149. *(Charleston) Southern Inventor,* 15 January 1858.

46. *Sumter Watchman,* 28 June 1859. Account books of George S. Cook, George Smith Cook Collection, Manuscripts Division, Library of Congress. Record Group 58, Microform Publication, M-789, reels 1 and 2, National Archives.

47. *Charleston Courier,* 13 October 1856.

48. *(Columbia) South Carolinian,* 18 June 1854. *Historical and Descriptive Reviews of the State of South Carolina, Including the Manufacturing and Mercantile Industries of the Cities and Counties. . ., Volume III* (Charleston: Empire Publishing Company, 1884), 185–86.

49. John S. Craig, *Craig's Daguerreian Registry,* (Torrington: Conn.: John S. Craig, 1996), 3:602. *(Georgetown) Winyah Observer,* 8 December 1852. *(Sumter) Black River Watchman,* 17 June 1853. SCL.

50. *Charleston Courier,* 6 August 1853.

51. Rinhart and Rinhart, *The American Daguerreotype,* 404.

52. *Charleston Courier,* 6 August 1853.

53. Ibid., 17 March 1854.

54. *Charleston Courier,* 6 and 24 August, 21 and 29 October and 10 December 1853; 4 January, 11 and 28 April 1854. Rinhart and Rinhart, *The American Daguerreotype,* 404.

55. *Charleston Courier,* 28 February 1854.

56. *(Chester) Palmetto Standard,* 12 May and 23 June 1853.

57. *Charleston Daily Courier,* 23 November and 12 December 1853; 3 and 8 February 1854.

58. *(Sumter) Black River Watchman,* 24 February 1854. *Marion Star,* 25 March 1856.

59. *Charleston Courier,* 12 December 1853; 10 April 1854; 19 January and 10 December 1855.

60. Ibid., 25 December 1855; 24 February and 2 December 1857.

61. Ibid., 23 and 27 November 1858.

62. *Charleston Mercury,* 7 December 1859.

63. Ibid., 31 October 1860.

64. Photographic collections, SCL, Columbia, South Carolina, and South Carolina Historical Society, Charleston, South Carolina. Copies of photographs in the possession of Bob Zeller and an interview with him on 2–16–99. *Charleston City Directory,* 1860.

65. Photographic collection, Florence Museum, Florence, South Carolina. Photographic collection of a private collector.

66. Rinhart and Rinhart, *The American Daguerreotype,* 380. *Sumter Banner,* 11 December 1850. *(Greenville) Southern Patriot,* 9 May 1851. *Charleston Courier,* 28 February 1855.

67. *Charleston City Directory,* 1855.

68. *Sumter Watchman,* 16 January 1856. *Spartanburg Express,* 21 March and 20 August 1860, 30 January 1861.

69. *Charleston Courier,* 10 December 1855; 24 December 1856.

70. Ibid., 18 and 19 March 1856.

71. Account books of George S. Cook, George Smith Cook Collection, Manuscripts Division, Library of Congress. Rinhart and Rinhart, *The American Daguerreotype,* 412.

72. *Charleston Courier,* 18, 19, and 20 November and 18 December 1856.

73. Beaumont Newhall, *The History of Photography from 1839 to the Present Day* (New York: Museum of Modern Art, 1949), 58.

74. *Charleston Courier,* 24 December 1856; 19 February 1857.

75. *Charleston City Directory,* 1856.

76. *Charleston Courier,* 18 December 1856; 19 February 1857.

77. Ibid., 2 February, 3 July, 24 September and 31 December 1856.

78. Ibid., 26 January and 10 March 1857.

79. Matthew R. Isenburg, presentation to the Daguerreian Society at their annual convention, Syracuse, New York, 1993.

80. *Charleston Courier,* 15 January 1858.

81. Ibid., 29 March and 29 May 1859.

82. Massengill, "Portraits by the Sunlight Made," *Carolina Comments* 41:5, 148. *(Georgetown) Pee Dee Times,* 5 February 1856. *Charleston Courier,* 31 March 1856.

83. *Chester Standard,* 11 September 1856. Massengill, "Portraits by the Sunlight Made," *Carolina Comments* 41:5, 148.

84. *Charleston Courier,* 22 December 1856.

85. Ibid., 31 December 1857.

86. *Charleston Courier,* 19, 24, 26, and 27 February 1857; 4, 5, 10, and 19 March and 10 October 1857. *(Charleston) Southern Inventor,* 15 January 1858.

87. *Charleston City Directory,* 1860.

88. *(Cheraw) Pee Dee Herald,* 5 August 1856. Massengill, "Portraits by the Sunlight Made," *Carolina Comments* 41:5, 147.

89. Ibid., 16 March 1857.

90. "Humphrey's Daguerreian Artists' Register 1850 and 1851," *Daguerreian Annual* (Green Bay, Wisc.: Daguerreian Society, 1993), 156. *(Chester) Palmetto Standard,* 1852–1853. *Chester Standard,* 16 April 1854; 20 September 1855; 26 February 1857.

91. *(Chester) Palmetto Standard,* 9 June 1853. *(Columbia) South Carolinian,* 8 and 10 June 1854. Massengill, "Portraits by the Sunlight Made," *Carolina Comments* 41:5, 148.

92. *Chester Standard,* 6 March 1856. Account books of George S. Cook, George Smith Cook Collection, Manuscripts Division, Library of Congress.

93. *(Abbeville) Independent Press,* 10 November 1858.

94. Account books of George S. Cook, George Smith Cook Collection, Manuscripts Division, Library of Congress. *Columbia) Daily South Carolinian,* 2 December 1852. *Yorkville Miscellany,* 3 February 1853. *(Chester) Palmetto Standard,* 9 February 1853. *(Columbia) South Carolinian,* 8 June 1854.

95. *(Columbia) South Carolinian,* 8 and 10 June 1854.

96. Rinhart and Rinhart, *The American Daguerreotype,* 304. *(Columbia) South Carolinian,* 17 November 1854.

97. *(Columbia) Daily South Carolinian,* 22 November 1854.

98. Letter of John Usher, Jr. to Tucker, 19 October 1856; letter in the collection of the author. *Columbia City Directory,* 1859.

99. *Columbia City Directory,* 1859. *Augusta City Directory,* volumes for 1872 through 1883.

100. *Columbia Phoenix,* 12 January 1874.

101. Account books of George S. Cook, George Smith Cook Collection, Manuscripts Division, Library of Congress.

102. *(Abbeville) Independent Press,* 27 March 1856.

103. *(Newberry) Conservatist,* 16 March 1858. *Columbia City Directory,* 1859. *Transactions of the State Agricultural Society of South Carolina for 1858* (Columbia: Robert M. Stokes, 1858), 46. For the 1859 fair, see pp. 19, 24, 26, and 27 of the 1859 *Transactions.* SCL.

104. *Columbia City Directory,* 1859. *(Columbia) Daily Phoenix,* 8 March 1866.

105. *(Columbia) Daily Southern Guardian,* 16 April 1860.

106. *Third Annual Fair. Catalogue at the Fair of the South-Carolina Institute, November 18, 1851.* Account books of George S. Cook, George Smith Cook Collection, Manuscripts Division, Library of Congress.

107. *Edgefield Advertiser,* 2 January, 27 March and 24 April 1850; 27 February and 7 August 1851; 9 March and 11 May 1853; 29 November 1854.

108. *Laurensville Herald,* 30 May and 11 July 1856. *Edgefield Advertiser,* 30 September and 5 November 1856.

109. *Laurensville Herald,* 27 February 1861.

110. *Edgefield Advertiser,* 19 December 1855.

111. Ibid., 16 July 1856.

112. Letter of John S. Duffie to I. Tucker, 16 November 1856; copy of letter in the collection of the author.

113. *Edgefield Advertiser,* 23 May 1859.

114. *(Georgetown) Pee Dee Times,* 6 December 1854; January 1855.

115. Ibid., 16 December 1857.

116. Account books of George S. Cook, George Smith Cook Collection, Manuscripts Division, Library of Congress.

117. *Sumter Banner,* 12 December 1850. *(Greenville) Southern Patriot,* 8 May 1851. Journal of Thomas Stephen Powell, 14 August 1851, SCL. *Charleston Courier,* 28 April 1855.

118. Anna Wells Rutledge, "Artists in the Life of Charleston through Colony and State from Restoration to Reconstruction," *Transactions of the American Philosophical Society,* vol. 39, part 1 (Philadelphia: American Philosophical Society, 1949), 155–56.

119. *Edgefield Advertiser,* 9 March 1853. *Abbeville Banner,* 17 April 1855. *(Abbeville) Press and Banner,* 8 February 1855. *(Sumter) Black River Watchman,* 31 October 1855. *Abbeville Banner,* 10 March 1859. *Spartanburg Express,* 17 April 1861.

120. Journal of Thomas Stephen Powell, 19 September 1855, SCL. An example of a Furman diploma designed by Powell is held in Furman University Library's special collections.

121. Rinhart and Rinhart, *The American Daguerreotype,* 139. Journal of Thomas Stephen Powell, 17 July 1856, SCL. Clyde Graham Hopper, Jr., and Bobby Gilmer Moss, *Toward the Light: Photography and Limestone College* (Gaffney, S.C.: Limestone College, 1998), 7.

122. *Lancaster Ledger,* 15 September 1852; September 1853.

123. Ibid., 10 November 1852.

124. Ibid., 15 March 1854.

125. Ibid., 14 April 1858. Also see footnote 23 in this chapter.

126. *Lancaster Ledger,* 23 September 1857.

127. Ibid., 28 September 1859.

128. *Laurensville Herald,* 25 January 1850. Floyd Rinhart and Marion Rinhart, *Victorian Florida: America's Last Frontier* (Atlanta, Ga.: Peachtree Publishers, 1986), 208.

129. *Laurensville Herald,* 3 January 1851.

130. *Laurensville Herald,* 29 August 1851. Account books of George S. Cook, George Smith Cook Collection, Manuscripts Division, Library of Congress.

131. *Laurensville Herald,* 23 March and 18 May 1855.

132. Ibid., 12 October 1855; 24 December 1856; 1 March and 3 May 1860.

133. Ibid., 14 April 1859.

134. Hopper and Moss, *Toward the Light,* 7.

135. *(Newberry) Conservatist,* 16 March 1858. *(Newberry) Rising Sun,* 21 February 1860; January 1861. Cook Collection. Valentine Museum.

136. Account books of George S. Cook, George Smith Cook Collection, Manuscripts Division, Library of Congress.

137. Ibid.

138. Account books of George S. Cook, George Smith Cook Collection, Manuscripts Division, Library of Congress. Newhall, *Daguerreotype in America,* 100.

139. *(Pickens) Keowee Courier,* 14 May 1857.

140. *(Pickens) Keowee Courier,* 10 July 1860. *(Walhalla) Keowee Courier,* 9 June 1871.

141. Account books of George S. Cook, George Smith Cook Collection, Manuscripts Division, Library of Congress.

142. *(Columbia) Daily South Carolinian,* 13 January 1857.

143. *Sumter Watchman,* 13 January, 4 April, and 5 October 1858.

144. Stowe, "Development of the Commercial Photographic Industry in Sumter," 21–23. *Sumter Watchman,* 2 October 1858.

145. *Sumter Watchman,* 28 June 1859.

146. *Sumter Watchman,* 29 November 1859. *Spartanburg Express,* 21 March 1860. *(Greenville) Enterprise and Mountaineer,* 12 June 1878. *Greenville City Directory,* volumes for 1880 and 1881.

147. *(Abbeville) Independent Press,* 6 July 1857.

148. *(Winnsboro) Tri-Weekly Register,* 11 December 1856; 24 September 1857; 21 January 1858.

149. *Yorkville Miscellany,* 22 January 1851. Massengill, "Portraits by the Sunlight Made," *Carolina Comments* 41:5, 147.

150. *Yorkville Miscellany,* 10 April and 1 May 1952. Massengill, "Portraits by the Sunlight Made," *Carolina Comments* 41:5, 147.

151. Massengill, "Portraits by the Sunlight Made," *Carolina Comments* 41:5, 149.

152. *Yorkville Miscellany,* 7 December 1853.

## NOTES TO CHAPTER 4

1. See Wallace, *South Carolina, A Short History.* David Duncan Wallace, *South Carolina History and Resources* (Chicago: Denoyer Geppert Company, 1968). The map from this set of fifteen titled "War of Secession" was used as a reference for dates and locations of battles and lines of march of Confederate and Union armies.

2. Robert Taft, *Photography and the American Scene: A Social History, 1839–1889* (New York: Dover, 1964), 234.

3. Ross J. Kelbaugh, *Introduction to Civil War Photography* (Gettysburg: Thomas Publications, 1991), 9. Record Group 58, Microform Publication, M-789, Reel 1 description, National Archives. *Charleston Daily Courier,* 8 June 1865.

4. Frederick Bischoff's journal, 9 August 1861, SCL.

5. *Anderson Intelligencer,* 14 August 1860; 28 February 1861.

6. Ibid., 16 November 1865; 3 July 1867; 10 September 1868; 18 October 1870.

7. *Camden Weekly Journal,* 1 May and 23 October 1860; 5 March 1861. *Camden Journal,* 24 September 1868. *Sumter News,* 31 May 1866. *Sumter Watchman,* 4 July 1866.

8. *Camden Weekly Journal,* 24 July 1860.

9. *Charleston City Directory,* 1860. Letters from A. McCormick to George Smith Cook, 9 and 20 April, 17 May, 2 June 1861, and account books of George S. Cook, George Smith Cook Collection, Manuscripts Division, Library of Congress. Record Group 58, Microform Publication, M-789, Reel 2, National Archives. *Charleston City Directory,* volumes for 1867 and 1868.

10. *Charleston City Directory,* volumes for 1859 and 1860. Letters from F. W. R. Danforth to George Smith Cook, 9 January and 1 February 1861, and a letter from a Mr. Vanderwedge to Cook, 19 January 1861. George Smith Cook Collection, Manuscripts Division, Library of Congress. June 1860 receipt for photographs in the James Simons account book, signed by Danforth of the Cook Gallery; account book is in private hands.

11. Peach, *George Smith Cook,* 22. *Anderson Intelligencer,* 28 February 1861.

12. *Charleston Mercury,* 8 February 1861. *Charleston Daily Courier,* 11 and 14 February 1861.

13. Abner Doubleday, *Reminiscences of Fort Sumter and Moultrie in 1860–61* (Spartanburg: Reprint Company, 1976), 119. Cook Collection, Valentine Museum, Richmond, Va.

14. *Harper's Weekly,* 23 March 1861. *Charleston Mercury,* 18 February 1861.

15. *Charleston Daily Courier,* 8 March, 16 April and 20 May 1861. William H. Chapman, undated manuscript, SCL.

16. Peach, *George Smith Cook,* 40–47.

17. *Charleston Daily Courier,* 12 September 1863.

18. Kocher and Dearstyne, *Shadows in Silver,* 9. Reed album, Beaufort County Public Library, Beaufort, S.C.

19. Letter of William Elliott to his brother, Stephen Elliott, 22 October 1863; copy in possession of the author. John Johnson, *The Defense of Charleston Harbor, Including Fort Sumter and the Adjacent Islands* (Charleston: Walker, Evans & Cogswell Co., 1890), 166–67, 187.

20. Francis Trevelyan Miller, *The Photographic History of the Civil War* 10 vols. (New York: Castle Books, 1957), vol. 3, 170. Ramsay, *Photographer. . . under Fire,* 69–70, 74.

21. Peach, *George Smith Cook,* 65–66.

22. Ramsay, *Photographer. . . under Fire,* 126–130.

23. The pre-1861 account of the Osborn & Durbec firm was presented in chapter 3. Account books of George S. Cook, George Smith Cook Collection, Manuscripts Division, Library of Congress. *Charleston Daily Courier,* 20 May 1861. SCL. *Charleston City Directory,* 1868–69.

24. Photograph of the Gamble House located at the Florence Museum, Florence, South Carolina. Photographs of a private collector.

25. *Charleston Daily Courier,* 12 September 1863. Reed album, Beaufort County Public Library. *Charleston City Directory,* 1867–68. Miller, *Photographic History,* vol. 1, 101.

26. Record Group 58, Microform Publication, M-789, reel 2, National Archives. *Charleston City Directory,* 1867–68. Keith F. Davis, *George N. Barnard: Photographer of Sherman's Campaign* (Kansas City, Mo.: Hallmark Cards, Inc., 1990), 182. *Charleston City Directory,* 1882.

27. *Charleston City Directory,* 1860. *Charleston Daily Courier,* 16 April 1861. George Smith Cook Collection, Manuscripts Division, Library of Congress. Record Group 58, Microform Publication, M-789 reel 2, National Archives. *Charleston City Directory,* volumes for 1867 and 1868. *Sumter Watchman,* 16 February 1870. *Augusta Chronicle,* 14 December 1909, p. 9.

28. *Charleston City Directory,* 1860. George Smith Cook Collection, Manuscripts Division, Library of Congress. *Historical Images and Manuscripts,* a public auction catalogue for June 28, 1998, American Historical Auctions, a Division of Bernard's Gallery of Boston, Lot #1414, pp. 74–75.

29. *Charleston City Directory,* 1860. Rinhart and Rinhart. *Victorian Florida,* 209.

30. *Charleston Mercury,* 25 November 1862. *Charleston Daily Courier,* 30 January 1866. Davis, *George N. Barnard,* 181.

31. Letters of L. A. Green to George Smith Cook, 2 February and 8, 10, 24 April 1861 and account books of George S. Cook, George Smith Cook Collection, Manuscripts Division, Library of Congress.

32. Letter from J. T. Zealy to George Smith Cook, 20 April 1861, and George Smith Cook Account books, Manuscripts Division, Library of Congress.

33. The antebellum work of Wearn & Hix was treated in chapter 3 and the post bellum work will be treated in chapter 5. Collection of the Confederate Relic Room and Museum, Columbia, South Carolina.

34. SCL. *(Columbia) Daily Phoenix,* 9 September 1865. B. H. Teague Collection, Confederate Relic Room and Museum.

35. SCL. *(Columbia) Daily Phoenix,* 16 August and 9 September 1865. *Charleston Daily Courier,* 8 June 1865.

36. *Spartanburg Express,* 17 April 1861.

37. Account books, George Smith Cook Collection, Manuscript Division, Library of Congress.

38. Ibid., 27 February 1861.

39. Account books, George Smith Cook Collection, Manuscripts Division, Library of Congress. Cook Collection, Valentine Museum.

40. Cook Collection, Valentine Museum.

41. Account books and a letter of Charles H. Kingsmore to Cook, 2 April 1861, George Smith Cook Collection, Manuscripts Division, Library of Congress.

42. *Newberry Herald,* 16 January 1867; 29 January 1868.

43. Letter of E. J. Allen, 16 March 1861 to Cook, George Smith Cook Collection, Manuscripts Division, Library of Congress.

44. Letters of R. H. and F. M. Tuck to Cook, 2 and 21 April 1861, George Smith Cook Collection, Manuscripts Division, Library of Congress.

45. Letter of T. McKinny to Cook, 2 April 1861, George Smith Cook Collection, Manuscripts Division, Library of Congress.

46. Cook Collection, Valentine Museum. George Smith Cook Collection, Manuscripts Division, Library of Congress.

47. Cook Collection, Valentine Museum.

48. *Spartanburg Express,* 21 March and 20 August 1860; 30 January and 17 April 1861. Account books, George Smith Cook Collection, Manuscripts Division, Library of Congress.

49. Frederick Bischoff Journal, 11 September 1861, SCL.

50. Stowe, "Development of the Commercial Photographic Industry in Sumter," 22–23. Record Group 58, Microform Publication, M-789, reel 1, National Archives.

51. *Sumter Watchman,* 25 December 1861.

52. Charles Family, SCL. Collection of the Confederate Relic Room and Museum.

53. *(Winnsboro) Tri-Weekly Register,* 20 December 1860; 29 August 1865.

54. *Yorkville Enquirer,* September 1859 to January 1862. Mrs. Morton Gaines, "Biographical Account of John Schorb," 12 August 1963, Winthrop University Archives, Rock Hill, S.C.

55. Account books, George Smith Cook Collection, Manuscripts Division, Library of Congress.

56. Shelby Foote, *The Civil War: A Narrative,* vol. 3, *Red River to Appomatox* (New York: Random House, 1976), 98.

57. *Charleston Daily Courier,* 24 December 1862.

58. *(Beaufort) Free South,* 9 April 1864.

59. James D. Horan, *Timothy O'Sullivan, America's Forgotten Photographer* (Garden City, N.Y.: Doubleday, 1966), 1–33.

60. Ibid., 34–35.

61. Ibid.

62. Ibid.

63. *War of the Rebellion Records of the Union and Confederate Armies,* series 1, vol. 14, 154.

64. *(Beaufort) Free South,* 1 June 1863.

65. Samuel A. Cooley account book, SCL.

66. *(Beaufort) Free South,* 12 December 1863.

67. *(Beaufort) Free South,* 21 May 1864. Reed album, Beaufort County Public Library.

68. Reed album, Beaufort County Public Library.

69. Martha A. Sandweiss, *Photography in Nineteenth Century America* (Fort Worth, Tex.: Amon Carter Museum, and New York: Harry N. Abrams, 1991), 161–65.

70. *(Beaufort) New South,* 16 June 1866. Interview in 1994 with Dr. Stephen R. Wise, director of the Parris Island Museum, United States Marine Corps, Beaufort, S.C.

71. In 1992 the author examined a few of Cooley's glass negatives at the Western Reserve Historical Society in Cleveland.

72. *(Beaufort) Free South,* 26 March, 21 May, and 1 September 1864.

73. Ibid., 1 November 1863.

74. *(Beaufort) Free South,* 12 August 1863. *The Hospital Transcript,* 1 July 1865.

75. *(Beaufort) Free South,* 13 August 1864. Christiansen Family Collection, SCL.

76. *(Beaufort) Palmetto Herald,* 1 November 1864. Reed album, Beaufort County Public Library.

77. Reed album, Beaufort County Public Library. *(Beaufort) Free South,* 16 June 1866. Christiansen Family, SCL.

78. *(Beaufort) Free South,* 26 March 1864.

79. *(Beaufort) Palmetto Herald,* 1 September 1864.

80. *Charleston Daily Courier,* 23 and 25 June 1865. Record Group 58, Microform Publication M-789 reel 1, National Archives.

81. Reed album, Beaufort County Public Library.

82. Sherry Buckband Wilding-White, "Civil War Photographs by Henry P. Moore," *Historical New Hampshire* 49:1 (Spring 1994), 25–44.

83. Clara Childs Puckette, *Edisto: A Sea Island Principality* (Cleveland, Ohio: Seaforth Publications, 1978), 30–35. Henry P. Moore Collection, Western Reserve Historical Society.

84. Charles McCracken and Faith McCracken, *A Photographic Essay on Civil War Hilton Head Island* (Hilton Head, S.C.: Time Again Publications, 1993). W. Jeffrey Bolster and Hilary Anderson, *Soldiers, Sailors, Slaves, and Ships: The Civil War Photographs of Henry P. Moore* (Concord: New Hampshire Historical Society, 1999).

85. William Marder and Estelle Marder with Sally Pierce, "Phillip Haas: Lithographer, Print Publisher, and Daguerreotypist," *Daguerreian Annual* (Pittsburgh: Daguerreian Society, 1995), 21–34.

86. United States Army Military Institute at Carlisle Barracks, Carlisle, Pa., the South Carolini-ana Library, the South Carolina Historical Society at Charleston, and many other institutions and individuals have varying numbers of Haas & Peale photographs.

87. Marder and Marder, *Phillip Haas* 31.

88. SCL.

89. *Charleston Daily Courier,* 12 September 1863.

90. Keith F, Davis, *George N. Barnard,* 14–63.

91. Ibid., 63–77.

92. Ibid., 77–94.

93. Reed album, Beaufort County Public Library. See note accompanying photograph #6 in the album.

94. Davis, *George N. Barnard,* 94.

95. *Charleston Daily Courier,* 4 and 21 April 1865.

96. *Columbia Phoenix,* 18 May 1865.

97. *Augusta Chronicle,* 4 June 1865.

98. *Columbia Phoenix,* 1 June 1866.

99. Davis, *George N. Barnard,* 170, 177.

100. Photographic collections of the Western Reserve Historical Society and the New Hampshire Historical Society. Research notes of Hilary Anderson.

## NOTES TO CHAPTER 5

1. Wallace, *South Carolina, A Short History, 1520–1948.* Historical facts about South Carolina, 1865–1880, included in this work may be verified in Dr. Wallace's history.

2. Each photographer mentioned in the "Recovery" section of this chapter is given fuller treat-ment in other sections of the chapter. Sources are cited when appropriate in these sections.

3. United States Census, 1870.

4. Ibid., 1880.

5. Lou M. McCullough, *Card Photographs: A Guide to their History And Value* (Bax E. Exton, Pa.: Schiffer Publishing, 1981), 41–45.

6. *Abbeville Press & Banner,* 18 March 1870, 31 March 1871. *Camden Journal,* 6 October 1870; 9 March and 28 December 1871; 10 October 1872. Carte de visite of Rev. William T. Capers, photo-graphic collection, Wofford University, Spartanburg, S.C. *Camden Journal,* 11 September 1873.

7. Stephen E. Massengill, "'To Secure a Faithful Likeness': A Roster of Photographers Active in North Carolina, 1865–1900," *Carolina Comments,* 44:1 (January 1996), 32.

8. *Abbeville Press and Banner,* 7 July 1871.

9. *Aiken Press,* 4 July 1867.

10. Research notes taken by Joe Lee from the Naturalization Index located at the Georgia His-torical Society, Savannah. 1870 and 1880 United States Censuses. Contract of sale between Palmer and his wife, dated 5 December 18; copy in the possession of the author. *Aiken Journal and Review,* 23 June 1896. Mr. Joe Lee of Covington, Ga., kindly loaned copies of his research notes on J. A. Palmer and copies of Palmer stereographs from his collection.

11. *Aiken, South Carolina as a Health and Pleasure Resort* (Charleston: Walker Evans & Cogswell Co., Printers, 1889), SCL.

12. *Aiken Recorder,* 14 September 1886.

13. *Anderson Intelligencer,* 13 October 1870, SCL.

14. Ibid., 11 January 1872.

15. *The South Carolina Gazetteer and Business Directory* (Charleston: Lucas & Richardson, 1880 and 1883). *Anderson Intelligencer,* June 1884; 6 May 1886; 6 May and 18 August 1887; 14 July 1888; 10 October 1889; 3 April 1890. SCL.

16. Private collection of Shannon family photographs, containing one produced by Hughes & Burr. *Camden Journal,* 25 January 1867. *(Columbia) Daily Phoenix,* 2 April 1867.

17. *Camden Journal,* 24 September 1868.

18. *Kershaw Gazette,* 19 July 1876. *Camden Journal,* 26 February and 27 August 1878; 28 November 1889.

19. W. S. Alexander and John W. Corbett, *A Descriptive Sketch of Camden Containing Some of Her Ancient History, Her Present Condition, and Her Prospects for the Future* (Charleston: Walker, Evans & Cogswell Co., Printers, 1888), SCL.

20. *Camden Journal,* 25 September 1879; 26 February 1880.

21. Record Group 58, Microform Publication, M-789, reel 1, National Archives. *Charleston Daily Courier,* 27 January 1866. Davis, *George N. Barnard,* 180.

22. *Charleston City Directory,* 1869–70. Davis, *George N. Barnard,* 181.

23. *Charleston Daily Courier,* 25 October and 10 November 1870. Davis, *George N. Barnard,* 181.

24. Record Group 58, Microform Publication, M-789, reels 1 and 2, National Archives. *Charleston Daily Courier,* 23 June 1865.

25. *Charleston Daily Courier,* 23 June 1865.

26. *Charleston Daily Courier,* 9 August 1865. *(Columbia) Daily South Carolinian,* 19 November 1865; 1 March and 14 April 1866. Record Group 58, Microform Publication, M-789, reel 2, National Archives.

27. *Charleston City Directory,* volumes for 1872–73, 1874–75, 1875, and 1876–77.

28. *Charleston City Directory,* 1867–68. Carte de visite of Haman Berkham, SCL.

29. Dated photograph of Miss Hannah Anderson, Wofford University Archives, Spartanburg, S.C. *Charleston City Directory,* 1869–70.

30. Davis, *George N. Barnard,* 181. *Charleston City Guide* (Charleston, S.C.: J. W. Delano/Sunday Times, 1872), 32.

31. Davis, *George N. Barnard,* 186.

32. Ibid., 180.

33. Davis, *George N. Barnard,* 229 n. 48.

34. Arthur Mazyck, *Guide to Charleston: Illustrated* (Charleston: Walker Evans & Cogswell, 1875).

35. Davis, *George N. Barnard,* 194–195, SCL.

36. SCL.

37. Davis, *George N. Barnard,* 188–189.

38. Barnard advertised in the *Charleston Daily Courier* on 24 and 29 November 1875; 11 and 12 April and 16 August 1876; 9 November and 12 December 1877; 21 November 1878; 11 May 1880. *Charleston City Directory,* 1875. *Walterboro News,* 13 September 1873. *Newberry Observer,* 19 September 1877. *Laurensville Herald,* 20 September 1877.

39. *(Sumter) True Southron,* 20 May 1879. *Columbia Daily Register,* 22 February 1880.

40. Davis, *George N. Barnard,* 193.

41. Davis *George N. Barnard,* 182. *Charleston City Directory,* volumes for 1875, 1876–77, and 1878.

42. SCL.

43. Davis, *George N. Barnard,* 196.

44. Ibid., 205.

45. *Charleston Free Press*, 14 July 1871. *Charleston City Directory*, volumes for 1872, 1874–75, and 1875.

46. *Charleston City Directory*, 1874–75.

47. Photograph of A. J. Stafford dated 7 December 1870, Wofford University Archives, Spartanburg, S.C. *Charleston City Directory*, volumes for 1872–73, 1874–75, and 1875. *Orangeburg News & Times*, 21 August 1875.

48. *Charleston City Directory*, volumes for 1875, 1876–77, and 1878.

49. *Charleston City Directory*, volumes for 1876 through 1880. Photograph of Albert Tabor and carte de visite of Haman Berkham, photographic collection, SCL.

50. SCL.

51. *Charleston City Directory*, 1878; *South Carolina State Gazetteer and Business Directory*, 1880-81.

52. Kocher and Dearstyne, *Shadows in Silver*, 12.

53. Ramsay, *Photographer. . . under Fire*, 31. *Charleston City Directory*, volumes for 1875 through 1880.

54. *An Historical and Descriptive Review of the City of Charleston* (New York: Empire Publishing Company, 1884), 53–54.

55. SCL. Ramsay, *Photographer. . . under Fire*, 140.

56. *Charleston City Directory*, volumes for 1869 through 1890. Davis, *George N. Barnard*, 196. *An Historical and Descriptive Review of the City of Charleston*, 145.

57. Laura Witte Waring, *You Asked for It* (Charleston, S.C.: Southern Printing & Publishing, 1941), 33–34.

58. *An Historical and Descriptive Review of the City of Charleston*, 155–156.

59. Reverse of photograph of a bust of Robert Fulton, photographic collection, South Carolina Historical Society.

60. William C. Darrah, *The World of Stereographs* (Gettysburg, Pa: W. C. Darrah, 1977), 199.

61. *Charleston City Directory*, volumes for 1886 through 1906. SCL.

62. *Charleston City Directory*, volumes for 1860, 1867–68, and 1869–70. Davis, *George N. Barnard*, 182. *Charleston City Directory*, volumes for 1874–75, 1876–77, 1878, and 1882.

63. *Chester Reporter*, 18 September and 10 November 1874; 8 June 1875. This June ad ran until 1878. *Yorkville Enquirer*, 5 November 1885. The Knox-Wise family album at the Winthrop University Archives, Rock Hill, S.C., contains a number of George T. Schorb cartes de visite.

64. *Abbeville Press and Banner*, 31 May 1876, 25 April 1883.

65. Notes from John Hammond Moore, Columbia, S.C.

66. *Lexington Dispatch*. 7 August 1872; 7 October 1874. *Columbia City Directory*, volumes for 1875–76, and 1876–77.

67. *(Columbia) Daily Phoenix*, 16 August, 7 and 9 September, 24 October 1865. SCL.

68. *Columbia City Directory*, 1875–76, unnumbered page following 192.

69. *Newberry Herald*, 24 February 1875. *(Columbia) Daily Register*, 22 February 1880. *Columbia City Directory*, 1883.

70. *South Carolina State Gazetteer and Business Directory*, 1880-81, 313. SCL.

71. *(Lexington) South Carolina Temperance Advocate*, 12 April 1877. SCL.

72. *Kershaw Gazette*, 12 August 1874. *Columbia City Directory*, volumes for 1875 through 1900. *Premium List of the State Agricultural and Mechanical Society of South Carolina* (Columbia: Bryan Printing Co., 1895 and 1898).

73. *Columbia City Directory*, volumes for 1875 through 1914.

74. D. P. Robins, *Descriptive Sketch of Columbia, S.C.* (Columbia: Presbyterian Publishing House, 1888), 72–73.

75. *Aiken Recorder,* 22 August 1882. *Newberry Observer,* 3 February 1886. *Camden Chronicle,* 27 November 1891 and 2 July 1897. *Lexington Dispatch,* 10 October 1888; the 10 October 1888 ad was published through 1901.

76. SCL.

77. *Newberry Observer,* 3 February 1886. Robins, *Descriptive Sketch of Columbia.* Letters of W. A. Reckling to John Gary Evans, 25 and 29 April 1908, 16 April 1911, Evans Collection, SCL.

78. *Columbia City Directory,* volumes for 1875 through 1895. *Columbia Register,* 29 September 1875. *Newberry Observer,* 10 October 1875.

79. Interview in 1994 with Barbara Wise, granddaughter of Hennies. *Columbia City Directory,* 1879–80.

80. Ross. A. Smith, *The South Carolina State Gazetteer and Business Directory* (Charleston: Lucas & Richardson, 1886). SCL.

81. *Columbia City Directory,* volumes for 1888 through 1903. George V. Hennies, *Souvenir of Columbia, S.C.* (New York: The Albertype Co, 1889).

82. *Columbia Daily Register,* 19 March 1895, p. 4, c. 2.

83. *Columbia City Directory,* volumes for 1903 through 1925.

84. *Columbia City Directory,* volumes for 1880 through 1922. *Columbia, South Carolina Shopping Center: The Distribution Point for South Carolina* (published by Montant Studio, Columbia, S.C.; printed by the Seemen Printery, Durham, N. C., 1921). Wise interview, 1994. SCL.

85. *(Abbeville) Press & Banner,* 26 October 1871; 27 May and 10 June 1874.

86. *Edgefield Advertiser,* 14 February 1866.

87. Ibid., 18 January 1871; 28 February and 1 December 1872; 6 January 1873; 11 November 1896 (same ad ran in 1897); 23 May 1902. *S.C. Coeducational Institute,* 1906 catalog.

88. *Edgefield Advertiser,* February 1897; 7 July 1897; 10 May 1910. *S.C. Co-Educational Institute,* 1906 catalog, SCL.

89. *(Batesburg) This Way,* 18 April 1895. *S.C. Co-Educational Institute,* 1906 catalog.

90. Record Group 58, Microform Publication, M-789, reel 1, National Archives.

91. *South Carolina State Gazetteer and Business Directory* (Charleston: R. A. Smith, 1880–81).

92. SCL.

93. *Greenville Enterprise.* 18 May 1870.

94. *Greenville Mountaineer,* 31 May 1872; 18 January 1893. *Greenville Daily News,* 15 January 1881. *Greenville City Directory,* volumes for 1881 through 1930.

95. Stereoscopic view of Governor Benjamin F. Perry's residence, photographic collection, SCL. *Newberry Herald,* 12 October 1872. *Rock Hill Herald,* 5 May 1911. Photograph of James Harrison Maxwell, SCL.

96. *(Anderson) Peoples Advocate,* 22 November 1897. *Rock Hill Herald,* 17 June 1910; 5 May 1911.

97. *Smith's South Carolina Business Directory, Trade Index and Shipper's Guide, 1876–'77* (Charleston: Marion C. Smith, Publisher, Lucas & Richardson, Print, 1876–77).

98. *Smith's South Carolina Business Directory, Trade Index and Shipper's Guide. (Greenville) Enterprise and Mountaineer,* 12 June 1878. *Greenville City Directory,* 1880–81. Massengill, "To Secure a Faithful Likeness," *Carolina Comments* 44:1, 30.

99. *Edgefield Advertiser,* 18 November 1873.

100. *Lancaster Ledger,* 17 March 1869. *Camden Journal,* 24 June and 28 October 1869.

101. *Lancaster Ledger,* 2 July 1866.

102. Ibid., 8 July 1866.

103. *Laurensville Herald,* 17 August 1866; 26 October 1867. Photograph of the Marshall House in the collection of John Blythe. Photographic collection, Museum of the Confederacy, Richmond, Va..

104. *Newberry Herald,* 18 December 1867; 29 January, 15 April, 24 June, and 14 October 1868. Caldwell family, SCL.

105. O'Bear family, SCL. *Abbeville Medium,* 3 April 1878. *Smith's South Carolina Business Directory, Trade Index and Shipper's Guide.* Strauss family photographs, SCL.

106. *(Walhalla) Keowee Courier,* 27 June 1878. *Weekly Union Times,* 29 June 1883. *Anderson Intelligencer,* 6 May and 18 August 1887; 10 October 1889.

107. *Laurensville Herald,* 6 February 1871.

108. *Laurensville Herald,* 21 February 1871. *Edgefield Chronicle,* 1 March 1883. SCL.

109. *Laurensville Herald,* 26 September and 1 November 1871; 4 October 1872; 20 January 1876.

110. Ibid., 17 May and 4 June 1872.

111. *Lexington Dispatch,* 7 August 1872; 7 October 1874. *Columbia City Directory,* volumes for 1875 through 1877.

112. *Marion Star,* 23 July 1873; 10 December 1874 (this ad also ran in 1875). Cartes de visite in the author's collection.

113. *The Dillon Herald,* 2 February 1905 and 1906; 27 February 1908; 13 May 1909; 13 January 1910.

114. Record Group 58, Microform Publication, M-789, reel 1, National Archives. Carte de visite of Reverend Y. W. Wells dated 20 March 1869, Wofford University Archives, Spartanburg, S.C.

115. *Newberry Herald,* 13 February 1867.

116. Ibid., 26 June 1867.

117. *Newberry Herald,* 26 February 1868; 16 March and 25 October 1870 (this ad ran to 1872); 8 October 1875 (this ad ran to 1877); 7 March 1877. SCL.

118. *Newberry Herald,* 7 March 1877; 12 and 26 February and 7 March 1879; 16 November 1882. John Belton O'Neall and John A. Chapman, *Annals of Newberry: In Two Parts* (1892; repr. Greenville, S.C.: Southern Historical Press, Inc., 1994), 791.

119. SCL.

120. *Historical and Descriptive Review of the State of South Carolina,* 277–278.

121. *(Orangeburg) Times & Democrat,* 5 September 1883; 17 July 1884 (this ad ran to 1886). Baxter family photographs, SCL. *(St. Matthews) Calhoun Advance,* 19 January 1911; 5 July 1916. Carte de visite in the author's collection.

122. Baxter family, SCL.

123. Record Group 58, Microform Publication, M-789, reel 2, National Archives.

124. Holleman, Francis. *The City of Seneca South Carolina, the City of Opportunity, Its Centennial August 11–18, 1973* (Greenville: Briggs & Associates, 1973), 52. Innesfallen, SCL.

125. *Historical and Descriptive Reviews of the State of South Carolina,* 185–186.

126. Photograph by S.C. Mouzon dated 24 November 1871, Wofford University Archives, Spartanburg, S.C. *Converse Concept,* January 1894, photographic collection, Spartanburg County Historical Association, Spartanburg. SCL.

127. *Sumter News,* 31 May 1866. *Sumter Watchman,* 4 July and 8 August 1866; 20 November 1867; Stowe, "Development of the Commercial Photographic Industry in Sumter," 41.

128. *Sumter Watchman,* 3 November 1869; 1 June and 10 August 1870; 17 January 1872. *(Sumter) True Southron,* 30 December 1874; 2 April 1878.

129. *(Sumter) True Southron,* 21 August and 8 September 1873.

130. *(Sumter) True Southron,* 2 April 1878.

131. *(Walhalla) Keowee Courier,* 13 July 1870.

132. *(Winnsboro) Fairfield Herald,* 21 August 1867. *Chester Reporter,* 11 May 1871. SCL.

133. *(Winnsboro) Fairfield Herald,* 20 May 1873; 12 February and 12 June 1874.

134. *(Winnsboro) Fairfield Herald,* 2 October 1874. SCL.

135. *(Winnsboro) Fairfield Herald,* 2 February 1875; 5 May 1877. *(Winnsboro) Fairfield News & Herald,* 23 April and 4 June 1890. *The Exposition,* 1901, p. 386; this was a publication of the Inter-State and West Indian Exposition held in Charleston, S.C., 1901–1902. *Greenwood City Directory,* volumes for 1908–09, 1912–13, 1915 through 1917, and 1936 through 1939. SCL.

136. *Yorkville Enquirer.* 12 October 1865; 14 June 1866; 3 June 1869. *Chester Reporter,* 10 November 1874. *Yorkville Enquirer,* 31 January 1884. *Rock Hill Herald,* 8 July 1910. Winthrop University Archives, Rock Hill, S.C. SCL. Schorb Collection, Historical Center of York County, York, S.C.

### Notes to chapter 6

1. Clifton Cedric Edom, *Photojournalism: Principles and Practices* (Dubuque, Iowa: Wm. C. Brown, 1976), 14–19.

2. *Art Work of Charleston* (Chicago: W. H. Parish Co., 1893).

3. *Art Work Scenes in South Carolina* (Chicago: W. H. Parish Co., 1895).

4. *Art Work of Columbia, South Carolina* (Chicago: Gravure Illustration Company, 1905). *Art Work of Piedmont Section of South Carolina* (Chicago: Gravure Illustration Company, 1920).

5. Robert Taft. *Photography and the American Scene.* New York: Macmillan, 1938), 378–83.

6. Ibid., 384–97.

7. Ibid., 383. (Also see Hermann Leidloff in chapter 5).

8. United States Censuses of 1890 and 1900.

9. *(Abbeville) Press and Banner,* 2 and 9 December 1885. Ross A. Smith, *The South Carolina State Gazetteer and Business Directory, etc.* 1886-87 (Charleston: Lucas & Richardson. 1886). SCL.

10. *Chester Lantern,* 12 December 1908. *Aiken Recorder,* 19 September 1890. *Weekly Union Times,* 21 December 1888. *Abbeville Press and Banner,* 1 May 1895.

11. *(Gaffney) Ledger,* 23 July, 27 September, 5 November, and 24 December 1896.

12. *Laurensville Herald,* 11 November 1898; 30 June 1899.

13. Photographic collection, Spartanburg County Historical Association, Spartanburg, S.C. Massengill, "To Secure a Faithful Likeness," *Carolina Comments* 44:1, 33.

14. *Abbeville Press and Banner,* 1 May 1895. *Cokesbury Conference School Record,* 1893, p. 20. *Business and Professional Directory of Cities and Towns Throughout the State of South Carolina* (Charleston: Young & Co., 1900). SCL.

15. *Aiken Recorder,* 31 August 1886. *Augusta, Georgia, City Directory,* volumes for 1895 through 1997.

16. *(Aiken) Journal & Review,* 11 March and 3 June 1896; 18 April 1898. *Business and Professional Directory of Cities and Towns* for 1900.

17. *Business and Professional Directory of Cities and Towns* for 1900. Dated photograph, collection of Paige Sawyer.

18. *Anderson Intelligencer,* 3 November 1887. *Augusta, Georgia, City Directory,* volumes for 1899 through 1917. SCL. Photographic collection, Spartanburg County Historical Association, Spartanburg, S.C.

19. *Rock Hill Herald,* 18 July 1888. *Anderson Intelligencer,* 21 September 1890. *The South Carolina State Gazetteer and Business Directory* (Charleston: Compiled by Wm. R. Walsh, Lucas and Richardson Company, 1898) and *Business and Professional Directory of Cities and Towns* for 1900. *(Anderson) People's Advocate,* 13 and 27 May 1901.

20. *Anderson Intelligencer,* 21 September and 21 December 1890. *(Anderson) People's Advocate,* 3 July 1893. *Piedmont Messenger,* 1 August 1899.

21. *(Anderson) People's Advocate,* 8 February 1892; 30 May 1900. *Anderson City Directory,* volumes for 1905–06 and 1909–10.

22. Carte de visite in the author's collection. SCL.

23. *The Barnwell People,* 22 November 1900.

24. Information about Penn School photographers and photographs was taken from the description of the collection, in the Southern Historical Collection, University of North Carolina, Chapel Hill.

25. *South Carolina Gazetteer and Business Directory* (Charleston: Lucas & Richardson, 1886–87.)

26. *Bennettsville Review,* 12 May 1894.

27. Gold Collection at the Historical Center of York County and SCL. Collection of the author. Interviews with Marion Manheim, 1995 and 1999. Display ads in Presbyterian College Annual, the *Collegian,* December 1906, December 1907, February 1908, February 1909. SCL.

28. *Barnwell People,* December 1884–September 1886; September 1886–into 1887. Knox-Wise family album, photographic collection, Winthrop University Archives, Rock Hill, S.C.

29. SCL. Photographic collection, South Carolina Historical Society, Charleston. Massengill, "To Secure a Faithful Likeness," *Carolina Comments* 44:1, 29. *South Carolina State Gazetteer and Business Directory* for 1898.

30. SCL.

31. *Charleston City Directory,* volumes for 1882 through 1909. *South Carolina State Gazetteer and Business Directory* for 1898.

32. *Charleston City Directory,* 1888.

33. *Charleston City Directory,* volumes for 1888 through 1894. Photographic collection, South Carolina Historical Society, Charleston. Lightsey Family Papers, SCL.

34. *Charleston City Directory,* volumes for 1890 through 1914. SCL. *Charleston . . . and Vicinity, Illustrated* (Charleston: Walker, Evans & Cogswell, 1901), 159.

35. *Charleston City Directory,* volumes for 1892 and 1893. Thornwell Jacobs, *Diary of William Plumber Jacobs* (Atlanta, Ga.: Oglethorpe University Press, 1937), 27 April 1892. *The Pine Forest Echo* 1:4 (August 15, 1892), 154.

36. *Pine Forest Echo* 1:4 (August 15, 1892), 154.

37. *Charleston . . . and Vicinity, Illustrated,* 161.

38. *Official Programme* (Charleston: Walker, Evans & Cogswell, 1895), 16. *Charleston City Directory,* volumes for 1894 through 1940. John Johnson, *Historic Points of Interest in and Around Charleston, S.C.* (Charleston: Confederate Re-Union Edition, 1896), 24. *A New Guide To Modern Charleston* (Charleston: Walker, Evans & Cogswell, 1912), 25.

39. *Charleston City Directory,* volumes for 1895 through 1900. J. Dean Enlow, *The Resources and Attractions of Charleston, S.C.* (Charleston: Lucas & Richardson, 1898), 104.

40. W. P. Dowling, Jr., *Art Souvenir, South Carolina Inter-State and West Indian Exposition, Charleston, S.C.* (n.d.)

41. *Charleston City Directory,* volumes for 1904 through 1918.

42. *Greenville City Directory,* volumes for 1923 through 1945.

43. Furman University annual, the *Bonhomie,* 1925 and 1928. *(Greenville) Parker Progress,* May 1931.

44. *(Greenville) Parker Progress,* May 1931.

45. Display advertisement in the Furman University annual, the *Bonhomie,* 1934.

46. *Charleston City Directory,* volumes for 1898 through 1917.

47. *Charleston City Directory,* 1898. Cabinet photograph in the author's collection.

48. Charleston Museum Collection.

49. *(Charleston) Evening Post,* 5 December 1934; 5 March 1964.

50. *The South Carolina Gazetteer and Business Directory* (Charleston: Lucas & Richardson, 1890).

51. *South Carolina Gazetteer and Business Directory* (Charleston: Lucas & Richardson, 1886–87). Knox-Wise family album, photographic collection, Winthrop University Archives, Rock Hill, S.C.

52. *Chester Reporter,* 28 October 1881.

53. Ibid., 2 November 1882.

54. *Chester Lantern,* 15 July 1898. *Fort Mill Times,* 9 May 1900–into 1902.

55. *Business and Professional Directory of Cities ans Towns* for 1900.

56. Photographic collection, Spartanburg County Historical Association, Spartanburg, S.C.

57. *Laurens Advertiser,* 3 November 1886.

58. Ibid., 10 August 1887.

59. *Columbia City Directory,* volumes for 1888 through 1916.

60. *(Kingstree) County Record,* 17 November 1898. Advertisement by Howie on back of stationery used by Columbia merchant J. P. Meehan, 15 January 1899, collection of the author. South Carolina College annual, the *Garnet and Black,* 1899. *Greenwood Index,* 19 July 1900.

61. *Columbia Daily Record,* Special Souvenir Number, 1912.

62. *Columbia City Directory,* volumes for 1899, 1903, and 1904–05.

63. Ibid., 1893.

64. *Columbia City Directory,* volumes for 1899 through 1915. W. S. Kline, illus. and comp., *Illustrated Columbia, South, Carolina 1904* (Columbia, S.C.: R. L. Bryan Company, 1904), 10 and 19. SCL.

65. *Columbia City Directory,* volumes for 1891 through 1900. *South Carolina State Gazetteer and Business Directory* for 1898. SCL.

66. Photographic collection, Historical Center of York County, York, S.C.

67. *(Gaffney) Weekly Ledger,* 14 November 1894.

68. Stowe, "Development of the Commercial Photographic Industry in Sumter."

69. SCL.

70. *Darlington News,* 14 April 1892. *Business and Professional Directory of Cities and Towns* for 1900. SCL. Letter from Horace F. Rudisill to the author, February 1997.

71. *The Exposition,* publication of the South Carolina Inter-State and West Indian Exposition, 1901, 260–61.

72. SCL.

73. Most of the information on the Hamilton studios was secured through telephone interviews in early 1996 and an in person interview on 21 February 1996 with Warren K. Hamilton's granddaughter, Mrs. H. R. Wyman.

74. *South Carolina State Gazetteer and Business Directory* for 1898. *Dillon Herald,* 2 February 1905 into 1906.

75. *Independent Republic Quarterly,* October 1970, 26. Picture postcard, collection of the author.

76. *Florence City Directory,* volumes for 1923 through 1937.

77. *Spartanburg City Directory,* 1896 (town of Duncan section of the directory).

78. SCL.

79. SCL. Massengill, "To Secure a Faithful Likeness," *Carolina Comments* 44:1, 33.

80. *Florence Daily Times,* 5 January 1895. SCL.

81. *Business and Professional Directory of Cities and Towns* for 1900.

82. *Business and Professional Directory of Cities and Towns* for 1900. *Florence City Directory,* volumes for 1913 through 24. SCL. Florence High School annual, the *Florentine,* for 1918 through 1921. *American Journal of Commerce,* April 1914.

83. Hopper and Moss, *Toward the Light,* 25.

84. *South Carolina State Gazetteer and Business Directory* for 1886-87, and 1890-91.

85. Hopper and Moss, *Toward the Light,* 25.

86. *(Gaffney) Weekly Ledger,* 2 March, 13 April, 4 May, 29 July 1894.

87. *(Gaffney) Ledger,* 23 December 1897; 6 January 1898. *Greenville City Directory,* 1899–1900. Massengill, "To Secure a Faithful Likeness," *Carolina Comments* 44:1, 34.

88. *(Gaffney) Ledger,* 8 August 1899; 6 and 10 April, 1 June 1900; 4 and 21 June, 2 July, 10 August, 10 December 1901; 30 June 1902. Photographic collection, Historical Center of York County, York, S.C. *Yorkville Enquirer,* 3 February 1911.

89. *Georgetown Enquirer,* 6 March 1882.

90. *South Carolina State Gazetteer and Business Directory* for 1898.

91. *Greenville City Directory,* volumes for 1883 through 1910.

92. *Historical and Descriptive Review of the State of South Carolina,* 119.

93. *Greenville City Directory,* 1888. *Greenville Daily News, Sunday Times,* 28 January 1899. *(Greenville) Evening Observer,* 16 March 1900. SCL.

94. Display ads in Furman University annual, the *Bonhomie,* 1901, 1904, and 1905.

95. *Greenville City Directory,* 1883–84.

96. *South Carolina Gazetteer and Business Directory* for 1890-91.

97. *Greenville City Directory,* 1888. SCL.

98. *South Carolina State Gazetteer and Business Directory* for 1886-87 and 1898. *Greenville City Directory,* volumes for 1888, 1896, and 1901–02.

99. *Greenville City Directory,* 1899–1900.

100. Ibid.

101. SCL. W. F. Watson, *Laboratory Courses in Chemistry* (Greenville: Shannon & Co., 1895).

102. *Greenwood Index,* 2 December 1897. Photographic collection, Greenwood Museum.

103. *South Carolina State Gazetteer and Business Directory* for 1898.

104. *Lancaster Ledger,* 6 June 1924 and 8 May 1934. *Fort Mill Times,* 1 July 1903. Clyde Calhoun Pittman, *Death of A Gold Mine* (Columbia, S.C.: R. L. Bryan Company, 1972), 54 and 56.

105. *Business and Professional Directory of Cities and Towns* for 1900.

106. *South Carolina State Gazetteer and Business Directory* for 1898.

107. *Laurens Advertiser,* 7 October 1885. *Easley Messenger,* 14 January 1887. *South Carolina State Gazetteer and Business Directory* for 1898 and *Business and Professional Directory of Cities and Towns* for 1900.

108. Wil Lou Gray Family Papers, SCL.

109. *Laurensville Herald,* 30 June 1899. *Scrapbook* (published by Laurens County Historical Society and Laurens County Arts Council, 1982), 272–73.

110. *Lexington Dispatch,* 22 October 1890. *Business and Professional Directory of Cities and Towns* for 1900.

111. *South Carolina State Gazetteer and Business Directory* for 1886-87 and 1890-91.

112. *South Carolina State Gazetteer and Business Directory* for 1898.

113. SCL. Winthrop College annual, the *Tatler,* 1904. *York City Directory,* volumes for 1909 through 1914. Photographic collection, Rock Hill Public Library.

114. *(Abbeville) Press and Banner,* 9 December 1885.

115. *Newberry Herald,* 16 November 1882; 5 February 1883. Salter Family Papers, SCL.

116. *Newberry Observer,* 9 February 1884. Newberry College publication, the *Stylus,* January 1908.

117. Salter Family papers, SCL.

118. Ibid. Newberry College annual, the *Newberrian,* 1912. *Newberry City Directory,* 1921–22.

119. Salter Family papers, SCL. Newberry College annual, the *Stylus,* January 1908.

120. Newberry College annual, the *Newberrian,* volumes for 1920 through 1925. *Newberry City Directory,* 1921–22.

121. SCL.

122. *South Carolina State Gazetteer and Business Directory* for 1898. SCL.

123. O'Neall and Chapman, *Annals of Newberry,* 791.

124. *Augusta City Directory,* volumes for 1899, 1903, and 1907.

125. SCL. *Georgetown Times,* 12 December 1891 through April 1892. *(Georgetown) Semi-Weekly Times,* 5 April and 11 November 1893; 6 November 1895; 13 November 1897. *Florence Daily Times,* 9 October 1896. *Business and Professional Directory of Cities and Towns* for 1900. *Orangeburg City Directory,* 1921–22.

126. SCL. Bill Cobb and Gene Weldon, *Memories of Pelzer* (Bountiful, Utah: Family History Publishers, 1995), 184 and 206.

127. *Business and Professional Directory of Cities and Towns* for 1900. *Greenville City Directory,* 1903–04. *Piedmont Messenger,* 1 July 1904.

128. *Rock Hill Herald,* 3 January 1882.

129. Ibid., 10 September 1890.

130. *Rock Hill Herald,* 7 March 1894. SCL.

131. *Rock Hill Herald,* 5 January and 24 August 1898; 8 April 1899 through 1900.

132. *South Carolina Gazetteer and Business Directory* for 1890-91.

133. Photographic collections of the Spartanburg County Historical Association, Spartanburg, S.C., and SCL.

134. *Historical and Descriptive Review of the State of South Carolina,* 195.

135. Photographic collection, Spartanburg County Historical Association, Spartanburg, S.C..

136. Wofford College *Wofford Journal,* June 1893, May 1896, December 1897, June 1900. *Spartanburg Almanac,* October 1903, 1906, 1907. *Spartanburg City Directory,* volumes for 1896 through 1920. *Spartanburg Herald,* 6 September 1906. Advertisement in Converse College *Concept,* May 1900. Wofford University Archives, photograph of C. R. Calhoun. Photographic Collection, SCL.

137. Advertisement, Converse College *Concept,* November 1895. Advertisement, Wofford College *Wofford Journal,* January 1896. *Spartanburg City Directory,* volumes for 1896 through 1924. *Spartanburg Herald,* 6 September 1906. *Spartanburg Almanac,* 1894, p. 20. Advertisement in Wofford College annual, the *Bohemian,* 1908.

138. Wofford University Archives, photographic collection.

139. *Spartanburg City Directory,* volumes for 1899 and 1908 through 1913.

140. *Spartanburg City Directory,* 1899.

141. *South Carolina Gazetteer and Business Directory* for 1886–87 and *Business and Professional Directory of Cities and Towns* for 1900. *Florence City Directory,* 1894. Stowe, "Development of the Commercial Photographic Industry in Sumter," 75.

142. *(Sumter) Watchman and Southron,* 5 November 1889. *(Sumter) Daily Item,* 25 October 1894. *(Charleston) News and Courier,* 20 December 1895, p. 2. *(Georgetown) Semi Weekly Times,* 25 April 1896.

143. *(Sumter) Daily Item,* 2 April 1897. Stowe. "Development of the Commercial Photographic Industry in Sumter," 67, 70. *Sumter Herald,* 16 September 1926.

144. SCL. Photographic collection, Sumter County Museum. *Sumter Herald,* 27 March, 3 April and 22 May 1924; 2 November 1926.

145. Stowe, "Development of the Commercial Photographic Industry in Sumter," 79–80.

146. Ibid., 65.

147. *Sumter Herald,* 2 April 1897. *Business and Professional Directory of Cities and Towns* for 1900.

148. *Edgefield Chronicle,* 20 January 1882.

149. SCL.

150. Collection of the author. SCL.

151. SCL.

152. Collection of the author.

153. *Business and Professional Directory of Cities and Towns* for 1900.

154. Hudson Family photographs. Stokes Family Papers, SCL. *(Walterboro) Press and Standard,* 7 October 1914.

155. SCL.

156. SCL.

## Notes to chapter 7

1. Ernest McPherson Lander, Jr., *A History of South Carolina, 1865–1960* (Chapel Hill: University of North Carolina Press, 1960). Wallace, *South Carolina: A Short History, 1520–1948.* References for information about photography included in the introduction to this chapter are found under the appropriate photographer later in the chapter. The source for all other historical information is either Lander or Wallace.

2. A. J. McKelvey, *Child Labor in the Carolinas* (New York: National Labor Committee, 1908), pamphlet 92. Edom, *Photojournalism: Principles and Practices,* 34–35.

3. *Abbeville Medium,* 17 February and 10 March 1910. *Abbeville Press and Banner,* 24 February 1949. Letter from John Blythe, Jr., to the author, 25 June 1998. SCL.

4. *(Anderson) People's Advocate,* 1 January, 3 March, 13 June, 18 July 1904. *Anderson City Directory,* volumes for 1905 through 1923. *Growth and Progress* (Anderson, S.C.: Anderson Printing and Stationery Company, 1907), 13.

5. *Anderson City Directory,* volumes for 1905–06 and 1909–10.

6. Ibid., 1905–06.

7. *Anderson City Directory,* volumes for 1909–10 and 1911–12. Postcard collection, SCL.

8. Postcard collection, SCL. *Anderson City Directory,* 1909–10.

9. *Anderson City Directory,* volumes for 1907 through 1921. *Growth and Progress,* 11.

10. *Anderson City Directory,* volumes for 1915 through 1940.

11. *Anderson City Directory,* volumes for 1914 through 1940. Anderson College annual, the *Sororian,* 1914 and 1917.

12. *Lexington Dispatch,* 24 June 1903.

13. *Batesburg Advocate,* 16 October 1901 and the year 1902; 23 May 1906. Photograph in collection of Paige Sawyer.

14. *Batesburg Advocate,* 14 August 1901.

15. *Beaufort Gazette,* 2 March, 13 April 1905.

16. *Beaufort Gazette,* 8 October 1903. *Report of Port Royal Naval Station by the Citizens Committee of Beaufort and Port Royal, S.C.*

17. N. Clark., ed., *Southern Auto Guide and Beaufort County Directory for 1918–19* (Beaufort: Editor & Publisher, 1918).

18. Postcard collection, SCL.

19. A 1913 postcard view of the McCall Hotel, collection of the author. SCL. Lowery-Avery family album, Winthrop University Archives, Rock Hill, S.C. Conversation between William Kenny and author, 19 April 1996.

20. *(Bishopville) Leader & Vindicator,* 4 February 1904.

21. Ibid., 6 May 1907.

22. *Camden Chronicle,* 29 April 1932, 18 April 1940, 2 November 1945.

23. Author's interview with Willene West Ogburn, September 1995.

24. Photographic collection, Camden Archives and Museum and SCL.

25. *Camden Chronicle,* 3 December 1909.

26. *Camden Chronicle,* 22 July 1910, 8 and 15 May 1914. SCL. Camden Archives and Museum, Camden, S.C.

27. *Fort Mill Times,* 28 April 1908. *Camden City Directory,* 1914–15. *Camden Chronicle,* 5 November 1926.

28. *Charleston City Directory,* 1902.

29. *Charleston City Directory,* volumes for 1903 through 1910. *Camden Chronicle,* 29 January and 23 April 1915. *Columbia City Directory,* volumes for 1922 through 1926.

30. *Charleston City Directory,* 1906.

31. *Charleston City Directory,* volumes for 1910 through 1932. *Columbia City Directory,* volumes for 1918 through 1921.

32. *Charleston City Directory,* volumes for 1912 through 1926.

33. *Charleston City Directory,* volumes for 1910 through 1940.

34. Ibid.

35. *Charleston City Directory,* 1919.

36. Postcard collection, SCL.

37. *Chester Lantern.* 6 February and 8 May 1906. Salter Family Papers and Postcard collection, SCL. *Columbia Record,* 5 May 1913.

38. *Chester City Directory,* 1908–09.

39. *Chester City Directory,* 1908–09. *Chester Reporter,* 18 November 1915. SCL.

40. SCL.

41. Ad in the Presbyterian College *Collegian,* April 1904.

42. SCL.

43. *Columbia City Directory,* 1904.

44. *Columbia City Directory,* volumes for 1906 through 1940.

45. "Industrial Number, Descriptive of and Illustrating Columbia of the Future," *American Journal of Commerce* 21:37 (March 1911), 26.

46. *Mercantile and Industrial Review of Columbia and Richland County South Carolina* (issued by the Industrial Department of the Seaboard Air Line Railway, 1907), 43. Walter L. Blanchard, *Camp Jackson and the City of Columbia, S.C.* (Columbia: Blanchard, n.d.). Postcard collection, SCL. Harold Tatum and W. L. Blanchard, *Buildings and Reminders of Early Days, South Carolina,* vol. 1 (sponsored by John R. Todd, Hugh S. Robertson, Dr. James M. Todd, 1931), SCL.

47. *Lancaster Ledger,* 4 August 1914.

48. *Camden Chronicle,* 12 January 1923.

49. Ibid., 29 June 1923.

50. *Columbia City Directory,* volumes for 1907 through 1918.

51. *Columbia City Directory,* volumes for 1911 through 1914.

52. Ibid., 1911.

53. Ibid., volumes for 1912 through 1919.

54. Ibid., 1912.

55. Ibid., volumes for 1914 through 1931.

56. Ibid., volumes for 1914 through 1927. SCL.

57. Ibid., volumes for 1918 through 1921.

58. Ibid., volumes for 1917 through 1940. Curtiss Bartlett Munn papers, SCL.

59. Photographic collection, South Carolina Department of Archives and History. Photographic collection, Camden Archives and Museum. Newberry College annual, the *Newberrian,* 1928–29, 1932. SCL. Stowe, "Development of the Commercial Photographic Industry in Sumter," 82–84. *Columbia City Directory,* volumes for 1930 through 1937.

60. *Columbia City Directory,* volumes for 1916 through 1955. SCL. Display ad in Columbia High School annual, the *Columbian,* 1930.

61. *Columbia City Directory,* volumes for 1918 through 1932. *Camden Chronicle,* 22 June 1922. *Bamberg Herald,* 27 January 1931.

62. Letter from Horace F. Rudisill to the author, February 1997.

63. Ibid.

64. Ibid.

65. Author's interview with Nyles Rowell, 1995. Photographic and postcard collections, SCL.

66. *Dillon Herald,* 3 February 1914.

67. *Easley Progress,* 30 July 1902; 15 February 1905; 7 June 1905 into 1906. Stokes Family Papers, SCL.

68. *Easley Progress,* 19 October 1933.

69. Ibid., 25 May, 29 June, 12 October 1921; 5 March, 16 October 1922; 16 May, 12 and 26 December 1923; 19 March, 30 April 1924; 11 March, 26 November 1925; 25 February 1926; 6 April 1928; 3 January, 4 April 1929; 9 March, 3 August 1932; 2, 9 and 23 March, 27 August, 19 October 1933; 21 June 1934; 21 February, 2 May 1935; 5 November 1936; 2 February, 31 August 1939; 15 February 1940; 8 May 1941.

70. Ibid., 2 May 1935.

71. *Fort Mill Times,* 16 October 1906.

72. Vassy Helen Callison and Bobby Gilmer Moss, *Cherokee County's First Half-Century through the Lens of June H. Carr, Photographer* (Gaffney: Southern Renaissance Press, 1975), vi–vii.

73. *Gaffney Ledger,* 18, 21 March, 1 and 18 April, 6, 9, 27 May, 21 October, 11 and 28 November, 16 December 1902; 1, 6, 27 January, 3, 24 February, 3, 17,31 March, 17, 28 April, 12, 26 May, 16, 23 June, 17, 21 July, 25 August, 20 September, 27, 30 October, 24 November, 1 December 1903; 12 January, 2 February 1904.

74. Callison and Moss, *Cherokee County's First Half-Century,* vi–vii.

75. Ibid., vii. Edom, *Photojournalism: Principles and Practices,* 25–28.

76. *(Georgetown) Sunday Outlook,* 1, 24 December 1901; 23 April, 10 October, 28 November 1903; 30 January, 11 and 18 June, 27 August, 8 October 1904; 25 February, 7 June, 5 August, 30 September 1905; 13 August 1910. *A Few Facts Regarding the Health of Georgetown and Georgetown County* (Georgetown: Times Job Department, 1911); printed letter by D. C. Simpkins dated 30 September 1911.

77. Morgan photographic collections, Georgetown County Public Library, and SCL.

78. *(Georgetown) Sunday Outlook,* 20 July 1907. Author's interviews with Mrs. Florence Potts, a granddaughter of Simpkins, conducted in 1993.

79. Postcard collection, SCL.

80. *Greenville City Directory,* volumes for 1910 through 1913. Display ad in Furman University annual, the *Bonhomie,* 1911.

81. *Greenville City Directory,* 1912.

82. Ibid., volumes for 1909 through 1921. Display ad in Furman University annual, the *Bonhomie,* 1910.

83. *Greenville City Directory,* 1912.

84. Ibid.

85. Ibid. SCL.

86. *Greenville City Directory,* volumes for 1913 through 1947.

87. Display ads in Furman University annual, the *Bonhomie,* 1915 through 1920.

88. *Greenville City Directory,* volumes for 1935 through 1947.

89. Ibid., volumes for 1901 through 1904 and 1917 through 1924. SCL.

90. *Greenville City Directory,* volumes for 1917 through 1921.

91. Ibid., volumes for 1919 through 1924. Display ads in Furman University annual, the *Bonhomie,* 1921 through 1923.

92. *Greenville City Directory,* volumes for 1919 through 1924.

93. Ibid., volumes for 1919 through 1935.

94. Ibid., volumes for 1919 through 1940.

95. Author's interview with Cynthia Martin and Mr. and Mrs. Murphy Hall, November 1998. *Greenwood Index,* 7 August 1902, *Greenwood City Directory,* volumes for 1908–1909, 1923–1924, 1927, 1929–1930, 1936, and 1938–1939. *Laurens City Directory,* volumes for 1911–1912 and 1917. Presbyterian College literary journal, *The Collegian,* April 1910. *Chester News,* 11 August 1906.

96. *Chester City Directory,* volumes for 1923 through 1990.

97. Presbyterian College annual, *Pac Sac,* 1933–36.

98. *Newberry City Directory,* volumes for 1933 to present. *The Newberrian,* 1935–38. Interview with family members.

99. *Greenwood City Directory,* volumes for 1912–1913 and 1916–1917.

100. *Greenwood City Directory,* volume for 1912–1913.

101. *The Erothesian,* display ad March 1920. *Greenwood City Directory,* volumes for 1917 and 1923.

102. *The Exposition,* 116. Postcard collection, SCL.

103. *Hartsville Messenger,* 18 June, 20 October 1908. *(Bishopville) Leader and Vindicator.* 10 November 1908.

104. Author's interview with Mary Ellen Osman, 1994.

105. Biographical sketch written by Elizabeth Cleland Peeples of her relative, Robert Lee Cleland. Photographic collection of Mildred Rivers.

106. Postcard Collection, SCL.

107. Author's telephone interview with Mrs. Miles O'Reilly, Jr., 1993. North Studio mailing envelope, in the collection of the author.

108. Photograph in the collection of the author.

109. *Orangeburg City Directory,* 1920–21.

110. Display ad in Winthrop College *Collegian,* 17 July 1902. SCL.

111. Postcard Collection, SCL.

112. *Rock Hill Herald,* 17 February, 5 September, 3 November 1906; 2 January, 2 July, 14 December 1907. *Rock Hill–York City Directory,* 1909.

113. *Rock Hill Herald,* 11 and 26 December 1907.

114. *Rock Hill Herald,* 5 May 1911. Winthrop College *Journal,* December 1913. *Rock Hill City Directory,* 1913–14.

115. Display ads in Winthrop College annual, *The Tatler,* 1922 and 1924. *Rock Hill City Directory,* volumes for 1925 through 1940.

116. *(St. Matthews) Commercial Advance,* 16 March 1907; 4 April 1908. *(St. Matthews) Calhoun Advance.* 11 February, 31 March 1910; 5 October, 11 November, 14 December 1911; 4 January, 28 November 1912.

117. Display ad, *Wofford Journal,* December 1910.

118. Stowe, "Development of the Commercial Photographic Industry in Sumter," 74–75.

119. *Spartanburg City Directory,* volumes for 1905 through 1930.

120. Ibid., volumes for 1911 through 1914. Display ad in St. John's High School annual, *Echoes,* 1918.

121. *Spartanburg City Directory,* 1913.

122. Ibid., volumes for 1914 and 1915.

123. Ibid., volumes for 1914 and 1915.

124. Ibid., volumes for 1918 through 1920.

125. Ibid., volumes for 1918 through 1940.

126. *Spartanburg City Directory,* volumes for 1920 through 1934. Display ad in *The Sentinel,* vol. 2 (published by the Student Body of Wofford Fitting School), 1920.

127. Stowe, "Development of the Commercial Photographic Industry in Sumter," 75–76.

128. Ibid., 75–76.

129. Ibid., 75–77.

130. *Charleston City Directory,* 1912. Stowe, "Development of the Commercial Photographic Industry in Sumter," 76–79.

131. *Columbia City Directory,* volumes for 1938 through 1940.

132. Author's interview with W. C. Smith, son of Vivian Smith, November 1995.

133. Ibid.

134. *Union City Directory,* 1911–12. SCL.

135. *Union City Directory,* 1911–12.

136. Postcard collection, SCL.

137. *Union City Directory,* 1920–21.

138. Postcard collection, SCL.

139. SCL.

140. *(Walterboro) Colleton News,* 19 May 1909. Author's interview with Howard Woody, October 1998.

141. Postcard collection, SCL.

142. *(Walhalla) Keowee Courier,* 22 June 1909.

143. SCL.

144. *Yorkville Enquirer,* 3 October 1902. SCL.

145. SCL.

## Notes to Chapter 8

1. Lander, *A History of South Carolina, 1865–1960.* Wallace, *South Carolina: A Short History, 1520–1948.* Unless otherwise noted, these two sources were consulted for the historical information in the introduction to this chapter. Population statistics are quoted from U.S. censuses and from map 9 of a set of maps originally edited by D. D. Wallace and re-edited by Carl L. Epting (Chicago: Denoyer-Geppert Company, 1968).

2. Jerry L. Thompson, *Walker Evans at Work* (New York: Harper & Row), 118–19.

3. Ibid., 98. Annemette Sorensen, *Peter Sekaer, New Deal Photographer* (Copenhagen: The Royal Library, 1990). Author's interview with Marion Hunter, 12 March 1999.

4. Constance B. Schulz, *A South Carolina Album, 1936–1948* (Columbia: University of South Carolina Press, 1992), 1–19. Schulz chronicles the history of the Farm Security Administration's photographic activities in detail. Included are biographical sketches of the photographers and a total of 113 South Carolina photographs by FSA photographers, 46 of which date to 1940, the last year covered by this study.

5. Federal Writers Project files, SCL.

6. Photographic collection, SCL. Letter from George W. Cronyn to Mabel Montgomery, 13 July 1936, Federal Writers' Project Archives, SCL.

7. South Carolina Department of Agriculture, Commerce and Industry, *Handbook of South Carolina* (Columbia: The State Company, 1908).

8. *The (Columbia) State,* 31 October and 24 November 1911; 9 February 1913. *Lancaster Ledger,* 4 August 1914. *Columbia Record,* 12 August 1925.

9. South Carolina State Museum Collection.

10. Photographic Collection of Aiken County Museum. Harry Worchester Smith, *Life and Sport in Aiken and Those Who Made It* (New York: Derrydale Press, 1935).

11. Photographic collection of Aiken County Museum.

12. Ibid.

13. Horry County Museum photographic collection. Author's interview with Stewart Pabst, February 12, 1999.

14. *(Batesburg) Summerland Headlight.* 21 April 1924.

15. Display ad in the Beaufort High School annual *Beaufortonian,* 1940. Author's interview with Lucille Culp, 2 July 1999.

16. Photographic collection of Camden Archives and Museum.

17. *Charleston City Directory,* volumes for 1921 through 1942.

18. *Charleston City Directory,* volumes for 1921 through 1940.

19. *Columbia City Directory,* volumes for 1921 through 1940. *Columbia Telephone Book, 1939.*

20. *Columbia City Directory,* volumes for 1937 through 1970; *The (Columbia) State,* 5 May 1996, section F, p. 2.

21. Horry County Museum Collection.

22. *Darlington City Directory,* 1924–25. Letter of Horace F. Rudisill to the author, February 1997.

23. Letter of Horace F. Rudisill to the author, February 1997.

24. Ibid.

25. *Easley Progress,* 21 February 1935.

26. Ibid., 23 March 1939.

27. *Florence City Directory,* volumes for 1929 through 1938. Display ads in *The Florentine,* 1926, 1930–31, 1949.

28. *Florence City Directory,* 1938.

29. *Greenville City Directory,* volumes for 1921 through 1940.

30. Ibid.

31. *Greenville City Directory,* volumes for 1930 through 1970. Author's telephone interview with Judy Bainbridge, Furman University, 4 December 1997.

32. *Greenville City Directory,* volumes for 1930 through 1938.

33. Ibid., volumes for 1930 through 1940.

34. Ibid., volumes for 1937 through 1942.

35. Ibid.

36. Ibid., volumes for 1938 through 1940.

37. Ibid.

38. Ibid.

39. SCL.

40. Letter from Horace F. Rudisill to the author, February 1997, and a copy of an undated newspaper clipping.

41. Ibid.

42. Hartley, Lodwick. *Plum Tree Lane.* (Columbia: Sandlapper Store, 1978), 172–73.

43. *Orangeburg City Directory,* volumes for 1938 through 1940. SCL.

44. Ibid.

45. *Spartanburg City Directory,* volumes for 1924 through 1940. SCL.

46. *Spartanburg City Directory,* volumes for 1926 through 1928.

47. Ibid., volumes for 1934 through 1936.

48. Ibid., volumes for 1936 through 1940.

49. Ibid., volumes for 1938 through 1940.

50. *Sumter City Directory,* 1940.

51. *Union City Directory,* volumes for 1925 through 1927.

52. Unless otherwise noted, photographs listed as "Unknown" are all located in the photographic collection of SCL.

53. Chester County Museum.

## Notes to chapter 9

1. Wallace, *South Carolina: A Short History, 1520–1948,* pp. 709–10.

2. Marina Wikramanayake, *A World in Shadow: The Free Black in Antebellum South Carolina* (Columbia: University of South Carolina Press, published for the South Carolina Tricentennial Commission, 1973), 183.

3. Ibid., 47–48.

4. Ibid., 440.

5. Ibid., 566–67.

6. Ibid., 597–606.

7. I. A. Newby, *Black Carolinians: A History of Blacks in South Carolina from 1895–1968* (Columbia: University of South Carolina Press, published for the Tricentennial Commission, 1973), 80–135.

8. *Georgetown Enquirer,* 6 March 1882.

9. *(Gaffney) Ledger,* 27 September 1896.

10. *Anderson City Directory,* 1905–1906 and 1909–1910.

11. *Fort Mill Times,* 16 October 1906.

12. South Carolina Historical Society.

13. Thomas Birch, *Zip Coon* (New York: 1834); cover of "Zip Coon" song by Endicott & Swett of New York, 1834. Miss Ann Rives Music Book at SCL. Postcard Collection, SCL. An examination of most dealer stocks in postcards today will reveal a section on black caricatures dating from the 1905–1920 period.

14. *The Guidon,* annual of Bailey Military Institute of Greenwood, S.C., 1927.

15. Lander, *A History of South Carolina, 1865–1960,* 105–121.

16. In the preparation of this work all of the major and most of the minor collections of photo-

graphs in South Carolina were examined. Included were collections of historical societies, colleges and universities, and museums as well as a number of private collections. Several out-of-state collections were likewise studied.

17. Barger and White, *The Daguerreotype,* 72.

18. *Charleston Mercury,* 31 October 1860. SCL.

19. Davis, *George N. Barnard,* 186–190.

20. Ibid., 191.

21. Ezekiel Jeremy Charles Wood, *Wandering in the Wilderness,* compiled by William Elliott Wood (Richmond: Dietz Printing Company, 1945), 232. Dr. Wood indicates that Palmer also photographed their Aiken home, called "Homestead," in 1888 (see frontispiece of this book). Wood's reference to "strange customs" probably referred to the African American practice of placing some items possessed by the deceased on top of the grave."Harriett" was the name of one of Dr. Woods's African American servants. An inquiry at the Smithsonian Institution failed to unearth these Palmer images.

22. SCL.

23. Ibid.

24. Photographic collection and anonymous 1901 Camden scrapbook, SCL.

25. Anonymous Camden scrapbook, SCL.

26. Special Collections, Duke University.

27. Nina J. Root, "Legacy of a Reluctant 'Cameraman,' " *Journal of the American Museum of Natural History,* 105:8 (8 August 1996), 78–81.

28. D. Audley Gold Collection, Historical Center of York County, York, S.C.

29. Callison and Moss, *Cherokee County's First Half-Century,* vi–viii.

30. SCL.

31. SCL.

32. Julia Mood Peterkin, *Roll, Jordon, Roll* (New York: Robert O. Ballou, 1933). The South Carolina Historical Society photographic collection contains a number of Ulmann photographs.

33. Doris Ullman, with preface by William Clift and "A New Heaven and a New Earth" by Robert Coles, *The Darkness and the Light: Photographs by Doris Ulmann* (Millerton, New York: Aperture, 1974).

34. Information about Penn School photographers and photographs was located in the description of the collection at Chapel Hill, Southern Historical Collection, University of North Carolina.

35. Edith M. Dabbs, *Face of an Island: Leigh Richmond Miner's Photographs of Saint Helena Island* (Columbia, S.C.: R. L. Bryan Company, 1970).

36. Wallace, *South Carolina: A Short History, 1520–1948,* appendix 3.

37. *Anderson City Directory,* volumes for 1905 through 1923.

38. James Artemus and Juanita Artemus, *The Legacy of Black Pioneers, 1907–1980: East Church Street, Anderson South Carolina* (Anderson, S.C.: City of Anderson, 1982).

39. *Anderson City Directory,* volumes for 1925 and 1927.

40. P. E. Rowell, *The Towns of Lexington County, South Carolina. Columbia City Directory,* volumes for 1898 through 1907. SCL.

41. Record Group 58, Microform Publication, M-789, reels 1 and 2, National Archives. *(Charleston) South Carolina Leader,* 23 December 1865.

42. *Charleston Advocate,* 11 May 1867. *Charleston City Directory,* volumes for 1867 through 1870.

43. Record Group 58, Microform Publication, M-789, reels 1 and 2, National Archives.

44. *Charleston City Directory,* volumes for 1878 through 1881.

45. *Charleston City Directory,* volumes for 1882 through 1906.

46. Research notes of Thomas L. Johnson, Columbia, S.C.

47. SCL.

48. *Charleston City Directory,* 1892. Research notes of Thomas L. Johnson, Columbia, S.C.

49. Abby D. Munro Papers, SCL.

50. *Charleston City Directory,* 1892.

51. *Charleston City Directory,* volumes for 1906 through 1932.

52. Flowers Collection, Duke University.

53. Jeanne Moutoussamy-Ashe, *Viewfinders: Black Women Photographers* (New York, Writers & Readers Publishing, 1993), 34–39. A dozen examples of Harleston's work are included in this book. Deborah-Willis Thomas. *Charleston City Directory,* volumes for 1922 through 1932. SCL.

54. *Charleston City Directory,* volumes for 1940 and 1942.

55. Ida R. Massey, *Ida Massey's Cook Book* (Chester: Arts Council of Chester County, 1976). *(Chester) News & Reporter,* 31 March 1976. Author's interview with Ann Marion, 15 March 1999.

56. *Columbia City Directory,* volumes for 1918 through 1921. SCL.

57. *Columbia City Directory,* volumes for 1919 through 1922.

58. Ibid., volumes for 1921 and 1922.

59. *Charleston City Directory,* volumes for 1922 through 1929.

60. SCL.

61. *Columbia City Directory,* volumes for 1920 through 1922.

62. Thomas L. Johnson and Phillip C. Dunn, *A True Likeness: The Black South of Richard Samuel Roberts, 1920–1936* (Columbia: Bruccoli Clark and Chapel Hill: Algonquin, 1986). Pages 1–10 of this book are the source for most of the information about Roberts.

63. Allen University annual *The Allenite,* 1938, last page.

64. SCL.

65. *Greenville City Directory,* 1923.

66. *Greenville City Directory,* 1924.

67. *Greenville City Directory,* volumes for 1926 and 1928.

68. *Orangeburg City Directory,* 1920–21.

69. Author's conversations with Thomas L. Johnson, 1996.

70. Stowe, "Development of the Commercial Photographic Industry in Sumter," 81.

71. Stowe, "Development of the Commercial Photographic Industry in Sumter," 81. SCL.

72. Stowe, "Development of the Commercial Photographic Industry in Sumter," 81.

73. *Sumter City Directory,* 1934.

## Notes to chapter 10

1. *Charleston Courier,* 14 February 1842.

2. Undated manuscript, private collection of Matthew R. Isenburg.

3. Ralph Greenhill and Andrew Birrell, *Canadian Photography: 1839–1840* (Toronto: Coach House Press, 1979), 26.

4. Photographic collections of the Greenwood Museum, Greenwood, S.C., SCL, and Greenville Public Library.

5. *Charleston City Directory,* volumes for 1872 through 1874.

6. Davis, *George N. Barnard,* 181.

7. Klugh-Hartley family album, in collection of the family.

8. *(Columbia) South Carolinian,* 17 April 1845.

9. *Yorkville Miscellany,* 7 December 1853. Massengill, "To Secure a Faithful Likeness," *Carolina Comments* 44:1, 147.

10. *Charleston Courier,* 25 April 1856.

11. SCL.

12. SCL. *Greenville City Directory,* 1883–84. Author's interview with Barbara Wise, granddaughter of George V. Hennies, 1994.

13. Letter of Thaddeus Mason Harris to his father, Dr. Thaddeus William Harris, 14 January 1834, SCL. Davy-Jo Stribling Ridge, *A Load of Gratitude: Audubon and South Carolina* (Columbia: Thomas Cooper Library, University of South Carolina, 1985), 17, 45. Margot Williams and Paul Elliott, "Maria Martin, the Brush Behind Audubon's Birds," *Ms.* 10 (April 1977), 14–18.

14. *(Columbia) South Carolinian,* 8 December 1842; 21 August 1847. *(Columbia) Southern Guardian,* 16 December 1846. *Charleston Courier,* 27 November 1846.

15. Photographs of late-nineteenth-century studios presented in chapter 13 show some of these features added for the benefit of women.

16. *Charleston City Directory,* volumes for 1884 and 1885; *South Carolina Gazetteer and Business Directory,* 1883-84.

17. *Historical and Descriptive Review of the City of Charleston,* 155–56.

18. Marius B. Peladeau, *Chansonetta: The Life and Photographs of Chansonetta Stanley Emmons, 1858–1937* (Waldoboro, Me.: Maine Antique Digest; Dobbs Ferry, N. Y. , distributed by Morgan & Morgan, 1977).

19. *Chester Reporter,* 6 December 1889. *(Chester) Palmetto Standard,* 28 May 1895. *Business and Professional Directory of Cities and Towns* for 1900.

20. *Chester Lantern,* 8 May 1906. Salter Family papers, September 1906, SCL.

21. *Chester Reporter,* 17 January 1906.

22. *Business and Professional Directory of Cities and Towns* for 1900. *Columbia City Directory,* volumes for 1903 through 1905. Author's interview with Mason Gibbes, 1994.

23. *Laurensville Herald,* 30 June 1899.

24. *Scrapbook* (published by Laurens County Historical Society and Laurens County Art Council, 1982), 272–73.

25. Francis Hollerman, *The City of Seneca, South Carolina, The City of Opportunity, Its Centennial, Aug. 11–18, 1973* (Greenville: Creative Printers, Briggs & Associates, 1973), 52.

26. Information about the photographic work of these women at Penn School was taken from the calendar description of the collection at UNC–Chapel Hill and from the collection itself.

27. Myra F. Wyman, "Fifty Years in Photography," *The State Magazine,* 30 May 1954.

28. Ibid.

29. Author's interview with Barnwell, S.C., Public Library staff, 1993.

30. Author's interview with Isabella Murphy Meaney and her daughter, Mary M. Lucas, 1 June 1995.

31. Wyman, "Fifty Years in Photography," 30 May 1954.

32. *Camden City Directory,* 1914–15.

33. *Camden Chronicle,* 22 July 1910; 8 May 1914.

34. *Charleston City Directory,* volumes for 1901 through 1919.

35. Ibid., volumes for 1921 through 1943.

36. Ibid., 1938, display advertisement.

37. *Charleston City Directory,* volumes for 1917 through 1927.

38. Elizabeth Gibbon Curtiss, *Gateways and Doorways Of Charleston, South Carolina in the Eighteenth and Nineteenth Centuries* (New York: Architectural Book Publishing, 1926), vii.

39. *Columbia City Directory,* volumes for 1906 through 1918.

40. Ibid., volumes for 1918 through 1948.

41. *Camden Chronicle,* 28 November 1919. *(St. Matthews) Calhoun Advance,* 23 October 1919. Display advertisement, *Columbia City Directory,* 1922.

42. *Columbia City Directory,* volumes for 1919 through 1922.

43. Hopper and Moss, *Toward the Light,* 23–24.

44. *Greenville City Directory,* volumes for 1903–04, 1907, and 1909. SCL.

45. *Greenville City Directory,* volumes for 1913 through 1940. Furman University annual, the *Bonhomie,* volumes for 1915 through 1920. SCL.

46. *Greenwood City Directory,* volumes for 1912–13 and 1916–17.

47. Photographic collections, SCL and South Carolina Historical Society.

48. Louise Pettus and Martha Bishop, *Lancaster County: A Pictorial History* (Norfolk/Virginia Beach: Downing Company, 1984), 76, 91.

49. Lalla Stevenson and Foy Stevenson, *Charlotte Stevenson, Pioneer Social Worker: Her Life and Letters* (West Columbia, S.C.: Wentworth Printing, 1974), 251.

50. Most of the information about the Hamilton/Blackmon studios was provided through phone calls and an interview on 21 February 1996 with Mrs. H. R. Wyman, the granddaughter of Warren K. Hamilton.

51. *Augusta City Directory,* 1912.

52. *Rock Hill Herald,* 5 May 1911. *Wofford Journal,* December 1913. *Rock Hill City Directory,* 1913–14.

53. Wofford College, *Wofford Journal,* June 1902. *Spartanburg City Directory,* 1903–05. Converse College annual, *Y's and Other Y's,* 1907–08.

54. *Spartanburg Herald,* 6 September 1906. *Spartanburg City Directory,* volumes for 1905 and 1908–09.

55. *Spartanburg City Directory,* volumes for 1920 through 1924. *Spartanburg Almanac,* 1906 and 1907. *Spartanburg Herald,* 6 September 1906. Wofford College annual, *The Bohemian,* 1908.

56. Stowe, "Development of the Commercial Photographic Industry in Sumter," 79. SCL.

57. Stowe, "Development of the Commercial Photographic Industry in Sumter," 79.

58. *Sumter City Directory,* 1923–24. *Sumter Herald,* 14 April 1927. Stowe, "Development of the Commercial Photographic Industry in Sumter," 80–81.

59. Stowe, "Development of the Commercial Photographic Industry in Sumter," 76.

60. *Yorkville Enquirer,* 1903: November 27, 1904: April; May 27; August 30; October 4, 18 and 25; November 4 and 25; 9 December 1905: January 17 and 27; February 24; April 4 and 18; May 2 and 19; 6 June; July 21; August 15; October 31. 20 September 1907. Postcard collection, SCL. *Yorkville City Directory,* 1909.

61. *Yorkville Enquirer,* 4 October and 4 November 1904; 21 April 1905.

62. *Anderson City Directory,* 1922–23.

63. *Bennettsville City Directory,* 1925–26.

64. *Columbia City Directory,* volumes for 1932 through 1950.

65. *Columbia City Directory,* volumes for 1936 through 1943.

66. *Columbia City Directory,* 1939.

67. *Florence City Directory,* 1938.

68. Ibid.

69. *(Gaffney) Cherokee Times,* 28 November 1928.

70. *Greenville City Directory,* 1930.

71. Ibid., volumes for 1937 through 1947.

72. Ibid., 1937.

73. Ibid., 1937.

74. Ibid., volumes for 1938 through 1940.

75. Ibid., 1938.

76. Display ads in Newberry College annual, the *Newberrian,* 1925 and 1927. *Newberry City Directory,* 1932.

77. *Rock Hill City Directory,* volumes for 1936 through 1940.

78. *Rock Hill City Directory,* volumes for 1925 through 1940. Winthrop College annual, *The Tatler,* 1922 and 1924.

79. *Spartanburg City Directory,* volumes for 1935 through 1940.

80. Photographic collection, SCL. ALS from Bayard Wootten to Chapman J. Milling, March 18, 1948, Chapman J. Milling Papers, SCL.

81. Photographic collections of SCL and the author.

82. Schulz, *A South Carolina Album, 1936–1948,* pp. 16–17.

## NOTES TO CHAPTER 11

1. Rinhart and Rinhart, *American Daguerreotype,* 199–207. William Culp Darrah, *The World of Stereographs* (Gettysburg: W. C. Darrah, Publisher, 1977), 1–5. Edward W. Earle, *Points of View: The Stereograph in America, A Cultural History* (New York: Visual Studies Workshop Press, 1979), 9–14.

2. Waring, *You Asked for It,* 74.

3. *Graham's Magazine,* November 1853, 537–42.

4. *Charleston Courier,* 3 December 1858; 13 and 19 January, 29 October, 1859.

5. Darrah, *World of Stereographs,* 9–14.

6. Lou W. McCulloch, *Card Photographs: A Guide to Their History and Value* (Exton, Pa.:, Schiffer Publishing, 1981), 79. Darrah, *World of Stereographs,* 9–14.

7. Darrah, *World of Stereographs,* 197–212.

8. Photographic collection, SCL. Special Collections, Furman University Library.

# Index